16 ⁱ⁰⁄₀₇(¹⁴⁄₀₇)

GENUINE
AUTHENTIC

GENUINE
AUTHENTIC

The Real Life of Ralph Lauren

Michael Gross

HarperCollins*Publishers*

HarperCollins books may be purchased for educational, business, or sales promotional use. For information, please write: Special Markets Department, HarperCollins Publishers Inc., 10 East 53rd Street, New York, NY 10022.

FIRST EDITION

Designed by Sarah Maya Gubkin

Printed on acid-free paper

Library of Congress Cataloging-in-Publication Data

Gross, Michael
 Genuine authentic : the real life of Ralph Lauren / by Michael Gross–1st ed.
 p. cm.
 Includes bibliographical references.
 ISBN 0-06-019904-0
 1. Lauren, Ralph. 2. Fashion designers–United States–Biography.
I. Title.

 TT505.L38 G76 2003
 746.9'2'092–dc21
 [B] 2002032337

03 04 05 06 07 ❖/RRD 10 9 8 7 6 5 4 3 2 1

For Jane

I have tried to be authentic in everything I do.
—RALPH LAUREN

That's Ralph Lauren. I wish I were him.
—RALPH LAUREN

Contents

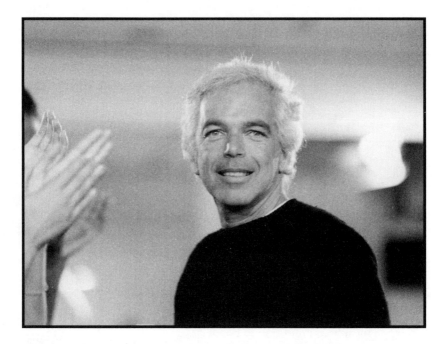

On the runway, April 1989.

Author's Note

I am making a commitment to you. I am giving you
anybody that you want to talk to.

— RALPH LAUREN

T hough I had met him and interviewed him a few times before, my rela-
tionship with Ralph Lauren really began in summer 1988 when he called
to congratulate me on a controversial magazine article I'd written about
Calvin Klein, the only other American fashion designer whose stature
outside the fashion business rivals his. A few years apart in age, Lauren and Klein
had grown up within blocks of each other in the Bronx, New York, had entered
the fashion business around the same time, and had risen to fame together,
locked in a spiral of opposition: Klein, square-jawed and handsome, a fashion
and disco darling, projected a sort of polymorphously perverse hedonism;
Lauren, a short, not terribly attractive family man, disdainful of and disdained by
fashion, was seen as a straight arrow traditionalist. Though they both deny it, they
have been and remain bitter rivals, in large part because of their shared origins,
but also because they both grew rich and powerful as much through canny
image manipulation as through designing skill.

My magazine story on Klein began with his cooperation, but ended up with-
out it. Contrary to the prevailing ethic of fashion journalism, my editors and I
believed that we worked for our readers, not our advertisers. "The Latest Calvin"

was considered a blistering exposé, and was apparently widely read, as that issue was the magazine's best-seller that year, even though it never openly stated the obvious fact of Klein's bisexuality. Still, Klein pulled millions of dollars of advertising out of the magazine—and kept it out for years.

Lauren called to express his delight that someone had finally written "the truth" about Klein. Though the piece was "unauthorized," Ralph clearly didn't think it was unfair.

Things are different when the story is about you.

This story began on October 5, 1999. I was having lunch at Harry Cipriani, one of New York's power dining rooms. Goldie Hawn and Kurt Russell were there, and so were Revlon's owner, Ronald O. Perelman, and Ralph Lauren, who was with a mutual friend. I went over to say hello, and we chatted a bit. Just before I returned to my table, Ralph said, "Hamilton [South, then the president of his company, Polo Ralph Lauren, and an acquaintance of mine] and I were talking about you this morning. Would you be interested in writing my biography?"

I said I was and we should talk more about it.

Two months and two days later, I called Hamilton South and asked him if Ralph had been serious. I told him I was about to meet with my publisher and wanted to propose a Lauren biography, but he could stop me if he spoke up. South told me to go ahead.

A few days later, I got a box of frozen steaks from Lauren's Double RL Ranch in Colorado as a Christmas present. The last time I'd received such a gift from him was in the mid-nineties, after I wrote a cover story about him for *New York* magazine; after I left the magazine to write a book about fashion models, he sent me a leather jacket. Considering him something of a friend, I kept it. A year later, I bought a Lauren wardrobe at a discount to wear on my book tour for *Model*. This was good for us both: I looked good, and my clothes got written up in the papers, as intended. Now, I decided that since we were about to do a book together, I would accept another gift. The Double RL steaks are really good.*

In January 2000, my publisher agreed to a Lauren book, and I called South to discuss it in more detail. Halfway through the conversation, he asked, "What about Ralph's private life?" I told him biographies were about lives. I would want to write about both Ralph's business life and personal life, and about the places

* I also wear other Lauren clothes, drink from Lauren Home Collection glasses, and sometimes sleep on Lauren sheets beneath a Lauren blanket—all bought at full retail.

where they mingled. South started to hem and haw, and I realized what the problem was.

"Shall we put a name to the elephant sitting on the coffee table?" I asked.

"What do you mean?"

My next two words sealed the fate of this book, though I wouldn't know that for months. I said the name of Polo Ralph Lauren's Safari fragrance model from a few years before: "Kim Nye." Lauren had had a messily public affair with Nye that was common knowledge in the fashion business—and had even been mentioned in the press. I would certainly have to write about her. A day or two later, South called back and said that he thought Ralph and I should speak directly from that point on. A lunch with Lauren was set up to take place at another power restaurant, the Four Seasons, on January 20, 2000.

That morning, Ralph's secretary called. He wanted to change the venue to his office because it was snowing. A few hours later we sat on leather and chrome chairs around a low glass table eating chicken and mesclun salad prepared by a private chef in Ralph's modest, all-white office on Madison Avenue—surrounded by a quarter century's accumulation of Lauren memorabilia. There were models of classic cars, airplanes, and a Zeppelin; a mock-up of the Rhinelander mansion, Lauren's New York City flagship store; framed magazine covers—including the issue of *New York* magazine that featured my story on him; photos of Lauren with famous favorites like Cary Grant and Audrey Hepburn; a framed invoice dated April 6, 1965, from A. Rivetz & Co., where Ralph had once been a tie salesman; a fire chief's hat; teddy bears; a marionette; old clothes and shoes; CFDA Awards; a Mercedes steering wheel; and a framed poem penned by Lauren's father, Frank Lifshitz, that began, "Hoping and praying that your dreams should be kept up. . . ."

Ralph, who wore hiking boots and a flannel shirt over another shirt, didn't waste much time on pleasantries before he brought up Kim Nye and his concern over how I would portray his relationship with her.

The problem was his family, he said—especially Ricky Lauren, his wife of thirty-five years. He said he'd asked his personal trainer—Ralph is buff—whether he should allow a book to be written about him. The trainer had wondered why he would do that since a book would have to get into things he wouldn't want publicized.

He'd made only one mistake in his life, he said—his affair with the model—and had regretted it ever since. He'd admitted it to his wife, and his marriage had survived. But whenever they watched a movie in which a character committed

adultery, the wound reopened. Ricky no longer reacted violently, but Ralph still cringed. Certainly, a book would be worse.

I was cringing a little at that point. Then he claimed that the affair had never been made public. I reminded him of an item that ran in *Spy* magazine that had him licking Nye's fingers in a restaurant. "Nobody read that," he said.

Ralph Lauren's skill at turning his fantasies into reality was one reason I was sitting there having this conversation, but another was my feeling that he'd asked me to write the book because I, too, had a reputation, and it had a value to him. In fifteen years of writing on fashion, I'd become a bit of a pariah for not pulling any punches, for saying out loud that fashion journalism is an oxymoron, for being the kid on the side of the road calling out the emperors of fashion for prancing around naked. So I told Lauren that I had to be free to write whatever I wanted, and I said aloud that an independent book would be better for him since he's often tarred as a fake. My idea was to argue how authentic he really is.

We talked about Kim Nye for another half hour—and then for another nine months. But right there and then, I asked if there were any other skeletons in his closet; in my years covering fashion, I'd heard about several, but I didn't want to show him my hand yet. He said, "I'm clean." Not a one. Except Kim Nye.

In that case, it shouldn't be an issue, I said. But then he asked about how I'd handle rumors about him. He told me that over the years he'd heard that he'd slept with many women—any woman I walk down the street with," including one of his top executives, Buffy Birrittella—and even heard rumors that he'd slept with other men. I kept to my message—there'd be no problem; I'd write about his one affair with sensitivity, assuming there was only one. Indeed, Kim would humanize him—and give the book a happy ending. He'd just celebrated his thirty-fifth wedding anniversary with Ricky at their Caribbean retreat in the exclusive vacation colony of Round Hill in Jamaica. I figured if he talked about Kim, I wouldn't need to write about any others I might find. Others I was pretty sure were there.

Lauren finally acceded. We'd do a book together as long as I was careful about Kim. We shook hands. I told him I expected to announce the book publicly any day and asked if that was a problem for him.

"Go ahead and announce it," he said.

I hoped to do that at Lauren's fall fashion show, on February 9, 2000. I went backstage to congratulate him afterward, a regular aspect of the collection ritual. When I reached him, he shook my hand and held it. "I'm worried about Kim," he said.

Ricky Lauren was standing inches away.

Something told me not to announce the book yet. Later that week, I was back in Lauren's office, talking about Kim Nye—again. He was still worried. I tried to be reassuring. After almost two hours of talking in circles, I left; once on the street, I called my editor and made it clear that I didn't think I could count on Ralph's cooperation. I also said I'd decided to proceed with the book regardless.

In mid-March, I called Lauren's secretary and left a message that I was finally signing a contract to write his biography. I made a date to see Lauren later that week—and then told a magazine gossip columnist and a newspaper editor about the book.

On Thursday, March 16, I arrived at Lauren's office for a ten A.M. meeting. As was his habit, he turned up about fifteen minutes later, dressed casually, having come from his home where he'd again been with his personal trainer. Again, he started in on Kim Nye.

If I insisted on writing about her, he said, he would withdraw his cooperation before it had even begun. A biography of Hollywood mogul David Geffen had just been published; Geffen had stopped cooperating with its author midway through the book, and several magazines and newspapers had done stories on the ensuing controversy. Lauren said he didn't want to be involved in anything like that.

Then it was back to Kim—"the only mistake I ever made, and I've been haunted by it ever since," he said. Not only would he not allow me to write about her, he said he would bar any mention of any rumors or hearsay or gossip about him. I told him I would check rumors out, and, if they weren't true, I wouldn't write about them, except perhaps to knock them down. That wasn't good enough. "You want to control the book," I told him. He insisted that wasn't the case. He just wanted veto power over Kim—and by the way, veto power over anything else that might come up that he didn't like.

I said no, that wasn't acceptable. A cloud crossed his face—quite literally; it turned scarlet, then almost black, and he scowled and his eyes seemed like gun barrels aimed at me. I'd later hear that this happened to employees; I wouldn't have understood how scary it was if I hadn't seen it for myself.

"You can't do the book without me," he announced.

This was not the Ralph Lauren I'd known for years. But, in truth, it was a far more fascinating Ralph Lauren. Rattled, I told him that I would consider leaving Kim out of the book in exchange for his total cooperation. "I want to live in your

pocket and crawl into your head," I said. But I also told him I couldn't and wouldn't agree to give him blanket veto power over the book. Then I got out of there as fast as I could and called my agent and my editor. "Maybe you'll be better off without him," my editor said.

Those words were still ringing in my head when I met Ralph again at ten-thirty A.M. on April 6 in his office. He arrived after me, wearing a brown leather fringed jacket, a skintight gray sweater, black jeans, and a belt with a big buckle. Quickly, I told him I couldn't agree to what he'd asked at our last meeting. Two gossip items about my book had been published in the interim, and he answered by saying that they'd made him feel he was being stalked. He accused me of being dishonest with him. But I realized with a start that we were negotiating again. I did not yet know that constant vacillation was Lauren's modus operandi.

We discussed what I wanted to do with the book, how a writer's job is to tease a narrative line out of events that can seem chaotic. I told him I was worried that he'd demand a veto again, reminding him how he'd bristled and refused even to discuss it when I mentioned the charge made by some that he was a self-loathing Jew. On this day, he was his old charming self. All he wanted was a ban on Kim Nye.

I told him how, at lunch a day or so earlier, the editor of a major magazine I sometimes wrote for had asked me, "Are you going to write about his girl-friends?" Ralph didn't acknowledge the plural; instead, he demanded, "Who said that?" I would later tell that editor not to worry: I'd refused to answer; the magazine would not lose its Ralph Lauren ads. I have nonetheless never been asked to write for that magazine again.

I had yet to lose Ralph Lauren, though. "Don't close the door on me," I said. "Leave it open a crack." He agreed and we parted with a handshake.

The conversation still wasn't over.

Lauren called repeatedly the next day, tracking me down until he found me. Nye was still on his mind. The idea of their story being told in a book was "making me ill," he said. He couldn't look at his wife without getting tense. "You've got to tell me what you're going to write about that," he went on. "I like solutions. I want to know what you want to write about her, so people won't knock you, and you've done what you've got to do."

I said I couldn't do that on the spot.

"I want you to react now," he said.

I said again that I couldn't.

He said, "This biography is not what I was interested in. I was interested in an overall picture of Ralph Lauren's working career, what he achieved." A book involving his private life made him "a lot more uncomfortable . . . not because I feel guilty but because people will buy it for the wrong reasons. It can be promoted for the wrong reasons. It's not my life; it's not who I am. I have nothing to be embarrassed about." He said, "I don't have problems, but I have nuances." Then he returned to Kim Nye. Again, he demanded that I tell him immediately and precisely what I would write about her. I said I couldn't until I'd reported the story. But he'd already decided what he wanted me to write: "There was a rumor and I don't know if it's true."

By then, I was convinced that my editor was right: I'd have a better book without Ralph Lauren's help; indeed, if I kept talking to him, I wasn't sure I'd ever have a book at all. I spent the spring reading everything I could find about Lauren, and I found that though the literature is voluminous, there were huge gaps in the record. His interviews all read the same; he told the same stories over and over; often, he used the same words. And the story generally started with some variation of the words, "It started with a tie."

On June 19, a media gossip columnist printed an item saying Lauren had decided not to cooperate with me—and I called Lauren to see if that was true. It was. But he wrapped his refusal in compliments. "Here is my feeling," he said. "I feel like you can write a good book. And I like you. And there is a part of me that really wants to help you and work with you, and there is a part of me that says don't touch this because it's not the right thing to do. And the reason is the issue that I told you about."

He'd decided that he had to be able to tell his wife that he had nothing to do with this book. "She is going to be sick," he said. "She is going to be very upset." Nonetheless, he agreed to not stand in my way—an important concession. "Whoever calls me, I will say, 'You can talk to him, I have nothing against Michael. I think you should talk to him.' Because I can't see anything wrong with anybody friendly talking to you. I am making a commitment to you; I am giving you anybody that you want to talk to. I want you to get what you need."

For a while, he nearly lived up to that commitment.

Lauren initiated our last lengthy conversation in June 2001, after I approached his aging aunt Bessie, who was very close to his mother, for an interview. Ralph

called to tell me she was ill (she would die about six months later) and to ask me to leave her alone. This time, I taped the call.*

How, I wondered, would I go about finding out more about his family?

"I can't help you," he answered. "I don't know."

I told him about several others who'd refused to be interviewed, his brother Jerry Lauren and his best friend, Steve Bell, chief among them.

"They are all close to me," he said. "I have spoken to every single one of them. They called me, and said, 'Ralph, I don't need this, it is not going to be good.' So that is basically where they're at. These are smart people, they have been around and they don't like these books, they don't want to get involved."

The people closest to him wouldn't talk to me unless he told them to, and he wasn't going to do that. Unless, of course, I agreed to make Kim Nye disappear as surely as she'd disappeared from his life and indeed from the fashion world after their breakup.

"You are going to write whatever you want to write," he said.

I sputtered, "You see, there you go. You think I'm going to write a bad book about you."

"Michael, you know I did not want this book."

"You did want the book."

We argued like that for several minutes, both frustrated, interrupting each other. Finally, Ralph came back to where we'd started. "My aunt, she is ninety-eight years old; I know she should not do it, and my best friend, Steve, and my brother should not do it because they should not be a part of this. Nothing they are going to say is going to be important. Believe me."

I told him I would get my information where I could, just as I had with Calvin Klein all those years ago. "I will get the story," I said, "but your point of view can be reflected in this book in any number of ways besides you giving me more interviews. I know you have a great story. It might even be better then you think. I think that it will be even more nuanced and even more accurate and comprehensive and fair and honest if I can talk to somebody in your camp. You are not doing yourself any favors, and I wish I could get that across to you."

"You know my issue here," Ralph said. "You know that it is going to cause a lot of misery, and you are the one who is going to be doing it."

"All I am going to be doing is reporting something that *you* did." I hadn't had an affair with Kim Nye. It wasn't me who'd licked her fingers in a restaurant.

* The dialogue is verbatim, although I've edited the transcript of the conversation for the sake of space and clarity.

"Michael, I'll say this once more to you. I think more than anyone, you could do a good book."

"And you know what? I'm going to. Your changing your mind, which is how I perceive it, isn't going to change the initial impulse, which is, I can write a great book about this guy, this is cool, this is going to be important and fun and you can help me or not. It's not black or white, Ralph. It's shades of gray."

"What does that mean?"

"That means that you can impede me—"

"I'm not—"

"—or you can be neutral, or you can be neutral with a slight bias toward helping him get what he needs so he can write a fair, honest, and complete book. I'm trying to get across to you, it's good for you, too. And I'm just asking you to think about that."

"Michael, why should I do that?"

"To make sure that it's a fair, honest—"

"When I have issues with you ? I couldn't care less how this book is—"

"You're blowing Kim Nye out of proportion, Ralph."

He let out a derisive laugh.

"If I write it as fully as I can possibly write it," I pressed, "Kim's a couple pages in a three-hundred-fifty-page book."

"That's not what's going to get promoted."

"I already have stuff that's better than that."

"I don't think so."

It went on for forty-five minutes. "What can I do?" Ralph asked me. "I'm not going to give you my brother. I can't do that because that's going to be totally cooperative. You've probably spoken to enough people. You know who I am. You know me by now. There's nothing you're going to not know."

"I've learned a lot about you in the last year."

He sighed, a bit glumly. "I would love to sit down and give you everything I know about my life."

"I'm still hoping you will."

"I can't get myself to do it because it's sort of painful."

I asked for a surrogate—someone like his best friend, Bell, to speak for him, even anonymously. He asked what message I thought my book was going to send. I asked him what message his next collection was going to send. He changed the subject and asked me what I'd thought of his show several weeks earlier. "You're usually very critical," he said. So I played fashion critic and told

him I'd liked it better than the one before, when he'd sent out nothing but black and white. "That was too pared down and simple," I said. "Don't get me wrong. It was beautiful—"

"I wish you were the editor of all the magazines. What did you see in *this* collection?"

"You being very true to yourself."

"That's good."

It was like that throughout the ten-month-long negotiation over Lauren's cooperation. And despite his promise of neutrality, he told some people not to give interviews and tabled/vetoed other key interview requests. As I worked, and called his friends, relatives, and current and former employees, his attitude seemed to harden—or at least that of those closest to him did. As a result, a handful of significant figures in his life, including his best friend, Bell, his sister, one of his two brothers, and the executives closest to him at Polo Ralph Lauren refused to give interviews, or, in some cases, even to confirm, deny, or clarify information gathered elsewhere. Lauren's longtime spokeswoman Buffy Birrittella said she didn't want to be seen "lending authenticity" to "a book we don't control."

I have done my best to make up for the absence of their voices and hope readers will agree that although this biography is unauthorized, it is neither inauthentic nor unfair.

In part, that will be because, in the years that preceded that negotiation, I spent a lot of time following Lauren around and interviewing him. I also had long conversations in those years with his middle brother, Jerry; his right-hand woman, Buffy; and many others in his life. Additionally, several very generous writers and journalists, notably Marty Friedman, Jeanette Friedman, and Charlie Rose, gave me access to lengthy interviews they had conducted with Lauren. They were invaluable.

I also gained insights, facts, and quotations from hundreds of articles about Lauren, and a previous biography, *Ralph Lauren: The Man Behind the Mystique* by Jeffrey Trachtenberg. For the purposes of fluid narrative, the sources of quotations from those interviews and other sources are not always made explicit in what follows. I hope it will suffice to say here that remarks made directly to me in interviews are generally attributed in present tense (i.e., he says), and quotes from interviews by others, as well as from previously published articles, interviews, and books, are similarly attributed in the past tense (i.e., he said, or he has said). More information on sources can be found at the end of the book.

It should also be noted at the outset that Ralph Lauren is a very rich and influential man; and despite his mostly benign image, he inspires fear in others, particularly those in the fashion, retail, and media trades. "I don't want to get on Ralph's wrong side," said Louis Praino, a former production executive at Lauren's women's wear company, refusing an interview. Lauren's current employees are instructed not to speak about him. And some even for good reason. "I wasn't allowed to talk to the press because of what I did," says Bob Melet, who for many years bought vintage clothes as "inspiration" for Polo designers. "I was behind the curtain."

That's where Ralph Lauren, the great and powerful Oz of fashion, also resides. So a significant amount of what follows—particularly in those parts of the book that deal with the present and recent past—came from sources who agreed to speak only on condition of anonymity. Having seen Ralph Lauren angry, I understood their concern. I hope readers will, too. Each of those sources is described as accurately as possible under the circumstances.

Biographies of the living are works about works in progress. So this is not intended as, nor should it be read as, the final word on Ralph Lauren—but only as an attempt to shed light on the remarkable journey he has taken so far.

GENUINE
AUTHENTIC

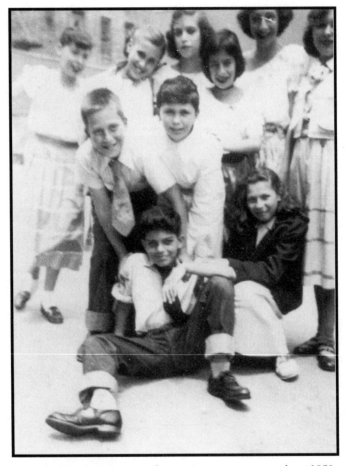

Portrait of the designer (*seated, center*) as a young man, about 1950.
(Photographer unknown; courtesy of Janie Guerra Paris)

Introduction

*You can make a statement by how you dress. Clothes are really
part of an expression; they make a statement about you.
It's sort of an introduction; it's not you.*

— RALPH LAUREN

There's a year-old black Bentley parked just up the street from the red-brick street-level space where Ralph Lauren is mounting his fashion show of women's clothes for fall 2000. Crouched on West Broadway in New York's SoHo, the car's gleaming black curves welcome invitees to the private runway event.

Here are the firsts among fashion's unequals — the editors of *Vogue, Elle,* and *Harper's Bazaar;* correspondents from the *New York Times* and the *Wall Street Journal;* celebrities like country music's Reba McEntire and Hollywood's Penelope Cruz, who is Lauren's advertising spokesmodel. Seated all together in the center of the room is his family — Ricky, his wife of thirty-five years, and their children: Andrew, an actor and film producer; David, Ralph's carefully unshaven heir apparent; daughter Dylan, a student about to embark on a career as a high-end candy-store proprietor; and Ralph's brother Jerry, who heads Polo Ralph Lauren Inc.'s men's design department.

Nearby sit top executives from Goldman Sachs (which took Polo public in 1996 and owns a large chunk of the company) and from every major retail chain

in America. And that's just the front row. Behind them, a Lauren minion whispers, exaggerating only slightly, are "two thousand piranha crammed into a small closet."

They've come out this crisp February morning in the year 2000, for a quintessential mass-marketing event, a ritual as well oiled and sleek as that Bentley outside. Lauren's is arguably the best-selling and certainly the best-known of all the world's stylish brands, his Polo logo a symbol of the best of fashion—and more recently its successful mating with high finance. Polo Ralph Lauren Inc.'s worldwide success is a recognition of the universality of American-style aspiration, and a symbol of the awesome rewards of our freedom for self-invention. Lauren is a visionary merchant of shared fantasies, a master of marketing make-believe, the embodiment of one-world marketing and a one-man brand—Henry Ford crossed with Walt Disney.

Lauren, for good and ill, is the haberdasher of modern ambition.

During a typical fashion show week in New York (or, for that matter, Paris, London, or Milan), this scene will be re-created several score times as the world's top designers trot out their seasonal wares. They are masters of illusion, imagicians who whip up the world's prettiest lies: they make us look healthier and wealthier and more beautiful. But Lauren's is no more a mere *fashion* show than that Bentley is just a car.

Ralph Lauren's car bespeaks the quietest kind of style this side of an old Woody station wagon, one that demands and rewards close inspection. For this is not just any old Bentley but one customized to suit an international style arbiter, a man whose fashion empire is one of the world's largest, whose car collection is considered one of the world's best, one whose attention to detail—every last excruciating detail—and need for control—absolute, total control—is legendary in the already tightly wound world in which he works.

Ralph Lauren's Bentley Arnage Red Label Saloon is 5,556 pounds of automotive perfection. But anyone can have that if they have $210,000. Ralph Lauren's car is about more than money. It isn't just black, it's all black, black on black—there's not a speck of chrome on it except on the door handles. Nothing breaks its clean lines. It has special eighteen-inch wheels, too. "You can't get those," says Lauren's longtime chauffeur, who is standing watch over the ritzy ride. He is a large African American in crisp black livery. He says his name is Carrington.

Perfect.

Almost nothing remains of what our protagonist once was. Ralph Lauren, né Ralph Lifshitz, is a figment of his own imagination, just like F. Scott Fitzgerald's

creation, Jay Gatsby, né James Gatz, who "sprang from his Platonic concep-
tion of himself." The making of Lauren, a hand-me-down child of Eastern
European Jewish immigrants who came to America on an Horatio Alger–esque
voyage some fourscore years ago, is not just one of the world's great business
success stories. Lauren is a symbol of, as fashion critic Holly Brubach once
wrote, "the apotheosis of a self-made man" at the dawn of the new millenni-
um. His saga opens a window onto one of the most taboo subjects in our
increasingly borderless world—our lust for roots we no longer have and for sta-
tus as a replacement for the privileges of birth. It also reflects our abiding inse-
curity about class, and the paradox of the extraordinary wealth and cultural
power that spring from the common clay of our multiethnic, multicultural
democracy. Ralph Lauren thrives in that swarming pool of ambition, anomie
and avarice, pride and disapproval, self-expression and imitation, privilege and
pretend.

His is also the story of the commodification of status, of the democratization
of symbols of the haute monde, of the perfection of luxury merchandising and
the rise of "lifestyle" marketing, and of the globalization of branding and the
simultaneous Americanization of international fashion.

Despite his demonstrated mastery of their world of evanescent image, the inner
clique of fashion has never embraced Lauren. It has disdained him for thirty
years as a pushy, lesser talent, a garmento, not a *créateur*. He is a man whose
high-fashion designs are worn neither by the fashion elite, who think them dull,
nor by the masses; most women *can't* wear them unless they are 5' 10" and 110
pounds. And the clothes he makes that *do* sell—like Oxford shirts and khaki
pants—are far too generic to be taken seriously by style's snobbish elite. In his
turn, Lauren rightly balks at being called a mere fashion designer, even though
he is one of the world's most successful.

It's not about the dress, he'll say; it's about the dream.

Lauren doesn't do fashion. He does lifestyle. Understanding the difference is
easy. Some people put on outfits. To Lauren, outfits are not just signifiers of
identity but seven-league boots that take you there. You can be a cowboy if your
boots are the right kind. "I present a dream," he says. "They are worlds you
would like to be a part of. In that world, you'd wear that kind of thing. I see a
whole feeling. I don't see a pant. Everything is connected to something else.
Nothing is apart. I design into living. It's a lifestyle."

He is like one of the old Jewish movie moguls who conjured up not only
Hollywood, but an idealized America, an America of wide Main Streets, clap-
board houses, friendly smiles, and high ideals. Lauren embodies both our

ingrained class insecurity and its all-American antidote, upward mobility, and turns it into a seductive fairy tale.

What kind of man has a customized Bentley driven by a man named Carrington? Someone you wish you could be, Lauren knows. Someone who is a great deal richer than you. Someone who had a dream and made it real. Someone who needs people to know that.

To fans, who feel he has permanently raised America's lowest common denominator with his obsessive focus on quality, Lauren's products say, If you wear it, you can be it; you can be anything you choose. He has plugged into the desires that have driven America—and driven it a little crazy—from the nation's beginning. In his homeland, and increasingly, around the world, we insist on our right to strive, to claw our way to the top, to remake ourselves—even if that means we have to fake what we can't afford, have to choose style over substance.

To his critics, who feel all he's accomplished is the usurping of the icons of our brief national past—whether Native American or Anglo American— Lauren's relentless focus on externals, on trappings, is evidence of a dangerous soullessness, a nihilism that threatens all they hold dear: How dare he steal our old school ties when he wasn't born to them!

Who does he think he is?

Though he poses as Everyman, Lauren isn't one. If you like him, he's one of the most creative, powerful, and driven entrepreneurs in the world. If you don't, he can seem a megalomaniacal control freak. What he's *not* is ordinary. Neither is his life, which is both grand and hermetic. He owns a duplex on Fifth Avenue; an estate in Westchester horse country; a beach house on the Atlantic on Montauk Point, Long Island; two houses in the exclusive enclave of Round Hill, Jamaica; and a huge cattle ranch in Colorado. He can wake up in the morning and be a captain of industry, a patrician, a beach bum, or a rancher. Or he can change his mind and fly to another of his multimillion-dollar homes in Polo's Gulfstream jet or its Sikorsky helicopter. His collections of antiques, photographs, and sixty-some classic cars and motorcycles are scattered among them. The car collection is one of the best in the world and has won the awards to prove it.

He can afford it all and then some. Lauren is one of America's richest men, the ninety-seventh richest, according to *Forbes* magazine's famous rich list, which pegs his personal fortune at $2 billion and counting. He earns $1 million a year in salary, and, in 2001, he took home another $8.8 million in bonuses and other payments. He and his family own more than 43 million shares of Polo Ralph Lauren, and options on a million more shares, giving him control of 88.9

percent of what is ostensibly a public company, traded under the RL symbol on the New York Stock Exchange.

Though its share price doesn't always reflect it, that company is as successful as he is. In 2002, its thirty-fifth year, Polo Ralph Lauren was a four-headed Hydra. It is a wholesale clothing company selling eight lines of clothing for men, from the rare, tasteful, top-priced Purple Label suits; the better-priced, logo-splattered and ubiquitous Polo Sport brands; three more lines for women; a licensing company with thirty-two separate deals for everything wearable, from men's jeans to toddler togs at every possible price, as well as luggage, golf bags, other leather goods, ties, underwear, loungewear, swimwear, shoes, gloves, scarves, eyeglasses, jewelry, hosiery, fragrances and cosmetics, furniture, sheets, other bedding, towels, other bath products, silverware and other tabletop items, hardware, antiques, lighting accessories, rugs and carpets, and paint. There are even silver-clad $150,000 Lauren-customized Airstream trailers, and limited edition, numbered replicas of a 1909 teddy bear. Many assume that a line of food products (Lauren has seven hundred head of cattle on his Colorado ranch), and a collection of Ralph Lauren hotels will be the next products to carry one of his brands: Ralph Lauren, Polo, Polo Jeans Co., Polo Sport, Ralph Lauren Sport, Ralph, Lauren, Polo Golf, RLX, Double RL, and Chaps.

Then there's his newest brand, polo.com, the Internet site he co-owns with NBC, the General Electric subsidiary. Though it has stalled like everything else dot.com in recent years, Lauren hopes it will be the acorn from which a mighty media empire will one day spring, encompassing periodicals, books, television shows, and movies. And finally, there is Ralph Lauren retail, a collection of thirty-nine full-price Polo shops, fifty-four stores in the Club Monaco chain, 141 discount stores selling marked-down, damaged, and out-of-season Polo, Ralph Lauren, Polo Jeans, and Club Monaco clothing, *and* a Ralph Lauren restaurant. All told, they earned $172.5 million in income in the year ended March 31, 2002, on net revenues of $633 million. But big as those numbers are, they don't tell the whole story. Around the world, Ralph Lauren products rang up $10 billion in retail sales in fiscal 2002. Which is how he and his licensing partners can afford to spend an awesome $222 million a year advertising his name and his brands.

But none of that satisfies him.

When, as often happens, Lauren runs into old acquaintances from his boyhood in the Bronx, he often asks the same question about the people he used to know, people who knew him under the name he was born with, Ralphie Lifshitz.

"Do they know who I am?"

He's an affirmation junkie, constantly in need of fresh proof that he's special. He gets it not just because he's needy ("Aren't I handsome?" he'll ask). He's also enormously seductive at close range. You *want* to please him. Not just because he's rich but because he reflects who Americans want to be, soft-spoken and modest, and at the same time wildly ambitious and never content.

Lauren also reflects us at our worst. He is pre-Copernican in his self-absorption. His confidence borders on arrogance, but he is simultaneously uncomfortable in his own skin, rarely socializing outside a close circle of employees, family, and friends—all of whom depend on him for their salaries, their self-image, their children's jobs, the roofs over their heads. He's a control freak; he'll demand approval of magazine stories before he will give interviews or pose for photographs. No one in his company can make a move without him. Yet he's tortured with doubt about his place in a wider world he doesn't control.

Constantly playing dress-up, the star of his own mental movies, Lauren is at his most authentic and secure when he's lost in one of the quasi-mythical, archetypal roles he loves. Immersing himself in imagined worlds—the English country, the American West, the near-future—as his defense against the memory of a drab, joyless Bronx boyhood, he's become the ultimate millennium marketing man, selling the promise of self-re-creation for the price of a pair of pants.

"I came from nowhere," Lauren says. "I had nothing." Ralphie Lifshitz grew up sleeping three to a room, the shortest kid in his class, with a lisp, a lazy eye, an acne-spotted back, and two taller, handsomer, more athletic older brothers, but he dreamed of being a Brahmin. Under his photo in his high school yearbook, in the spot where students predicted what they'd grow up to be, he wrote "Millionaire." So Ralph Lauren claimed his right to invent a better life for himself—a better self, in fact—and then package it for everyone else. Lauren says he dreams up worlds, but it's really alchemy. He's taken the sartorial relics of fallen empires and turned them to gold by focusing on their essential elements of pedigree and style. His products are no chintzy knockoffs of the past; his flannel tennis trousers are every bit as good as those worn on Main Line Philadelphia tennis courts when Ralph's elders roamed New York's Lower East Side. Yet he's transformed such formerly rare status symbols into commodity products.

Polo Ralph Lauren's "real" clothes and home furnishings have an aura of heritage that makes them seem superior to mere fashion, even as they reflect it. He has transformed an apparent oxymoron—faux authenticity—into a great selling tool, and he has managed the neat trick of balancing mass commerciality with luxe exclusivity in the process.

The audience for Lauren's audacity encompasses Paris *couturiers* (Christian

Lacroix swears by Lauren), Harlem homeboys and rap moguls like Sean "Puffy" Combs (who once came backstage at a Lauren fashion show, dressed in a chubby silver fur, to tell the designer that he, Puffy, was "just gettin' started" with his own fashion line, but hoped he would "have the longevity like yours"), Milanese *ragazzi*, Greenwich Connecticut weekenders, and Hollywood heroines. His triumph is our triumph. He even sells to the British royals, whose approval has been the holy grail of Yank social climbers since the founding of the republic. The image marketing and branding techniques he pioneered and perfected are the gold standard to which others—human brands like Martha Stewart and Tommy Hilfiger, retailers like the Gap, and huge multinational manufacturers like LVMH and Prada—aspire.

All you need do is walk the streets of any neighborhood, rich or poor, in the developed world to see that Lauren's logo—inextricably linked to Lauren's adopted persona and to the flag of his parents' adopted country—has become a universal symbol of the common need of citizens of the twenty-first century to be something other than common.

Despite all this, it is almost touching how much Ralph Lauren needs the approval of others. Sixteen months after that February 2000 fashion show, he would still be railing about the review he got in the next day's *New York Times*. The *Times's* critic, Cathy Horyn, aimed straight for his vulnerabilities, calling the diminutive Lauren "a small man with a big gift for dreaming," bringing up a recent article in *Vogue* that had similarly infuriated him with its reference to his kinky hair, then calling his constant self-comparisons to idols like Cary Grant and Gary Cooper "a weakness that doesn't let light into the dream."

She didn't like the clothes, either—she described Lauren's latest equestrian-inspired line as "boots-and-breeches chic" that, while "skillful," seemed like clothes for "a static life." Never mind that other critics called his thoroughbred dressing the look of the moment and Lauren's infinite reworking of some of his signature themes one of the season's best shows.

The *Times* even found something to criticize in Lauren's traditional, lingering stroll down the runway at the end of the show. "People stood," Horyn wrote. "Mr. Lauren kissed the members of his family. He grinned and raised his arms in triumph like a gladiator who had just slain the last Christian. He did a little jig, too." Horyn tsk-tsked that Lauren "took an excess of pleasure in his bow." He'd failed to be blasé, as everyone knows *real* Old Money should be. Horyn's criticisms, her dexterous verbal sleight of hands and skillful sniping, would lead Lauren to snipe back a few weeks later when he and I had our last lengthy conversation about this biography.

"I'm never mean to people and I never called anybody about her and I didn't call her and I didn't call anybody and I just accepted what she wrote and I thought it was unprofessional, period," Lauren fumed. Horyn had reviewed *him*, not his designs. "And it was upsetting because I don't deserve it. And it was interesting because I say, Where is this coming from? It was just interesting how it was so personal. I wouldn't care if she wrote, This sucked. I couldn't care less if she thought it was the worst piece of junk, that's okay. . . . Do you like her writing?"

In fact, I thought that for once, Horyn—a perceptive writer and critic who years ago wrote the best profile of Lauren I'd ever read, for the *Washington Post*—had missed the real story, even as she was right in finding her subject in the man, not what he'd made. She'd never mentioned the song Ralph chose to accompany all the models in their horse-bit belts as they marched down the runway for the finale, like so many well-groomed thoroughbreds.

It was a revealing one: "Like a Bird," by a then-unknown singer, Nelly Furtado, that spoke not just to Lauren's suave lifestyle dreams but to the realities they'd helped him transcend. "I am like a bird," Furtado sang. "I don't know where my soul is. I don't know where my home is."

His many fine homes notwithstanding, neither does Ralph Lauren. The irony is, if he'd only known the story that follows, he might have been confident in his nobility all along.

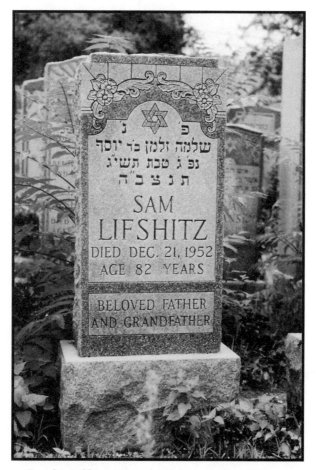

Grandpa Lifshitz's grave, the Hebrew reading, "Shlomo
Zalman the son of Yosef," in Montefiore Cemetery,
Queens, New York. (*Michael Gross*)

PART ONE

Patrician:
From the Pale to the Promised Land

It is funny, you get to a certain age, and all of a sudden you do want to see what you came from, you don't want it to disappear, really.

—RALPH LAUREN

1

At the end of 1984, Polo Ralph Lauren acquired a twenty-year lease on the landmark Gertrude Rhinelander Waldo House, a five-story French Renaissance Revival palace completed in 1898 at the corner of Madison Avenue and Seventy-second Street in Manhattan. Waldo, a socialite, had spent half a million dollars erecting her tribute to a chateau in France's Loire Valley. A riot of bay windows, dormers, statuary, and chimneys, its Gilded Age exuberance contrasts with the neo-Gothic brownstone plainness of its next- door neighbor, Saint James Episcopal Church, where New York's oldest families — families with names like Rhinelander — still worship.

For reasons unknown, Mrs. Waldo never moved in, but her sister, Laura, and her son, Rhinelander, a hero of the Spanish-American War and future New York police commissioner, lived there until 1912, when a bank foreclosed on the property. In the 1920s, it was converted for commercial use and was occupied over time by an antiques dealer, interior decorators, the Phillips auction house, a society florist, and one of Eli Zabar's specialty food boutiques.

After it reopened in 1986, with its newest owner, the Rhinelander mansion became the Polo mansion, the engine driving Lauren's image — his Disneyland and Disney stores rolled into one. It also became New York's newest tourist attraction, with its oak floors, Honduran mahogany paneling, vaulted ceilings, ornate plasterwork, Waterford chandelier, antique Cartier vitrine and green glass Art Deco panels etched with polo players (discards, appropriately, from the old Polo Lounge in New York's Westbury Hotel), gas-burning fireplaces, and a plethora of "real" old drawings, photographs, bound volumes, aristocratic bric-a-brac and shabby chic gewgaws: elaborately framed photos, walking sticks, picnic baskets and hatboxes, steamer trunks and sticker-covered old luggage, antique tennis racquets, fishing rods and lacrosse sticks artfully left about as if waiting for the house's long-departed occupants to finish packing for a summer in Newport, on the Cape, in the Adirondacks, or in Sun Valley.

But most of all, people came to see its central staircase, modeled after the one in London's Connaught Hotel. Dressed up with antique carpets, green felt

walls, and hand-carved balustrades, it's studded with the sort of gilt-framed ancestral portraits one might find in a drafty old English country house. Whose ancestors are they? The forebears of the worshippers next door at Saint James, no doubt.

No matter. Lauren has claimed them as his own, as props for his personal movie.

On the day the Rhinelander opened, Lauren took Marvin Traub, the former chairman of Bloomingdale's, the New York store most associated with Polo, and his wife, Lee, on a private tour of what the designer called "the ultimate Ralph Lauren shop." Traub admired the detail, the fanatic perfection of each department, each display, each luscious, colorful pile of Shetland sweaters. Then, Lauren walked them down that ceremonial staircase and stopped beneath one of those portraits of an unnamed and quite likely unloved English gentleman—a man whose descendants, assuming he had any, had long since disposed of his picture.

"That," Ralph said, pointing up at the old Anglo-Saxon's face, "is Grandpa Lifshitz."

As with all good jokes, there was pain underneath it. Ralph Lauren admits he has little or no idea where he came from—and he's never stopped to look. So his heritage has remained a mystery to him throughout his sixty-three years. What Ralph didn't know, and may not to this day, is that through his mother, who was born Fraydl Kotlar, he is related by marriage to a Jewish dynasty that was considered aristocratic as long as, if not longer than, the Anglo-Saxons whose portraits hang on the walls of the Rhinelander.

2

No one ever painted a picture of Ralph's grandpa, Sam Lifshitz, né Shlomo Zalman Lifshitz—and the word pictures painted by his remaining relatives have all the depth of gossamer. As far as they know, he was a nobody with nothing from nowhere.

The public record offers up precious little to counter that impression. Ralph's oldest sibling, his sister Thelma Fried, by all accounts the most traditional and family-oriented member of his brood, is said to know more. But Lauren, who let

all but a few friends and business associates give interviews for this book, wouldn't let her speak. "He doesn't want me to discuss our family—not that we're ashamed of anything," she says in a brief phone call. Before declining an interview, Thelma says she knows very little and expects that Ralph knows even less.

None of this is uncommon. Many descendants of eastern European Jewish refugees know nothing of their families, whose desperate desire to leave their homelands at the turn of the twentieth century was outweighed only by their subsequent determination to leave their memories behind as well. "They left a great deal of unpleasantness," says a distant relative of Lauren's, Carol Skydell, the executive vice president of jewishgen.org, the leading Jewish genealogical website. "So what's to remember?"

After World War II, most of those memories disappeared; the Jews and their towns were swept away by the Holocaust. An oft-asked question—Where did we come from?—was afterward, often as not, answered with a dismissive wave and some vague geography: "Russia." "Poland." "Minsky-Pinsky."

That last phrase, joining two cities that are 123 miles apart in the country now known as Belarus, was meant to shut down conversation rather than dredge up the vast swampy area known as the Pale of Settlement, where Minsk and Pinsk were located. The Pale was a strip of eighteenth-century Poland that was taken over by Czarist Russia in 1795 and declared the only place in that country where Jews could legally live. By 1885, over 4 million Jews lived in a Pale expanded to include land annexed from Turkey. Six years later, seven hundred thousand more arrived, many of them deported from St. Petersburg, expelled from Moscow. (The Pale statutes were revoked after the Bolshevik revolution. Today, the homeland of Grandpa Lifshitz has been carved up into pieces of Belarus, Latvia, Lithuania, Moldova, Poland, Russia, and the Ukraine.)

The Jews of the Pale were Russia's middle class: middlemen, merchants, trades people, craftsmen, tax collectors, and tavern keepers. Christian nobles, landowners, and the serfs who slaved for them filled out the population. Many of the Jews descended from ancient Palestine; some bore names that dated back to biblical times. These wandering Jews made their first appearance in Russia in the tenth century. They came via the Crimea, the Caucasus Mountains and present-day Turkey, Iraq, Iran, and later, middle Europe.

When Grandpa Lifshitz arrived at Ellis Island in New York harbor in 1920, with two of his five children, a daughter Mary and a son Frank, who would become Ralph Lauren's father, he said they'd come from Pinsk. The first Jews in Pinsk—which was at various times part of Lithuania, Poland, and Russia—arrived in about 1500.

Pinsk was hardly nowhere. It was a center of Jewish population and produced

renowned religious leaders and scholars. Jewish culture flourished in the Pale—they spoke their own language, Yiddish; had their own schools and houses of worship; their own theater, literature, and newspapers—despite the fact that Jews there had been insecure for centuries. Protests against their presence and confiscation of their property were the norm. Organized massacres of Jews were common enough at the turn of the twentieth century that they had their own name: pogroms. Through it all, the Jews persisted.

When the Pale became part of Russia, Jews were forced to urban areas and tiny villages called shtetls; among them were Ralph's great-grandfather Yosef Lifshitz and his wife, Leah Schmuckler, who had a son named Shlomo Zalman. Most Eastern European Jews had both secular and religious given names, and were also known by nicknames. Shlomo, aka Schleime and Shmuel, was born just before Christmas in, depending upon which of the contradictory documents you believe, 1870 or 1872. The Lifshitzes were Ashkenazim, German Jews, and their surname, too, came from someplace in present-day Germany or the Czech Republic, where there were towns named Liebschuetz, Leobschutz, and Liebeschitz. One of them was the source of Grandpa Lifshitz's name, which means "loving support" in German.

Though Ralph Lauren would drop it, Lifshitz is a Jewish name of renown. The first prominent Lipschuetzes were rabbis in sixteenth-century Poland—and their line is unbroken to this day. Descendants of the family used many spelling variations—and so did other Jews who were forced by law to assume Christian-style hereditary surnames beginning in the late eighteenth century when the Hapsburg ruler Joseph the Tolerant sought to integrate them into the European society.

How did Yosef Lifshitz get his name? It's hard to say. Surnames were often assigned by Jewish administrators. If Yosef was a typical case, his father would have adopted the name at the start of the nineteenth century, when imperial Russia decreed that all Jews had to take surnames—and stick with them. "Perhaps, some Lifshitz are indeed unrelated to the rabbinical families," says Alexandre Beider, an authority on Jewish names. "But I can hardly see how a person unrelated to these rabbinical families could adopt such glorious names without being ridiculed by other Jews."

Ralph Lauren's grandfather Shlomo Zalman Lifshitz bore the exact same name as the first rabbi of Warsaw, circa 1821. He could also be a descendant of the sixteenth-century rabbis Moses ben Isaac Lipschuetz of Gdansk or Isaac Lipschuetz of Poznan. But then again, young men born in the Czarist empire would sometimes change their names in order to avoid compulsory conscription into the Russian army. Who is to say? Ralph Lauren may not be the first in his family to reinvent himself into a better life.

3

The Jews of Pinsk were a prosperous lot. As Shlomo Lifshitz was growing up, the town was a business hub and import-export center. Jews formed a large merchant class; some of them even kept yachts on the Pina River and sailed throughout Europe on rivers and canals. At least one local Lifshitz family was wealthy. They lived in a shtetl near Pinsk called Antopol, where they were leading citizens. Ralph's mother's family—they were called Kotlar in Europe, Cutler in America—came from Antopol, too. And they were even more distinguished. Neil Rosenstein, a researcher into Jewish genealogy and a distant relative, has traced the Cutler lineage and found connections through marriage to the elite of Jewry, and to two of the greatest rabbis of all time. Ralph's mother's family socialized with aristocrats.

In the beginning of the heritage Ralph unwittingly turned his back on, there was Moshe Heller-Wallerstein, a Bavarian who, in 1579, begat a son named Nathan who begat a son who became the chief rabbi of Prague.

Yom Tov Lipmann Heller was one of the great rabbinic scholars of middle Europe. Lipmann Heller and his wife, Rachel Ashkenazi, begat a daughter named Nissel who begat a son, Nathan, who married into another of the great rabbinical clans, the Katzenellenbogens, descendants of Meir Katzenellenbogen, the sixteenth-century rabbi of Padua, whose descendants include prominent rabbis through history. Through them, Ralph is related by marriage to the founders of several Hasidic dynasties, and also Karl Marx, Helena Rubenstein, England's Montefiore and Salomon families, two of London's lord mayors, Moses Mendelssohn, the eighteenth-century philosopher and proponent of assimilation, his grandson, Felix Mendelssohn-Bartholdy, the composer, the matzoh-making Horowitz-Margareten family, and the Hirshhorns, who created the teabag, as well as doctors, diplomats, aristocrats, artists, actors, archaeologists, historians, bankers, scientists, industrialists, and mystics.

Moshe Heller, Nathan's son with Hanale Katzenellenbogen, begat a daughter whose daughter married another rabbi named Yoel Buchover, whose son, Ze'ev Wolf, yet another rabbi, begat a daughter, Dvora, who begat a daughter

named Rivka, who married a man from a family called Gerstein. Their daughter Freda Chaya married Zahar Hirsch Waldman, whose sister Chana Waldman married Yakov Koppel Kotlar, a coppersmith in Antopol (*kotlar* is Yiddish for kettle maker).

Chana Waldman and Yakov Koppel Cutler were Ralph Lauren's maternal great-grandparents.

Koppel's children moved away from Antopol. Ralph's maternal grandfather, Netanel "Sanya" Cutler, lived in the next shtetl, Droghicyn, midway between Pinsk and Antopol, beside a railroad line. He'd married up, too. Rachel Pomerantz, Ralph's maternal grandmother, was connected to a prominent family in the Pale. Rachel's uncle Mordechai Perkovitsky had married into another of the great rabbinical families.

The news that he is related to Lauren makes Perkovitsky's great-grandson Rabbi Yechiel Yitzchok Perr let out a resigned sigh. Ralph Lauren, he says, "has a whole family he doesn't know about." Several, in fact.

Antopol and Droghicyn—part of the greater Pinsk community—were in a swampy area called the Polesian Plain, a treacherous terrain that stopped Napoleon Bonaparte's troops in the nineteenth century and the German army in the twentieth. The Jews who lived there, like their counterparts in Pinsk, had a decent life punctuated with periods of frightening instability. In 1882, for instance, they were ordered out of their homes, which were saved only by the payment of bribes. A few months later, Droghicyn's Jews were the target of a pogrom. Still, in 1897, there were 3,140 Jews in Antopol, out of a total population of 3,870, and they were on their way to becoming the majority in Droghicyn as well.

Fraydl Cutler, Ralph Lauren's mother, was born in February 1905. That year, the big news in Droghicyn was the installation of wooden boardwalks on the one street that ran through the town, which flooded whenever it rained. When Fraydl was five, a second road was built between the city and its train station, which the Russians had situated several miles away after the townspeople refused the chief engineer a bribe. A synagogue sat to the south of the road, a market to the north.

After World War I broke out in 1914, Droghicyn and Antopol were invaded by Germans who occupied the towns until fall 1918. Jewish homes were burned, and the children were sent to labor camps. Anarchy reigned in the months after Germany's defeat as the invaders were replaced by Ukrainians, then Bolsheviks, then Poles who killed residents, took their property, and plundered their homes. In July 1920, war broke out between the Poles and the Bolsheviks, and in March 1921, a peace treaty was signed giving the entire Pinsk

region to the Poles, who instituted new laws against the Jews. Antopol's rabbi began urging his flock to leave for America, even walking the first mile out of town with any who chose to go.

At fifty-one, Ralph's maternal grandfather, Sanya Cutler, left Droghicyn, sailing to Philadelphia from Antwerp with his wife, Rachel, aged fifty, and four of their eight children, according to the ship's manifest, Szaja (or Charlie), nine, Pesla (or Bessie), seven, Sora Zysla, nineteen, and Ralph's future mother, Fredja (or Fraydl—she would take the name Frieda in America), seventeen.

An older daughter, Sophie, had paid the family's way to America. She'd come before and married a man who owned a factory that pleated skirts, "the only *garmento* in the background," says Lenny Lauren, Ralph's older brother.

4

Ralph's paternal grandfather, Shlomo (later Sam) Lifshitz, was meantime living in Pinsk, working as a bookbinder and, Lenny's belief notwithstanding, a dressmaker. He was married to Tamara Schneider and had five children. Three left for America before Sam did in 1920. Their older son Eisik sailed from Bremen, Germany, to New York, aged seventeen, a year before war broke out in 1914. Left behind with their parents were Mary, born in 1900, and Frank, Ralph's father, who was born in the spring of 1904.

Unlike the Cutlers, no Lifshitz knows the whole story of their family's immigration. Eisik Lifshitz's son Seymour Linden says his two older aunts, Basche and Rose, left Pinsk first, but no one knows more than that. The only Basche Lifschitz from Pinsk listed in Ellis Island arrival records of the era left from Bremen in March 1914. No arrival record for Rose can be found.

Neither Linden nor the Rothenbergs even know Basche's American name. "We weren't a very close family," Ralph's cousin Seymour says. "It's kind of touchy."

"Some families were close," says one of Mary's sons, another cousin of Ralph's named Irving Thomas Rothenberg. "Ours wasn't. It was really a motley crew. It hurts me." Though he went to Ralph Lauren's 1964 wedding, Irving Rothenberg has seen his cousin only a few times since.

The two older Lifshitz sisters appear to have become estranged from the family in America. Though one of Mary Lifshitz's sons thinks his mother lived with her sister Rose when she first got to America, he doesn't dispute the notion of familial estrangement. Part of the reason for that distance may be found in the belief of these nephews that both aunts married well—one or both of their husbands owned real estate in the Bronx—but they don't seem to have helped in the effort to bring their relatives to America, or provide them with a soft landing here.

Back in Pinsk, life had been hard. Ralph's aunt Mary would later tell her sons about the deprivations of war, how she liked the Germans who would care for them and feed them, but not the Bolsheviks who would storm the town on horseback. Mary would hide potatoes in her bloomers to keep them from the hated Russians. "My father [Frank] guided her and took care of her," says Ralph's brother Lenny. "He must have been seven or eight years old. He was always running and hiding and scrounging food, trying to stay away from the Russians."

Frank Lifshitz delivered the books his father bound, sewing them by hand. "Besides delivering them, he also read them," says Michael Fried, one of Ralph's nephews. "In this way, he told me, he learned the whole Book of Psalms by heart."

Ralph's uncle Eisik, now calling himself Izzy, was working in a leather factory in Newark, making luggage and saving the little money he earned. It took him seven years to get his father, Sam, and two youngest siblings to New York. Ralph's grandmother Tamara Lifshitz had died, likely in the flu epidemic spread by troops at the end of World War I that killed half a million people between 1917 and 1919.

Immigration slowed to a trickle after that war began, but afterward, it picked up, and not only because borders were open again. In 1919, the Jews of Pinsk lived under the shadow of a new wave of pogroms. Jews were regularly robbed on the street and held hostage for ransom by Polish soldiers. On April 5 of that year, thirty-five men and two teenagers attending an organizational meeting for a charity to aid the town's poor were lined up against a monastery wall and shot by Polish soldiers who'd heard they were Bolsheviks. They were buried in secret, but word of the massacre leaked out, and an international outcry ensued.

Fifteen months to the day later, Sam and his children Frank and Mary Lifshitz left Antwerp, Belgium, bound for New York aboard the S.S. *Lapland,* a 620-foot steamship flying the British flag. It held 2,536 passengers, 1,790 of them in steerage. They got to America on July 14, 1920. On the ship's manifest, they are listed as Schleime (i.e., Sam) Lifschutz, fifty, and his children Berg (Frank), sixteen, and Marime (Mary), twenty.

Three Hebrews from Poland.

5

Rootless now, the Lifshitz family moved from home to home, job to job, in the concrete strangeness of New York City. When Sam's eldest son, Eisik, arrived in 1913, he told officials he was joining Max Wilewski. Wilewski would later be listed in the New York City Directory address book as a "huckster"—a peddler—living on the Lower East Side, the Jewish 'hood.

Izzy, as Eisik called himself in America, relocated to the Bronx. In 1917, an Isadore Lifshitz, usher, is listed living at 1381 Franklin Avenue in a downscale neighborhood in the core of what is now called the South Bronx. In 1918, an Isadore Lifshitz, a tailor, lived at 1330 Franklin. In 1920, when Grandpa Lifshitz arrived with Frank and Mary, he gave Izzy's address as No. 1342 Franklin—and said that was where they were heading. From 1920 to 1923, an Ike or Isaac Lifshitz lived at No. 1379. In the 1920–21 City Directory, a Samuel Lifshitz of the Manhattan Metal Spinning and Stamping Co. lived on Franklin. From 1922 to 1925, Samuel L. Lifshitz, a salesman, was at No. 1330. So was Jack Lifshitz, an actor, one of five children of Israel and Fanny Lifshitz. Another was Dora, twenty. Sam Lifshitz had a niece named Dora whose family owned a grocery in the Bronx. Izzy would soon own a grocery store, too. Whether or not Izzy, Eisik, Isaac, Ike, Isadore, and Israel were the same, or related, or totally different people, Franklin Avenue was Lifshitzville.

Sam's son Frank (the former Berg) didn't live there anymore. But tracking his movements isn't easy in the few, and often contradictory, records of the time. In 1923, on his Declaration of Intention to Naturalize, the diminutive—just 5 feet 3 inches—brown-haired, blue-eyed, almost-American gave his address as 283 South Fifty-seventh Street, Brooklyn. That address did not exist in the 1925 census. And there is no South Fifty-seventh Street in Brooklyn today—just an east-west Fifty-seventh Street—near the waterfront. No Lifshitzes lived anywhere nearby. No matter. By 1928, according to his naturalization papers, Frank had moved back to the Bronx.

That October, he married Frieda Cutler and they moved to Kelly Street, not far from their first Bronx address. Lenny Lauren thinks his parents met through

a Jewish organization, one of the many societies for Pinskers, Antopolers, and the like that sprang up all over New York. They were married in their new apartment by Abraham Isaac Cutler, Frieda's second cousin, who'd also come to America and become a Brooklyn rabbi. Then they procreated in the face of the Depression that began after the stock market crash of 1929. Thelma Lifshitz was born in 1930, Lenny in 1932, and Jerry, who they called Yussi, in 1934. Ralph came along just as the clouds lifted from the economy—the brink of World War II—October 14, 1939. "She called the other children by their names," says one of Frieda's cousins from Antopol, Hilda Riback. "But she called him 'my Ralphie.' Maybe because he was the baby."

6

"About ten years ago, Ralph Lauren sent to the store one of his twenty-two-dollar-an-hour-guys, the ones who look at old merchandise," says Eugene Eckstein, one of the third-generation owners of the now defunct H. Eckstein & Sons, a dry goods store on Orchard Street on the Lower East Side of Manhattan. "I showed this fellow underwear—a three-button long-sleeve shirt by Johnstown Knitting Mills. He said, 'This is a new shirt.' That's where he got the idea for the Henley shirt." The $22-an-hour guy couldn't have known he was standing where Grandpa Sam Lifshitz once did.

At the start of the Depression Sam Lifshitz moved to the home he would live in for the rest of his life, a dark apartment around the corner from Eckstein's at 65 Ludlow Street. There was a toilet in the hall and a bathtub in the kitchen. Just up the street was Grand Mansion, a wedding and bar mitzvah hall owned by the father of the famous cantor and operatic tenor, Jan Peerce. Across the street was an alimony jail. One door down was a livery, where horses that pulled ice wagons and milk trucks were stabled at night; when the wind was right, the smell would sweep up Ludlow Street.

Grandpa Lifshitz "was sort of a lone ranger, a hermit, he wanted to be by himself," says Ralph's cousin Irving Rothenberg. Sam got a job, twelve hours a day, six days a week, for about ten dollars a week at Eckstein's, where one hundred skull-capped salesmen wholesaled underwear and hosiery, towels and

sheets amid a helter-skelter of narrow shelves lined with ladders, stacked cloth-ing, and spilling cardboard boxes. They sold to poor, mostly Jewish hucksters, street peddlers, and small retailers. The store was so successful that in the depths of the Great Depression, its owners loaned their suppliers—the big fabric mills—money to meet their payrolls.

Few Eckstein employees are still alive. Some of them remember Sam Lifshitz. He was one of ten Sams who worked in the store—so many they were given numbers: Sam No.1, Sam No.5. There was another Mr. Lifshitz who sold ladies' lingerie. But Grandpa L. wasn't a salesman, more like a watchman, a janitor. "He wasn't talkative," says David Eckstein, another of the owners, a teenager when Lifshitz worked there. "He did his job. He was just there. If you asked him a question, he answered."

"He'd shovel the walk, sweep the place," says Lipshe Katz, a bookkeeper. "He was an old man, very quiet."

Sol Henkind, a co-worker, remembers him as Sam No.9—"a little guy," sit-ting on a stool in front of the store, "'til nine at night watching people didn't walk out with packages they didn't pay for."

One day, Sam brought a stack of mail into the office to give to the elder Mr. Eckstein, who was otherwise engaged. "Throw it in the fire," he barked in Yiddish. So Sam tossed the letters in a fireplace. "There was such laughter! I had nothing to deposit in the bank that day," says Lipshe Katz. "He was very obedient."

Sam Lifshitz's grandchildren remember him slightly; they have that in com-mon. They disagree on one point—whether or not their grandfather was reli-gious. Ralph's older brother Lenny insists his grandfather wasn't pious in the slightest.

Seymour Linden, on the other hand, would visit Ludlow Street a few times a year. "Read, Seymour," his father would command. "Read for *zeyde*." For grand-pa. "I had to read out of the Bible," Linden says, "so he knew I could read Hebrew." His father brought the old man clothing—"socks, a sweater, whatever he could gather," Linden says. "[Sam] was a heavy smoker. My dad would admonish him."

Like father, like son. Sam Lifshitz was a stern fellow. Shortly after he came to America, he joined a shul, a small synagogue on the Lower East Side called Congregation Beth Israel Chasidin de Stolin. It was the first American outpost of a Hasidic Jewish sect that was founded in the Pinsk suburb of Karlin in the mid–nineteenth century, and later moved to nearby Stolin and spread through-out the Pale. The group's founding rabbi was renowned in Pinsk for bringing eighty-four thousand Jews back to religion. A group of the Karlin-Stolin Hasidim

fled for America during the 1903 pogroms and established a shul—a house of worship—at 48 Orchard Street, named in honor of the great-great grandson of the sect's founder. Just like the English aristocrats Ralph Lauren seems to imitate, Hasidim, too, honor their forefathers and venerate great lines of familial descent.

Today's Hasids, in their dark coats and hats, are seen as ultra-Orthodox Jews, the equivalent of fundamentalist Christians and Moslems. But when Hasidism was founded in the mid-1700s, it was a liberal, populist revolution against the ascetic, scholarly rabbis of the day. The founder of Hasidism said those rabbis leached the joy out of being a Jew. His followers became *tzaddiks*, religious quasi-royalty, each with his own court. Only in the nineteenth century, when a truly liberal form of Judaism arose, valuing secular life and encouraging Jews to speak local languages, not Yiddish, did the Hasidim become the pillars of orthodoxy they are today.

Sam Lifshitz was a devout, observant Jew. He wore a yarmulke or a hat at all times, and every weekday morning he tied *tefillin*, two small black boxes containing four biblical verses (Exodus 13:1–10, 11–16; Deuteronomy 6:4–9, 11:13–21), handwritten on a scroll, to his head—directly between his eyes—and to his left arm, wrapping the straps around seven times while he *davened*, or prayed.

Shortly after settling on Ludlow Street, Sam was named to the committee of the shul's burial society and his name was carved on the gatepost of its burial plot in a New York cemetery. "They were true followers," says Rabbi Israel Pilchick, now head of New York's Karlin-Stolin Hasidim. "If he was on the committee, he must have been a close disciple, very close to the dynasty." Sam's given names, the rabbi continues, were likely a tribute to a leader of the sect, a rabbi named Shlomo Solomon. Of Lenny Lauren's doubts about his grandfather's devotion, Rabbi Pilchick says with disappointment, "He's running away from royalty."

Sam's religion could be harsh. He wouldn't speak to his daughter Mary's sons, because her husband didn't keep kosher. In the 1940s, the Rothenbergs got an apartment on Hester Street, right around the corner. "We lived three blocks away and my mother went to feed him his supper—borscht and potatoes," says another of Mary's sons, Ralph. "He drank tea out of a saucer with a cube of sugar in his mouth. He was a very religious man and my parents were not, and he wouldn't have anything to do with his grandchildren. In his eyes, we didn't exist. We were outcasts. If we walked by the store, he would ignore us. Nobody spoke to each other. It was unbelievable that somebody could be that way to their own flesh and blood."

Ralph's brother Irving, the oldest, wouldn't even walk his mother to her father's building. "He didn't care if his daughter came or not," he says. "So there was no sense in my going." Bad feelings persist. When Mary Lifshitz's husband died in 1970, Frank rode to the cemetery with her. But Ralph Rothenberg wouldn't drive his uncle home after hearing Frank "criticize my father because he was not religious," Ralph says. "I never spoke to him again."

Sam Lifshitz worked at H. Eckstein "until the end," says Eugene Eckstein, another of the owners. "He was senile. There was an incident." Soon thereafter, he moved into the Daughters of Israel Nursing Home and Hospital on upper Fifth Avenue. "There was a big room full of cots," remembers Seymour Linden, who visited his grandfather one last time in 1943, before going off to World War II.

Grandpa Lifshitz died of natural causes in December 1952. Mary Rothenberg's sons still complain that whatever money he had went to Izzy and Frank—and not a penny to their mother. "I was told he had lots of money," says Ralph Rothenberg. Adds Irving, "If there was any money, my mother's brothers got it. That I remember. He gave nothing to his daughter who took care of him." None of the Rothenbergs attended his funeral. Seymour Linden doesn't even know when his grandfather died. But Lenny Lauren visited him the night before it happened. And Lenny and Ralph's father, Frank, filled out the death certificate. "My father was the cement that held that family together," Lenny says.

7

The Cutler family's glue was religion. A coppersmith, just like his father, Ralph's other grandfather, Sanya Cutler, was "a very warm, very, very quiet Orthodox man," says Ralph's brother Jerry, and "very learned," according to Sylvia Ettenberg, one of Ralph's second cousins, who teaches at the Jewish Theological Seminary. "He read Torah." Sanya's brothers Charlie and Zelig were *chazzans*, or cantors. Zelig earned a meager living. Charlie was moonlighting; he was also in the pharmaceutical business.

Lenny Lauren recalls that his maternal grandfather was an expert on Jewish law. "He was not fanatical, but he explained it," Lenny says. "He was the sage of

the family." Sanya always wore black. And a "cumbersome, old-fashioned yarmulke," says the older son of Frieda's sister Bessie, Seymour "Sim" Storch, who never knew his grandfather's first name. Nor did he know his grandmother, Rachel. "She was not alive when I was aware, and I'm sixty-five," Storch says. So Ralph, who was four years younger, didn't know her, either.

Their grandfather "clearly had characteristics of an Oriental man," Storch continues. "He rolled cigarettes in the early mornings. He was light-bearded, a very gentle man. He came here with no trade applicable to the South Bronx. He really was a *kotlar*. He'd had a forge and made pots in Europe. I have one of his pots. Here, he adapted himself to sewing and would take in clothing. He had machinery to make buttons. It's similar to metal, the way they're stamped out."

Passover seders at Sanya Cutler's house were a family institution. Nat Buchman, a distant cousin, remembers that everyone brought a dish. "It would take hours to get there," Lenny Lauren says. "We had to take a trolley. But that seder was so rich. The men spoke and they sang because they were cantors. It was like the painting, like *The Last Supper*, nice people, and warm and loving and the food was sensational."

8

When Ralph was born, the Lifshitz family lived in a two-bedroom apartment—No. 2C at 3220 Steuben Avenue. Then mostly Jewish, now occupied by black and Hispanic families, it is a six-story red-brick building with a fire escape running down the front. It sits atop an urban hillock, adjacent to the sprawling, paved schoolyard of P.S. 80 and Isobel Rooney Middle School, which occupy an entire block of East Mosholu Parkway North, one of a three-mile-long braid of similarly named streets, bounded by grassy meridians, running between the Bronx Zoo and New York Botanical Gardens at one end and Van Cortlandt Park at the other. Frieda's siblings Bessie and Charlie lived just a few blocks away. Set apart from the city by the parks that surround it, their neighborhood, now known as Norwood, is a triangular enclave of considerable charm.

The residents of 3220 Steuben would have been lower middle class in the

best of times; Ralph Lifshitz was an infant in war time. "We lived with food stamps," remembers Harriet Hand, who lived in the building. 3220 Steuben was a magnet for local kids, who would play in its checkerboard-tiled lobby when it was cold or stormy outside. "People left their doors open," says Fred Fredericks, who lived there, too. "Neighborhood life was different then."

Few outside the family saw the inside of the Lifshitz apartment. "They minded their own business," says Hand. "They were very private." The Lifshitzes entered their apartment through a long hallway with a dumbwaiter, a bedroom to one side, an eat-in kitchen on the other, and a second bedroom and living room at the end of the hall; it doubled as a dining room. There was only one bathroom, next to the living room. Ralph and his two big brothers shared one of the bedrooms, which overlooked the P.S. 80 school yard. "I couldn't wait for one of them to move out so I could have half the drawers," Ralph said. "That molded me."

Frank and Frieda shared the second bedroom. Thelma slept on a pull-out sofa in the living room—which was furnished with a mix of unremarkable furniture. "It was very nice," Lenny says. "I only remember the good things." It was a typical immigrant household. "They were old country," says Helene Gerhardt Bond, who lived in an identical apartment one floor up. "They spoke broken English."

"Our neighbors were basically all immigrants," says Natalie Albin, Harriet Hand's sister. "I don't think Mr. Lifshitz was educated, but he was different from the others. He wasn't yelling from windows or throwing things. They never gossiped. They stayed to themselves."

Frieda Lifshitz was "pretty, good-natured, terrific smile, a look like an opera star, likable, *schmart*," says her cousin Hilda Riback. "A lady, *acch*, my God," says Esther Wyszkowy, herself from Poland and the wife of a rabbi, who went to temple with Frieda. She had "a robust, Russian peasant look," says Frieda's nephew Sim Storch. "Not the kind of good looks thin, athletic people might admire today, but she was sturdy and handsome. She had a lot to say about things, an opinion about proprieties. She wasn't a passive woman."

A love of learning and of God were her inheritance. "They were overly proud of the Cutler family for their religiosity and their contribution to Judaism," says Storch. "The Cutler name was a brand name in the scholarly end." Frieda "spoke Hebrew fluently, which was very unusual," says Lenny Lauren. Ralph Rothenberg says his uncle Frank wasn't as religious as Frieda, but faked it when he had to. "Frieda was dominant," Rothenberg says. "She ran that house with an iron fist. What she said, everybody did." But she wasn't distant or stern or impressed with herself. "She was a *yiddishe mama* in every sense," says Roz Barasch, a cousin. "She did *alles kinder*—everything for the children."

They noticed. "My mother was an administrator; she ran the family," Lenny has said. "Dad has his castles in Spain." Though neighbors describe him as stoic, silent, and unsmiling, if polite, his children say Frank Lifshitz was also a dreamer and a Yiddish boulevardier. Lenny says his father lived in downtown Manhattan as a young man (there is no record of his living in Manhattan). That he studied art at Cooper Union (it has no record of a Frank Lifshitz). And that he hung out with a bohemian crowd of Jewish writers, actors, and artists; acted in and wrote for the Yiddish theater; wrote for the *Daily Forward,* the big Yiddish newspaper; idolized violinist Jascha Heifetz, whom he knew slightly; and longed for the freedom to make great paintings. "He was like DaVinci," Lenny says.

When he was an old man, Frank Lifshitz would turn up at a Yiddish reading by Isaac Bashevis Singer, and be quoted in the *New York Times* recalling the Depression, when he read his own writings at Schildkraut's, a Lower East Side vegetarian restaurant. The reporter, Richard F. Shepard, recalls only that Frank was diminuitive and wore an elegant, checked three-piece suit. Shepard learned who he was from Sam Norich, the president of the *Jewish Forward.* "[Frank] was a man of parts," says Norich, "a presence, imposing but very gentle, dapper, but with no bluster." Today, Norich says, no record remains of Frank Lifshitz at the *Forward.* But it's possible, he thinks, that Frank may have contributed briefs to a humor column.

Writing wasn't his forte; Frank Lifshitz longed to be a fine artist. His paintings, many of them copies of works in the Metropolitan Museum, hung everywhere in the house. He gave them to relatives, too. Hilda Riback's mother had a Frank Lifshitz original. So does Ralph's cousin Sim Storch. But Storch doesn't have his on his wall, and Riback gave her mother's away, much to Frieda Lifshitz's distress.

"I used to marvel," says neighbor Helene Bond. "A Jewish artist? You know what I'm saying?"

Frank Lifshitz had some talent, but Picasso he wasn't. "He never said he was a painter," says neighbor Norman Schlissel. "He always said he was an interior decorator." But to make a living, he was a *schmearer*—the guy who painted neighborhood apartments. When somebody moved, there'd be a job for him. People moved all the time. "In those days, when your lease was up, you moved because the landlord painted and gave you two months rent free," says George "Fuzzy" Fusfield, Fred Frederick's brother. Their mother and Frieda often babysat each other's kids. Fuzzy says Ralph's father had a contract with the owner of 3220 Steuben to paint all the apartments there.

When he could, Frank talked his clients into something more than a coat of white paint. For Harriet Hand's parents, he painted French doors to resemble

curtains. At Emanuel and Samuel Topal's apartment, he finger-painted delicate little flowers on glass. "He'd joke as he painted," says Samuel, "smiling and asking if I liked it." When he could, Frank painted murals in building lobbies and fashion business showrooms. "Scenes were very popular in dining rooms," Ralph has said. "Now it would be wallpaper, but it used to be painted, all kinds of things, like a wall [to] look like wood or marble. But he could not always get that kind of work."

"He didn't get the right break," Jerry Lauren says of his father. "He was forced into house painting to feed his family." He even painted *for* family to feed his family. "He begged to paint my daughter's apartment," says Hilda Riback, who was married to a rabbi and lived on Park Avenue. "They were the poor relations—at the time." They were even poor according to the standards of Steuben Avenue. "They were poorer than average," says Fred Fredericks. "My mother mentioned a couple times that Frank didn't have work."

"My father was an entrepreneur, really," Thelma Lifshitz has said. "It wasn't always easy, but we had what we needed. None of us felt deprived. We weren't materialistic; our values were simple." Even after his son soared to fame, Frank stayed grounded in his own modest talent.

Still, the Lifshitz boys all ended up fascinated with material things. In recent years, Ralph Lauren has built a world-class collection of classic cars, and he traces the fascination back to the deprivations of childhood. "I knew every car," he said. "We'd sit and look at cars and say, 'Oh that's a Chevy, that's a Buick.' I started learning about cars when I was a little kid and my parents couldn't afford to get me a bicycle. I never had a bike when I grew up. I would borrow my friends' bikes. And there were these two twins in my neighborhood," Ralph continued. "I remember looking out the window on Sunday morning and they were very beautifully dressed kids. They wore these camel hair coats like Prince Charles. In my neighborhood! And they went riding around in a little red fire truck." His voice went breathless and dreamy. "Oh, would I have loved to have one of those trucks!"

Painting had one perk: brushes with the famous. Frank painted Grand Mansion, the kosher catering hall near his father's apartment on Ludlow Street. The owner's son, the tenor Jan Peerce, was Frank's age. Edward R. Murrow and Eleanor Roosevelt, two of the customers his kids claim for him are gone, but another, Suzy Parker, the model, remembers him with pleasure. Frank marbleized her penthouse in the 1950s and her house on Washington Mews in the sixties. "Last of the great ones," she says. "Old school. Extraordinary. Marble was his specialty. 'Do you want Siena?'"

Frank was a gentle, smart man. Sim Storch recalls him as accepting and non-

judgmental. "Frank had a brain that couldn't quit," says Seymour Linden. "He had common sense, vision; he was tender. He was a dreamer, a philosopher. I would talk to him for hours about life, about a million things." Frank was something of a renaissance man. Besides painting and acting and writing, he played guitar and violin and mandolin and longed for the Russian stringed instrument called a balalaika—Ralph would eventually buy him one. "He sang Yiddish songs all the time," says another of Lauren's cousins. "He was the most magnificent person, very nervous, hypertense, always snapping his fingers, but a wonderful, wonderful man."

Frank and Frieda were a formidably loving couple. "They complemented each other," says Sim Storch. "I envied the relaxed atmosphere in their household. The time to spend in artistic exercises was nurtured in that household because [of] the general quiet and, perhaps, encouragement to be creative. I don't know if it was a form of play, but I very much doubt they saw it as [having] a potential for commercial success. Being an artist was equated with being a starving artist."

Hilda Riback suggests that equation made an impression on Ralph. "I think to Ralph, his father didn't make enough money," she says. "He spoke with an accent, you know? He didn't ask his father to paint a picture for him until a couple years before he died [in 1994]. I said to my children, 'He's arrived if he feels he can do that.'"

9

All the Lifshitz kids could draw. "The artistic, they all got," says Bessie Storch. Thelma, who went to the High School of Music and Art, was acknowledged as the most talented, but the kids were all visual. "It went through the family," says Sim Storch, who was Jerry's age. "They never pursued art in its pure form because it didn't look like a promising career."

Lenny and Jerry were taller versions of their mother, Thelma and Ralph resembled their father. Lenny and Jerry got the better part of the bargain. They were considered gorgeous, lady killers. "Everybody had crushes on Jerry," says

Helene Bond. "Lenny was a real Beau Brummell," says Natalie Albin. Ralph is remembered as cute.

Thelma Lifshitz, the oldest Lifshitz child, was sweet but unattractive, introverted, and self-conscious, according to their neighbors. "She was a tomboy, an athlete, and a great artist," says her brother Lenny. Today, she lives quietly in a suburban community north of New York City, where her husband is a county planner, and she often visits Israel, where one of their children lives.

Lenny was quite the opposite. "Full of life," says Fred Fredericks. "He had the most character." Fred's brother Fuzzy calls Lenny "the personality kid. Everybody liked him. The girls liked him." Another neighbor, Warren Balsam, says, "Lenny had a great sense of self. He was well dressed in whatever the style was, well groomed, gregarious, and he worked; he wasn't an idle kid."

Like Thelma and Lenny, Jerry Lifshitz loved sports, although "he wasn't especially good," says Fusfield. "He was a scrawny, skinny kid." But most agree with Harriet Hand, who says Lenny and Jerry were "personable, popular, and outgoing. They were leaders. They had friends who followed them." Albin goes further. Lenny had "an entourage of sycophants," she says.

Like Jerry, Ralphie was scrawny—and also sickly, with a sinus condition and a runny nose. His cousin Nat Buchman remembers wiping it for him. "Ralph was a very big baby, but he didn't develop as rapidly as we would like to have seen him," Thelma once said. "He had to have special care; we had to squeeze beef juice to build him up."

Joseph "Jeb" Buchwald met Ralph in the first grade—and has remained a friend for more than fifty years. He says Ralph wasn't so much sickly as moody. "We'd come up to his apartment, and he wouldn't want to come out," Buchwald says. "He'd want to listen to Sinatra or Perry Como. He wouldn't go out as much as we'd like. He was thoughtful, quiet. But we were sometimes outrageous. We had fun."

Buchwald and a couple other local boys were close to Ralph, but his brother Jerry was really his best friend. "Jerry had a big influence," Buchwald says. "Ralph really looked up to Jerry. Jerry would say, 'I have a mission for you.' It would be some kind of secret. They would keep it to themselves."

In the rare instances when he speaks about it, Ralph Lauren paints an idyllic picture of his early childhood. "I was the baby; I was well taken care of," he told a neighbor, Marty Friedman, who interviewed him for a never-completed book on growing up in the Bronx. "I had it totally made; I was totally left alone. It was very peaceful; it was a nice childhood. I would not trade my childhood with anybody. I was very happy. I loved where I grew up. It was fabulous to get out of my house from the age of five, to go down my steps and roller skate through the school yard, always somewhere to go."

Lenny Lauren calls Ralph "an adorable little brother, a good, quiet little kid. I wheeled him in his carriage; I was so proud of him. He never compared himself to us. He could do no wrong. He had a lot of friends."

But beneath the veneer of fond recollection, Ralphie's life wasn't quite perfect. "I knew what it was like to have nothing," he told the *Washington Post* in 1997. Neighbors recall a withdrawn child with a lazy eye and a speech impediment who spent hours on the marble stoop at 3220 Steuben with the wives of the building who would set up lawn chairs on the sidewalk when the weather was warm—nobody had air-conditioning, and the apartments were all crowded. "Ralph was a weak little kid, he was considered homely, he was conscious of his lisp," says Fuzzy Fusfield. "Jerry and Lenny and Thelma would come down to the school yard and we'd say, 'Where's Ralph?' He'd be sitting on the stoop."

Fusfield's mother told him that finally Ralph underwent speech therapy.

Next door, the P.S. 80 school yard was informally divided into three areas where neighborhood kids would play basketball, stickball, and slap ball with pink rubber Spalding—aka *spaldeen*—balls. "Everyone used to participate except Ralph," says Fusfield. "He sat on the stoop. He was always on the stoop. He was a loner. He didn't smile. He was very self-conscious. He was always thinking while the other guys played ball. I guess he thought good."

But nobody thought about what Ralphie was thinking—not in those days. "He was a squirt," says Fuzzy's younger brother Fred, who was Lenny Lauren's age—and, like the Lifshitz boys, would later change his last name.

Little Ralphie. That's what everyone called him. "An outcast," says Fredericks. "He was too young. There was no one his age around. Groups formed to play stickball, and he would try to attach himself without success. I couldn't play with *my* brother because I was too young. It was a very strict thing for some reason. He had to seek his own identity."

Once, Fredericks asked him what he wanted to do in life.

"Be rich," was little Ralphie's reply.

So he was no different than any other kid around. "Everybody there was aspiring," says Harriet Hand. "They were the children of first generation Americans who all wanted their kids to better themselves." Their children's lives seemed carefree on the surface—growing up in an expanding economy between World War II and the Korean War, but just beneath the surface, "we were suffused with guilt about our parents," says another neighbor, Joel Rudish, "because of the hardships they'd had in Europe and in the Depression." Adds Don Guerra, yet another, "In a mile square there were close to one hundred thousand people, every one of them on the make. We were all needy for recognition, for attainment."

Their neighborhood was insular, but vistas were opening. In 1950, when Ralph was ten, he got his first girlfriend, June Hochwald, who lived behind P.S. 80 on Rochambeau Avenue. "He didn't have a TV, and we were fortunate enough to have one," says Hochwald, who assumed Ralph's family was "very poor." Her parents let them share a love seat—"of course, we only sat there"— and they would watch *Six Gun Playhouse* and *Hopalong Cassidy*, new television westerns that featured cowboy stars like Cassidy, Hoot Gibson, and Tex Ritter in half-hour serials emphasizing positive values, heroism, and patriotism. And they went to the movies at the Tuxedo—the local movie theater. All the kids went from noon until five on Saturdays for the double feature, plus newsreels and cartoons.

Those TV shows and movies had a profound influence. Ralph was captivated by the image of "the good guy, the Hopalong Cassidy," he told Charlie Rose. "Not the corny guy, but there was the man on the white horse." Sure, a few months before that, he'd said he disliked "the fancy cowboy with big white fringe and a banjo and a white horse, Hopalong Cassidy, Roy Rogers." He was, perhaps, tailoring his recollections to his audience, or remembering the evolution of his own taste. "I wanted to be Randolph Scott," he told *Vogue*'s readers. "He was tough, he wasn't a fancy cowboy."

Either way, June Hochwald was captivated by her little cowboy. "He was the cutest kid on earth," she says. "Adorable, sweet, quiet. He was my boyfriend!" Ralph called her Snuffy. "We were together so much, he gave me his skeleton ring." Made of fake silver, it had green eyes and a red mouth.

On the surface, Ralph seemed a placid little boy. "He was laid back; he was mellow," says Helene Bond. "Nothing bothered him. He never got excited." What he did best was watch. As he sat on his stoop. Or hung out his bedroom window as the bigger kids played in the P.S. 80 school yard. "I would see kids out the window all the time," Ralph said. It was easy to join in. Just run down a flight of stairs, leave the building, and turn left.

But he wasn't part of it yet.

10

f, instead of turning left out Ralph's old front door, you turn right and walk half a block up Steuben Avenue, you come to Young Israel of Mosholu Parkway, the tiny temple Ralph Lauren attended after it opened in 1952. Today, forty-nine years later, it is Purim, the Feast of Esther, celebrating the defeat of a plot to kill the Jews of Persia and the once-bustling synagogue is less than a quarter full. Its population base is gone; the Jews have left the Bronx. A few women and children sit in a balcony. About two dozen men, mostly elderly, *daven* on the ground floor before a wooden altar trimmed in red velvet, beneath a brass plaque commemorating lives lost at the Auschwitz death camp in World War II. The plaque features a quote from Isaiah. "And I will give them a place and a name in my house. An everlasting name that will not be cut off." Directly opposite on the wall is a small plaque honoring Frieda and Frank Lifshitz, signed Ralph and Ricky Lauren.

Young Israel is musty and run-down. The brown and tan checkerboard tile floor is worn, the prayer books tattered, like the clothes of some of the congregants who wander around, talking among themselves, as others pump back and forth, praying.

At a podium is a gray-bearded man in an eye patch and fedora. His visible eye is piercing. He is Rabbi Zevulun Charlop. Later, he will point out the faux finish in a small chapel, the marbleized walls in a hallway, and, in an apartment lobby across the street, a triptych mural of a sailing ship on a lake, all painted by Frank Lifshitz.

Charlop met the Lifshitz family in the early 1950s, and made a study of them. "To understand Ralph, you have to understand the balance and the dialectic between father and mother," he says. "The mother was down to earth, extraordinarily pragmatic, feet always planted firmly on the ground. At the same time, she was uncompromising about religion, deeply, profoundly religious. She believed in God in every way. She wanted heaven, but her feet never left the ground. The husband was always soaring. He wanted to be something. He felt he had it. He had a sense of himself. He was artistic. He was poetic."

Though he's recently had a stroke and moves slowly, Charlop gets up behind his desk and does an animated little dance, one jaunty hand in the air, his hat tipped low on his forehead. "Ralph came from a very conservative, very decorous home," Charlop says. "He's a combination of conservative and artistic."

Frieda sat apart from her husband at services, with the other women, but to Charlop, it was clear she was the force behind the family's religion. Charlop remembers the fights they would have if Frank got home late on the Sabbath. Frank never disagreed with her in front of the kids, even when he felt she was wrong. "She was very conscious of the religiosity of her family," Charlop says. "I had the sense she was aristocracy. She bore herself with tremendous dignity. She was strong as nails. She wanted Ralph to be a rabbi."

That would become a point of contention. Lenny Lauren insists that there was nothing excessive about his family's practice of religion. "We didn't follow rituals," he says. "We didn't go to shul. We played ball on Friday nights and Saturdays. She was not unreasonable. It was follow the rules as my mother interpreted them. She imposed them on herself more than anybody. Later, she imposed them on my father."

Still, Lenny, the rebel, never ate Chinese food until he was eighteen. Ralph stayed kosher until he was twenty-one. "I went to synagogue on Saturday all my life, early life, young adult life," Ralph said. And others recall that the Lifshitz family said *Kaddish*, lit *yartzeit* candles, were temple regulars. Before Young Israel opened, they walked to services at the Mosholu Jewish Center on nearby Hull Avenue. "*Shabbos* was big," says Helene Bond, who remembers their walking to synagogue together. Frank would take off his painter's overalls and put on a shirt and tie and coat. Everyone wore hats. Says Harriet Hand, "Frieda in a hat without a purse because it wasn't appropriate among Orthodox Jews to carry a purse."

When Ralph was eight, the Mosholu Jewish Center became famous when a rabbi named Herschel Schacter took over. Two years earlier, he'd been the first Jewish chaplain to enter the Nazi death camp at Buchenwald; he would later become an intimate of President Richard Nixon. Even before Schacter, it was one of the most popular houses of worship for the six hundred thousand Jews of the Bronx. It had thirty-five hundred members. On High Holy days, the most important Jewish holidays, they would worship in shifts.

Though he was superficially observant, neighbors agree with his nephew's assertion that Frank Lifshitz wasn't terribly religious. He would dutifully go to synagogue on Saturdays and on the holidays, with his *tallis* and a prayer book, often sitting with the Fusfield men, but he also broke the rules—just as he did by doing figurative paintings—and let his boys go to the movies on Saturday after-

noons. "A ten-cent ticket and five-cent chips," Fusfield recalls. "It was a cheap baby-sitter."

Frieda yearned for her children to be devout, to go to yeshiva, and she dreamed that one of her sons would continue the family tradition. "We're the sixth or seventh generation of rabbis," says Rabbi Irwin Cutler, a son of Abraham Isaac Cutler.

"You might find a couple of horse thieves," adds his brother Jerry, a rabbi in Beverly Hills.

"They had to have a Hebrew education," says Hilda Riback, who'd married a rabbi. "It's tradition. It's what represents you." As usual, Sanya Cutler played Solomon and cut through the argument. "*Zeyde* said, 'This is a new country,' " recalls Sim Storch. " 'I don't know what it will mean to them as Jews.' He said, 'Minimally, let them know their roots.' I felt it was very wise."

Lenny didn't. "He rebelled," says a contemporary, Hank Brown. "He was not religious. He considered himself a ladies' man. He liked to cat around. He was outside the Orthodox fold." Lenny went to public school. "I was one of the better athletes in the neighborhood and I didn't want to go [to yeshiva]," he says. "I did not go because they did not have a basketball team."

Yussi—Jerry—went along. "She was very proud of the fact that he went to yeshiva," says Riback. "She boasted to me. I don't think her husband cared." Jerry enrolled in Yeshiva Rabbi Israel Salanter, where half the day was spent studying in Hebrew and Yiddish. He would go on to the Talmudical Academy in Manhattan, a school that trained rabbis and Hebrew schoolteachers, and then to Yeshiva University. "My mother thought she had a rabbi there," says Lenny. "Jerry spoke Yiddish before he spoke English. He was the darling of the family. He was gonna be the messiah."

For two and a half years, from kindergarten through second grade, little Ralphie followed in Lenny's footsteps and went to P.S. 80 next door to the Lifshitz apartment. In many ways, he was a typical kid. After school, he'd have milk and cookies with his upstairs neighbor, Helene Gerhardt, who also went to P.S. 80, then climb down the fire escape to his apartment; he was always forgetting his keys. But he missed twenty-four days of school in first grade and twenty-three days in second grade. And he got less than satisfactory marks on his report card in "practices good health habits," "speaks clearly," literature, spelling, arithmetic, and penmanship; he did better in music, art, and shop. In 1947, he started third grade at P.S. 80, but after missing ten of the first forty-three days of school, he transferred in mid-November to Yeshiva Salanter, where Jerry was in his last year—eighth grade. "[Ralph] wanted to be in public school," says his friend Jeb Buchwald. "He was kind of pushed into yeshiva."

June Hochwald, his girlfriend, was crushed. Ralph "said he was going to yeshiva and we were going to be separated," she says. "I had no idea what he was talking about."

Lauren has always acknowledged that he spent time in the yeshiva system, but his years at Salanter have never been mentioned in articles or books about him nor in interviews with him. Questioned about apparent gaps in the record of his schooling, Lauren responded through a spokeswoman and offered the news that he'd attended Salanter from the third through the sixth grade.

That—it would turn out—wasn't quite accurate, either. Salanter would be the first, but not the last thing in his life that Lauren and his mythmaking machine would equivocate about. "In your formative years," he has said, "everything is just a blur and you're being led someplace and don't know where or why you're going there."

What Ralphie wanted, though, was plain as the view out his bedroom window, to the school yard of P.S. 80 and Mosholu Parkway beyond. Mosholu ran up to Grand Concourse, the Jewish Park Avenue, and then north toward the bucolic horse trails and thoroughbred lifestyle of Westchester County.

But that would all have to wait for another day.

'Today, I am a man.' *(Yeshiva Rabbi Israel Salanter 1953 graduating class; Ralph Lauren second from right in the middle row; courtesy of Jay Ladin)*

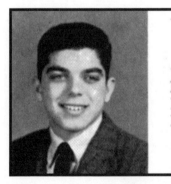

C.C.N.Y.
Lunch Room Squad, "Clinton News," Dean's Office Squad, Health Ed. Squad
Millionaire

The future millionaire. *(Lauren's senior photo, 1957 DeWitt Clinton High School yearbook)*

PART TWO

Aspiration:
From Lifshitz to Lauren

Your early youth is what you remember the most. Your life, what happens after, is like you are living a role, instead of your life, almost. Not that you are fake.

—Ralph Lauren

11

alphie Lifshitz entered Yeshiva Rabbi Israel Salanter in November 1947—unwillingly. "He went because our mother wanted him to go," says Lenny. Ralph had no say in the matter. He was going to be a rabbi.

Founded in Harlem in about 1920, Yeshiva Salanter moved to the Bronx in 1926 when the Yeshiva of the Bronx went broke and merged with Salanter to survive. Salanter's roots were in New York schools of the late nineteenth century called Talmud Torahs. By 1910, ten thousand children of orthodox Jewish immigrants were going to public schools all day and Talmud Torahs afterward. Fervent Jews felt that was an inadequate religious education, though, and created the first yeshivas, where students studied holy texts most of the day, and English subjects for an hour each afternoon. The next wave of yeshivas offered half a day of secular studies. The Talmudical Academy, the first Jewish parochial high school in America, was founded along those lines in 1916, dedicated to helping Jews stay true to their faith *and* be Americanized.

Yeshivas teaching younger students were begun to serve as feeders for the Talmudical Academy, which itself fed Yeshiva University. Once Yeshiva and the Talmudical Academy were established in northern Manhattan, Salanter, just across the river in the Bronx, became *the* Jewish day school in the area. It was religious but not too religious. A majority of the students in the Talmudical Academy came from Salanter.

The school was named for Rabbi Israel Lipkin Salanter, a nineteenth-century educator who advocated *musar*, a moral doctrine stressing humility and scrupulous behavior. *Musar* promoted those values through the unison singing of sayings from ethical writings: the Bible, the Talmud, and other religious texts. It encouraged Jews to be involved in community affairs but also to practice self-reflection to identify and rectify personal shortcomings. It was a perfect first-generation mix of orthodoxy and modernity. Yeshiva Israel Salanter didn't always follow the *musar* path, but in 1943, a new head rabbi, who'd escaped from Nazi-occupied Belgium, revamped the curriculum according to *musar*.

Despite the emphasis on personal improvement, Salanter didn't help Ralph's

academic performance. According to his public school transcripts he showed up ninety-eight times and skipped fifty-one times in the 1947–48 school year. He maintained a decent average that year, but the next (when he skipped fifty-eight out of 172 days), he got an A in art, but a 30 out of a possible 100 in arithmetic, a 25 in geography, and a 40 in history and civics.

Salanter Yeshiva still exists, but it has long since merged with other schools and moved to another location; all records of the yeshiva Ralph Lifshitz attended have been lost. But former students still remember the huge utilitarian brick building where they went to school, with its lunchroom, tiny interior recess yard, and small synagogue where eighth graders, who'd already been bar mitvah'd and become "men" in the eyes of Judaism, could pray. "It was not a joyous place," says sportswriter Vic Ziegel, a Salanter graduate. School was in session six days a week. Students got Saturday, *shabbos*, off. On Fridays and Sundays, there was school for a half a day. Mornings, from eight-thirty A.M. until noon with one fifteen-minute recess, were spent praying and then reading the Torah, Talmud, the Bible, and other religious texts in Hebrew, and studying Hebrew grammar, Jewish literature, and history. After lunch, students took secular classes—subjects like math, science, English, and art—until five in the afternoon. Ralph had to get up every morning at six A.M. to get there by bus; he sometimes took a trolley home on Friday afternoons, when school ended at one and some of the kids would play basketball in the courtyard until three P.M.

Ralph was at an extreme disadvantage at Salanter. He didn't know Hebrew or Yiddish well, and, says Norman "Nasan" Friedman, who was both a student and a teacher there, "You needed all three languages." So in the mornings, Ralph was placed in a class with younger boys like Saul Krotki, whose mother taught English in the afternoon. Krotki remembers the day the new yeshiva *bochur*, as the boys were called, this one with a funny name, arrived well into the term. They both sat in the last row, separated by an aisle. "He was never up to the level we were," Krotki says. "The devout kids had a certain rhythmical way they spoke Hebrew. They were total rabbinical students. They enjoyed the ritual. It was the nature of their families. Ralph didn't have that. He was not a kid who got up and danced the *horah*."

Luckily, his brother Jerry had gone through Salanter before him and was in his last year—eighth grade—when Ralph entered the school. So he already knew that the place ran on fear. Corporal punishment was the norm. "You stopped to pass a note, you got whacked," Saul Krotki says—with a hand or a ruler or a hanger or a chair leg. The slightest infraction—not hanging on the rabbi's every word, losing your place in a text, smiling, laughing—got you a whack. The greater the offense, the worse the punishment. Lesser sins earned

you a shot in the head with a piece of chalk or an hour locked in a closet. "Today, we'd call it assault and abuse," says classmate Herb Schimmel. "Then it was discipline."

When a rabbi caught some classmates stockpiling spitballs, Ralph witnessed the punishment. "It was a sadistic, primitive ritual," says Krotki. The offenders held their hands palm up as the rabbi smacked them—once for every spitball in their pockets—until he drew blood. The rabbis were fierce and old world; many were Holocaust survivors. "They didn't get secret decoder rings and the Lone Ranger," says Vic Ziegel. "They were still in the shtetl."

"We all hated it on a certain level," says Avram "Doc" Nathanson, who was in Ralph's class. "You'd get your ass kicked. But it was an education that made high school a piece of cake. You'd learned to learn. It was a real high-powered environment intellectually. Many of the kids were *really* smart."

The rest could breathe only at midday, when the boys would eat lunch—usually subsidized government-issued food served with crusty, fresh rye bread—then tear down a fire escape to play with pink *spaldeen* balls in the recess yard. "It was the high point of the day for most of us," says Rabbi Michael Hecht, now dean of the Talmudical Academy. Some kids also gambled with baseball cards, but Ralph would play marbles or sit by himself and doodle until Marvin Feinsmith, who was a bit older, befriended him and initiated him into slug ball—a baseball-like game played against the courtyard wall. There was a park across from the school on Webster Avenue, and sometimes the older boys would go play pirates there. Ralph was afraid, "so we'd have to cross him," Feinsmith says. Or they'd see the candy man, a gent in Coke bottle–thick glasses who passed by each day with a wooden rack on his back and a baby carriage full of Delisha Bars, Good & Plenty, Double Bubble, baseball cards, and pretzels.

This regime created two kinds of students; some were true believers, "possessed with religiosity," says Krotki. The rest "didn't pay attention, didn't give a shit. They were lending money, trading candy and zinc pennies, working all kinds of deals."

Except Ralph. "Ralph was a bird of his own feather," Krotki says. "He was kind-hearted, charismatic, intelligent. He was not popular, not cool, but he had a gentle cleverness. He was secular. He had class, a way of handling himself. He was very politic. I thought the idea was to cause trouble. He had a word to the wise. You needed a strategy to survive. He had a limited comprehension of what we were doing, but he nodded at the right times, and the rabbis had their hands full, so he easily convinced them that he was on the ball. Only when I met him did I learn to sit back and observe." Krotki watched Ralph. Smelled him, too. "He was clean and cologne-y, not in the ghetto clothes we all had."

Ralph *didn't* fit right in. He was a commuter—taking the bus to and from school, so he didn't socialize much with the other students. His friends were the nonreligious sorts. But he wasn't one of the wild kids. "When there was rough play in the yard, he would move away," says Marvin Feinsmith. "That's why I liked him." The feeling was mutual. Like Frank Lifshitz, Feinsmith's father was an artist—a musician—and Feinsmith also drew and played clarinet. Ralph would show him the drawings he made in his *mach beret*, a specially lined Hebrew notebook. "When do you have time?" Feinsmith asked him.

"In class," Ralph said.

Ralph looked different, too. "He stood out," says Rabbi Hecht. "He wore pastel button-down shirts; he had a sense of fashion no one else did." Hecht ran for class president one year, and Ralph was his campaign manager and painted his posters. "He was very creative," Hecht says. Years later, classmates would recall Ralph's loafers, his sweaters, how well groomed he was, and how they wrote his name under Best Dressed in their graduation autograph books. On Thursdays, when the yeshiva *bochurs* gathered for assembly in white shirts and big, broad, hand-me-down ties, Ralph would wear narrow, preppy knit ties, and his shirt sleeves would be rolled up just so. "He was light-years ahead of us," says a classmate. "The rest of us were schlepping."

Ralph was also supposed to wear a yarmulke—or skullcap—and *tzitzis*—a fringed garment worn under the shirt—every day. "With the fringe hanging out of your clothes," says classmate Steve Heitman. "It wasn't normal."

Kids tucked them in. Then, after school, they couldn't wait to flip their lids—take their yarmulkes off. "The first thing I did when I got out of school," says Herb Schimmel. It was advisable in the part-Irish neighborhood near Salanter. "One time I forgot to take it off, and I got a beating," says Ziegel. The same thing happened to fellow student Jack Hiller, who took the bus with Ralph every day. "The neighborhood had a lot of Irish Catholics," Hiller says, "they didn't like yarmulkes and they would start up with you, call you Christ killers, so you were careful unless you were in a crowd." No one remembers Ralph being beaten, but "older boys made fun of him," says Louise Dichter Wilson, who'd met him at P.S. 80. "It irked me. I went 'Good for you, Ralphie,' when he made it."

Citizen Kane, Orson Welles's fictional retelling of the life of William Randolph Hearst, begins with a McGuffin, a word coined by Alfred Hitchcock to describe an object, a person, or event, around which a plot revolves. *Kane* gave the movies its most famous McGuffin, Rosebud, a long-lost sled that set the film's hero, Charles Foster Kane, on his lifelong quest for wealth, power, and possessions. There is no single sled that turned Ralphie Lifshitz into Ralph

Lauren—yet every time he whipped off his skullcap, every time his face lit up upon leaving Salanter's fundamentalist, atavistic, old-world culture, another rosebud blossomed. It couldn't have been easy. "I think he probably got his ass chased more than once," says Warren Helstein, a neighborhood kid who became a friend. "If three wise guys saw a little kid with a yarmulke, they chased him. It happened to me, and thinking about it, I wanted to un-Jewish myself. You can't escape; you think you can, but you still look Jewish."

The worst part, though, was losing your life. Yeshiva became your life. "I remember being angry all the time," says classmate Louis Levine. "But we were obligated. Our parents insisted." In winter, by the time they got home, it was dark. "It kept me from playing ball," says Jay Ladin. "I didn't get home until six at night. I felt I was missing out." "I wanted to be with kids in my neighborhood," says Herb Schimmel. So did Ralph, who often looked unhappy, even though by fifth grade, he'd finally managed good grades.

"He hated and disliked it," sighs Lenny Lauren. "Those poor guys."

Yeshiva was like prison. "You belong to your own world, not necessarily the broader American world," says another classmate, Tzvi Abusch, now a professor at Brandeis. "You want to be one of the guys, yet you are influenced by your family and drawn back in. For some, this results in alienation, for others, a drive to become a part of that other world."

Young Jews of the time were of necessity bipolar—their world was a divided, often unhealthy place. "We were ambivalent in many ways about who we were," says Salanter graduate Michael J. Horowitz, a senior fellow at the Hudson Institute, who used to have a recurrent nightmare. "I was standing on two rocks in a white water rapids," he says, "and they'd split and move apart, and I'd negotiate this until I was at the point of splitting up the middle. That's when I'd wake up in a cold sweat. You had to act as if you were still Orthodox, though you weren't. Salanter created the illusion that you could do it all. What it did was split you down the middle. You were turning your back on fifty generations, the pull of the past, the lurking tragedy."

12

The world beyond the Bronx kept intruding, no matter how hard Frieda Lifshitz sought to fend it off with religion. Frank bought a TV set—a Dumont. "There wasn't much on," Lenny Lauren recalls, but Ralph loved whatever there was. The other thing he loved was dressing up. Little Ralphie had a thing for clothes. "The creativity was lurking, even as a child," says brother Jerry. "Ralph had an urge, an ache."

At age three, he'd try on hats, his father's, his brothers'. He always wanted to have a hat on, just like his grandfather, Sam. "He would put the metal cover of a potato boiler on his head—it looked like a helmet," says Lenny.

A secret Superman, he would wear blue ski pajamas under his clothes, and keep a folded towel in his pocket—"that was the cape," he once told *Women's Wear Daily*—just in case a damsel in distress needed him.

Ralph's inchoate refinement may have come from his mother. "My mother had very good taste and an eye for what was correct," Thelma Lifshitz said. But no one knows where the urge to dress up came from. "Not from Jerry or me," or their father, Lenny insists. "I was more cosmopolitan; I had a million friends, but I was not into clothes. My father was a very tasteful guy, but he was not a dandy."

That may be, but Ralph and his brothers looked at getting dressed as a means of expression. "We all loved clothing," Jerry says. "It was in him even as a child. I'm talking about before fashion. He'd look at me and say, 'I love your reindeer sweater.'" That love was a beginning. "It stirred a certain inspiration. Lenny had a varsity sweater. We'd aspire to it. If you have an older brother and he outgrows it, you're happy to wear it. It's about a natural taste level, lurking, waiting for someone to expose you to it. As you learn, as you read, as you're exposed, the world opens up to you. He had a natural talent to discern good taste from bad."

Ralph often points to his brothers as the source of his sense of style. "When you have older brothers to look up to, in a way, you're advanced more than the kids your own age," he's said. "I wore what my bothers wore. I never thought about style."

Ralph had grown into a preteen many thought handsome, always dressed

like a preppy in chinos or jeans and white or pink Oxford cloth, button-down shirts. "When all the kids in our area were wearing motorcycle jackets, I was wearing white bucks," he's said. He found he made an impression by dressing up—and being different. "He was a quiet boy with a very sophisticated air," says neighbor Loretta Wein Zimmer. "I remember him in jeans, loafers, white long-sleeved shirts," says Helene Bond. "He was a very preppy kid. He was collegiate. A college kid who wasn't one."

13

In fall 1950, Ralph returned to P.S. 80. "There were certain times that he could not take [Salanter]," says Lenny Lauren. "It was too much for him." How he talked Frieda into setting him free is a mystery. Perhaps he was being rewarded; he was regularly getting passing grades. "She was *very* Jewish," says Ralph's childhood friend, Jeb Buchwald, who sometimes slept over at the Lifshitz apartment. "She hit on him a lot. 'Ralphie, do this,' 'Ralphie, do that,'" Buchwald says. "But he would fight back for the things that he wanted. 'Oh, c'mon, ma!'"

Back at P.S. 80, Ralphie blossomed. "Everyone knew Ralph," says Susan Gilbert Levine, a fellow student who was fascinated by him. "He was always in the school yard playing basketball." As at Salanter, his clothes stood out. Neil Betten, who was in an advanced art class every day with him, says that while Ralph sketched well, his real art was dressing well. "These raglan coats came out," Betten says. "He had the first one in the neighborhood. I thought, 'Boy, that looks good.'" Ted Broome, who knew Ralph from kindergarten onwards, even remembers being styled by Ralph in the sixth grade. Every time they got together, Ralph would push down his pompadour and say, "Wear it that way."

Girls noticed him now, too—there'd been none at Salanter. In his last days at yeshiva, Ralph started hanging with Louise Dichter Wilson and Janie Guerra in the neighborhood. "We'd yell up, 'Ralphie!' and he'd come to the window," recalls Wilson, who lived around the corner. "Weekdays after supper we'd go to the school yard or we'd ride bicycles."

He didn't fit in with the rest of the neighborhood kids—at first. "He had long

sideburns when guys were into crew cuts," Wilson says. "He didn't go to school with them, he went to yeshiva, he was different. He was short. They played basketball. He didn't participate. He wasn't part of that. Boys made fun of him."

Of his name, especially. "Always with the name," Wilson says.

Other kids were the worst. But America at its best was right out the window of the room that Ralph, Yussi, and Lenny Lifshitz shared. Their neighborhood was a crucible; it would become famous for producing an abnormal number of public personalities, designers, entertainers, managers, lawyers, and writers. There was Lauren, Calvin Klein and his business partner Barry Schwartz, television producer Garry Marshall and his sister actress Penny Marshall, the comedian Robert Klein, then a red-blazered member of a singing group called the Teen Tones, and the adult film star Gloria Leonard, then one of the Earth Angels, in pink and black club jackets.

"We all grew up on the cusp of great change," says Leonard, "which many of us were in on. Humor and high intelligence were the hallmarks of our crowd, though I don't think any of us thought at the time that we were different from other teenagers. But the high number of overachievers from that time and place does suggest that there may have been something in the water."

All of them, and hundreds of others, spent their free time on a short stretch of East Mosholu Parkway North, across the street from P.S. 80, where a long, low iron fence known as "the rail" separated the sidewalk from a wide, grassy meridian. Why the rail? "There were no buildings around, and the cops would come [if kids gathered] anywhere else," says Janie Guerra's brother Don, a year older than Ralph. It was a colony of kids, leaning on the rail, lying on the grass, talking sports, and one-upping one another. "It was amazing how many hours you could spend just passing time, playing cards, telling jokes," says Oscar "Ockie" Cohen, who lived nearby. "It was nirvana," says Marty Friedman, a future Hanna Barbera animator and writer. "Nobody had a neighborhood like we did. It was a huge gathering of kids from age eleven into their twenties, drug-free, always something happening."

In that company, Ralph Lifshitz was not a star—indeed, he was a minor player. "There was nothing outstanding about him," says Friedman. "He hung with his brother Jerry. They weren't in the center of it, but they were there. If I'd been asked to predict who'd become the most famous person in the neighborhood, it would not have been him. He was decent, he was nice, but he wasn't particularly sharp. He was one of the cast." It was a verbal culture. Ralphie wasn't verbal. "And there were lots of well-dressed people," Friedman continues. "Thinking about kids from childhood, he doesn't pop into my mind as stylish."

Year after year, new kids came. "We all hung out on the rail," says Erwin

Grossman, who lived at 3220 Steuben. Grossman says his older brother and friends, who were more than a decade older than Ralph, were the first to perch there. "Then came my group. Lenny Lauren was a younger group to me. We knew everyone. It was a neighborhood of boys. We all played ball. When they locked up the school yard, we'd loosen the wires. We put so many holes in the fence, they left it open."

It was a moment of opening for America, too. "The war had just ended," says Helene Bond, also of 3220. "It was a very happy neighborhood. You were never alone. You could always be with someone. The parents lined their chairs up and down Steuben Avenue. The kids were on the parkway."

The parkway. Say those words to kids who lived near Ralph then, and their eyes go distant and they purr. "Groups and groups of kids hung out," before school, at lunchtime, and then again after school and on into the night, says Bond. "It was the place where everyone was gonna be," Ralph says. "This group and this group and this group and this group, all the way down the parkway. You could not walk down the parkway." The kids would crowd the rail, "to sit, to talk, to see cute guys," says Marsha Bratter. "Everyone was included. It didn't matter if you were fat or skinny or didn't have the right clothes. There were different cliques, but it was very inclusive." Every group had its own piece of the rail.

Even on the Sabbath and High Holy days, after synagogue, the kids would gather on the rail—only in better clothes. Everyone in the neighborhood—every-one—put on their best. "It was important to every Jewish family that wanted relief from the drabness of their everyday life," says Seymour Storch. Neighbor Fuzzy Fusfield remembers how Frank Lifshitz "came home every day in his little truck, with his overalls and his paints." Saturdays were different. "Frank would get dressed up. He always had a shirt and tie on."

On those days, Ralph would take out a handkerchief and lay it on the ground before sitting on the grass. "He was the only one who did that," says Susan Gilbert Levine. Years later, she'd run into him and remind him. "Was I a fag?" he worried. She assured him he wasn't. "He was a boy's boy," she says. "But he cared about fashion."

His other love was movies. Like most of the parkway kids, he went with his friends to the double features at the Tuxedo Theater, later renamed the David Marcus after an Israeli independence hero. As they grew older, they would trav-el farther afield, and take in films at the Paradise Theater, a four-thousand-seat movie palace on the Grand Concourse, with a Baroque lobby, a grand staircase, a ceiling that sparkled with stars, and, as Stephen Samtur and Martin Jackson described it in their book *The Bronx: Lost, Found and Remembered 1935–1975*, "towering marble pillars and a magical fountain complete with swimming gold-

fish. The staircases were clad in deep carpets, the walls hung with tapestry and adorned with statuary. Along the walls were wrought iron benches and throne-like chairs for the weary, or for the nearly delirious children to sit briefly. In the restrooms were uniformed attendants, dispensing towels, perfume and a sense of wealth to those utterly without such prior experiences."

Going to the movies with his brothers and friends influenced everything Ralph would become. He and Jerry called themselves the Corsican Brothers, after the movie based on the Alexandre Dumas novel that starred Douglas Fairbanks Jr. as a pair of Siamese twins. The movies let them dream, and clothes were their way into the fantasies they saw on the screen. "Garfield, Bogart," Jerry Lauren says, savoring the names of two early well-dressed influences. "It didn't look contrived when somebody wears something with confidence."

14

Ralph's neighborhood clique was tight. Steve Bell, who lived in the same building as Penny and Garry Marshall, was his best friend. Bell was pudgy and the richest of the group; his father owned bowling alleys. Then there was Jeb Buchwald, whose father owned real estate (when Frank Lifshitz needed work, he painted for the elder Buchwald). And Phil Hirsch, whose father owned a gas station.

When he was still in yeshiva, Ralph had watched them all out his window. "I was a punch ball star," Bell boasts. "He wanted to be down there with me. He was not a happy camper. He wanted to be with the kids out his window."

Now, Ralph was "one of the guys," says Neil Stoller, who was in the same homeroom as Hirsch and Buchwald, the best ballplayer and best student of the bunch. In sixth grade, they would all play slug ball, stickball, and half-court pick-up basketball together in the center court of the P.S. 80 school yard. In winter, they'd even shovel snow off the court. Afterwards they'd get together at Bell's to play poker. Some of them had nicknames—Stoller was Butch, Buchwald was Jeb, Hirsch was Herc. Some, like Bell, just went by their last names. Ralph was Ralph.

In seventh grade, P.S. 80 students moved to a different section of the same

building, a junior high fed by several primary schools. Bob Steckler, who came into J.H.S. 80 at that time, recalls an assembly on his first day of school. "I heard his name, Lifshitz, I sort of had a reaction to that, and he and I made eye contact, and that was my first encounter with Ralph," he says. "I sort of felt bad that I made fun of his name."

Their next encounter came when Phil Hirsch set up a team to play in local basketball leagues, and both Ralph and Steckler joined. Hirsch even had a name picked out: The Comets. It would be more than a basketball team—it was a social athletic club—the parkway equivalent of a fraternity. These weren't the Jets and Sharks of *West Side Story* fame. Though there was an S.A.C. called the Jets, it was a far more innocent agglomeration of teenagers. Anyone who was anyone was a Clover or a Collegian or a Falcon or an Eagle or one of the Sparks. Lenny Lauren had been a Spartan. Now it was Ralph's turn.

Guys who weren't part of the Comets wanted desperately to join. "Everyone in the neighborhood was in awe of this team," says Steve Solomon, who tried for years before he was allowed in. The Comets were a clique, and there were cliques within the Comets. Ralph was closest to Hirsch, now an administrator at Youngstown State University in Ohio, and Buchwald who, after earning a Ph.D., would become a teacher and then a peripatetic globe-trotter, constantly on the move between Asia and Amsterdam and Canada, and Bell, now Ralph's stockbroker, then "a sweet, chubby all-around guy," says Warren Helstein. "Steve sucked up to Ralph. He looked to Ralph for stature. Ralph had bravado. Not outside his circle. But inside, he was the boss. He wanted to be the center of attention and surrounded himself with people who gave him the spotlight."

"They asked him advice on how to comb their hair—kid stuff," says Comet member Neil Betten. "Which was unusual because status was based on being a good athlete or being smart. Ralph was a second-string guard; he couldn't hit from beyond the key and neither could I. And he was probably the weakest student among the Comets. I am sure all the Comets were in the honors school except Ralph. But somehow, he had something; others looked up to him. At the time I could not figure out why. Not that I did not like him."

The Comets played ball afternoons at P.S. 80, in a night league at various schools that were kept open at night, and in a Parks Department league. Hirsch, at six feet one inch the tallest on the team, was the center. He and Bob Steckler alternated as captain. Ralph "tried very, very hard, athletic-wise," says Steckler, "but he was just marginal. He used to ask me if he could start, but there were better players on the team, and Ralph not being very tall, there was only one position he could play, guard, and Joey Buchwald was a guard, and he was excellent, so that position was definitely taken." Ralph's size was a real handicap.

"Guarding Ralph was like guarding Billy Barty," a midget actor, says Hank Meyerson, an older J.H.S. 80 student.

In later years, after Buchwald moved away, Ralph got to play more often. When Steve Solomon joined the team as a forward, Ralph was regularly at guard. "I'd always follow him because he missed layups and I'd get cheap baskets" by rebounding Ralph's shots, says Solomon. "Ralph had great form. Everything he did was all about form. He looked great doing it, but he didn't score."

"Everything *had* to look good," agrees Alan Cooper, who also played against the Comets. "He took seriously the way he looked doing it. It was like he was posing for a picture. He took the right amount of time. He held the ball the right way. Not that putting it in the hoop wasn't right, but I got the feeling he wouldn't get down and dirty. That wasn't the aim."

Oscar "Ockie" Cohen, a member of the rival Sparks, is more generous describing Ralph's play. "He was very graceful, very smooth, a calculating, intelligent athlete," Cohen says. "He was always looking to set up a play." Ralph also designed the Comet uniforms and team jackets—by all accounts his first fashion commission. "We had flashy uniforms," says Betten. "Sky blue satin pants and clingy shirts. People would whistle and make fun of us, but they didn't make fun of us when we played."

Ralph did better off the boards. "Everybody wanted to be Ralph," says Susan Gilbert Levine. "Everyone followed Ralph." But he kept a bit aloof; there was a part of him no one could see. "He didn't get into the rough and tumble. We'd *tummel,* sing rock and roll, arm wrestle, fool around, and Ralph would be off to the side, watching, not among us, I don't know if he was judging us or if he was a late bloomer. But he was considered . . . the word *elite* comes to mind. And not just in dress. It was also an attitude."

Ralph's self-image was evolving. "I had a sense of leadership," he said, "a sense of feeling good about what I did . . . where I was. I sort of felt like I was special but I did not know why. I mean, I had my own mind. I did my own thing. I wore the kind of clothes I wanted to wear when no one was wearing the same clothes. I felt like I was a leader, not a follower. I had a sense of myself."

Despite his wiry hair ("you could break a comb going through it," says Lewis Aaronson, who was on a team called the Eagles) and his lazy eye, he'd come into his own. "I think the instinct was sensitive individuality," Ralph says. "I had a lot of friends, but I was always individual, I was always very sensitive." No wonder he always had girls after him. "Ralph, I think I'm going to hang around and wait for your rejects," Aaronson would tell him. The girls thought he was great looking. "Like, *wow,*" one sighs.

Ralph loved and encouraged it. "Girls would line up!" he exulted. "I used to

feel like I was Eddie Fisher—Eddie Fisher was very popular at that time—and I remember, I always wondered why they would line up to come over to me."

"He was always different," says classmate Susan Gilbert Levine. "If white bucks were in fashion, he wore saddle shoes. When we wore crew necks, he wore V-necks. He was always a step ahead."

Ralph says his talent was natural. "I was not a kid who walked around all day in beautiful clothes and pranced in front of a mirror. I was a very natural kid, did all the things everyone did. But I wasn't afraid of taste. I was not afraid of expressing myself, and a lot of kids were." Some felt that was a problem: he seemed to hold himself superior. "We were happy-go-lucky," says schoolmate Joel Rudish. "Ralph was a little pompous. He thought more highly of himself."

"Neighborhood girls didn't get to first base," admits Levine. "We knew if Ralph would date anybody, she'd be very pretty. Everything about him was upscale."

Janie Guerra, now a film actress, was friends with Ralph's cousin Roberta Storch, one of Ralph's closest confidantes until her premature death from breast cancer. Janie had an insane crush on him. "I don't think he knew I existed." Though it was years before she put together the Lauren/Lifshitz connection, she always held on to two snapshots of him in the P.S. 80 school yard. In one, he eats an ice cream while clinging to a chain-link fence. In the other, he's the center of attention, sprawled on the concrete surrounded by other kids, dressed in a white shirt and a pair of jeans, cuffs rolled just so.

Marcia Hirsch, a vivacious Gidget type, met Ralph that year, also through Roberta Storch, who was in her homeroom. Roberta forced Marcia to go to an after-school dance and introduced her to Ralph. When she said she couldn't dance, he taught her. They went to Friday night dances all the time and did the Lindy. She preferred to slow dance. "He was just adorable," she says. "We were children. He'd walk me home but only halfway because his mother was always hanging out the window watching for him. There were times he had to go home, had to go upstairs for whatever reason. He was uncomfortable. 'I *have* to go!' "

Marcia would hang out with Phil Hirsch, Roberta, Ralph, and his brothers. But she never saw Ralph on Saturdays. She had no idea he'd ever gone to yeshiva. She never entered his apartment. She never met his father and met his mother only briefly.

They kissed. "Yes we did," she says. "But that was it. We were twelve."

She felt the Lifshitz boys were different. "Not cool, not suave, I don't want to say conceited; it bordered on that, but a conceited person isn't nice." Ralph was. "He knew what he was about, and he let it out but not in a bad way. He was very sure of himself. He knew what he liked. You should have seen him on the dance floor."

He liked knowing people were watching. Even his gait seemed to set him apart. He walked with shoulders back, his head high, and his nose in the air—literally. "Whereas most of us walked with a New York shoulder roll that was as indigenous as a Bronx accent," says Don Guerra. "He looked like a snooty kid."

No one seemed to care that he didn't have money like his friend Bell, and another boy he'd met through June Hochwald, her other beau, Mike Steinberg, whose father was a real estate developer. "The richest guy in the neighborhood," says Steve Finkel, who played ball with the Cadillacs. "[Steinberg] was the kind of guy everybody wanted to be friends with: luxury apartment, country club in Westchester, the first guy with a car—a Chevy convertible." The other kids flocked to him like moths to a flame.

The Steinbergs' wealth made a real impression on Ralph—and he felt covetous for the first time. "You know, you grow up, you have like different goals," Ralph once stumbled in an interview. "Like you go to a friend's house. Mine was, mine had no elevator. Mike Steinberg's house had a nice elevator . . . that was fabulous. That was rich."

"Did you feel that you had less than your friends?" he was asked.

"I felt it in different areas," Ralph said, "in that I don't know if it was a matter of less, but some of my friends' parents would go away. My parents were European, so they were not modern, that is the word. They did not play cards, they did not go away on vacations, you know? It was economics and a certain style. I don't know."

Inexorably, through encounters with people like the Steinbergs and through exposure to the movies and to magazines like *Esquire*, economics and a certain style became linked in Ralph Lauren's mind. "I never knew whether I was poor or wealthy," he said. "I grew up playing a lot of basketball, reading, and living at the movies. I guess they influenced my taste level. I liked the good things and the good life. I did not want to be a phony. I just wanted more than I had."

In that same interview, given just at the point that he'd established his business, he made a rare admission of the desires he'd once had while describing his delight that he no longer felt them. "I am more secure in myself now," he said. "I don't hunger for things anymore. My nose is not pressed up against the window of anything anymore."

15

While neighborhood acquaintances are proud to say they knew him, most of Ralph's Lauren's closest boyhood friends are uncomfortable talking about him. His best friend, his brother Jerry, agreed to an interview, then delayed it, then canceled it through a spokesperson. Shortly afterward, at the opening of Polo's spring 2001 line, he explained. "I need to be with Ralph in my mind," he said, "and I don't want to say the wrong thing."

Steve Bell was happy to kibitz but refused to be interviewed and tried to convince other old Bronx friends not to talk either. Phil Hirsch and Barry Fink never responded to repeated interview requests. Warren Helstein did give an interview about their boyhood—but prefaced it by saying how disappointed he was with Lauren later in life. Many from the Bronx said similar things—Lauren didn't return calls, didn't attend reunions, didn't respond to requests for charity, didn't even answer when they reached out to reminisce. But others make a point of saying how Ralph has never forgotten them.

Lauren holds his friends close, and holds in contempt those who claim to have been friends but weren't. "A lot of people call and say they grew up with me that I don't know," Ralph said. "They want things, you know, some kind of bullshit. I know who I knew."

But Helstein's complaint—Lauren never called when his son almost died— is different. Especially since he was Lauren's first and oldest friend in the clothing business. Helstein has since dropped out of the garment grind to devote himself to his son. His feelings about Ralph are complicated. "I always wanted to be on top—Ralph is—I'm not," he says.

In 1951, Warren Helstein entered seventh grade at J.H.S. 80 and started playing basketball in the school yard most Saturdays against combinations of Buchwald, Bell, Hirsch, Fink, and Lifshitz. "Then we'd go to Bell's house by the Grand Concourse to eat," Helstein says. Or to Ernie's, the local candy store, where they'd drink egg creams at the soda fountain. Or to the local pizza parlor, Jim's, or its competitor, Goff's, where the sauce was spicier. "I was in the gang,

but I wasn't. I always played against them. But I liked those guys." He got closest to Ralph. "We had an affinity. We liked a lot of the same things. I tried to be tougher than I was. He wasn't hard enough. He was a good guy, not a wise guy. The guys I hung around with stole cars. He'd go to a swimming pool. He was sort of the ringleader but not with me. He would call me: 'What are you doing?'"

Bell and Buchwald "were not curious guys," Helstein says. "Ralph had a curiosity about the finer things. He was a lousy student. His interests were elsewhere. He responded to fine things, fine people, fine places. He had a thirst for a world that was almost forbidden to him. He was always insecure. He was probably the poorest of all the kids. At least it appeared that way. When everyone chipped in for pizza, he counted his pennies. He was loath to give them up." Yet he dreamed—fiercely and quite specifically. "I remember not wanting a Cadillac, but a Rolls-Royce," Ralph says. "Somehow, the taste was there. I didn't have a lot of exposure, [but] when I saw it, I knew it. I couldn't tell you why."

Helstein saw a lot of the Lifshitz family—and thought highly of them. "They were humble. They didn't look to finery. They didn't want to be noticed. They wanted to raise their kids, and they did a great job. But Ralph was also exposed to people who were flashing it. He didn't invent anything, but he absorbed everything—a piece here and a piece there—and made it into a crazy quilt that everybody wants."

Helstein and Ralph started out talking likes and dislikes. "I was more worldly," Helstein says. "From me, he took an opening to the nonparochial world. If he went to a pizza place, he didn't have sausage. I know he didn't have shrimp until he was in his twenties because I bought it for him. I got him out of the Bronx."

They'd sit in Ralph's house ("people didn't go to his house very much"), listen to Frank Sinatra on the radio—another taste Ralph had acquired from his older brothers—and discuss who was cool and who wasn't. "It was fun and very private," says Helstein. "Some of the guys I hung around with thought he was a little faggy, but he wasn't."

The conversations inevitably turned to clothes. Ralph knew nothing about clothing. "I wore button-down shirts, but I didn't know what Brooks Brothers was," he's said. Helstein knew a lot—his father was in the garment business. They'd also talk about people. "We'd label people," Helstein says. "The thing we most had in common was that we never cared what anybody said. We *knew* what was right. It didn't matter if you thought I looked good. All that mattered was what we thought. If I want to wear a pink shirt, I don't care if you say it's faggy. It was confidence, serenity, security, knowledge, arrogance almost."

Helstein was the first person to see Ralph's style as something more than a reflection of his brothers. Though he considered them "heroic" because of their size, Helstein says, Lenny and Jerry "were nowhere near as noteworthy as Ralph was."

Ralph had come into his own. He was popular. He had a girlfriend. He had a team. Then his mother pulled the rug out from under him. He was going back to Salanter Yeshiva for a year—*one more year*—to graduate. "He was driven crazy," says Steve Bell. "He didn't want to be there. His mother wanted him to.' He lost every fight."

It was the year he'd turn thirteen and have his bar mitzvah, becoming a man in his faith. But that wasn't all. Ralph told his girlfriend Marcia Hirsch he was going back to Salanter to become a rabbi. Since she'd never even heard about Salanter before, this came as something of a shock—and she dumped him.

Back at Salanter, Ralph made good. He even grew close to the school's principal, a Rabbi Kagan. "Ralph found in him a very supportive person," says Zev Charlop, the family's rabbi. But Ralph's Salanter classmate Rabbi Michael Hecht doesn't think Ralph ever really intended to become a rabbi. "If it was in his mind, I'm sure it was fleeting," says Hecht. "He was not particularly strong in Judaic studies." Ralph was elected class vice president, though. "The most popular guy in the class," says Gary Goldberg, now a radio talk show host. "He was not particularly outgoing, but he was very receptive to other people. He was magnetic. And he could draw. Most of us were doing stick figures. He could put pen to paper." Often, he sketched clothes.

Harold Baron, now a stockbroker, also noticed Ralph's talent for drawing. Baron considered Ralph a slacker. "He wasn't a guy who raised his hand; he was uninterested," Baron says. Except in science class where, twice a year, the students were required to hand in notebooks full of drawings and diagrams. Ralph would draw them for other students. "We passed around the books during morning classes," Baron says. "He was very gracious, very likable. He didn't sweat it. He was never frazzled. That's what cool is. Nothing rattled him."

That June, Ralph smiled broadly as he joined his classmates and faculty on the front steps of the yeshiva, where they posed in white shirts, ties, jackets, and yarmulkes for a graduation photo. His Brillo-pad hair was neatly combed, his rep tie nicely knotted beneath a collar that rolled just a bit more perfectly than those of the boys around him. He'd clearly reached puberty—a hint of a mustache is visible, while the other boys sport no more than peach fuzz.

Then, on Monday night, June 22, 1953, Ralph was among the fifty-four yeshiva *bochurs* who graduated Yeshiva Salanter. He won no awards and was listed in the graduation program without the asterisk that symbolized merit. "To Herbie,"

he wrote in Herb Schimmel's graduate's autograph book, "On this page so pinky pink, I sign my name in stinky ink. Ralph Lifshitz." The page was green.

It was the second important ceremony Ralph attended that school year—and they were linked. He'd returned to Salanter just before he passed the most important milestone in a Jewish boy's life. The previous October 1952, he'd turned thirteen and been bar mitvah'd at the Judean Temple, just up the street from his apartment. It was co-owned by Rabbi David Savitz, the director of Salanter Yeshiva, and he'd performed the ceremony. Shortly afterward, the temple closed, and the building was rented by a new congregation, albeit one composed of people who'd previously worshipped at the Judean.

Young Israel of Mosholu Parkway was founded by neighborhood Jews who had grown concerned with the way their religion was being practiced around Mosholu Parkway. As congregants grew affluent and upwardly mobile, there was a push for modernization or, some felt, deviation from beloved norms. "These people were unhappy," says Rabbi Charlop. "They wanted a real orthodoxy that was absolutely rigorous in the maintenance of standards, yet was American and attracted young people."

The son of a rabbi and just ordained as one himself, Charlop took over the temple born in the crossfire of that desire. "There was a fistfight my first *shabbos*," he says. "Blood was running. Their *lives* were involved with this." Frieda Lifshitz's brother Charlie started splitting his *davening* between Mosholu Jewish Center and Young Israel. Frank and Frieda Lifshitz joined, too. The combat among the members soon caused the congregation to split in half. But four weeks later, Young Israel started up again—and soon moved into a home of its own, just a block from the Lifshitz apartment.

As the Lifshitzes fought for orthodoxy, their youngest son was fighting for a cause, too. "Oy, *oy*, did he give me a headache," Frieda Lifshitz would tell Hilda Riback when they discussed his bar mitzvah years later. "He only wanted a flannel suit. I went to look everyplace and I couldn't find one! In the end he picked out some sort of blue jacket with shiny buttons."

A navy blazer. Just like the gentiles wore.

16

In September 1953, Ralph entered Manhattan Talmudical Academy, like his brother Jerry before him. On his application for entry, filled out that February, he'd written that his father was an interior decorator, and under extracurricular activities, said that he was an artist and captain of Salanter's basketball team. Apparently no one noticed that Salanter didn't have a basketball team.

Ralph no longer wanted to be a rabbi, if he'd ever really had that desire. He wanted to be a hero, a star, a somebody. What kind of somebody changes every time he tells the story. He wanted to be a baseball player. "I wanted to be Mickey Mantle, but couldn't be." "My dreams were of how many shots I was going to hit over the fence, of making spectacular catches, landing on my backside and still holding the ball."

He wanted to be a teacher, too. Talmudical Academy was split into two divisions, a yeshiva, for those planning to become rabbis, and a teacher's institute that trained Hebrew school teachers; Ralph checked the box for the latter. "I wanted to be a teacher at one time," he's said. "I never thought of money—I thought of loving what I did."

Like most kids, when it finally came down to it, he wasn't sure what he wanted. "I would have loved to be a movie star; didn't think I was handsome enough." "I wanted to be an artist, but I wasn't good enough." "I wanted to be a basketball player, but I wasn't tall enough." He was afraid he would fail. That didn't mean he wouldn't try.

Ralph's year at Talmudical Academy was so extraordinary, it's a wonder he didn't stay there and become a Hebrew school teacher. Only a freshman, he made the varsity basketball team—and an historic team at that. On Sunday, March 21, 1954, Talmudical Academy of Manhattan played Talmudical Academy of Brooklyn, a newer branch of the school, for the championship of the Metropolitan Jewish High School Basketball League at Madison Square Garden before a New York Knicks game. The league was only four years old; it was only the second time its championship game had been played in a real

arena with professional referees. And this was the most famous basketball court in the world.

The thrills had started the preceding fall for Ralph, the last of three freshmen to win a varsity jersey that year—and at five feet five inches and 120 pounds, the smallest (by one inch) and lightest (by ten pounds) man on the team. But his size didn't matter. Making the team "was a big deal, and we acted accordingly" says Abe Wiesel, another freshman on the squad. "We were kings of the hill."

Like the school-yard critics of the Comets, Wiesel was more impressed with Ralph's style than his play. "He had a smooth move and look about him," Wiesel says. Ralph looked even better off court. "We came to school like bums," Wiesel says. "Ralph wore pressed khakis, white bucks. He was a preppy kid in a yeshiva."

Ralph didn't get to play much—the starting five were all seniors; it likely frustrated him all the more that one of those five, No. 77, was his cousin Sim Storch, playing left guard—*Ralph's* position. Led by six-footer Norm Palefski, an outstanding athlete and the most popular boy in the school, the TA squad had a dream season—running up a twenty-four-game winning streak, begun the previous year, defeating not only other yeshivas but also Cathedral High and the High School of Music and Art, before finally losing one, to Columbia Grammar, in a breathtaking overtime period.

"The rest of the season went by without a loss and once again the team was invited to play in the Garden," *The Elchanite*, TA's yearbook, would soon report. "As the team stepped onto the magnificent court, they could remember how they felt when they appeared on the small, poorly lit court of the TA gym. They warmed up and then heard their names announced on the Garden loudspeaker." Despite a tense third quarter, the team pulled off a 65–45 victory—and Ralph was at the center of the locker room celebration after the game.

That year's team would be long remembered, and not just because of its lopsided victories (scores like 106–19 and 103–37), or because its only loss was by a single point. With his breathtaking 68 percent shooting average, Palefski, who would die in a car crash the next summer in the Catskill Mountains, became the first Jewish league player to make New York's prep school All Star team, and earned himself write-ups in local newspapers.

No such honors came to Ralph. Sim Storch won a photo, a full paragraph of praise, and a mention in the season highlights in *The Elchanite*, but the diminutive freshman was merely a name in a list of players showing promise—and as D. Lifshitz, a misstated name at that. And the final statistics of the season showed No. 8, Ralph "Lifschitz"—the same misspelling as appeared in the Madison Square Garden program—tied for last place in games played (six). He did score once and made a free throw in his only varsity season, for three of the team's

1,376 season points (for comparative purposes, Palefski scored 51 points in a single game and 530 points that season). But Ralph didn't make much of an impression on the man who put him on the team. "I can't remember him at all," says retired TA coach Hy Wettstein. "The guy was not significant enough to remember. If he was five feet five inches, he was no doubt at the end of the bench."

"Freshmen just didn't play," concurs starting forward Nathan "Sunny" Meiselman. "If he got in, he got in for thirty seconds." Abe Wiesel calls it "junk time," but that didn't matter. "We lived basketball," Wiesel says. "It was our life." They even played at a local court at lunchtime instead of eating. "He didn't play well," says Stanley Moses, who'd attended TA with Jerry Lifshitz, and came back to watch Ralph play. "He wasn't as good as Jerry, and Jerry wasn't that good. Ralph couldn't handle the ball, he had no eye for the basket, but he ran up and down the court. He tried."

It beat school. "TA was not a fun place," says Dave Perlmutter, the last of the three varsity freshmen. "We had school Christmas Day, New Year's Day." Perlmutter was regularly admonished for failure to wear his yarmulke—even 144 blocks away from school in Times Square. "A guy would feel you to make sure you had your *tzitzis* on," he says, still amazed. As at Salanter, they studied religion—in Hebrew—all morning, then had secular classes until six in the afternoon. Basketball practice followed—for two more hours. There was hardly time to study—not that Ralph cared. "He was ignorant intellectually, as were all the Lifshitz boys," says Moses. "The rabbis, in their infinite wisdom, broke us down into three groups: those who learned, those who didn't but could, and those who never would." Like Jerry, Ralph was in the third group. "Not everyone could handle the rigor and the burden," says Al Wiesel. "If you can't keep up, you drop out. In September, Ralph was gone."

He transferred to DeWitt Clinton High School at the start of tenth grade in 1954. Clinton, an all-boys school across from Van Cortlandt Park, was an imposing Bronx institution with a twenty-one-acre campus arrayed around a three-story cupola-topped building modeled after the Palazzo Farnese in Rome. It had a student body of about thirty-five hundred. Among those who'd passed through its hallways lined with trophy cases recalling fifty years of athletic glory were composer Richard Rodgers, basketball greats Nate Archibald and Dolph Shayes; Burt Lancaster and Judd Hirsch, the actors; Lionel Trilling, the literary critic; Avery Corman, James Baldwin, and Paul Gallico, the writers; Neil Simon and Paddy Chayefsky, the playwrights; Robert Klein, the comedian; Robert Hofstadter, the Nobel laureate in physics; Congressman Charles B. Rangel; television newscaster Daniel Schorr; and Mortimer J. Adler, the philosopher.

Ralph "came into Clinton disoriented, disconnected, floundering a bit," Steve Bell says. He'd won the final battle with his mother and would spend the next three years in public school: his religious education was over. But he paid a steep price for freedom. At Talmudical Academy, despite his small stature, his drive had won him that coveted varsity jersey. At Clinton, desire wasn't enough. New York's public schools sent a half-dozen players to the National Basketball Association in 1957. As many as three hundred boys would vie for Clinton's team each year. "Just to try out was an event," says Sal Vergopia, who despite being six feet four inches, made it only his senior year—and then became the leading scorer. "You had five minutes to show what you had. If you didn't get the ball, you were dead."

Ralph tried out every year and was "a decent player," says team captain, Richard Khentigan, but Clinton was a huge school, "and when you've got four thousand kids to choose from and half the school was black . . . y'know? It was very difficult for guys like Ralph to break in." There were only four white players on a team of more than twenty, and most of them knew one another and played together at a camp in the Catskill Mountains where Clinton's coach had a job every summer. Nonetheless, Ralph made an impression. "We knew him because he played in the intramural leagues," says Vergopia.

"He was always dressed nice, and we weren't," says Khentigan.

In his famous entry in Clinton's Class of 1957 yearbook, Ralph said he hoped to grow up to be a millionaire. Today, a millionaire many times over, he seeks to distance himself from that teenage dream. "I was not a money person," he insists. "I don't think about money today. It was a dumb statement. It was 'Get off my back.'"

Warren Helstein isn't so sure. "I think Ralph always felt deprived," says Helstein. "He was determined to be on top." And Helstein wasn't the only one who thought that. "It was bred in his atmosphere," says Ralph's cousin Sim Storch. "He was driven very much with the anxiety to be successful." In a later conversation, Storch amplifies. "He sees it as weakness, but he did compensate for the inferiority we experienced." That sense of inferiority was drummed into Storch as a boy, too. "The Germans promoted it and we listened as kids," he says. "So we tried to get over, to pass. We couldn't believe the world would applaud a girl with a nose like Barbra Streisand's. There were no Jewish Miss Rheingolds. Every Jewish family wanted relief from the drabness of their everyday life. We were lower middle class. There were always things we wanted that we didn't have yet."

Ralph's yearbook entry also predicted that he would be going to City College of New York, and listed his high school extracurricular activities as Lunch Room Squad, Clinton News, Dean's Office Squad, and Health Ed. Squad. Most mem-

bers of those school groups do not remember him, and he is neither listed on the masthead of the Clinton News, nor, unsurprisingly, given his lack of verbal skills, does his name appear as a byline on any stories in the paper. Classmates remember him on the Dean's Office Squad, though, for good reason; a few hours a week, squad members stalked the halls carrying a list of the names of fellow students who'd showed up late or cut class—a list on which Ralph himself would have once held a prominent place.

"You'd go to classes and ask for the kid," recalls squad member Pete Korn. "Then the dean of discipline would read 'em the riot act. We were sort of the sheriff's posse." In the era before the sixties, it was an honor to make the Dean's Office Squad. You had to be recommended and selected. "You had to be an outstanding fellow," Korn says. "It was a classy assignment." But then, Ralph was a classy guy, always dressed up, a little fellow who made a big impression. "He was very serious, focused" but "nonchalant," says Daniel Feigen, who headed the squad. "It was a nice experience. You got control of the whole place. You could do what you wanted to do. But there was nothing to do." When Feigen left school in January, he recommended that Ralph take his place.

Ralph was now a solid B-plus student. He was also making up for lost time with the opposite sex. Though Clinton was an all-boys school like TA and Salanter, it was far easier for him to meet girls there than it had been before, even if, as one schoolmate puts it, "We are talking about the fifties. You could not put your hands on a girl in that neighborhood." But Ralph did.

"Ralph was always up and down," says Jeb Buchwald. "He could be moody, but if he was with a girl, he'd be happy." In what may have been boyish braggadocio, Ralph told Warren Helstein that he'd had oral sex with a girl in the woods near their homes. Now another girlfriend, Ralph's latest, was a redhead named June Aroueste, a Sephardic Jewish girl with "a great figure" who'd previously been known as "one of the parkway girls," as Steve Solomon puts it, part of a group centered around Lefty Farrell and Roy Drillich, two of the neighborhood "rocks"—borderline juvenile delinquents who wore leather jackets and ducktail haircuts. The rocks were big *machers* on the parkway—and remain so in the memory of all who knew them. Drillich inspired the character Arthur Fonzarelli, or the Fonz, played by Henry Winkler, on neighbor Garry Marshall's famous sitcom *Happy Days*. (In 1980, Drillich would kill his father and then himself.) By going from them to Ralph, Aroueste gave him status he'd never had before. Suddenly, he and his friends were "sharp guys," says another ballplayer, Steve Finkel. "There was no cool—we were all such assholes. Cool was the tough guy, the guy who could play basketball best. They weren't the best basketball players, but they were very sophisticated for that time."

Right up until they started going out, Ralph thought June liked Jeb Buchwald better. Winning her was good for his sometimes-shaky self-esteem. "I was cool," he's said. "I knew just when to come into the dance." Aroueste was the evidence. "Yeah, she was beautiful," Ralph said.

Now married and a mother in an Illinois suburb, June Aroueste Ainsworth won't discuss her relationship with Ralph Lifshitz. But she told a previous Lauren biographer about their special private dates, listening to Sinatra records, and about how shy Ralph was. Shy, but preternaturally sure of himself. "Ralph was born and finished at age sixteen," she told Jeffrey Trachtenberg. "He was molded and done. He was firm in his ideas about fashion, who he was and how things should be. He molded my ideas. I had to be an extension of him." That caused their breakup. "It was too smothering."

It happened that June and Ralph both had older brothers—and they were friends. "It was simple innocent puppy love," says Howard West (né Aroueste), now a Hollywood producer and manager, then a member of the Warriors, who played against Lenny Lifshitz's Spartans. "They were kids dating with their older brothers watching." Which was one more way that Lenny and Jerry loomed over Ralphie; they were larger, more handsome, more athletic, more popular versions of him. As popular as Lenny was, that's how good-looking Jerry was with his square jaw and penetrating blue eyes. "Jerry's good looks were clear to everyone at a very early age," says Sim Storch, who compares him to Rudolph Valentino. "Jerry had that kind of a look you just stopped and looked at."

Goldine Eismann dated Jerry Lifshitz when he was at Yeshiva University. "The handsomest guy I ever knew," she calls him. "A face like a chiseled sculpture. Fabulous eyes and lashes that swept across a room. All the girls were after him because he was so cool and good-looking. All the girls wanted him." Jerry was well dressed, too. "I can picture him," she says. "White bucks, nice slacks, cotton shirt with a sweater over it. I'm sure he glanced in the mirror from time to time."

I suggest to Lenny Lauren that his brother Jerry looked like the young Tony Curtis, the former Bernie Schwartz. "God, no! I was the one that looked like Tony," Lenny protests. "Everyone used to mix me up with Tony."

17

Wherever Ralph went, the reputation of his brothers preceded him. It was impossible for him to step out of their shadow in the Bronx. But it would prove easier in the Catskill Mountains of upstate New York, the easygoing resort so popular with Jewish immigrants it became known as the Borscht Belt and the Jewish Riviera.

The Lifshitz family had spent summers there for years. In the 1930s, Ralph's uncle Izzy Lifshitz opened a produce store in Monticello, and soon became a wholesaler supplying fruits and vegetables to the many local summer camps and hotels. Eastern European immigrants had vacationed in the mountains since the turn of the century, converting farmhouses into boardinghouses, boarding houses into hotels, and hotels into grand resorts like Grossinger's, Kutshers, and the Concord. Several members of the Cutler family owned property there, too. One of Frieda's brothers had a bungalow colony. Frank and Frieda Lifshitz had a *kochalayn* — a rooming house with a communal kitchen.

Frank bought the Green Mountain House (aka Lifshitz Bungalows) but hated it because he had to commute every weekend while Frieda and the kids got to stay all summer. When he got there on Fridays, he'd be overwhelmed with repair and painting chores. The big white house atop a wooded rise had two bedrooms on its ground floor, three more upstairs, and two separate bungalows with five more bedrooms — every one with its own sink. The family was only alone outside the summer season; then the Cutlers and Lifshitzes would gather for Passover in the spring and Rosh Hashanah in the fall. Even Grandpa Sam Lifshitz came.

To Ralph's cousin, Ralph Rothenberg, this was heaven — of a sort. If the Lifshitzes were poor by the standards of Frieda's relatives, they were rich according to his. "They *never* came to our house," he says. Rothenberg recalls angrily that Frank Lifshitz charged his own sister rent whenever she visited.

Next door was the Hilltop Bungalow Colony, owned by the Pincus and Cohen families. All alone together on their hilltop, the two compounds were a world apart in the forties. "We were kept secluded and out of the mainstream,"

says a Cohen cousin, Barbara Levy. "We knew there was a war, but nobody talked about it."

They would all swim in the Hilltop's unfiltered, concrete block pool; climb the apple trees; go berry picking; play punchball; sneak into local hotels; and walk to the movies at the Rialto and the Broadway in town. "Whatever there was, we saw," says Doreen, who taught Ralph to play mah-jongg to pass the time. "We'd play guns and shoot each other, then go have ice cream sodas at Gusar's," the local pharmacy, across the street from Izzy Lifshitz's grocery store. On Saturday morning there were always fresh donuts, thanks to the dads. The mothers baked pies, fried up lettuce latkes, and spent their nights visiting one another. The kids would gather on a big rock on the border of the two properties to wait for their fathers on Friday nights. When they were older, they would go there to sneak cigarettes.

One summer, Frank Lifshitz got Jerry and Ralph jobs working for George Gusar, whose drugstore had a soda fountain—they made sandwiches and Coke floats. Lenny Lifshitz had a job as a waiter at a sleep-away camp, Camp Roosevelt, one of dozens of camps founded in the 1920s for Jewish children. Sited on 383 hilly acres on Monticello's Sackett Lake, Roosevelt had four hundred boys and girls aged five to seventeen, and 125 counselors. They lived in rows of bunks— girls and boys separated by a lawn and a flagpole—and spent their summers playing basketball and baseball, and swimming and sailing on the lake.

Lenny became a counselor and a camp celebrity, and by 1953, his last year there, he'd brought Jerry, too. Like Lenny before him, Jerry became a camp character, known for his looks, his athletic skill, and his occasional service as camp rabbi at Sabbath services. Ralph and his best friend Steve Bell got jobs as waiters in 1956. They did it for fun, not money. Jerry was a counselor that year and got paid $300—near the top of the pay scale. New counselors got as little as $80 a season. Waiters made even less, and their social status was as low as their paychecks.

A waiter who'd never been a camper was worse than a nobody. But instead of letting his low status set him back, Ralph fought back. At first, he had to live up to his brothers—again. But soon the head counselor noticed him and took the youngster under his wing. "There was a stigma when you came out of the dining room," says Arlene Morse, the counselor's daughter. "My dad saw potential in him and encouraged him [to] become a counselor and encourage the campers. He gave Ralph the feeling he was needed."

Camp Roosevelt opened up new possibilities for Ralph. It was his first real exposure to a world beyond the insular immigrant community his parents inhabited. Though most of the campers were middle class, some were rich—the children of hotel owners, real estate moguls, and newspaper distributors—and they were real preppies, not just dress-up wanna-bes. Their world, until then alien,

suddenly seemed within his reach. "Even then," says one of Jerry's campers, Alan Zaitz, "Ralph knew where to mingle."

18

Now, Ralph needed to look the part. But he couldn't afford the kind of clothes the sons of bankers and lawyers wore. Instead, he had to sniff them out in used-clothing stores. So he and his brother Jerry became Raiders of the Sartorial Ark. "Jerry and I were best friends," Ralph says. "We all had our own friends, but we spent a lot of time together." Usually, they were looking for great clothes. "I don't mean to say Ralph and I held hands every day and went shopping, but we loved to make these discoveries," Jerry says. "Stumbling over an old pair of army pants. What makes a perfect bomber jacket? It's seen some wear. It looks like it lived. It's the quest for real. That's what we looked for then. There was no grand design; we were just trying to find ourselves. We'd dream together early on. It didn't matter if we never went hunting or fishing; we could still spot a great leather jacket and recognize its gutsiness, or see the difference between a poor reproduction and the real thing. Ralph had a kind of ache. I honestly don't know where it came from. Other people went back to their lives, back to school, to their jobs. My brother kept dreaming."

Fate had led Ralph to a fashion secret of the rich: frugality. "We always valued looking good as a way to be more accepted in the world," says Ralph's cousin Sim Storch. "We didn't have the kind of wardrobe that was automatically seen as private school. We didn't buy things often, and we didn't buy things that didn't last. We looked for durability and value. It was something we had to do and did. If you looked around a bit as [Ralph] did, the British knew how to dress that way. They didn't have a lot of clothing, but it was built to last. The tweed and houndstooth were there to see. He kept his eye on clothing. He married style to that, and the rest is history."

Clothes helped Ralph distinguish himself from his brothers, too. Already, in high school, his style was individual, if not downright eccentric. "He'd wear an army coat down to his ankles," marvels classmate Jack Barry. And with that coat,

that cocky walk he'd always had, and June Aroueste, he could march down the parkway, a legend in his own mind.

As early as junior high, Ralph and Helstein had started shopping together. Steve Bell would join them, too. "They were really into clothes," says Jeb Buchwald. "They went to secondhand stores with furs and stuff. I got involved when it got to be rugged stuff like army coats."

Ralph started buying his own clothes after his bar mitzvah. "I remember, when I was thirteen, fourteen, I used to go look at a pair of brown suede shoes in a store window," he says. "I was saving money to get these brown suede shoes. But I wasn't thinking clothes. Clothes were not on my mind."

That changed as he moved into high school. Ralph had always had after-school jobs—he'd worked for his father; and as a stock boy at Alexander's, the big local department store on Fordham Road and Grand Concourse; and later, at Alvin Murray, a local preppy clothier that opened in 1957—and his paycheck came in handy when he and Helstein went shopping. They would take Frank Lifshitz's 1949 Pontiac, with cans in the back and the smell of paint permeating the upholstery, and go to Cross-County Center. "We'd go to Alexander's and get cashmere sweaters," Helstein says. "We'd go downtown, meaning Manhattan." Then, Helstein's father and uncle, who were men's clothing manufacturers, began making clothes for Ralph and Warren. Sometimes Ralph had to pay, sometimes not. Though he was still cheap, he indulged himself when he wanted something. He wanted to wear good suits. His parents didn't approve. "If I saved a hundred dollars to buy a suit, which in those days was a lot of money, my parents would say, 'Why didn't you go to this place? It's cheaper.' And I would say no," Ralph said. Helstein's family felt the same. "They thought he was nuts. He'd talk about fashion, and it was totally foreign to what they did," Warren says. "They weren't great, but they initiated us into what was what."

That initiation pushed Ralph a step ahead of the rest of the kids in the neighborhood. "He felt the pull of Manhattan before the rest of us—he knew something bigger was over the horizon," says Steve Finkel, whose basketball teammate Mike Steinberg had been Ralph's first rich friend. Wealth remained another hot topic for Ralph. The summer they all finished high school, Jeb Buchwald's family moved to Westchester, near the wealthy suburb of Scarsdale, and on trips to see him, Ralph and his friends discovered a new world. "It was nicer than the city," says Buchwald. "It was a bit . . . upper . . . from the Bronx. It did have an influence. It was fascinating to them. It was a community of classy dressers. The girls were classier. It was like another world."

Ralph had seen hints of that world at Camp Roosevelt, and when girls would come visit the Bronx from richer places like Forest Hills or Yonkers or Riverdale,

and when someone from the neighborhood would leave and come back . . . different. "It sort of starts to seep in," he said. "We started to go up there, spending weekends playing basketball. And all of a sudden you see another kind of world that seems nice, and you say, I'd like to live there. I thought I was the richest guy in the world, until I saw there was another world out there. Remember *Goodbye, Columbus?* I mean girls with Bermuda shorts and loafers and sweat socks? Those preppy girls?"

Ralph was torn. "He was obliged to be Jewish, but he was fascinated by things that weren't," says Helstein. "There's an honesty, beauty, and integrity to being ultra-Jewish. There's also a certain closedness. A lot of the world is cut off to you. But the doors were being cracked open and you were exposed and you wanted to know things. You're a little guy with a lisp, and you're not particularly smart. How do you get noticed? You fight. You steal. But he was a good boy, so he decided if he dressed better than everybody else, he'd get acceptance. He was shrewd. The clothing industry of the last fifty years was about Jewish guys fucking Christian girls. Dress well, get the blonde. That's what it was in that era. A yearning for acceptance."

All the Laurens bristle at the idea that Ralph's love of classic clothing came from an unhealthy obsession with gentiles or with gentile women or from any other Sammy Glick–like striving. Jerry Lauren says that if anything, just like everyone, they were looking for roots. "We were discovering the world," he says. "We'd go shopping just for fun, and we'd stumble over an old Huntsman item in a thrift shop. People from old money who are brought up with Brooks Brothers didn't appreciate it. We fell in love with this anti-fashion traditionalism. We dissected it. When we walked into an old-line place, we felt, 'Wow! This has been here forever. It's rooted. It has a reason for being.' "

That rootedness was in distinct contrast to the uprooted traditions of the Lifshitz and Cutler families. Like so many others of their time and place, Ralph and his brothers could expect to inherit no heirlooms, except perhaps a kiddush cup or a menorah. Yet they had inherited their mother's deeply held desire that they look just so, so no one could say they were the children of a poor man. Out of all that came Ralph's deep love of things with historical integrity, like military coats and western belts, and things that would last, like those Huntsman tweed jackets. He soon realized those "originals" weren't being made anymore—or, at least, not with the quality and integrity he thirsted for. And he would continue to wear those "found" originals even as he sold his own versions; he still favors antique Levis over Ralph Lauren jeans. Having sipped from the well in thrift shops, it was only a matter of time before the Lifshitz boys found their forte creating instant heirlooms for the legacy-deprived. But in high school, Ralph had not a clue that he wanted to be in fashion.

All there was was the yearning. "I could see what they were looking for from their conversation, their disparagement, their putting down the rabbis," says Jerry's friend Stanley Moses. "Their subculture was against the yeshiva tradition. Yeshiva was anti-American, a totally separate life. Jerry was trying to become something else, to leave behind the clumsy, sloppy yeshiva image. They wanted to break away from the past, from the foreign environment that meant we would forever be apart. There was something else in America that they aspired to: they were searching for thin-legged blondes, not short, squat Jewish women. How do you overcome? Become mainstream American: clothes, looks, girls. Ralph packaged that image for America."

"Jews born in that kind of [lower-middle-class] environment looked up to WASPs," says Lauren's rabbi, Zev Charlop. "You were an immigrant. Everyone wanted to be a WASP. They were the standard. The doors were closed to you. The parents came from a deeply religious society. Ralph didn't want to go to yeshiva. These are kids in America! They lived in a different world. Not only a different world, a different century. Everyone was playing ball. 'Why can he go to a movie when I can't?' There was a seismic change, a new standard. To be Mickey Mantle was better than to be a rabbi.

"The very religious said that America was the Golden Calf," a false idol, Charlop concludes. "Well, when you're denied for thousands of years, what do you expect? The only way to become total Americans was to become WASPs. Become the standard. Ralph has deep spiritual wellsprings, and those are Jewish; but to be a Jew in America is to be at once part of and apart from, and it isn't easy. It's a tremendous balancing act to retain the integrity of both."

Today, Ralph will say he has. Frieda Lifshitz, Charlop suggests, wasn't so sure. "I don't believed she was reconciled to what Ralph became," the rabbi says. "She would have been happier had he been everything he is and observed more."

Michael Horowitz, another Salanter student of the day, found himself drawn to the non-Jewish world, too, "always involved with non-Jewish women, running away from my roots," he says. "I remember listening to the radio and hearing about a burger-and-shake girl. Ohmigod!" Combining meat and milk was forbidden by Jewish dietary laws—as were pork and shellfish. They were all *trayf*—not kosher.

"The allure of *trayf!*" Horowitz exults. And it was all the more tantalizing because it was so close, yet totally foreign. The majority of the gentiles who lived in the Bronx were Irish and Italians, Roman Catholics, often immigrants, just like the parents of the Salanter students. "There were no Protestants; we didn't know any," Horowitz continues. "They represented an ideal we guiltily aspired to that was achievable only by running away from yourself. We saw it in World

War II movies. People would die, and there would be no tears, whereas in our houses, there was bathetic shrieking at a splinter. We guiltily saw emotional restraint, modesty, and understatement as a model. We only saw what we thought was class in idealized versions without warts or neuroses. And the irony is, who was making those movies? Jews!"

Ralph Lifshitz would soon do the same thing with clothes that the Jewish movie moguls did with celluloid—try to bridge the gap between old world and new, between Jew and gentile. "We both went down the same road, at the end of which is a paradisal thing," says John Weitz, a German Jew who was educated in England and became one of America's first men's clothing designers. "Wouldn't it be nice to look that way, behave that way, speak that way, live that way?" This ambition was as American as motherhood and apple pie—even if it was *trayf* to Ralph's mother.

19

Summer camps full of ten-year-olds can be cruel places, particularly for someone named Lifshitz. "If your lips shit, what does your ass do?" girls would taunt Ralph. Boys called him "Shitlips." Jerry and Lenny had first discussed changing their despised last name as early as the summer of 1953 at Camp Roosevelt. Though it harkened back to the great rabbinical lines of Europe and was the only connection that remained to the family's roots, the name Lifshitz was baggage the boys didn't want to carry around anymore. It was a bad joke—literally: Catskill comics would tell of the Lifshitz diamond, the third most famous diamond in the world after the Hope and the Koh-i-noor, but a diamond with a curse. And what was the diamond's curse?

"Lifshitz," came the inevitable reply.

Lenny's co-counselor in '53 was a law student, and he said he'd get the name change done, but then Lenny joined the army and shipped out for Germany, and the matter was tabled. But as first Lenny, and then Jerry, endured the taunts of their fellow servicemen at mail call—Jerry would soon join the air force—the Lifshitz curse took its toll.

By summer 1957, Ralph was coming into his own. As in the Bronx, he'd had

to distinguish himself from his brothers, which wasn't easy at the sporty camp; his interest in athletics was higher than his skill level. "Ralph wasn't particularly distinguished," says a fellow counselor, "but he never acted like a jerk, which was rare in a summer camp." And Ralph had his own way of standing out. His sense of style blossomed further. He was Joe Ivy, known for his preppy look: jeans or starched Bermuda shorts, white socks, loafers, madras-plaid shirts, crew-neck sweaters tied over his shoulders. He had so many sweaters, he stashed some in a friend's locker at the girls' camp. And he wasn't above borrowing a nice piece from a camper now and then. His fashion sense had a halo effect. People began to see him as someone special, someone uncommonly suave. "He was happy-go-lucky, above all the bullshit," says a fellow counselor. "He acted as if he had control of the situation. He had a maturity about him." Ralph and Bobby Roman, a camper-turned-counselor, had the same day off and got to like each other. "He wasn't brilliant, he didn't go to college," says Roman, "but he obviously had a flair."

Ralph and Roman sometimes visited the Lifshitz bungalow colony, but had more fun when a camper whose parents owned the lavish Concord resort would arrange a room so they could spend a day among the *alrightniks*, the Jewish nouveau riche, who'd done all right and showed it. Some of the counselors even took girls to those rooms or motels—but three or four couples would share them, so things never got much further than heavy petting. "We'd sleep because we worked so hard," says a counselor.

That winter, Roman visited Ralph in the city and went along on his sartorial safaris. "He'd take me to get discount clothes on Seventh Avenue," Roman recalls. "He'd critique what I was wearing. He'd get me discounts. He knew people."

Ralph's star rose in 1958, when he and Steve Bell were both named lieutenants in Camp Roosevelt's Color War, an annual three-day-long rite, when the camp was divided into two competing teams, blue and gray. It was a highlight of the summer. Suspense would build toward the middle of August, when Color War would always "break" with a surprise: a small plane would fly over the campus, or Chesty, the camp's resident character, a burly fellow with a past obscured in adolescent legend, would fire a rifle, and counselors would scatter mimeographed pages, announcing who was on which team. The counselors most in favor with camp management would get to be generals and lieutenants, leading troops in the war. Ralph had done something unprecedented, winning a key role though he'd been at Roosevelt less than three years.

But the eighteen-year-old Ralph's accomplishment was shadowed by the Lifshitz curse. That year, it became too much to bear. Bobby Roman would listen to Ralph's bitter complaints about his last name. Jerry felt the same way. Neither understood the nobility the name conferred. "It wasn't some family

dynasty," Jerry later grumbled. Indeed, many in their family had changed their names. There were relatives named Lipp in California. And Seymour Linden had been rechristened, too. "Four years in the army with that name was enough," Linden says. "I couldn't stand it."

That summer, Ralph determined finally to change it, and he asked his friends' opinion on his favorite alternatives: Ralph Lauren and Ralph London. "I think we all voted for Lauren," Roman says. "He didn't like it."

20

In later years, after he gained fame under his new name, the story of Ralph Lauren's name change became almost as sore a subject as the name had once been. Lifshitz was used as a dart to pin him as something other than authentic. And Ralph didn't help matters; he told a variety of stories about how it came to be changed. They all had one thing in common: It was always someone else's idea.

In the 1980s, for instance, Ralph told the *New York Times* that his father had changed the name, "for his reasons, whatever they were." That story had the virtue of being partly true. Frank Lifshitz once told his rabbi, Zevulun Charlop, that he'd changed his name—or at least used another at times. In later years—Charlop can't remember precisely when—Frank carried two business cards; he was Frank Lauren on one, though his attempts to hide his heritage quickly came up against his *yiddishe* accent. "He felt he had more to contribute as an artist and people didn't appreciate him because he was Jewish," says Charlop. But, in fact, Frank never changed his name legally and died as he was born, a Lifshitz.

On another occasion, Ralph said it was Lenny's idea. "The name had shit in it," Ralph said in 1992. "My father, my brothers, we sat around the table once, and my older brother said he wanted to change the name. I was sixteen years old. I didn't try to be anything but myself. I was cool. So I was short, so what? I went out with great-looking girls. I ain't never had a problem. I was a good athlete. I had all that. The name was a problem. Kids would laugh. In class, every time I got up it would make me sweat. A little kid with a funny name. If my name was Bernstein, I never would have changed my name. It was a difficult

name. I went to yeshiva. I go to synagogue. I don't pretend to be something I'm not. I'm very Jewish. There's no embarrassment. Totally the opposite." Yet the evasions and the defensiveness indicated otherwise.

When Warren Helstein heard about the name change, his intuition told him that it had been Jerry's idea. "Jerry wanted to become an actor and thought the name would improve his chances," he says. "I had the feeling Ralph went along for the ride."

That's certainly the impression you'd get from the official documents that were finally filed to effect the transformation in April 1959. They are captioned: "In the Matter of the Application of JEROME LIFSHITZ for himself and on behalf of RALPH LIFSHITZ an infant, asking for leave to change their names to JEROME LAUREN and RALPH LAUREN."

That infant was nineteen at the time. And capable of being disingenuous if it would get him a new name. Jerry, then a salesman at Korvette's, a discount department store in White Plains, said in his sworn affidavit that "for business purposes it would be more advantageous . . . to have names which would be less common and would enable them to be more readily identifiable as specific individuals." He and Ralph, the affidavit continued, "often encounter confusion and annoyance both at school and in their employment" when there was "more than one person named LIFSHITZ." Neither one of them stated the obvious: the annoyance came because people made vicious fun of their name.

In May 1959, notice of the name change was published in a local newspaper and Ralph Lauren, a nineteen-year-old infant with a new name that made him readily identifiable as a specific individual, was officially born—again.

Not long after that, Ralph ran into his boyhood friend Neil Betten in the P.S. 80 school yard. "I had not seen him for a long time, and he said he changed his name," Betten remembers. Ralph told him that all three Lifshitz brothers had become Laurens because "it was very hard to be in retail with a kind of a funny name." Betten asked how his father felt about that. "Well," Ralph allowed. "He's not happy." Warren Helstein knew why that was. "It was a shock to me," he says. "They were trying to not be Jewish all of a sudden."

And despite what Ralph told Betten and would later claim again, Lenny, who'd initiated the first discussion of a name change, had finally declined to join his brothers. "They asked me to do it," Lenny says, "but I was already a star. I played baseball, I played football, whatever sport there was. I said, 'Everybody who played basketball knows Lenny Lifshitz. I change my name and there goes my history.' "

Did Ralph Lauren care about his history? "I think it's sad he doesn't want to be Ralphie Lifshitz," says his aunt Hilda. "He wants to be somebody else."

That idea makes Ralph Lauren sputter in rage. "I don't want to forget," he insists. "They think you are hiding something . . . like changing the name was a sign of wanting to form another personality . . . another . . . hide . . . and become . . . I almost wanted to change my name back because I was so pissed off. It's the only thing that always comes up, that always gets me upset." But not upset enough to ever actually go back to being Ralphie Lifshitz.

21

The end of the fifties was a carefree time for the newly renamed Ralph Lauren. One holiday weekend, he and Jeb Buchwald drove an old convertible to Florida nonstop, crashed on the beach, dined in a restaurant they couldn't afford (Buchwald paid for the wine), and then drove back. Another time, Ralph and Jeb went to Florida with about a half-dozen friends, got kicked out of one hotel, and ended up all sharing a single room in another. It was Ralph's first experience with women's fashion. "I remember Ralph and I dressing up in girls' clothing and laughing a lot," Buchwald says.

Since fall 1957, Ralph had been enrolled at City College of New York, a public institution that had traditionally educated immigrants of modest means, commuting by subway to and from its campus on Twenty-third Street in Manhattan. For a while he went to day school. But then he asked himself why he was studying business when he could be doing business, and he switched to night classes so he could get a job at Allied Stores, a department store buying office—one of several in New York. Their employees, known as buyers, combed the garment disctrict that radiated from Seventh Avenue, just below Forty-second Street, seeking out manufacturers and ordering clothing for retail stores.

Ralph was called an assistant furnishings buyer, but he was really a clerk. The pay wasn't great, but it was enough to buy the clothes he loved, and to spend on girls. After all, like Jerry (who was just out of the air force), Ralph still lived at home and didn't have to pay rent. And the clothing business suited him. "I guess my color sense came through my father," he says. "And I always had a little more style than most of the kids. They'd say, 'Where'd you get this?' I never went to fashion school. I never heard of a designer. Fashion, for me, was in the

stores and on the streets. There was no training, but the instincts were there. And it was a necessity to work. I didn't know what it was not to work."

At first Ralph liked what he thought of as the business world. But the more he saw of Allied Stores, that feeling changed. Friends like Buchwald called him businessman. "I hated that," Ralph says. "I would have preferred to be in school, on a campus and all that. And I reached the point, I said, 'I don't want this anymore, I want to be a teacher.' I wanted to quit, I wanted to finish school, I wanted to wear tweed jackets with suede elbow patches and I didn't want to think about money and I wanted to be off in the summertime and have a quiet life. I did not want the business life. A lot of people I met in business did not have integrity. They were not honest." This post-adolescent revelation didn't drive him out of the fashion business, but it did give him pause.

Ralph broke his ankle in spring 1959, right around the time he changed his name, forcing him to skip the summer at Camp Roosevelt. A story went around the neighborhood that he'd broken it pushing a wheeled pipe rack full of hanging clothes through the garment center. People later joked that he'd vowed that if he was going to be maimed for fashion, he might as well be maimed for his own business. That was apocryphal. He actually had a car crash in a cousin's Volkswagen. But it's true that he wasn't long for Allied Stores.

Ralph was able to hide his inner turmoil. Even in a cast, he acted happy-go-lucky that summer, hobbling to the rail to hang out at night, but he was plagued with doubt. He was about to turn twenty and was desperate to succeed, to have all the things that Frank and Frieda couldn't buy him, but he didn't know how to do it. "His friends all went to college," says his Bronx friend Susan Gilbert Levine. "He knew that was not the part of his brain that would make him rich." He knew, too, that he had visual skills and told others he was thinking of becoming an advertising art director (which, in a way, he finally did). "He was having a pretty hard time," says Warren Helstein. "His friends were off and running. I left town—went away for college." So did Steve Bell, Jeb Buchwald, and Barry Fink (who would soon change his name to Barry Frank).

After working through that summer, Ralph decided to quit Allied and return to school full-time. Unfortunately, that fall, he realized that he hated City College, too. "The whole atmosphere, it was cold and impersonal, it was business school," Ralph says. "I did like a preppy life, maybe because I grew up where I grew up; I sort of liked college, I liked the atmosphere of college, walking on a campus, and girls. But I did not get that at CCNY. It was a factory. I mean, it was horrible. I didn't know what I was going to do."

He was floundering, and in June 1960, at the end of his third year, he quit CCNY for good. "I felt, 'Why am I going when everything I'm learning, I'm

learning at my work?' " he said. "I felt I was getting nowhere, so I left. [But] I was very upset that I did not finish school. It was tough on my family. Everyone went to college, and I was the one that did not make it."

Ralph didn't go to work, though. Instead, he stretched childhood to the limit and went back to Camp Roosevelt one more summer. But while it was the same, he wasn't. He had his new name. "All of a sudden it was Lauren," says a fellow counselor. No matter that his checks were still made out to Ralph Lifshitz.

Ralph had a new girlfriend, too; Sue Damsker was a petite beauty with a thick, dark ponytail and, as one of Ralph's friends puts it, "no tits but a great rear end." Two years younger than Ralph, she was captain of the cheerleading squad at Brooklyn's Samuel Tilden High School, where she'd be named Miss Tilden the following year. Every night after dinner at camp, there was an hour of free play when boys and girls could meet on the path that dissected Roosevelt's campus. By intent, it was very public, so Ralph and Damsker's flirtation was noted. "They were an item," says one of Damsker's campers. "We caught them making out." And wondered what they did when they left the premises together on their days off.

In midsummer, the camp director whispered to Ralph and another counselor, Marty Honig, that they'd be that year's Color War generals. Honig, now a lawyer, remembers liking Ralph. "You'd see him inhaling the atmosphere, learning, growing, and at the same time being casual," says Honig, who was impressed by Ralph's attitude. Until Color War broke, the two remained friends, but once it did, Ralph's desire to win took over. "I didn't know how much drive he had until Color War," says Ian Schrager, the Studio 54 co-founder-turned-hotelier, who was one of Ralph's campers that year. "I remember Ralph losing his voice. He was very focused, all over the place, rooting for everybody. He was emotionally involved."

Lauren's embryonic management style was visible those three days in August 1960. He made his lieutenants dress alike—in blue Oxford shirts, white Bermudas, and black-and-white saddle shoes. No deviations were allowed. Jeb Buchwald, who'd joined his friends at camp that summer, remembers Ralph giving his blue team a motivational speech. "You are all shit," he began, but then, Buchwald says, "went on to say what they could do to win." When Ralph's team lost anyway, he was crushed. And an incident at the concluding Color War sing added insult to injury. Each year, Camp Roosevelt's girls would pen a gossipy "roast" song set to a popular tune, full of inside references to the summer. That year, it singled out the newly renamed Color War general.

"We know a man whose name is Ralph Lifshitz," the girls sang. "Whoops!" Everyone laughed. Ralph Lauren cringed.

Lauren wearing Lauren, in Trastevere, Rome, with Ed Brandau, 1970.
(Photographer unknown, courtesy of Ed Brandau)

PART THREE

Inspiration:
It Started with a Tie

My goal was always to be myself.

—RALPH LAUREN

22

As he approached age twenty-one, Ralph wasn't having an easy time making the transition to adulthood. That last sylvan summer at Camp Roosevelt, he'd befriended another counselor, Dave Richman, from Brooklyn. Sue Damsker, Ralph's new girlfriend, came from Brooklyn, too, so Ralph—who still lived with his parents in the Bronx—would sometimes spend the night at the Richmans' after double-dating. If the relationship with Damsker was intimate, Richman never saw it. "He'd take her to the door and get back in the car," he says. "Ralph liked the idea that she was good-looking. He basked in her reflected beauty." They dated off and on for two years.

In 1962, Ralph asked Damsker to marry him, and she agreed. But the engagement lasted only a short time before she dumped him. Damsker, now married, admits she saw no sign of the man her boyfriend would become. "I knew he was interested in clothing, but I don't think he had any particular direction," she says. "He had no ambition that I recall. I stopped seeing him before whatever got him where he is took place." Why did they break up? "I realized I didn't love him enough." Unlike many of his other ex-girlfriends, she betrays no regrets about losing Ralph. "I haven't thought about him in a zillion years." But then, the man she married is filthy rich, too.

Damsker was right: Ralph was unsure of his ambition. He still toyed with the idea of going into advertising, like his brother Lenny, who'd joined the Grey agency. "The man in the gray flannel suit," Lenny says. But style had conquered Ralph's consciousness; he couldn't stop thinking about clothes.

Ralph already knew he didn't like what people wore in the Bronx, where they dressed Broadway, not Traditional. The distinction is crucial. There were two kinds of menswear in those days. "Broadway" was for strivers, immigrants, ethnics (which then meant Italians and Jews), salesmen, pimps, and sports stars—shiny suits and sharkskin. Traditional was preppy, Ivy League, white Anglo-Saxon Protestant; it was for those who'd arrived or wanted to look as if they had. It was sold and worn on Madison Avenue, not Broadway. The few blocks were worlds apart.

At Camp Roosevelt, where he first encountered them en masse, Ralph had asked the kids who impressed him, who all dressed Traditional, where they shopped. "Go to Brooks," they told him. "So that's where I went," he says. Dave Richman's family was in the clothing business, and David had been named best-dressed boy in high school, so Ralph constantly asked his opinion. "Do I look okay?" he'd worry, gazing at his chinos and penny loafers.

"Who gives a shit?" Richman would reply. "We're going to get a garlic pizza."

Richman eventually decided that they'd gotten along because he was willing to talk to Ralph about clothing. "He wasn't intellectually curious," Richman says. "We couldn't talk about books or ideas. He didn't care." But Ralph idolized Fred Astaire (né Frederic Austerlitz Jr.) and Cary Grant (the former Archibald Leach)—and would talk about them for hours.

The fantasy world those stars inhabited was real to Ralph, who still whiled away the hours at the movies. "I'd go to a movie, I'd fall in love with the girl," he says. "I fell in love with Audrey Hepburn. I fell in love with Grace Kelly. And I always wanted to be the star of the movie. But I never thought I'd be a movie star. It's not that I wanted to be Gary Cooper or Cary Grant." He wanted to live the fantasy. "Being the star of the movie meant you're the guy in the romance. That's why people go to the movies. People want to be that."

As a child, he'd been introduced to the movies by his older siblings. After Thelma and Lenny moved out in the early 1950s, Ralph and Jerry shared films and fantasies. At fifteen, Ralph saw Audrey Hepburn in *Roman Holiday* and dreamed of going out with her—as Gregory Peck did in the picture. Jimmy Stewart's "personal conviction and honor" in Frank Capra's *Mr. Smith Goes to Washington*, made the year Ralph was born, captivated him, too. Warren Helstein recalls him being riveted by *The Picture of Dorian Gray*, the Oscar Wilde story about a man obsessed with youth and possessed by sin, which was made into a movie when Ralph was six. He may have even read a book now and then. As an adult, whenever he was asked to name one that inspired him, he'd mention Ayn Rand's seven-hundred-plus-page intellectual potboiler, *The Fountainhead*, which he said he'd read at age sixteen. But Ralph wasn't a reader, so, more likely, he'd seen King Vidor's film version, released the year he turned ten; it starred another of his idols, Gary Cooper, as Howard Roark, an architect who refuses to compromise his dreams.

Ralph would later emulate Roark professionally. But by the time he hit his late teens, he'd already decided that to live *his* dreams, all he had to do was to dress like them. That way, he could emulate "a certain character in a certain movie, a guy in an ad, a salesman we thought was cool, a chemistry teacher who buttoned his jacket in the wrong hole and it was so cool," says his friend Warren

Helstein. By dressing like them, you could both be like them and stay yourself, they decided. "There was no role model," Helstein says. "Ralph created the role. He, out of whole cloth, had a vision of himself in the role of Prince Albert. He envisioned things, and he stuck to them."

What he envisioned then, a mix of Hollywood style and preppy insouciance, became Ralph's look long before it became his business. "He was going to Brooks Brothers, buying the uniform of the day, a blazer, gray slacks, button-down shirts," says Dave Richman, who was intrigued. "Clothes were not a big item on anyone's agenda." Ralph didn't know quite where they fit in his agenda yet, either. He was still "a little lost about what he might do career-wise," Richman says. "But he had a bee in his bonnet about the clothing business. It had to come from going to the movies."

The movies weren't life, though, and Ralph's life was stuck in limbo. There was a draft, and now that he'd quit college, he was eligible. "I was going [into] the army, and I could not get a job until I had the army over with," he says. "Nobody would hire you until you got the service out of the way." But he hadn't been called up yet.

Jerry Lauren stepped in to help out his little brother. He called a friend from college, Neal Fox, who worked as a salesman at Brooks Brothers. Could Fox get his kid brother a job? Fox referred Ralph to Brooks personnel with a personal recommendation, and he was hired as the store's youngest sales assistant. After a training class in which he learned the history of Brooks, how to fill out a sales slip, and how to handle returns, he was assigned to the sixth floor. Known as '346,' the floor offered mid-priced, middle-quality clothes and furnishings; better-quality goods were sold elsewhere in the store. Ralph made $65 a week.

"He was responsible for the neckwear," recalls Joe Barrato, now the CEO of Brioni USA, then the manager of the Brooks custom suit department. "When he finished sorting ties, they looked like soldiers at attention, so beautiful. I asked who did that. That's how we met. We bonded. I don't know how to say it without offense but here was a Jew from the Bronx and an Italian from New York City, and blue-eyed blondes were running around the store—I couldn't believe my eyes: Grace Kelly!—and we both wanted to be part of it."

Barrato had his limits: when Brooks management told him his name belonged in a vineyard, and suggested he change it to Barrett, he declined. Ralph, of course, had already changed his. "He believed in that Brooks world of the 1930s and 1940s," says Barrato. But it wasn't only Brooks. Brooks was the Ivy League shrine, but it was only one of many in what had become a veritable menswear's mecca. Arrayed around Brooks's Madison Avenue location were other holy houses of prep: J. Press, Chipp, Abercrombie & Fitch, and Paul

Stuart, as well as a dozen other great men's specialty stores with names now forgotten. The neighborhood was the center of the Establishment universe, where couples met under the famous Biltmore Hotel clock a block away, and advertising men had three-martini lunches.

Ralph would walk the neighborhood in awe, soaking it all up and spending every penny he earned shopping. "He came in with Jerry, and he wanted a gabardine suit," says Clifford Grodd, owner of Paul Stuart. But not just any gabardine suit. "Selling Ralph a suit is an adventure," Grodd continues. "He was impossible to please unless you gave him exactly what he wanted, so I took care of him myself. He had fitting after fitting after fitting. The suit came in. 'Can you make it a little closer?' He was a kid, but he was beguiling. He charmed me. He was so sincere. He never demanded, he pushed and cajoled. He had a tiger in his tank, such great conviction. He had a great eye, great aim. He observed. He was totally enamored with the way actors dressed in English clothes. He was a total neophyte, but he knew what he wanted. I thought, 'This is one of those sales that will go on forever.'" Though he was paying for off the peg, Ralph ended up with a custom-made suit. "I knew I'd never make any money on Ralph Lauren," Grodd realized. "But I felt that whenever he got the money together, he'd buy a suit. His finances were marginal, but this was a kid that loved cloth. And he had a tremendous instinct for quality."

Though he loved its air of quiet, understated status, and its all-American authenticity, Ralph had found Brooks Brothers wanting. "Brooks built that world, it was like a club, and kids would go to the store because that's where their fathers went," he said. "I loved the Ivy League look, the chinos with little buckles in the back, the white bucks, the brown-and-white saddle shoes, the Oxford button-down shirts, which only came in white, pink, blue, yellow, and a blue-and-white stripe." But Brooks was limited, and it never changed.

Ralph's idea of what Brooks *should* have been was a lot better. "I'd thought it was a real country tweedy thing," he said. "I asked for hacking jackets, with those vents in the back, like the ones I'd seen on TV on Fred Astaire. That's not what they made. One day I saw Douglas Fairbanks Jr. walking down the street. Wow, look at the guy! He looks great. Spread collar. Suit with side vents. I said, Where do you get those? That's what I want. No one had it. I shopped Brooks Brothers; I shopped at Paul Stuart. No one had that."

23

Ralph Lauren was drafted on December 30, 1960, and joined the U.S. Army Reserves, assigned to Battery Bravo in the 6th Battalion Howitzer of the 5th Field Artillery. It wasn't as glamorous as it sounds. He shipped out to Fort Dix in central New Jersey three months later for basic training—as a supply clerk. His experience at the induction center proved his wisdom in changing his name eighteen months earlier. "First guy I sat down next to—from the reception center, I got on the bus—and the guy was from somewhere in Pennsylvania and his name was Lifshitz, and I watched him get hazed by guys all the time," Lauren said.

Ralph liked the army even less than he had CCNY and Allied Stores. "You have no face, you're not a person, you're a robot," he'd say. He didn't mind the uniform, though. "I wear khaki, I love army clothes." A good thing, because part of his job as a supply clerk was to hand them out—along with boots, beans, and Band-Aids—to other soldiers. After he completed his training in September 1961, Ralph remained on call in an Army Reserve Contingency Group until early 1963, and was required to be on active duty a couple weeks a year. He never rose above private, never won any awards or decorations.

He never traveled and saw the world, as the army's advertising promised, either—Battery B in the 6th Battallion Howitzer of the 5th Field Artillery wasn't in the field; it was based in the Bronx. So twenty-two-year-old Ralph moved back into his childhood bedroom—and found a new job through an employment agency as a shipping clerk at a glove company called Meyers Make. Before long, he'd risen to salesman and could be found pounding the pavement, going door to door to clothing stores, selling elbow-length women's gloves. It was a job with no future. In the carefree days of the Kennedy administration, old-school items like men's hats and elbow-length gloves were on their way out of fashion, and Meyers Make was on its last legs.

In spring 1963, Ralph bumped into a former colleague from Brooks Brothers, Ed Brandau, on the street. Lauren admired him; the first time they met, Ralph had eyed Brandau in a green gabardine suit, blue shirt, and yellow

tie on the main floor at Brooks, and had pronounced, "You know what it's all about."

Now, Ralph said he needed a new job, and Brandau thought he could help. He was head of sales for Daniel Hays, which claimed to be the oldest glove maker in the world. It had outfitted Theodore Roosevelt's Rough Riders during the Spanish-American War, and now made patented seamless gloves that fit "like the skin on your hand," Brandau says. Brandau figured that if Ralph sold more than gloves—if he could find several related products that complemented gloves and could be sold to the same stores—he'd earn more money. Soon, Ralph was selling gloves for Daniel Hays and a men's cologne called Zizanie out of Brandau's Madison Avenue office.

Zizanie, a scent created by Fragonard, the French perfumer, was licensed to a one-time silent-film star named Carmel Myers. The raven-haired Myers had starred in seventy-five films, usually playing a wicked vamp, and had gained a certain fame when she saved Rudolph Valentino from drowning when they co-starred in A *Society Sensation* in 1923 ("I'm a lover, not a swimmer," Valentino famously sputtered as she dragged him from the surf). After World War II, Myers quit the screen and went into the perfume business. Brandau had suggested she try Ralph out as a salesman. Ralph made 6 percent commission on gloves; he could make 10 percent selling fragrance.

Myers bonded with her young salesman. "She liked him, he was helpful to her, opening new accounts," says her son Ralph Blum. Myers's daughter Susan Kennedy and her college roommate, Monica Moran, the actress Thelma Ritter's daughter, would go to trade shows with Ralph to spray people with the fragrance. Says Susan Kennedy, "He was darling, a child, and [Myers] absolutely adored him." So did Ritter's daughter, who went out with him. "He was *sooo* cute," Kennedy says.

Lauren and Brandau shared a taste for soft-shouldered clothes, but already Ralph had seen that style was about more than suits and ties. One day he burst into Brandau's office: he'd just opened a new account, selling gloves to an equestrian shop on Madison Avenue that specialized in riding clothes and polo gear. He was fascinated by the store's clientele, Brandau realized. "He liked the lifestyle. You could see he wanted all those things."

Ralph was especially impressed by anything English. With the money he saved living at home, he bought a Morgan, a rare English sports car. Morgans are known for their fragile build—they have a wooden frame on a hand-formed aluminum body and a terrible ride, thanks to their frame-mounted axles and lack of suspension and shock absorbers. But they have drop-dead gorgeous lines. And they're fast. Style with some substance. Ralph's Morgan was dark green and

had a long, leather-belted hood, and he was very, very proud of it. But cars aren't everything. One night Ralph drove Brandau home to his apartment on the east side of Manhattan and was awed by his boss's collection of English antiques.

"Some day, I'm going to have all this," Ralph vowed.

Obviously, Ralph needed more money to do that—even though he wasn't paying rent, the $200 a week he earned was insufficient to support his increasingly expensive spending habits—so before long Brandau called another friend, Abe Rivetz, who owned A. Rivetz & Co., a tie company in Boston, and suggested it take Lauren on as a salesman, handling all of the company's accounts in the suburbs of Long Island and a few menswear specialty stores in New York. The addition of ties to his portfolio of products won Ralph his first mention in *Daily News Record*, or *DNR*, the menswear trade newspaper.

Ralph's old friend Warren Helstein had become a coat buyer at B. Altman, a dowager department store, making good money, and Ralph was impressed by that, too. "Altman's, to him, was a high-class WASPy story," Helstein says. Ralph's office was nearby, and they started hanging out again. "He was struggling; I bought him lunch three times a week," says Helstein, who also took him places he'd never been—a Japanese restaurant, a Moms Mabley show at the Blue Spruce Inn.

At age twenty-three, Ralph ate nonkosher food for the first time. "I gave him his first shrimp," Helstein boasts. And with Sue Damsker out of the picture and Ralph playing the field again, Helstein sometimes set up him up with girls. Not that he couldn't find his own. At a party on New Year's Eve in Brooklyn, as 1963 turned to 1964, Ralph was with a mousy date. "I was bored to death," says Helstein, who didn't like the crowd and wanted to leave—but he was driving and Ralph was behind a closed door with the girl, "banging her," Helstein says. "I had to wait for him to finish."

Lauren and Helstein had returned to their old shopping habits, only on a much higher level. Ralph's mother didn't always approve, but he no longer had to listen. He didn't care what anyone thought. "I could do whatever I wanted to, I always made money, I was always ahead of guys my age," Ralph said. "I was always able to do things. I always had a car if I needed it, no one gave it to me, I just did it. And I did not stop."

Helstein's father could no longer satisfy the dapper duo. "He was not able to deliver the kind of fabrics, design, and tailoring we looking for," Helstein says. "There were not a whole lot of people around who could." So they went to places like Gucci—then in its first blush of success in America—where Lauren bought a horse-bit-buckle belt. "It was an achievement," says Helstein, who adds that, despite his bluster, Ralph still wasn't making a lot of money. "We man-

aged," says Helstein. "Things weren't as expensive then. Everything was small and privately held, [and the owners were] not looking to pay for advertising and PR." That would all have to wait for the design generation that included Ralph Lauren.

At Ralph and Helstein's taste level, men's fashion was still a cottage industry where advertising was word of mouth. So Jerry Lauren introduced his brother to a tailor named Jimmy Palazzo, who made custom clothes for many men's specialty stores and samples for designers like Bill Blass and Halston. "Jerry wanted me to make Ralph something," says Palazzo. Ralph would come in the morning, bring Palazzo a cup of coffee, and batter him with questions. "He came to pick my brain," Palazzo says. "He had an idea of shape and flair on the English model. No one could make them. He wanted what he wanted, period."

Ralph's new look made an impression on his new boss. "Abe Rivetz fell in love with him right away," says Phineas Connell, A. Rivetz & Co.'s head salesman in New York. Rivetz became the young salesman's mentor even though his was a conservative firm selling conservative ties. Soon, others noticed Ralph, too, and in May 1964, *Daily News Record* ran an article about him called "The Professional Touch," featuring drawings and descriptions of the custom and customized clothes Ralph was said to wear on his rounds—clothes the paper deemed to be "a season's jump ahead of the market."

DNR revealed that Ralph was driving lots of tailors crazy with his requests for rare details like ticket pockets, suits finished without edge stitching, fewer belt loops, and rounder shoulders. He'd even had corduroy riding pants remade to his specifications in an equestrian shop in Cold Spring Harbor, on Long Island's exclusive North Shore. "He didn't have enough money to be so magnificent," says Abe Rivetz's son-in-law, Mel Creedman. "How he managed it, I don't know."

His magnificence paid dividends. "We had a section editor who wanted to do a feature on a tie salesman who was a unique dresser," recalls Mort Gordon, a *DNR* editor. "I said we don't write up salesmen, we write up presidents, and I vetoed the idea." Gordon was surprised when it appeared anyway. But no more so than Ralph's co-workers at Rivetz, who couldn't believe that the new kid was getting so much attention. "Who the hell was he?" one still sneers today. "A clerk at Brooks Brothers wearing English-cut clothes. He had jodhpurs, and he didn't know a horse's tail from its mouth!"

The other salesmen quickly realized that Ralph didn't like the ties he was selling. They were all about fitting in and looking right. He was all about standing out. "He pulls up in a Morgan wearing a World War II leather aviator's jacket, a leather aviator's hat with goggles," says Robert Stock, a salesman at Alvin

Murray, Ralph's local menswear store, and one of his Rivetz accounts. "Who is this guy?" Stock asked himself. "They told me he was a tie salesman. *Hmmm. Interesting.* He looked like somebody from outer space."

No one could fathom him, or change him, although Mel Creedman, the owner's son-in-law, says he made Ralph stop wearing a shabby, old rubberized cotton mackintosh raincoat he'd saved from childhood; Ralph stuck it in his closet and henceforth wore it only around friends who'd appreciate it. And Ralph has a somewhat different memory of Creedman's dress code. "I was wearing side-vent suits, not dumb, three-button clothes. They said, 'We don't like the way you dress, we don't want you in here wearing what you're wearing.'"

Even Abe Rivetz had his limits. When he saw a box of his ties strapped to the hood of Ralph's Morgan, getting soaked in a rainstorm, he told the salesman to get a car with a trunk. "Ralph was broken-hearted," says Phineas Connell, who still remembers the day Ralph drove up to Connecticut to visit—and Connell's son bought the Morgan on the spot. "Ralph turns around and buys a classic Thunderbird, and the first night, in front of his apartment in the Bronx, it's stolen, and he never sees it again," the amused salesman relates. Ralph soon bought himself another Morgan.

Ed Glantz started working as a stock boy at R. Meledandri, a men's custom tailor shop just off Park Avenue, in New York's carriage-trade hotel zone in 1963. The store's namesake, Roland Meledandri, was a character: bald with a waxed head and handlebar mustache, hunched but solid, and always with a pipe in his mouth. A detail freak, Meledandri soon had Glantz soldiering sleeves—lining them up like recruits in formation—folding pants, and wrapping packages so the patterns on the wrapping paper always matched, before letting him graduate to sales. "He didn't teach," says Glantz, "you watched and you learned." Steve McQueen, Henry Ford, Tony Bennett, Ted Kennedy, and Mayor John Lindsay were the sort who sat in Meledandri's Mies van der Rohe chairs, hanging out while having clothes made. "It was the place to be," says Glantz. "People flew in from the coast. Meledandri's clothes said, 'I'm wearing the best there is.'"

Glantz remembers Ralph coming in as a vendor, selling ties and gloves, but also as a student of the business and, now and then, as a customer. Ralph came in with Warren Helstein. "I'd buy three suits," Helstein says. "Ralph would buy one. It was competitive but friendly. Look at this tie. Look at this shirt. We were just buying clothes for ourselves. We'd do a lot of stuff together in search of elegance."

Ralph also visited Meledandri with Joe Barrato, who'd left Brooks Brothers to sell for a trouser company. They'd have to wait an hour or more, because they

weren't important, and, even if they had been, Meledandri was terrible with appointments. But Ralph was still in charge. "He took Roland's expertise and made it Ralph," says Glantz. "Ralph wanted softer shoulders, pants with an extension waistband."

Meledandri made a real impression on Ralph—so much of one, in fact, that, looking back, many later felt that Ralph had modeled himself on Meledandri and appropriated Meledandri's fashion ideas. "There was nobody like Roland," says Helstein. "Ralph questioned him incessantly. He'd found his role model. Roland was so cool and perfect, and everything he did was right. Roland this and Roland that. I was busy having a life, but maybe Ralph perceived this was his vehicle. Copy Roland and give it to the masses."

Risha Meledandri, Roland's widow, agrees, even as she calls Lauren "an absolute genius." But she doesn't agree with Helstein's opinion that had he lived—Meledandri died in 1980 at age fifty-one—he'd have been as big as Ralph Lauren. "Roland had none of Ralph's charm," she says. "He was very temperamental, he didn't endear himself. People were really treated badly by Roland. He was an elegant, angry man, a one-man band who could have never been a Ralph."

And Ralph could have never been Roland, says Ed Glantz, who went on to become a top executive at Giorgio Armani. "Ralph was a traditionalist," says Glantz, whereas Meledandri sold Italian-style suits—which were more restrained than the suits Ralph knew as Broadway-style, yet far more fashionable than what was sold at Brooks or Paul Stuart.

"Did he copy Roland?" Glantz howls. "Absolutely not! The difference between Roland's suit and your skin was two inches. You couldn't carry anything in your pockets. That has nothing to do with Ralph. Ralph's style—he couldn't buy it in that store. But he could buy ideas and incorporate Ralph into them."

If indeed Ralph was watching and learning, Roland Meledandri could not have cared less at that point. "Ralph wasn't an intimate, he was a salesman," says Risha Meledandri, "a little guy." Meledandri was a big guy, and his clients were heavy hitters. He looked down on Ralph in more ways than one. "Roland had no belief in Ralph," adds Glantz. "But Roland had no belief in anybody. He thought Armani was a flash in the pan!"

24

'm getting married," Ralph said shyly to a neighbor one day toward the end of 1964. He'd gone to see an eye surgeon at Montefiore Hospital. Ricky Anne Low-Beer was the receptionist—and she was just like he'd been a few years before, unformed but full of yearning. "She was very European," Ralph has said. "She was an only child and very sheltered; she never even had an ice-cream soda until I met her. She had a little accent and was unlike any American girl I'd seen. She told me she liked me because I was dressed like one of her Viennese uncles, a wealthy man who has his suits made at [the famous Viennese tailor] Knize." Ralph liked the way she looked—she was a stunning blonde with sharp features, pale blue eyes, and a full figure on a slight frame— and quickly told Jeb Buchwald about her. She was an English major at Hunter College, and taught dance at a local studio. "Ralph said she was nice and every-thing, should he ask her out?" recalls Buchwald, who asked if she was pretty. Ralph said yes. "He asked me what to do—silly, but that was Ralph."

"He thought I was so cool, but I was really nervous and shy," Ricky later told *Women's Wear Daily.* "He looked like a prince. He said to me, 'If I asked you, would you go out with me?' I said, 'I don't know, call me. We'll see.' "

Buchwald and his girlfriend, a Norwegian housekeeper, went along on Ralph and Ricky's first date, a ride to Jones Beach, followed by dinner in a Chinese restaurant. Ralph was so enthused that over egg rolls, he asked Ricky to marry him. She blushed. She didn't seem very worldly. Ralph was surprised that someone he thought so beautiful would find him appealing. "She was a drug," says another man who knew her then, "so beautiful you wouldn't believe it, with innate style." Yet she was bowled over by her new beau, who took her to one of New York's newest "in" spots—L'Interdit, a discotheque in the Gotham Hotel on Fifty-fifth Street.

"I picked her up wearing my striped suit with a navy tie, in my cream Morgan with the leather strap across the hood," Ralph once told *Vogue.* "She was very pretty, wore a cream dress and her hair the way it is today; we were both very quiet; when we danced she was a great dancer, and I fell in love." Ricky

thinks she surprised Ralph. "In my mind, I was something like Grace Kelly in *To Catch a Thief*, sweet, quiet, but with a certain edge," she said. "I was this little European-American girl, but I could surprise Ralph. I could dance. I understood about clothes. He never knew what would come out of me next."

One day, they walked past a store window and Ralph "asked me which jeans jacket I liked; there were several," Ricky recalled. "I identified the one that appealed to me and then explained why—the loops, the stitching, the length of the jacket, and so on. He looked at me and said 'That's great.' Not long after that he asked me to marry him." Ricky, who'd had a sheltered childhood, had never encountered anyone like her new beau.

"Ralphie's a genius," she would soon tell her friends.

Ralph Lauren and Ricky Low-Beer had a lot in common—both were the children of first-generation immigrants. Ralph spoke Hebrew. Ricky spoke German. Her father, Rudolph Loew-Beer, was an Austrian, but was almost certainly descended from the Löw Beer family of Frankfurt, Germany. They were among Germany's eighteenth-century court Jews: money changers, lenders, and agents for aristocratic families who came to wield great influence in European economic and political affairs. Despite confinement in Frankfurt's ghetto, they were a rich and privileged elite; among them was the better-known Mayer Amschel Rothschild, founder of the Rothschild dynasty.

Members of the Löw Beer family spread throughout Eastern Europe in the nineteenth century. One branch was prominent in what is now the Czech Republic. Descendants of wool buyers, they opened several textile mills, and expanded into the concrete and sugar businesses until World War II, when the Nazis invaded and took their factories. Not only had they been wealthy before that, they were also renowned as pioneers in providing benefits for their workers. Today, descendants of that branch of the family are intellectuals, doctors, and scientists.

Another, less wealthy line, calling themselves Lowbeer (like Lifshitz, the name has many spellings) lived in Vienna, Austria, where one of them owned a clothing store. But while the name Rudolph appears several times in various Löw Beer family trees, there are few traces of Ricky's father or his wife, an Austrian, Margaret Vytouch, who was born in 1909. In the 1920s, the families disappear from records kept by the Jewish community of Vienna. Many left town, and others renounced their religion and fell from view, which was not uncommon in Vienna at the time.

That was the source of another Lauren family secret: Ricky Low-Beer was not born Jewish. It's unclear if Rudolph Loew-Beer remained a Jew, but he definitely

married outside the faith. Ricky's mother was a Catholic. By religious law, Judaism is passed down through the female side of a family. So, formally speaking, neither are Ralph Lauren's children Jewish. But like many second-generation American Jews, the Laurens are more lax about their faith than their Lifshitz and Cutler forebears. Frank Lowbeer, Ricky Lauren's cousin twice removed, says they have traded Christmas cards with him. "I'm not Jewish," Lowbeer says. "Our great-grandfather was, but my grandfather converted, and my grandmother was Catholic." Just like Ricky Anne Low-Beer.

That doesn't mean Ricky was spared a direct link to the Holocaust generation, however—another connection she shared with her future husband. Ricky's father and one of Frank Lowbeer's father's cousins escaped Nazism by leaving Vienna together just before the start of World War II, and moving to Shanghai. The Chinese city had been home to a large community of Jews ever since the city's port was opened by treaty in 1842, and at the beginning of the war, Shanghai took in thirty thousand more Jews fleeing the Nazi threat in Europe. As a textile center, it was also a comfortable place for a Low-Beer to find work. A 1939 Shanghai refugee address book lists a Rudolph Loew-Beer from Vienna, living in the city's Hongkew slum district and working as a merchant. Luckily, he left for America before Shanghai's Jews were forced into a ghetto by the Japanese in 1942. Ricky was born a few years later, in January 1945.

Ralph knew Ricky wasn't Jewish, and even told some of his friends, but he kept it a secret from his parents. "She's half-shiksa," says a friend from the early days of the marriage, using the Yiddish term for a non-Jewish woman. "He didn't want his parents to know. He didn't tell me why he didn't. It was a compulsion, I think. He never talked politics, he never talked sports. Only taste. It was what he lived for. He liked her. He liked her looks." And they were all shiksa.*

Ralph was twenty-five when he and Ricky were married on December 20, 1964, at Burnside Manor, a catering hall in the Bronx, where Ricky walked down a small ceremonial staircase. Steve Bell was Ralph's best man. Jeb Buchwald drove the couple to the airport afterward for their honeymoon. On their return, Ralph wanted to move into an Art Deco building on Knox Place, near his parents' house, where there was an apartment available that he liked, but he didn't have enough to pay for a month's security.

Frank Lifshitz went to Rabbi Charlop. The building's owner was president of their shul, Young Israel. Could Charlop put a word in? He did, the deposit was

* Years later, when Ricky appeared in a fashion magazine's Christmas issue, and talked about some antique Christmas tree decorations that had been in her family for years, several friends from the early sixties chewed the news over on the telephone. "We'd never discussed religion with her, " one says. "But that gave new meaning to the saying 'Funny, you don't look Jewish.'"

waived, and Ralph and Ricky got their first home—a one-bedroom apartment with a kitchen in the living room and the El, New York's famous overhead subway, roaring by just outside their window.

Frank Lifshitz painted the place faux-mahogany. And Ralph's imagination turned the Bronx tenement into a town house off Washington Square. "It was like *Barefoot in the Park*," he says. "We hung pictures on the walls [that] we'd taken out of magazines. We went to get director's chairs at one of these crummy stores on Second Avenue. Orange director's chairs. Bright. Canvas. We went to the Lower East Side and got antique furs and put them on the bed. You dream. It's a dream of saying, 'Hey,' saying *something*."

Their landlord may have approved of the honeymooners, but not everyone in Ralph's family did. Neighbors and relatives recall the time when Thelma Lifshitz (who'd married young and moved away) stopped talking to her youngest brother after Ricky came between them. "These things happen," says the wife of one of Ralph's cousins. "Sibling rivalries. Men tend to go along with their wives. Thelma was not materialistic. If girls are not similar," she continues, choosing her words carefully if inexactly, "if they wouldn't be friends if they weren't sisters-in-law, this is what it was about." The breach has since been repaired.

Conversely, Warren Helstein rubbed Ricky Lauren the wrong way. The Laurens soon moved to Manhattan—to an L-shaped alcove studio apartment on Third Avenue at Seventy-fourth Street. "He didn't have two nickels to rub together," says a co-worker from Rivetz. "They had no furniture, but they had a doorman." Helstein visited one night. "I had jeans on with holes in them," he says. "Ricky was offended. The wife was coming between friends. Ralph told me I'd never be invited back."

In holding to standards, at least, Ricky was just like Ralph's mother. "Once, Ralph drove up in a sports car, wearing jeans," says a neighbor on Steuben Avenue. "Frieda was horrified. Jeans were a mark of being poor. She gave him hell. 'If you want to see me, you dress properly!' He came back the next week in a suit. His mother was the boss."*

Frieda Lifshitz didn't approve of Ricky Low-Beer, either—and her attitude would never change. Twenty-three years later, at the bat mitzvah of the Laurens' third child, their daughter, Dylan, Frieda shared a table with Hilda Riback, Riback's husband, a rabbi, and the president of his synagogue, a young woman

* "My mother once threw away a pair of jeans that were all ripped and faded," Ralph griped to New York's *Daily News* in 1986. "I'll never forget it. I was so angry. She threw them out and they were just at the point where they looked perfect. To this day, when I go to visit, my family smiles about it. And about the way I dress. They say, 'What's the matter, Ralph? Can't you afford a new shirt?'"

who doubled as a cancer doctor. They spoke "like daughter to mother," Riback recalls.

"You're such a wonderful girl," Frieda told the young woman. "I wish my son would have married you."

25

R alph's boss Abe Rivetz died the day Ralph and Ricky got home from their honeymoon. Ralph mourned for the man who'd become his mentor. Even more so when Mel Creedman, Rivetz's son-in-law, became the new boss. Ralph had recently seen something new in men's fashion, where novelty was usually at a premium: European men were wearing uncommonly wide neckties. Ralph told Creedman that A. Rivetz & Co. should get ahead of the trend and make some. "They could never sell Bloomingdale's, this company," Ralph recalls. "They were too traditional. I said, 'I want to take these to Bloomingdale's.' "

"The world is not ready for Ralph Lauren," Creedman snapped back.

Regardless, Ralph worked for Rivetz for two more years, though "it felt like more than that," Creedman says. "We were completely Ivy League. His taste was well beyond us. He was advanced Ivy League." On such distinctions, fortunes are made.

Ralph told Creedman he'd made a study of every movie Cary Grant had ever been in. "How his shirts fit, how his jackets were made, how many buttons, whether they had riding flaps or single vents," Creedman says. "He'd frequent stores Grant visited. He put everything he had into being Cary Grant." But also, into making other men dress like his idol. "He saw things no one else in the industry saw," Creedman admits. "He was right, and I was wrong. But he'd talk for hours about how wide a belt loop should be instead of selling ties." And when he did sell, he was selling to weird, avant-garde stores like Meledandri that weren't even in his territory, and had a minuscule, if wealthy, clientele.

Ralph didn't see it that way. "The necktie industry was full of men wearing hats, old men, and it was a very dead industry," he said. "I came along, and I had a sports car and a tweed jacket." He was a stew of male mythology: a hatless JFK,

Cary Grant on the Riviera, and a tweedy, suede-patched history professor, all rolled up in one. Not only did the fellows at Rivetz not know what to make of him—they didn't know what to make, period. "These guys were from out of town," Ralph said. "They'd come to New York. The foreign resources, fabric people came in to show their products to us, I was there when they were selecting, and I started to see that I had a lot of good ideas and they did not listen to me and six months later the ideas I had would pop up in someone else's line, so I said, 'Hey, I could have done it.'"

Abe Rivetz had listened to Ralph, and even let him design ties. "I hadn't the faintest idea how to make a necktie, but I was pretty sure I knew what the men wanted," Ralph said. Now, Ralph started to hock Creedman for the chance to redesign the Rivetz line. His importuning went on "for weeks on end, until I got desperate," Creedman says. "Ralph was absolutely a genius," but also, "a pushy pain in the ass." So Creedman and his head salesman Phineas Connell tried to accommodate Ralph, letting him design prints and concoct color combinations with a company that sold fabric to Rivetz.

"We let him have his head," Connell says, "but he was premature, too far ahead, too wide, too wild." And he was so intense about it all. When Connell rejected the colors he'd developed for striped Shantung silk, "he actually broke down and cried," Connell says. And not out of weakness; he was just that sure of himself. "He had his mind made up."

Ricky Lauren was the same. "She called me one day and said, 'Give Ralph his head. Some day you'll regret it if you don't. He's gonna be a success,'" says Connell. "But he was costing us money. It wasn't our trade. I had a terrible time with him." Creedman and Connell finally decided that Ralph wasn't a very good salesman, either. He could only preach to the choir, to people who agreed with him.

Ralph was having none of that. They were stuck in their old ways and he was part of something brand new. "It was a time in America to change," he says. "It was a time to break the rules." Hard as it is to believe today, back then, Ralph's version of Traditional style was incredibly radical.

Nonetheless, by 1966, there were more than a few men around who believed in it. It was Abe Rivetz & Co. that was out of step. On London's Carnaby Street, young men had begun dressing up in ways they hadn't since the days of Beau Brummell. Velvet suits, pointy-toed Spanish boots, and Edwardian silhouettes accessorized with ruffled jabots were as ostentatiously popular as micro miniskirts. Youth was all, and it rejected the sad-sack silhouette of Brooks Brothers. The Peacock Revolution was happening, baby, and its street style soon filtered up into the highest realms of men's fashion.

Eccentric fashion entered the mainstream. Turnbull & Asser's Michael Fish, who'd worked among London's famed Jermyn Street haberdashers as a boy, had introduced brash, luxurious, extra-wide neckwear that became known as "kipper" ties, in a play on his name. Mr. Fish, as he was called, was catapulted into the fashion pantheon, opening his own eponymous shop in 1966 with a label that read *Peculiar to Mr. Fish*. The ties those labels adorned required shirts with bigger, wide-spread collars and flaring jackets with wider lapels. Cutting edge retailers began to stock them.

Roland Meledandri had caught wind of the trend and began making suits with wide lapels that required a wider tie. When Ralph saw that, he begged and pleaded with Mel Creedman at Rivetz. "It's what the young guys want," he'd cajole. "It's what I want." Creedman finally allowed Ralph to develop some wide tie designs, even though "only a handful of customers were interested at that time," he says. Stores would order "one of this, two of those," he continues. "I had to custom cut them. There was no profit in filling those orders. Ralph wanted to do everything except what our customers wanted." And to make matters worse, Ralph was demanding a bonus atop his salary and commissions, which totaled all of $12,000 a year (he made a few thousand more from Zizanie).

Finally, Creedman couldn't hide his feelings any longer. He took to calling Ralph "Shorty" in the office. "From that point on, he detested me," Creedman says. Ralph detested his job at Rivetz, too, and started looking for a new one. "I was very frustrated," he says. "I had to go." He tried to get a job at Rooster Ties—which made skinny, preppy knit ties—but its owner said no.

But Ralph made a friend at Rooster—one who would later help the young salesman take a giant step in his fledgling career. When he was still selling Meyers Make gloves, Ralph had sought out Joe Aezen, a Rooster salesman from Philadelphia, at a trade show, telling him how much he liked Rooster's ties, which were then considered hip and bohemian, the sort of thing jazz musicians in Greenwich Village would wear. Aezen took to him instantly. "He was totally devoted to taste."

By the time they bumped into each other again a few months later, Ralph was a tie salesman, too. After that, they met once a week to walk up Madison Avenue, look in store windows, and talk fashion. They'd start at Thirty-eighth Street, where Rooster had its offices. Sometimes they'd go by Miller Harness, an equestrian shop with a western tilt. Other times they'd walk up Madison past Brooks, Paul Stuart, J. Press, Chipp, and Herzfeld, and then turn east and head for Bloomingdale's, which was just winning its reputation as the alternative to the dowager department stores of Fifth Avenue.

"Ralph was so intense," Aezen says. "All he talked about was clothes, fashion,

taste. He was totally devoted." And, of course, when it came to his own clothes, Ralph still had to be a step ahead. Having bought a Gucci belt, he'd gone on to acquire a pair of Gucci shoes. But by 1966, Gucci had become known as the "in" store—which made it too popular for refined Ralph. "I'm paying for his lunch and he throws his Gucci shoes away because too many people have them!" Aezen marvels.

When he wasn't talking fashion, Ralph was usually venting about Mel Creedman, Phineas Connell, and his frustrations at Rivetz. "He was doing all the styling, and he wasn't get paid for it," says Aezen. "Mel didn't have taste. Phineas had all the cream accounts. They'd had a very good year [in 1966], and Creedman gave Ralph a nothing raise and told him it was a team effort, like 'Go fuck yourself.' He decided he wanted his own business."

Ralph applied his considerable will to getting his own line. Nat Lobel, a successful manufacturer of cocktail dresses for teenagers, lived in the Laurens' Upper East Side apartment building, and Ralph asked his advice. He talked to Dave Richman's father, the ladies' dress manufacturer, too, about how to get credit to launch a line of ties, and then he started looking for someone to back him in business. He asked Alvin Kohn and Murray Burton, who ran Alvin Murray, his neighborhood clothing store in the Bronx, if they'd back him, but they were renovating their store and passed. "If only we'd known," Kohn sighs.

"Ralph already had the idea of being just what he is today," a maker of fine things of all sorts, remembers Murray Burton. "I'm going to be in everything," Ralph told him. He told another friend, "I'm going to be the new Brooks. I'm going to be the new Ivy League standard." But his Ivy would be sexy. And he was starting small, with what he knew—ties.

Ralph had some samples made by George Bruder, one of the preeminent tie makers of the era. Decked out in one of his updated English custom suits, Ralph arrived at Bruder's workroom on Thirty-second Street, showed him fabrics and his fully developed ideas for a new tie line, and asked if Bruder could produce it. "I went to places that had fabrics, piece goods, odds and ends," Ralph said. "I went totally in another route than anyone else did. I'd cut up a couch, cut up the fabric just to make the tie. I was so loose in terms of feeling the mood, and I wanted individuality, and I felt there were things that weren't done and I came up with the wide tie and that was my claim to fame."

He'd actually borrowed the wide tie, but he did come up with the concept of making them different and elegant and pricey. Ties topped out at $5 apiece then. He wanted to price his at $7.50 to $15—and give buyers their money's worth. "It was completely different than what was being done," George Bruder recalls. "Ties were quite narrow. He started at four to four and a half inches. He

was buying fabrics that were completely unusual: heavy and carpetlike fabrics that no one had ever used in ties before. I looked at it and thought, 'My God.' I said, 'How in the world can we make these?' But we struggled and made them."

Unlike Mel Creedman, Bruder didn't think Ralph was crazy, just exacting. "He was completely different from the people I was accustomed to. He had distinct demands, and he stuck to them and wouldn't deviate. No one is always right, but his worst looked good." Ralph's favorite remark, Bruder adds, was, "It's not quite right."

Finally, though, it *was* right. Friends from the Bronx and Camp Roosevelt remember how Ralph would pull out his sample case when he met them and show them the weird, wide ties he was so proud of. He'd pop the case open on the sidewalk if need be.

Frank Lifshitz gave Rabbi Zev Charlop one of Ralph's first ties. "They were very heavy, very wide, very expensive," says Charlop. "They made an impression." So did the prices Ralph was charging. Esther Wyszkowy still lives across the street from the old Lifshitz apartment on Steuben Avenue. The wife of a rabbi, she *davened* with Ralph's mother at Young Israel. "Ralph came in to sell ties, and some of the people resented that he sold them for a dollar and they got ties for fifty cents in Manhattan," she recalls. "My husband said, 'Give a Jewish boy a break.' He bought something. They did the same because of my husband."

All that was left was to find someone to put him in business. Meanwhile, though, Ralph had talked the buyer who purchased Rivetz ties for A&S, a down-market department-store chain, into letting him spend the store's entire neckwear budget—it was called the "open to buy"—on the ties he'd designed for Rivetz, and others he'd cherry-picked from the company's line. "All high end, the extremes," Creedman recalls. "We cut them and made them and shipped the order." A few days later, the buyer called, screaming, "If you don't get this shit out of my stores immediately, I'll never sell your ties again!" Rivetz salesmen fanned out to A&S stores, packing up the ties and replacing them with more traditional goods. Ralph wasn't part of the recall. He'd quit just before that anguished telephone call.

Creedman was just happy he didn't have to fire him.

26

Ralph had finally networked his way into a deal. Dick Jacobson was a piece goods jobber; he sold odds and ends of tie silk to the Rivetz company. "Jacobson was an excellent merchant, with good taste, and we'd take Ralph with us when we went to see him and he fell in love with Ralph," says Phineas Connell. Jacobson and Lauren shared a fascination with old fabric swatches, old clothes, and old men's fashion magazines like *Esquire* and *Apparel Arts*—and the jobber conspired to find Lauren a backer. "Unbeknownst to our firm," Connell says, Jacobson "tried to arrange with another manufacturer to back Ralph in business."

First, Jacobson sent Ralph to see the Gant family, the premier preppy shirt manufacturers, who were looking to branch out into ties, but when the cocky twenty-seven-year-old pulled no punches and told them how badly they were running their business, they felt he was out of line. As it happened, Ralph was right. A revolution *was* coming in menswear—and Ralph had not only seen it coming, he was one of the front-line troops.

By 1967, the Peacocks were giving way to anti-fashion hippies. But inevitably, the pendulum was going to swing back—and smack in the head those who weren't ready for it. Those who were attuned, even a traditionalist like Ralph Lauren, saw that the youthful trends of the early sixties would grow up as surely as the youth of the era would. Men would soon be ready for more color, more quality, more choice, more style. And not only that, they'd be willing to pay more for it.

Jacobson hit pay dirt when he told his friend Ned Brower about Ralph. Brower's father had started Beau Brummell, a neckwear company based in Cincinnati, Ohio. By spring 1967, it had become the second-largest maker of neckties in America. Ralph met Brower, now deceased, for drinks at the Palm Court in the Plaza Hotel, and told him about the problems he was having at Rivetz, and about his dream of having his own company. "We are just talking," Brower said when they first sat down. But by the time they got up to leave, he was convinced. "I think we're going to do something," he said.

Beau Brummell's look was the opposite of everything Ralph stood for. Its ties were shiny, they were Broadway, the sort of neckwear used-car salesmen wore. Yet unlike Creedman, Brower wasn't threatened by Ralph's outlook or his obvious ambition. Lauren's wide ties would complement, not compete with, Beau Brummell's. "Ned was looking to give somebody a break, and that's what happened," says his widow, Shirley Brower. Brower offered Ralph his own division, although not a cut of the profits. And for the time being, he told Lauren, he'd have to do almost everything himself—purchasing, designing, selling, and shipping. Brower only wanted to make the ties at his Ohio factory, but Ralph said no—everything had to be done his way, under his direct supervision in New York.

It didn't matter that he didn't own it; Ralph now had his own line. "Ned let Ralph do it his way—as far as creating was concerned," Shirley Brower remembers. "He was just a pup, but he was never a schlepper; he was very sure of himself—and he was right. An artist has to draw, a musician has to play. Ralph wanted to be different. All Ralph wanted was a way to get it out, and Ned was his vehicle."

Ralph's brother Jerry had gone into the garment business, too. He started at M. Lowenstein, selling piece goods with Jerry Bond, who'd been a member of the Collegians SAC. Bond thought he was conceited and more interested in girls than in getting ahead. But then Jerry became a salesman for Jones Knitting Mills, which made sweaters and underwear, and by 1967, he was designing for the renamed Jones New York. Legend has it that Jerry came up with the name Polo for Ralph's division, but Shirley Brower says Ralph and her husband did. "It had snob appeal—which is what they were after," she says.

Ralph would later say that he wanted a name that was both sporty and elegant. He asked Warren Helstein, who'd taken him to his first polo match, his opinion when the choice had been narrowed down to Polo, Players, and a couple of others. It was all about positioning—even then. "I could not call it basketball or baseball," Ralph would say. But Polo had "an international quality, a sense of Europe, [a] sense of elegance." Polo had "an ambiance of style, so it was sports mixed with style and lifestyle." It was everything Ralph liked in four letters. "A little cachet," he says. "Glamorous, international, and playboyish. Very suave characters went to polo matches. That's how the whole story started."

Crashing Fred Astaire tribute, April 1973, with assistants Sal Cesarani
(over Lauren's shoulder) and Jeffrey Banks (smiling broadly).
(Photographer unknown, courtesy of Sal Cesarani)

PART FOUR

Perspiration:
From Bloomie's to the Brink

I didn't want to be one of many but the only one.

—Ralph Lauren

27

I n August 1967, Julie Baumgold, a young *Daily News Record* reporter, went to scope out Beau Brummell's new one-man brand, Polo. It was the Summer of Love and other twenty-seven-year-old men were wearing buckskin pants, listening to acid rock, and getting high. Ralph Lauren, Sinatra fan, wore a perfectly knotted navy grenadine tie and an electric-blue dress shirt under a beige custom suit with four-inch lapels, a pinched waist, flap-free patch pockets with inverted pleats, slightly puckered shoulders, and cuffed, deep-pleated pants with buckles at the waist. Baumgold noted that though he had a baby face, Lauren's hair was turning prematurely gray.

His ties were anything but gray—they were luscious, complexly decorated hand-mades in Indian, Swiss, and English fabrics, stitched in such a way that they couldn't be tugged from their fat bottle shape. Lauren smoothly spread them out on a table in his tiny, windowless office in the Empire State Building, romancing the reporter as he'd learned to romance buyers in his years as a salesman. He didn't sell; he believed. And already, he knew to stroke the right people: reporters—and even better, retailers.

"The romance is where you buy it," he said. "The store gives the tie the right or wrong connotations. I want a few good stores, not the commercial market. . . . I'm promoting a level of taste, a total feeling." Baumgold caught on to Lauren's secret: "He is not just selling ties."

"It *wasn't* just a tie," Ralph says. "It was a major statement."

Good thing he was making statements, because at that point, his business was no more than a drawer full of ties. He and Ricky and her mother, Margaret, would sit at the Laurens' kitchen table sewing the labels on. But the right stores started buying them. "He can sell anybody anything," says Cliff Grodd, owner of Paul Stuart. "He has such great conviction." Grodd thought the ties were "bizarre." Grodd's father-in-law, who ran the store then, was amused by this youngster who so loved the clothing business, but he didn't think the ties were right for Paul Stuart.

Lauren pressed: he needed Paul Stuart for legitimacy. "You've got to give me a chance." Grodd and his father-in-law were so taken with his sincerity, they bought a couple dozen ties "so he could say he sold Paul Stuart." But soon it was Paul Stuart claiming bragging rights. "It was a showstopper," Grodd admits. "We carried a lot of his merchandise. His timing was impeccable. They were quite successful."

The situation wasn't quite good enough for Ralph, though. The ties were shipped with Paul Stuart—not Polo—labels. "We had the cream of the line without the label," Grodd boasts. Nobody knew they were made by Polo. It was the same at Meledandri, where the only label in the store was Meledandri, even though the goods were made by Brioni, Douglas Leathers, and Greif, the suit makers. Ralph was in august, but anonymous company there.

Same at Neiman Marcus, the carriage trade Dallas, Texas, department store. One day Neal Fox, who'd gotten Ralph his job at Brooks and then left to become Neiman's vice president of men's and boys' clothing, was shopping the wholesale market in New York, when he got a call from Ralph, who reintroduced himself and asked Fox to come check out his new collection. "I fell in love," says Fox. "It was fabulous, a breakthrough in shape, fabrication, point of view." Fox cocks an eyebrow. "He had high prices for those days. He pushed the envelope there. But it was understandable." Ralph's ties were hefty—they used twice the fabric, they were worth it. "I knew we could sell it," Fox says.

Neiman Marcus had a middle-of-the-road business, neither Broadway nor Traditional but the top of the midwestern pyramid, a standard of all-American taste. And Fox was Ralph's kind of guy; he liked clothes with shape while most men still liked straight lines and no waist—narrow, high-buttoned Jerry Lewis suits.

"I wanted to move to two-button suits with a waist," Fox says. Suits like the ones Lauren was already wearing. "It was happening," Fox continues, "but not at a commercial level. There were guys with style and sensitivity, and it was beginning to emerge. *Shape*," Fox continues. "That was our word, and we promoted it. The buttons were coming down, lapels were widening, and here comes a guy with a wide tie that's got texture and feel and exotic fabrics. His timing couldn't have been better."

As a vice president at Neiman, Fox could have written an order then and there, but he knew that was bad politics. Better to let his necktie buyer make the decision. Fox asked Ralph to come to Texas, and before the week was out Ralph flew to Dallas with a couple of corrugated boxes full of ties. The buyer liked them, too, and Neiman's ordered a whopping hundred dozen units.

Now, he was important enough that he could push his own brand. Slowly,

the Polo label began to appear in stores. He sold to an Auntie Mame–like character named Lillian Owen, who had a store on Lexington Avenue in New York, and who told him, "You got it, kid." To Eric Ross in Beverly Hills, to Louis of Boston, and to Alvin Murray, the natural-shoulder clothing store in the Bronx, where he'd once worked part-time. "Jerry Lauren was the star, the one with fashion sense," its co-owner Alvin Kohn recalls. But Ralph was surpassing his brother, "and he kept getting better," says Kohn. "We were both on the same nouveau Traditional wavelength. We were good. He was better."

After six months, Beau Brummell's owner Ned Brower gave Ralph more space in the company's Empire State Building office; a ten-by-ten office he shared with a guy selling bowties. "It was like a prison cell," says Ralph's friend from Rooster, Joe Aezen. Ralph still had no employees. He did the packing and shipping himself, driving from account to account (there weren't that many) in his latest Morgan, the cream-colored one, hand-delivering ties, sometimes with Ricky, sometimes with his tie maker, George Bruder, who loved how Ralph loved his work, loved to watch as he meticulously set up his displays.

"Picture someone caressing a tie," Bruder says. "They were placed like they were diamonds. I saw a young man who had a fantastic drive and, once he was onto something, wouldn't let go." Indeed, he didn't want to let go of Bruder a few years later, when the contractor was offered a license to manufacture ties for a French designer. Ralph worried that Bruder would become a competitor and asked him to stick with Polo—exclusively. Instead, Bruder dropped Polo. It was the first, but wouldn't be the last time one of Lauren's core relationships foundered over his demand for absolute devotion, complete control. Many would come to believe that nothing short of giving up everything for Ralph Lauren would ever again be enough for him.

28

Despite Lauren's frequent claims that he was an instant success, reality was a bit slower. He only opened a handful of accounts in his first six months—and still lacked that big showcase store in New York that he had to have in order to be taken seriously—Neiman Marcus was impor-

tant, but it wasn't New York. He tried to sell Saks Fifth Avenue, Manhattan's toniest store, but its buyer wasn't buying. Ned Brower still believed in Ralph, but as weeks turned to months, and Ralph failed to find a store to sponsor him, Beau Brummell's owner started to worry.

Ralph could be his own worst enemy. He turned down orders from stores like Wallach's and Macy's that he felt were beneath him. For a beginner, decisions like that ran counter to common sense. "He was sort of out of control as far as budgets were concerned," Ned's wife, Shirley Brower, adds. "He didn't think about economics. Ned let Ralph do it his way as far as creating. But Ned always had to control him, stop him from buying too much yardage." Right from the beginning, excess would plague his business and be a near-fatal weakness. He was always more interested in perfection than profits. To balance his profligacy, he needed that big account, the marquee store that would sell lots of goods and provide the cash to finance his finicky fanaticism.

Finally, his persistence paid off: he landed a store that needed him as much as he needed it and forged a beautiful relationship that continues thirty-five years later. Bloomingdale's flagship store, fifteen blocks due south of Ralph's apartment and in the forefront of the fashion business, became and remains the cornerstone of Lauren's vast empire. As its slogan said, it was like no other store in the world.

Important as it is, today's Bloomingdale's is a shadow of its sixties self. The hip young "Saturday Generation" flocked to shop and be seen at Bloomie's every weekend, using it as a daytime version of the Second Avenue singles bars where they played at night. But happening as it was, Bloomingdale's had fallen behind in one key area. Until the sixties, American fashion designers had been either haute couturiers like Norell and Mainbocher, making custom clothes for the rich, or else they were invisible, hidden in the workrooms of brands whose labels bore made-up names or those of the garment center businessmen who owned them. Name-brand designers like Geoffrey Beene, Oscar de la Renta, and Anne Klein first emerged in the early sixties, via a new kind of women's clothing called "ready-to-wear" that merged the breezy spirit of American sportswear with the sophisticated sensibility of Parisian fashion. Less expensive, machine-made, and far more accessible than couture, the women's ready-to-wear clothing made on Seventh Avenue was the seed from which sprang the fashion business we know today.

Though before Lauren, they never had equal stature, "name" designers of menswear quickly followed. The Fifth Avenue department stores caught on to them first. Lord & Taylor had a new men's fashion line by the dashingly handsome ex-OSS officer John Weitz. Bill Blass, an urbane, Indiana-bred dressmaker,

signed a menswear license, too, and made a deal to sell his wares through Bonwit Teller. Bonwit also signed up Pierre Cardin, who was revolutionizing licensing, putting his name on every product he could. "The old women at Bonwit Teller are fitting young guys, and the stuff is flying out," says Neal Fox of Neiman Marcus.

Bloomie's prided itself on fashion leadership. But even the dowager Best & Co. was ahead; it had opened a shop for a young Italian men's designer, Nino Cerrutti. "So we were looking for new talent," says Bloomingdale's future chairman, Marvin Traub, then its general merchandise manager. And Lauren "desperately wanted to be in Bloomingdale's." It was *the* store to sell. "They were there before I was; they were hip, young, exciting," says Ralph.

It was a match made in fashion heaven and Joe Aezen, Ralph's friend at Rooster ties, played matchmaker. A hard-seller by nature, the turbo-charged Philadelphian made Polo his private project. Aezen always brought brownies when he visited Bloomingdale's on Monday and Thursday nights, when the store was open late. All the salesmen would stop in, if they were smart. Aezen started handing out Ralph's ties along with the sweets. "You've gotta wear this," he'd say to Jack Schultz, the divisional merchandise manager; Frank Simon, the men's merchandise manager; and Gary Shafer, the men's buyer.

Shafer, who "styled" Bloomingdale's own tie line, resisted at first, but he finally agreed to carry some of Ralph's ties, on the condition he narrow them slightly—and stick in a Bloomingdale's label.

Would no one let Ralph be Ralph? Recalling his favorite literary character, Howard Roark, Ralph refused to compromise. He wouldn't cut a fraction of an inch from his ties. And, he insisted, they'd carry a Polo label or Bloomingdale's wouldn't carry them at all.

"I walked out," Ralph says. "Because I believed in who I was."

Shafer relented—a little—and bought a rack of ties from Ralph (Rooster, by comparison, had two racks). They sold well. Well enough that Shafer took some of them with him on his next trip to Europe and had one of his contractors there knock them off—copy them—in fabrics he'd chosen. That way, he could sell them cheaper and, with no manufacturer's markup to pay, make more profit. Knockoffs were a garment center tradition; they were all that some clothing manufacturers did. But when Ralph found out—he'd taken to haunting Bloomingdale's ground-floor tie counters—he was livid.

Though he never mentions just who was knocking him off, he still tells the story. "I was all alone with the wide ties at Bloomingdale's, I was the hip guy, I was the guy, Bloomingdale's was the store, Polo was the tie," he says. "And all of a sudden, I saw other wide ties, I was upset as hell. There it goes, I'm not alone

anymore. And I said to one of the buyers, 'Jesus, they knocked me off.' He said, 'Do you know the difference between your ties and the other guy's ties? Love.' And I gotta tell you, it was true. I worked on those ties, I made them, I watched the pressing on them." He'd even try them on at night to be sure they fit right. "I wore 'em and I loved 'em," he says. "Money wasn't my goal. My expression was my goal." He didn't want to share the love.

Jack Schultz, who'd started wearing Ralph's ties regularly, told Shafer to knock off the knockoffs, pronto. "Shafer was a real prick," and in response he refused to buy from Ralph again, says Joe Aezen. But meanwhile, Steve Kraus had gotten a promotion to men's manager in one of Bloomingdale's satellite stores, in Queens, bridge-and-tunnel country. He'd bought some Polo ties, too, and they were disappearing in record numbers. Kraus, amazed, reordered. And they disappeared again. Senior management took notice. "None of us could understand it," says Schultz. Then they realized what was happening. The ties were being stolen and sold in a bowling alley near the store.

So Bloomingdale's reordered—again—and kept a closer eye on the stock. Now, the ties disappeared the right away—with a stop at the cash register first. "We could sell anything in New York," says Schultz, "but if it sold in a branch, you knew you had something." Frank Simon overruled Shafer and started stocking Polo ties in Bloomingdale's flagship New York store again. It was the first time, but not the last, that Bloomingdale's would save Ralph Lauren's business.

Like many young designers, Ralph was operating hand to mouth, barely able to finance his line. It's almost impossible for a designer operating on a shoestring to break out in fashion. Even great fashion talents fail as often as not because of the brutal, cannibalistic nature of their business. Knockoffs are only part of it. Big stores are apt to blackmail small manufacturers like Polo for what's called "markdown money," refunds for goods that haven't sold in exchange for continuing orders, or "chargebacks," fines levied on goods the stores claim have been improperly labeled or shipped. But in Ralph, they saw something special.

Bloomingdale's ran a double-page advertisement in the *New York Times* that year, touting Polo ties. It was an expensive, eye-catching affair that featured a naked model reclining, strategically draped in Polo's wide ties. "Ohmigod, it was sensational," Schultz recalls. "Nobody had ever done something like that."

And nobody did what Bloomingdale's, Neiman Marcus, and Saks Fifth Avenue (which also picked up Lauren's ties after Bloomingdale's ordered them) started doing for Polo then, either. "Ralph had no money and no credit," says Schultz, so he, Neal Fox at Neiman Marcus, and their counterpart at Saks, got together and "gave Ralph paper"—orders for hundreds of dozens more ties, so he could get credit from fabric suppliers and factors. Factors grease the wheels of

fashion's vicious cycle. They are companies that assess the creditworthiness of retailers small and large, approve and disapprove of orders, and then loan money to clothing manufacturers like Polo, secured by those pending approved orders, giving the manufacturers the liquidity they need to order fabrics and make the *next* season's goods while waiting for the last season's to sell and be paid for. By giving Ralph paper, the stores let him keep his tenuous enterprise afloat.

Retailers were Ralph's most important early friends, but they weren't his only ones. He found a lifelong ally in Michael Farina, a *DNR* illustrator who talked up Polo then and now manages Lauren's Bedford, New York, estate. And Ralph also caught the eye of Robert L. Green, a fashion editor at *Playboy*, who promoted designers he liked on his frequent television talk show appearances. Green had tried to help Roland Meledandri out, then switched to touting Ralph when he found Meledandri too difficult. Suddenly, it wasn't only Jerry Lauren popping into Ralph's Empire State Building office on his way to the track (Jerry wasn't obsessed with work like Ralph) or Frank Lifshitz stopping by after gold-leafing an apartment. The stores and the press started coming around. Now, Polo was the place to be.

Ralph even hired a salesman, Phil "Pinky" Feiner, a friend of Joe Aezen's from Philly. The day Feiner started, things were slow, so he and Ralph took a cab to Brooks Brothers where Ralph bought two pairs of expensive wingtip shoes he couldn't afford. He was furnishing his apartment, too. "He was really, really into it," says Feiner. "He had a great style sense." And he always seemed to *know* what was right. He liked a certain collar, with a wide spread and long points, for example, perfect for a man his size. Always a perfectly dimpled tie, too—he just loved that dimple. And "he knew you wore a crest ring, not a diamond," says Feiner. Lauren paid attention to the little things; in the year he worked for Polo, Feiner often had to shuttle ties back to George Bruder if they were a mere quarter inch too narrow. "Ralph was very precise," Feiner says. "He was a control freak, definitely."

"It's done *this* way," Ralph would snap at Arthur, the elderly gent who packed and shipped the ties. "He could really fly off the handle," Feiner says, "not yelling, but Ralph had a temper."

One thing bothered him most of all. "He doesn't like people who don't agree with him," says one of his early customers, a department-store buyer who likens the young Ralph to a bantam rooster. "Ralph wants to get even," the retailer says. And when he felt threatened, he'd fight. As a child, Ralph told the retailer, he'd been challenged by a bunch of toughs one day when he was out sledding. Instead of running, he aimed his sled right at them, and they scattered. "He has to control," says the retailer. "That's why he's so successful." That lust for control

is behind his soft-spoken, almost Mafia boss–like speaking style, too, says a former employee. He wants you to lean in, to bend to him. "He wants people to think he's tough and be scared of him."

Once he's got you, though, he makes you feel important. He loved to ask Feiner's opinion. He asked everyone's opinion, even the janitor. It was his favorite form of market research. "What do you think of this? Should I move to Palm Beach? What kind of car do you think I ought to have? What color tie should I wear? What kind of cake should I buy?" mimics an early employee.

"He'd sell a store in Brooklyn and then he'd say 'Did I do the right thing?' " says Feiner. "He'd have doubts. He needed reassurance. But he knew where he wanted to go. He knew he was going to [expand into] shirts and clothing." A Polo line of men's clothing. Feiner quit just before Ralph realized that dream. Ralph had his typical reaction when someone left him. "He was angry," says Feiner.

He was angry at his industry, too, when he gave his second interview to *DNR* in March 1968. Retailers and competitors cared more about deals and price than quality and taste, he complained. No matter that his fashion message wasn't one to make retailers happy: Ralph felt men should wear only things they'd owned a long time—nothing "bright and shiny," nothing "too fresh." "You must understand oldness to be a fashionable dresser," he said. "It's a new look based on old ideas." And the only thing worse than new looks based on new ideas? Near-new looks based on Ralph Lauren's ideas, he griped. He'd seen fabrics in other lines that were promised exclusively to him—and that really annoyed him. He was even angrier when he walked into Bloomingdale's and found another rack of wide ties, right next to his, this time made by another designer.

It was a turning point. Knockoffs were proof of his success. But Ned Brower, his backer, didn't see it that way. While Ralph worried that the wide-tie market was saturated and wondered if it wasn't time to move into other products, Brower was still worrying over how much Ralph was spending on the ties! "He'd bought expensive piece goods, home-furnishing fabrics," Jack Schultz of Bloomingdale's recalls. "Brower didn't get what Ralph was proposing. Ralph was about style, not profit." God forbid a businessman should make a profit!

Ralph told his problems to Joe Aezen, Frank Simon, and Schultz, who felt he had to get away from Brower and Beau Brummell. Bloomie's was pushing him to expand his line. He loved suits—couldn't he make some? Couldn't he do for shirts, pants, sweaters, and shoes what he'd done for ties?

Ralph was thinking he could. He'd kept up his relationship with tailor Jimmy Palazzo. "I found fabric," Ralph recalls. "I said, 'I want the lapels here,' and the guy said 'Ralph, you're crazy. You don't want that. Get out of here.' Then I'd wear the clothes and someone would say, 'Ralph, I want that.' "

He and Joe Barrato, his friend from Brooks Brothers, had been lunching out regularly ever since Barrato got out of the army and joined Corbin, a trouser company, in 1963. In the mid-sixties, the well-dressed Traditional customer wore Rivetz ties, Corbin pants, Southwick natural-shoulder jackets, Gant shirts, a Canterbury belt, and Bass Weejuns. Ralph told Joe he wanted to bring them all together—in slightly more sophisticated versions—under the Polo banner. But Ralph also wanted the Brooks customer at every age—prep schooler, Ivy Leaguer, privileged adult. And then he wanted to go beyond that, and reach out to the likes of Ralph Lifshitz and Joe Barrato, and give them the tools to turn their insecurity into aspiration and motivation. "I design for my world, for the people I know, whose lives I understand," Ralph would say. "Someone like me." His pitch hit a chord.

"I so much believed in him," says Barrato. "I believed in everything he said."

Finally, Ralph had overcome self-doubt. And why not? The ties were working, and job offers from other manufacturers were materializing. "All of a sudden the name Polo was hot," he says, "and I realized that I wanted my own business."

29

Norman Hilton was a third-generation natural-shoulder suit manufacturer with a family-owned factory in New Jersey and offices in a Sixth Avenue tower in midtown Manhattan. The Hilton family factory made suits for Brooks Brothers, among others. Hilton's suits were high-end— better than the Traditional standard-bearer, Southwick. And Ralph looked up to Norman, who was a graduate of Princeton and Harvard Business School and had started a line under his own name after World War II to help keep the family's factory operating at full capacity. Hilton was Establishment. Hilton was the real deal.

Norman Hilton says he started to notice that "people who were really hip began showing up with beautiful fat ties." So he called Peter Strom, his executive vice president, and asked him to find out where they were coming from. Strom, a handsome, tall man with heavy eyebrows whose grandfather owned a New Jersey clothing store, had been born Peter Strom Goldstein; Hilton asked

him to truncate the name shortly after he started work in 1956 as a floor boy, moving bundles of coats from one worker to another on the floor of the Hilton factory. A dozen years later, in spring 1968, Strom had become "my number one boy," Hilton says—when Strom called Ralph and set up a meeting between the hot young tie designer and the venerable suit manufacturer.

"He was already a winner," Strom says of the twenty-nine-year-old Lauren. "He ran a profitable division and was highly thought of by the best retailers in America." But it wasn't only that. He'd started a revolution that wasn't about to stop. If you liked his ties, you needed new shirts to go with them, and new suits, too. Suits and jackets were the big time; in the jargon of the trade, they were what was known as clothing.

All Hilton wanted was someone to design a line of what was called furnishings: ties and shirts for his label. "We had Norman Hilton ties, but they didn't amount to much," he admits. But like Ralph, he dreamed of selling a total look, so he was intrigued by the young man's big ambition. "Nobody had the concept as concretely as Ralph did," Hilton says. "He said, 'I can design anything—even automobiles.'"

He was full of himself, all right. "Norman Hilton came to me, he called me," says Ralph. "People kept telling him about me, he wanted to meet me, he wanted to start a new division, wanted to diversify. 'Would you like to work for me?' No, I want my own company, I don't want to work for anyone."

"He had a job," says Hilton. "He didn't want a job. He wanted his own line."

Ralph walked out of the meeting, but he didn't get far. Ralph, Ricky, Jerry Lauren, and his wife all spent the summer of '68 in Deal, New Jersey, a predominantly Jewish beach community. America was burning that summer. Half a state away, Newark, New Jersey, was in flames. Meanwhile, at the beach, Ralph Lauren was burning with ambition.

Years later, Ralph Lauren's name would be inextricably linked to the chichi New York beach communities collectively known as the Hamptons. So it's a little ironic that Polo's fate was sealed at the comparatively plebeian Jersey shore. Peter Strom and his wife were also in Deal that summer, and the families all belonged to the same swim club. Strom was fascinated with Lauren. "I thought he was really hot stuff," Strom says. That opinion solidified when Strom got a look at Polo's numbers. The tailored clothing Ralph wanted to make would require both a financial investment and a year of development, and even then, as suits offered meager markups, profit margins would be low. The ties more than made up for that, though. "In ties, the markup is huge, and there's a fast turn," Strom explains. "Within a week, you're making huge margins, and the kid was a huge success already."

Worried by Ralph's demands, Hilton was wavering, but Strom insisted, and

negotiations began. Ralph had heard that in exchange for financing, he'd have to give up half his business. Hilton demanded 51 percent. "Ralph said, 'Screw you,'" says Hilton, who finally loaned Ralph $49,000 and gave him $1,000 in working capital in exchange for 50 percent of a new business that fall.

But Ralph didn't want a new business; he wanted to keep the most significant asset he had, the Polo brand—and that belonged to Beau Brummell. So he went to Ned Brower and asked if he could take the name with him. Legend has it that Brower graciously bowed out. "Ned gave him his freedom," says Shirley Brower, who admits she wondered why her husband didn't take a percentage. "Big mistake," she says.

But Ned Brower, while no seer, was also no fool. "He wasn't upset to be rid of Ralph," Hilton says. Ralph was a pain, and, big as it was, Polo was only a tiny part of Brower's business. Still, Brower insisted that Lauren pay for another asset that Brower considered even less valuable, the excess inventory—both fabrics and finished ties—that had been such a thorn in his side. The money from Hilton was to "buy the piece goods and take 'em with him," says Jack Schultz of Bloomingdale's, along with the boxes and boxes of unsold ties that were lying around. "They were stocking all these fucking ties in a workroom," says Joe Aezen, the Rooster salesman. Neither Brower nor Ralph wanted to deal with them, so once again Aezen saved the day, selling them off wherever he could.

Lauren was more gracious with Brower than he'd been with others who'd given him a boost. He sent his ex-boss a solid gold fountain pen from Tiffany. And in later years, whenever Brower admired a Polo item, it would arrive in the mail. There would even be a label on the sleeve of the suits reading, "Made expressly for Ned Brower." And years later, when Brower died, Lauren sent Shirley Brower a letter she treasures. "Everything I am today, I can thank Ned Brower for," Ralph wrote.

Norman Hilton took it on himself to thank Peter Strom—giving him 10 percent of any profits Polo made. He never regretted his generosity. "The money started rolling in, and he knew I was worth it," Strom says.

Ralph had another concern. Who was going to run his business? "He was not a very good businessman—he'll tell you that," Aezen continues. "And guess who he asked to go with him? He begged me to be his partner." Aezen said no, though. He thought Ralph was a flake. Ralph asked his tailor Jimmy Palazzo, too, but Palazzo also said no and, for good measure, told Lauren that the name Polo stank. "That's why I'm here, and he's there," the eighty-one-year-old tailor chuckles from his small retirement home on Long Island.

But in those days, as Strom says, "Ralph didn't need a lot." Palazzo remained

involved. He'd made a couple suits for Ralph by then, and the fledgling design-
er was impressed. So before the deal with Norman Hilton was even done, Ralph
put Palazzo to work on samples for the first Polo suit line. "He was very, very
determined to be in the clothing business," Palazzo says. "The original samples
were made to fit him. He wore the clothes into stores so he could sell them. He
got his initial orders because of that. He went to Hilton with orders." One hun-
dred orders, in fact—far too many for Palazzo to produce.

As a result, Palazzo didn't fare as well as Brower. After he told Ralph he
couldn't make the suits, he was dust. Ralph never returned, never said thank
you. And in 1970, when Ralph won a Coty Award—then the fashion Oscar—as
best menswear designer, Ralph not only failed to mention Palazzo, but dispar-
aged him when a mutual friend noted the omission. "Aww," Lauren scoffed, "he
thinks he taught me everything I know."

Despite that, Palazzo is generous in his praise, even if he gets a subtle little
dig in, too. "He deserves all the credit he got," Palazzo says. "What you're selling
is style and make and he definitely wanted a better product. But designers have
to be number one. If it's not their idea, they're not the designer." He pauses.
"What we made for him, he's still using."

Before the ink was even dry on Polo's incorporation papers, Ralph Lauren
made his debut as a designer of something more than ties. On October 22,
1968, *Playboy's* Robert Green gave New York's men's fashion industry something
he dubbed the Creative Menswear Design Awards at the Plaza Hotel. *DNR* gave
the event two full pages, and—showing one Polo outfit, a 1930s-style one-button
suit with wide lapels, pleated pants, and a big-knot tie—put Ralph on a pedestal
with the likes of John Weitz, Mr. Fish, Roland Meledandri, Bill Blass, and Oleg
Cassini.

Though one of his competitors observed that Polo's wide tie was "wearing the
suit," it was an auspicious debut. It also marked the first encounter between
Ralph and the woman who would soon become his alter ego, his professional
wife, and eventually, the longest-tenured employee of Polo.

30

R oseann Birrittella grew up in a so-so neighborhood in middle-class Yonkers, New York, and attended Skidmore College in Saratoga Springs, New York, a remote, not-quite-Seven Sisters girls' school, where she distinguished herself by becoming editor-in-chief of the Class of 1966 yearbook, a work dedicated to Charles M. Schulz, creator of the *Peanuts* comic strip. Roseann, or Rosie, as she was called then, was an arty girl with long straight hair, who wore dark eye makeup, black turtlenecks, and skinny jeans in a place where most dressed in tweed skirts, Bass Weejuns, and white McMullen blouses. "She certainly did not look like anyone else from Yonkers," says another yearbook editor.

An English major, Birrittella got good grades and was thought to be bright and hardworking. "Everyone looked up to her intellectually," says one of her roommates. "She was deep; she read." She had an eye for design, too. Their suite, in a quadrangle of old Victorian houses, "always looked great."

Birrittella was no powder puff, so all of her friends were surprised when she started calling herself Buffy after graduation. Or rather, a boyfriend named Duffy started calling her that after she went to the Newport Folk Festival, attached herself to one of her favorite folksingers, the plaintive-voiced Cree Indian Buffy Sainte-Marie, and, briefly, became the singer's driver. "It had nothing to do with being a preppy or a WASPy or anything like that," Birrittella says. "It's not about being a phony or anything else. I loved her songs." All of her group at Skidmore did. "And so we became Duffy and Buffy."

Buffy moved to New York and went to work for *DNR*, which, along with its counterpart, *Women's Wear Daily*, was published by a puckish, mercurial journalist named John Fairchild. He asked her to change her last name, too, she says, but she refused. Still, over the course of the next two and a half years, she would become Ralph's favorite editor and sounding board. "Buffy was our biggest booster," says Joe Barrato. She was flattered by the attention of fashion's hot young kid: he was the first designer who'd really *talk* to her about clothes.

Ralph was gathering a new gang around him, and just like the Comets, it also

included people who were born better off than he was. Every summer, Norman Hilton held seminars at the posh Princeton Club for his sales force, favored editors, and retailers who sold his suits. Hilton's midwest salesman, Anthony Edgeworth, first heard Lauren speak at the 1968 seminar. Edgeworth, who looked the perfect patrician, had grown up going to boarding school and buying clothes at Brooks Brothers, Chipp, and J. Press, but he was impressed by Ralph's look. "He had a nicely fitted gabardine suit on and a tie—and it [was] gorgeous—and a spread collar because you can't wear one of his ties with a button-down, the knot you get, it's impossible, so you have to start buying new shirts in order to fit this thing. He was like Jesus in the temple, the little curly-haired boy, gesturing and talking and softly lisping, but with this very arch look. He would want me to say he looked like an English gentleman. But this was something that no one had ever seen before."

Edgeworth couldn't help but notice when Ralph turned up again in Hilton's offices that fall. "He wore these gusset-back suits, like 1930s movie costumes," Edgeworth says. "Pleats in the pants. Nobody was wearing pleats in their pants. My eyes popped out. No one in America could make a fitted jacket. They didn't know how to make a high armhole to get a fitted look across the chest." Ralph did. Edgeworth realized they shared an affinity for a certain kind of dress. Ralph's look was costumey, Edgeworth admits, "but then again, three years later, everybody was wearing his costumes."

It wasn't long before "Pinky" Feiner, Ralph's first employee, quit, and Ralph went to Hilton and said he wanted Edgeworth working for him. So Edgeworth moved from Chicago to New York and started in the old Beau Brummell office in the Empire State Building while Lauren looked for new office space. The only other employee was Arthur the messenger, who wore a stingy-brim leather hat he never took off. "I was the executive VP of this company, whatever that means," Edgeworth says. "Arthur could have easily been assistant VP. My job was to go with Ralph and look at goods and go out to the factory in Linden, New Jersey, and try to get the clothing going, but customers came in and I'd have to sell them these ties, but there wasn't any selling. Business was so incredible, we couldn't make the ties fast enough."

The press was calling, too. One day Bob Beauchamp, an editor from a menswear trade magazine, was visiting the Empire State Building office when a call came in from another reporter. Lauren listened for a few moments, then asked the caller, "Am I the only designer in your story? Because if you want a story on me, fine, but otherwise, I'm not commenting."

Beauchamp was astonished. "I thought, 'You gotta love this guy,' " he says.

Edgeworth loved it, too, when Ralph would break someone's balls, like the

time an out-of-town customer showed up in a Rolls-Royce and, sotto voce, as the guy walked in, Ralph muttered that he didn't want to sell ties to him anymore. "I'll order six dozen," the storekeeper said. Ralph declared that his new minimum order was a hundred dozen. "I stood there with my mouth open," Edgeworth says. "He was incautious and he was fabulous and these people would break down, practically sob uncontrollably, and say okay."

Polo was about to hit the big time. Norman Hilton was a going concern with credit lines, bank guarantees from the First National Bank of Boston, production facilities, and experienced executives like Peter Strom, who served as a liaison between Hilton and Lauren as Polo expanded, first into dress shirts, and then, quickly, into clothing—tailored jackets, trousers, and suits. But Hilton didn't want Strom and Lauren to get too close, so he moved Strom out of direct supervision.

"They didn't like each other," Strom says. "I got along with them both."

It turned out Ralph didn't want too close an association with Hilton either. Indeed, as Hilton feared, he craved his independence. So when Polo finally left the Empire State Building, instead of moving into Hilton's headquarters in a building full of menswear manufacturers on Sixth Avenue, Ralph took a place of his own a few blocks away, in an undistinguished residential building at 40 West Fifty-fifth Street between Fifth and Sixth Avenues. The designer John Weitz had just moved out of the two-bedroom apartment once occupied by Ella Logan, a star of Broadway musicals, and Ralph loved the location. Frank Lifshitz painted the apartment—doing tromp l'oeil marble on the fireplace—and Polo set up shop. Over the next twenty years, Ralph would slowly take over the whole building.

Shortly after the move, Ralph flew back to Dallas for the opening of a new men's fashion boutique at Neiman Marcus called One-Up. Neal Fox was introducing designer names to the store for the first time. Ralph's ties had previously worn a Neiman label. Now Fox was touting designers, and Polo would be a featured brand: One-Up sold Ralph's ties, shirts, and the Hilton-made tailored clothing, all carrying the Polo label.

The menswear industry took notice. "The best stores were coming in, the leaders were liking it and buying it," says Joe Barrato, who was about to join Polo. Lauren's confidence was innocent, boundless, contagious. When he saw someone wearing one of his ties, he'd stop them and say, "Hey, that's mine." He'd park his car at a meter outside Bloomingdale's and dash in to straighten his rack. On Saturdays, dressed in a bomber jacket and jeans, he'd stand there for hours, teaching customers how to tie a knot so the dimple would be just so. Now, he was being noticed and talked about. Ralph had broken out of the pack. He would never be an employee again. He would be his own man.

31

On February 26, 1969, Buffy Birrittella's byline appeared on *DNR*'s first page-one story on Ralph, titled "Lauren Look"—a report on Polo's spring clothing line, which was about to be delivered to stores. While Ralph's ties would be going to many stores, she wrote, his clothing would be in only six, Bloomingdale's and Neiman Marcus among them. Outside, on the streets, many of America's young were protesting, burning flags and buildings, and battling the police as Birrittella wrote that Lauren's line—with its 1930s-detailed suits, linen trousers, and madras jackets—"speaks today." In their interview, Lauren declared that radical change was over—at least in the way that men who still dressed up were getting dressed.

With the new proportions he'd championed in the mainstream, Lauren's traditional instincts were asserting themselves again. Ralph would make his name with Anglo-American clothes that wouldn't have looked out of place in the fabled wardrobe of the Duke of Windsor—the natty dresser who gave up the British throne for the love of an American divorcée. Indeed, that same year, Ralph called Warren Helstein, who'd gone to work in the fur department at Henri Bendel. He'd heard some of the duke and duchess's clothes were in cold storage there and "he had to see them," Helstein says.

Lauren was underwhelmed. "I tried on his jacket," he says. "I like mine better."

Nonetheless, that fall, he returned the favor, giving Helstein one of his new shirts, made of heavy, expensive tie silk. "It was kind of hard to wear," Helstein admits. "I still have it. But I never wore it."

Ralph's taste was still a work in progress. Norman Hilton wanted it broadened. Ed Brandau, who'd worked alongside Ralph at Brooks, had gone to work for Hilton, developing a line of Italian-made pants. Early in 1970, Brandau was planning a trip to Italy to work on that line when Hilton asked him to take Ralph along and show him around. *DNR* soon announced that Ralph was spreading his wings and would be in Europe looking for ideas to flesh out his line with sweaters, coats, socks, shoes, jewelry, and luggage.

Ralph had never been to Italy. "He wasn't worldly, he didn't know about money or traveling or going through customs," Brandau says. He was also uneasy about leaving behind his wife and their first child, Andrew, who was not yet a year old. When Brandau came to pick him up to go to the airport, Ralph kept getting in and out of the car and running back into his building to say good-bye to his family.

They flew first to Rome where they "shopped the stores," a fashion business euphemism for sniffing out ideas and buying items that can be knocked off or adapted. Italy, France, and England were considered a step ahead of the United States when it came to fashion. But Ralph found inspiration off the beaten track, as well. One night, Brandau took him to dinner at a restaurant in Trastevere in a converted eighteenth-century post tavern that served spit-grilled meats against a background of regional music. Ralph was wearing a dark jacket, white shirt, and a dark tie with a knot the size of a baby's fist. Sitting at a communal table covered with a checkered tablecloth in the brick-walled restaurant, which was "decorated" with old graffiti, Ralph smoked Marlboros, drank red wine from a carafe, and breathed in the atmosphere.

He kept staring at their waiter, and Brandau wondered why. Finally, Ralph gestured the fellow over; he was wearing a washable white cotton jacket, precisely the sort of thing waiters wear the world over—with no frills, no fancy tailoring, no interior construction, no fragile sewing. "But it had a look," Brandau recalls. Lauren announced that he loved the cut and bought the jacket off the waiter's back.

From Rome, they went to Milan on the Settobello, a first-class passenger train. Ralph then headed farther north to buy fabrics for his suits and to arrange for the factory in Parma that made Gucci shoes to manufacture a few styles for Polo. Visiting factories and mills in Como, Italy, with Peter Strom, who'd followed them, Ralph pored over an archive of old fabrics. Strom understood that clothes were really Ralph's obsession after he pointed out a couple on a Como street to the young designer while they were taking a walk there one day. The woman was gorgeous.

"Did you see her?" Strom asked.

"Did you notice the placket on the guy's shirt?" Ralph replied.

Back in New York, Ralph threw himself into designing his widening line. "He was reaching in all directions," says Neal Fox, "trying to decide what he was going to do." Whatever it was, Ralph had to have the best. He'd hired the shirt-maker who worked for Aristotle Onassis and the Rockefellers to make samples for his dress shirt line, which included a reinvented button-down collar shirt

with longer points to make room for a big-knotted tie. Ralph was simultaneously working with Hilton's master tailor, Michael Cifarelli, trying to translate that Roman waiter's jacket into a product that could be mass-produced.

That led to problems. Norman Hilton shared ownership of his family's factory with several uncles, and they didn't want to give their nephew's pet designer carte blanche. And worse, their tailor, Cifarelli, didn't want to take Ralph's orders. Ralph was fanatic about details, and it was hard for Cifarelli to admit that this untrained American kid knew his stuff. "Italian designers are proud and temperamental," says Hilton. "If Cifarelli had just gotten off his high horse, Ralph would've gotten off his, but he wouldn't." Indeed, Ralph remains unapologetic. "I couldn't get what I wanted," he says. Hilton's "people, his factory, were not cooperating."

The battles that ensued were operatic. "Cifarelli said Ralph was making 1930s gangster suits," says Polo salesman Anthony Edgeworth. "The two of them were oil and water." Cifarelli either couldn't or didn't want to make the jacket Ralph wanted. Finally, after Ralph nitpicked Cifarelli's work one time too many, the tailor threw a jacket on the floor and jumped on it.

"This is too small!" Cifarelli yelled. "It will never fit anybody."

"I don't care," a steely Lauren responded. "It's what I want."

That was the beginning of the end of Ralph's suits being produced in the Hilton factory. Ralph wouldn't rest until he found a way to get around Cifarelli. "He was never satisfied," says Peter Strom. Indeed, he never would be. And complaints about fit would follow him around for the next thirty years.

Murray Palatnick came out of the world of the shapeless three-button sack suit. He was selling Southwick suits in California, when Neal Fox invited him to Dallas for the opening of the One-Up boutique at Neiman Marcus. Palatnick was a dandy. He wore the best shoes, the best shirts, the best suits. But as models entered the party from the elevators that night, he looked down at his three-piece gray herringbone suit and was horrified to realize he'd fallen behind the times. Way behind.

Palatnick had already told Southwick's owner that the company needed to adapt to new looks—and had been shot down. The morning after the One-Up party, he called the owner's son and made his case again. But the son wasn't interested either and repeated what his father had told Palatnick: "You've lost your religion."

Furious, Palatnick considered his options. He visited the most fashionable stores in Los Angeles and San Francisco, and wherever he went, he found that

all people were talking about was Polo and the new silhouette that Neal Fox was championing at Neiman Marcus. So Palatnick and Southwick's piece goods buyer decided to build a factory and start a new clothing company. They approached Leo Lozzi, a brilliant, mercurial tailor who'd been brought to America years before by Southwick and had then struck out on his own. Lozzi had a factory in Lawrence, Massachusetts, and was already making the kind of clothes Palatnick wanted. Though difficult to work with, Lozzi had the right stuff when it came to cutting patterns and making suits. Lanham Clothing, as Lozzi's company was called, was making suits for Eric Ross, the best men's specialty store in Los Angeles. Early in 1970, Lozzi, Palatnick, and the piece goods buyer acquired Lanham from Lozzi's partners.

Ralph Lauren knew all about Lanham; Eric Ross was one of his best accounts. Its owner, Berny Schwartz, an Anglophile like Ralph, had been savvy enough to ask for an exclusive on Polo in his area, which was Rodeo Drive in Beverly Hills. Lanham also made suits for Roland Meledandri.

Early in 1970, Ralph was in Los Angeles, checking out Eric Ross and poking around the city's other stores when he bumped into Murray Palatnick. They already knew each other. Polo's office in New York had become a club for men's clothing insiders. "We'd sit around 'til ten, eleven at night and talk," Palatnick says. "Most guys talked about broads. We didn't." They talked clothing. "We loved what we were doing; we were so into the business."

That night, Ralph and Ricky had dinner at Palatnick's home, and a dialog began that continued a few months later when Palatnick came back to New York. After dinner at the Palm steakhouse one night, the two men walked up Lexington Avenue and struck a deal. "Michael Cifarelli was rigid and unbending," Palatnick says. "We could turn on a dime." Ralph shifted his production from Hilton to Lanham. Norman Hilton couldn't stop him. "What could Norman say?" Palatnick asks. "He probably wasn't happy about losing the production, but Ralph was causing him problems."

He sure was. "Ralph couldn't get what he wanted," Hilton sighs, admitting that as little as he liked Leo Lozzi, the tailor gave Ralph the fitted, soft-shouldered jacket he wanted. "But we sold some clothing, we made good clothing." In fact, Hilton says, in a parting shot, the suits he made for Ralph were "the only good clothing he ever had."

Ralph's relationship with Hilton had followed a similar trajectory to those he'd had with both A. Rivetz & Co. and Ned Brower at Beau Brummell. "Ralph did his work to express himself," says Ed Brandau. "Norman wanted to make a lot of money. At that time, Ralph wanted notoriety as opposed to money. He wasn't a businessman, he wanted recognition of his foresight. So there was a

conflict in how things were done. Norman was a peculiar man, not easy to get along with. He wanted a say for his money—which is understandable."

Hilton's revenge would be a long time coming, but come it would.

32

A year after *DNR*'s first front-page article on Polo, Ralph spotted Joe Barrato walking down Fifth Avenue, grabbed him, and dragged him to his apartment office at 40 West Fifty-fifth Street. Barrato soon quit his job with Hardy Amies, a British designer, and joined Polo as its sales manager, replacing Anthony Edgeworth, who left to become a photographer (and would later shoot ads for Lauren).

Like Murray Palatnick, Barrato was an instant convert to Polo's new fashion religion—and became the first among Ralph Lauren's disciples. "I loved everything he did," Barrato says. "I could explain it like no one else could."

Ralph's expansion had proved successful. Though ties still contributed about half of his volume (his best styles now sold for an unprecedented $25), suits and sport coats were catching up, garnering $1.5 million in orders; shirt orders had tripled to a healthy $950,000; knits and other imports were bringing in $200,000; and a new Polo pants line seemed likely to add the same amount. Ralph's share of Polo's earnings in the fiscal year that ended in spring 1970 was more than $100,000. He'd do even better the next year, and reward himself with a silver Mercedes 250 SL sports car. He'd really wanted a Rolls, but Barrato convinced him it would be too showy. "He walked around for weeks with swatches for the body paint and upholstery," says Barrato. "It was so Ralph Lauren."

Though Lauren wasn't able to deliver a lot of the unconstructed suits and jackets he'd based on the Italian waiter's coat, in the end, that may have been a good thing. Outside of the most fashion-oriented markets, retailers were skeptical. Scarcity increased the perception that his stuff was in demand. One-Up at Neiman Marcus sold every suit the store got. And Eric Ross in Beverly Hills did well with them, too, whether in cotton, denim, or canvas. The suits were successful enough that Ralph made warmer variations that fall. And in September 1970, his influence was acknowledged when he won his first Coty Award, a fash-

ion Oscar created by Coty Cosmetics at the urging of public relations dynamo Eleanor Lambert, a prime mover in the post-war rise of American fashion. Though tainted with commercialism and charges of favoritism, the Cotys were the only awards fashion had, and winning one was a big deal.

The clothes Ralph showed in his portion of the fashion show at Coty's black-tie event included paisley-printed dinner jackets and tartan trousers. They made a loud statement, but that's what he wanted. "Men's clothes are not about design or about quality," he says. "They're about image. The man that I was seeing in the streets of New York all wore three-button suits and button-down shirts, and they were very IBM; there was no imagination. I was injecting something exciting, and it hit the mark because it was wearable and yet unusual."

Winning a Coty catapulted Ralph into the top rank of American design. Many stores still resisted, though. That month, when *DNR* sent Buffy Birrittella to ask Ralph what he thought of the retail climate, he didn't mince words. "The stores have blown it," he said, by using designers as lures, but not buying enough of their goods really to present a point of view. "They didn't take a stand," he complained; "it was just defensive buying, a list of names to give them prestige." What did Lauren want? "A designer shop that has a point of view, that has stock, that has an atmosphere and room for a man to relax and try on clothes."

This was out-of-the-box thinking: no department store had ever given a designer a shop like Roland Meledandri's. It was unheard of! The business didn't work that way. Menswear was sold by classification: ties in one department, shirts in another, and suits in a third. But although he didn't say so to *DNR*, Ralph was already talking to Bloomingdale's about that very thing. Now that he was making all kinds of goods, he wanted a shop all his own in his favorite store, where everything Polo could be shown and sold together. But Frank Simon, Ralph's buyer at Bloomie's, wasn't buying, even if *DNR* was.

The trade paper showed no sign of letting up. In another article published fifteen days after his blast at stores, Buffy Birrittella described Polo's spring 1971 line of simplified soft suits, ties printed with partridges and polo players, nautical cottons, plaid wool, gingham and tapestry print shirts, and lots of red, white and blue, and gushed ink all over her favorite designer: "Ralph Lauren stuck his neck out several years ago and it's paid off," Buffy wrote. "The Boy Wonder of the tie business now heads an almost four-million-dollar company. . . . The kid from the Bronx who pulled himself up the menswear ladder by his Gucci brass bits . . . continues to take strong stands. . . . Ralph Lauren is an all-American designer, a man's menswear designer. And there are few of them indeed."

With that wind at his back, Ralph wouldn't take no for an answer from Bloomingdale's. He told Simon that if the store wouldn't build him a shop, he'd

find another store that would. He'd just won a Coty—it wasn't an idle threat. "He not only wanted a shop, he wanted a very expensive one," recalls Marvin Traub, who'd become the store's president in 1969. "Parquet floors, wormy chestnut wood, and a lot of leather."

Simon had handed the problem off to his boss, and a committee was convened to consider Lauren's unprecedented demand. Finally, it was decided: "This was absolutely right for Bloomingdale's," Traub says. "We had leadership in home furnishings but not in apparel. We were trying to build a fashion reputation, and we knew it would not come from established people. I saw what was happening, and I asked myself, How do we compete with Saks and Bonwits? Exclusivity was the point of building the shop." And if they were going to build it, they would do it right—$85,000 later, in September 1971, the first Ralph Lauren boutique opened on the north side of Bloomingdale's main selling floor.

Finally, Polo was galloping. "I was doing everything," says Joe Barrato. "I was Ralph's right hand, his confessor." He wouldn't be the last Polo person to describe his relationship to his employer in religious terms. He wouldn't be the last employee thought to be sleeping with the boss, either. "People thought we were lovers, we were so closely connected," he continues.

Barrato was just what Ralph wanted—an acolyte, totally committed. Indeed, Ralph wanted more just like him. Somewhere along the line they started calling themselves Poloroids and the nickname—which was both funny and appropriate—stuck. Poloroids weren't quite androids, but they did dress, look, and sound alike. "We were young and naïve but becoming significant, and we needed help in a lot of areas," Barrato says.

One such area was publicity. Though fashion promoters like Robert L. Green and Eleanor Lambert were helpful, Polo now needed a full-time press person. Ralph and Barrato were walking down Fifth Avenue one day when they ran into *DNR*'s Buffy Birrittella. "You guys really need someone like me!" she announced. Barrato thought she was high, she was so excited by the thought. Joe and Ralph kept walking, but they hadn't gone far before they decided to hire her. "She was a little bit of a snot," says Barrato, "but it was natural. It just worked perfectly."

It worked well for Buffy, too. Several early Polo employees say Polo didn't so much hire her away from *DNR* as rescue her. "There was a rule at *DNR* against moonlighting in the industry," says one. "Everyone did it because *DNR* paid no money." But when Birrittella wrote press-kit materials for a fashion company, her editors found out. Opinions differ on whether she was fired, or was merely worried that she might be. Regardless, she needed Polo as much as it needed her.

"Ralph felt really bad," says another early-seventies employee. "She was his favorite. Ralph loved her stories. She really understood what he was about." So it was only natural that she start writing *for* Ralph if she could no longer write about him.

33

t turned out that Poloroids were everywhere. Jeffrey Banks was a clothes-crazy youngster, a handsome African American who lived in Washington, D.C., and loved fine clothing more than anything else in the world. As a child, he'd only ever cried when his clothes got dirty. As a teen, he subscribed to *DNR*. Banks bought his first Polo tie when he was only fifteen. He'd found it at Britches, the top men's specialty store in the capital's poshest neighborhood, Georgetown. When his father heard what the tie cost, he made the youngster take it back. But Banks would not be deterred. A year later, when he turned sixteen, he got a job as a salesman at Britches.

The store's co-owner, Dave Pensky, had first seen Polo ties in the window of R. Meledandri—"the most fabulous ties I'd ever seen in my life, otherworldly," he says—and asked who'd made them. Meledandri wouldn't tell him. But Pensky wouldn't let it go. He *had* to know who was making those ties, and he asked around until he tracked Lauren down in his warren in the Empire State Building.

"Meeting a guy like Ralph was so important to my career," Pensky says. They'd eat at J. G. Melon's, a hamburger joint, or Ricky would cook at the Laurens' apartment and they'd talk clothes for hours. They'd talk about growing up Jewish in the Bronx, too; Pensky's grandfather had been a cantor there. "Ralph touched a nerve" among people who came from similar roots, Pensky thinks. "He represented aspiration, a gentrified being, a moneyed sense, and you felt it could be that way." But his appeal wasn't limited to Jews from the Bronx. Banks, as mad for clothes as were Pensky and Lauren, was a perfect example.

Jeffrey Banks first met Ralph when the designer came to Washington for a benefit fashion show on Valentine's Day, 1970. The young salesman cut school to pick Ralph up at the airport and got a flat tire on the way. Luckily the plane

was late. But when Ralph and Joe Barrato disembarked, they quickly fell into a foul frame of mind. They'd brought Pensky and his partner a present, a framed Italian scarf with a polo player print—but the airline had refused to let them carry it on the plane. When it emerged from checked luggage, not only had the glass shattered, it had torn the scarf. They started to relax only when they got in the car and learned that their driver was the Polo-mad saleskid from Britches whom they'd read about in the local papers.

That afternoon, and all the next day, Ralph hung out in the store, and he and Banks bonded. "When we talked about clothes, it was like two people who'd known each other their whole lives," says Banks, who can still describe the suede maxi-coat Ralph wore that day. Lauren told him how he'd loved working at Brooks and observing wealthy European customers who wanted to dress like the American preppies whose fathers and grandfathers had shopped there before them. And how he'd dreamed of restyling the shapeless Brooks suits. Then he invited Banks to visit Polo when he came to New York to look at colleges— Banks wanted to study fashion design. "Maybe I'll have a job for you," Ralph said.

It wasn't idle chatter. Ralph called back a few months afterward to say that he did indeed have a job for Banks. So in spring 1971, they were on the phone again, talking about how Banks would fit work into his class schedule. Before hanging up, Ralph asked what Banks planned to wear to his senior prom. When Banks complained he couldn't find the right peak-lapel tuxedo, Ralph sent his own down for him to wear. They were both the same size, Ralph said. But in fact, Ralph was a 37 short and Banks a 37 regular, so he had to let the pants down for the party, then sew them back up before he returned the dinner suit. He repaid the favor by ordering two custom-made Polo suits for his graduation.

Banks arrived at Polo at a crucial interval, just as Ralph made his first women's fashions. Joe Barrato had heard from retailers that they thought Ralph should make women's shirts. Ralph agreed—if he could design for men, then why not women?—and went to his key sponsor Marvin Traub for advice. They cooked up a plan: Ralph would use existing fabrics and create a line of distinctive man-tailored shirts for women—all with white collars and white cuffs adorned by an embroidered polo player, mallet raised, ready for action. Ralph would make them in a shirt factory Polo had just bought.

In exchange for the right to launch the line—and a New York exclusive on Polo's women's clothes for the next two years—Traub agreed to build Ralph a second boutique in Bloomingdale's flagship store for the shirts, "a tight little shop," Ralph would later say, right beside the third-floor escalator.

The shop wasn't the only thing that was tight. "They were very skinny shirts, very tight-fitting, for young girls, and I put a little polo player on the cuff," Ralph says. "My style was the girl in the convertible with the hair blowing. She was the girl in jeans and the white shirt. Garbo was the type. It wasn't Doris Day. She had style, but she never wore the latest clothes." The Polo girl was "the girl I was attracted to . . . the girl I wanted to be with."

The embroidered polo player on the cuff turned out to be a master stroke — it would quickly become one of the most potent status symbols of all time. Which makes it all the more amusing that Joe Barrato believes it was based on a preexisting print that anyone could have bought, just as Ralph had, to use on a tie. The day they decided to use it as Polo's logo, they literally clipped it from the back of a tie Barrato was wearing. And it was Barrato who suggested putting it on the cuff instead of the breast of the shirts to differentiate them from Lacoste shirts, with their little crocodiles. Adding further irony, years later, Barrato would go to work for Brioni, the Italian clothing maker. "Brioni is an island in the Adriatic sea off Yugoslavia and was, for many years, a luxury haunt for the super rich of Europe," Barrato says. "The island sport was polo and the exact logo Ralph uses was the logo of Brioni Island." Brioni's founder took the island's name (which is sometimes spelled Brijuni) to associate his new brand with the island's reputation and ambiance. And he purchased the European rights to the logo. Years later, Barrato negotiated with Polo lawyers to let Brioni use the polo action figure in the European market again.

Ralph learned all about trademarks thanks to those women's shirts. He's said he began using his own name — instead of or in addition to Polo's — on his products because he saw that designer names were gaining value. "I added Ralph Lauren, because at that point Pierre Cardin was coming into the fold, and Bill Blass," he says. "The designer Europeanness was coming. And there was a menswear image starting, people were aware of me, and I wasn't known in the women's business, so I put Ralph Lauren on the label with Polo." But there was another reason.

The day after Bloomingdale's ran an ad announcing the women's shirts, attorneys for Brooks Brothers served notice of a lawsuit against the store. Trademarks are valid only for specific types of goods, and it turned out that Ralph's former employer had owned — since 1930 — the right to use the Polo name on Oxford-cloth button-down-collar shirts like the ones Ralph was selling.

"We ceased selling them immediately," store executive Jack Schultz recalls, "and got ahold of Ralph. He responded and changed the label in all his shirts to read Ralph Lauren instead of Polo. From then on, all his women's products said Ralph Lauren." And to this day, while most of his menswear is still labeled Polo,

all his Oxford button-down shirts carry a Ralph Lauren label, even though years later he acquired those trademark rights from Brooks, which had long since ceased to be the preeminent preppy clothier.

There was another problem with the women's shirts: they didn't fit. Based on a slim, Saint Tropez–style blouse without bust darts, they were meant to be classic, yet have a Bardot fit. Just as he designed his first men's clothes for himself, Ralph made his women's clothes to fit Ricky. "Ralph thought Ricky was a size six," says Sal Cesarani, then a freelance designer at Polo, "but she shopped at Henri Bendel," the city's most fashionable store, "and they called a size four a size six." Fashion has never been kind to large women, but Henri Bendel was worse. "It was a status thing," says Jeffrey Banks. "It was their mystique. Are you small enough to get into your own size?"

Making matters worse, in those early days, Ralph fit his women's samples on Buffy Birrittella rather than a professional fit model. Buffy had been hired as a press person. Ralph had the vision; Buffy had the eloquence to express it. "I was showing the line, creating press kits, but that evaporated quite quickly into being a jack of all trades assisting him in everything," she says. "I just always had an instinct for what he was doing. I always identified, saw his vision and where it was going."

Buffy was also the perfect Ralph Lauren girl. Like that girl, she was a size 6, but she had small shoulders, a small waist, and big hips. Most women didn't look anything like either her or Ricky. And experienced women's fashion designers understood that the clothes they fit on models—who are generally perfect size 8s—need to be scaled both up and down to fit all kinds of bodies. The sleeves on Ralph's shirts were so tight a woman could barely bend her arms and "there was no room for tits," says Banks. Ralph knew that, but he didn't care. "I didn't know anything about the women's business," he said. "I just went and had the clothes made in a men's factory. I said, 'I want this suit made for my wife; scale it down.' I shortened the jackets, made them slim, with skinny arms. They fit some women, and others couldn't get into them. They were limited to flat-chested girls. I was aiming at women like Ricky, and models. It became an in thing." Which is all he wanted.

In later years, Birrittella would try to take the blame for Lauren's fit problems (which continue to this day). "I'm the culprit," she told his biographer Jeffrey Trachtenberg. "I was a thin little person at the time." But the truth is, unattractive girls with bad proportions simply didn't fit in Ralph Lauren's dream.

Jeffrey Banks started at Polo as a sales assistant just days before Bloomingdale's opened its Polo women's shirt boutique. But as with many Polo products, the shirts weren't ready for delivery, so Banks had to take a train to the

factory—which was in the New York suburbs—and carry them back in boxes bound in string to stop Bloomingdale's women's buyer from screaming bloody murder. Banks finally arrived at the store after five P.M. There was a strike on, and pickets blocked the entrances. No one was in receiving—everyone was on strike—so the shirts weren't ticketed properly. Most other people's wares would have been returned or delayed for that offense. Not Ralph's; the minute they hit the store they hit the floor and sold out. The Bloomingdale's customer was Ralph's, too.

Most designers would have understood they were cogs in a larger machine. Not Ralph. Deep in his heart he knew that he was now as important to Bloomingdale's as it was to him. "I think I gave them a little shot that they did not have before," he says. "And after that, they really started to go."

34

Right from the start, Ralph Lauren had a peculiar style of people management: it typically began with seduction and ended in abuse. Gil Trueddson was another Norman Hilton staffer whom Ralph lured to Polo. Truedsson, in his late twenties, was running an imported sportswear division for Hilton. Ralph would stick his head into Trueddson's showroom when he came for meetings with his backer. "Ralph's interests had much to do with a WASP-y look, for lack of a better description," says Truedsson. "That's my background, the old-money look and taste level. He kept finding time to chat." Truedsson approached Ralph for a job in 1968 and was hired to develop products to round out the Polo collection. He'd talk to Ralph about his ideas, then go to factories and create samples.

"Ralph lived what he was doing, but he couldn't articulate it," Truedsson says. "He has visions in complete detail, but unfortunately, he couldn't always represent what he was thinking and it presented difficulties. If we couldn't anticipate what was on his mind, he'd get frustrated and abusive, commenting on what we were doing. 'This stinks! I never asked for this!' He got quite livid." He could reduce his designers to tears.

In his first months at Polo, Joe Barrato would help Ralph with everything—

even choosing fabrics for him. "I'd bring him ten great fabrics that were perfect for Polo, and he'd put nine aside and dwell on one swatch," Barrato says.

"How can you do this to me?" Ralph would whine, pointing at the offending bit of fabric. "This is terrible."

"On and on like an old yenta," says Barrato. "It made me feel so insecure. I'd be heartbroken. He was like my brother. How could he do this to *me*?" Only years later did Barrato realize that the other nine swatches had gone straight into Polo's line. Dwelling on what he didn't like was Ralph's way of making others rise to his standards. But they didn't always see it that way. "He's enormously creative yet enormously destructive toward those who are closest to him," says a man who has known him for years. "They are left reeling by the assaults on their self-esteem, by his need to diminish people and make them feel helpless, infantile, and inept in his presence." Ralph was, this man suspected, "compensating for some huge hurt in his childhood."

Jeffrey Banks wasn't spared, though he took it better than Barrato. After Ralph plucked him from sales and made him a design assistant, working with him at back-to-back desks, Banks was thrilled. He considered Ralph a father figure. Ralph called him the Prince. "What's the Prince wearing today?" he'd say. Banks was desperate to please. "When it works," he says, "Ralph has a great sense of humor, a great laugh, he's effusive and you feel like the sun shines on you. The flip side is that when he's displeased, he can make you feel *this big* by the way he denigrates you. It's the most brutal, awful thing to make a mistake. He's not spiteful, he doesn't realize he's doing it, but you're devastated. It's about control, definitely. It's about having that vision and not letting anyone or anything get in your way."

Ralph developed a complex of working habits that continue to this day. A disproportionate amount of his time was spent in meetings brainstorming (if they were productive) or worrying (if they weren't). He had a lot to worry about. Ralph's design assistants understood that it took time to get samples right. Ralph, however, had no patience. "He'd want it perfect," says Banks. "He'd hammer away." Today, Truedsson laughs about "the constant remaking of patterns to fit an image Ralph had in his mind that nobody could wear," even in those rare instances when goods were delivered on time. Why the delays? Ralph would disappear, he'd come in late, he'd schedule meetings, keep everyone waiting, then cancel them, and then make everyone stay until midnight two or three nights in a row. That was tough on Joe Barrato, who had a wife and lived in the suburbs. But it was fine for Truedsson ("I was a kid," he says) and for Banks and Birrittella; they lived for Ralph.

Banks would work all day and early evening and then Ralph would take him

and whoever else was around to J. G. Melon's or Boodles in the Village for burg-
ers. "It was twenty-four/seven," Banks says. On weekends, Banks would baby-sit
for Andrew Lauren and his new little brother, David, who was born in October
1971. Banks even took Andrew, who years later would become a film producer,
to his very first movie, *What's Up, Doc?* at Radio City Music Hall. Though Ricky
Lauren was a full-time mom, Ralph was often an absentee dad.

Banks made a study of the boss. "He has a movie in his head," Banks says. "A
vision, a new role to play. 'I want to be a cowboy. I want to be an English lord. I
want to be in the tropics, in Monte Carlo.' He got to be a part of it through
clothes, and, eventually, own it himself and go to all those places." But Banks
thought Ralph knew the difference between life and the movies. "Deep down he
was still a real person who loved a pizza and seeing the Knicks. He may have
dreamed of being a land baron and even gotten those homes, but he doesn't
want to live in their world because that would be false. He wants the accou-
trements, but he wants to be Ralph."

A few years later, when Banks briefly began dressing up like the designer
Halston in black T-shirts and black cashmere and Elsa Peretti accessories,
Lauren fiercely admonished him. "I was not being myself," Banks admits.

Salvatore Cesarani started moonlighting for Polo as a freelance design assistant
while working as Paul Stuart's design director, in charge of windows and dis-
plays. A graduate of the Fashion Institute of Technology (better known as FIT),
Cesarani had first met Ralph when the young tie salesman would beg him to put
Rivetz neckwear in the Paul Stuart windows. Then they started running into
each other shopping on weekends and talking on the phone during the week.
"He was a very unique kid," Cesarani says. "He had a dream, and he was going
to realize it."

Ralph called Cesarani for advice when he was trying to name his company.
Fox Run was briefly a favorite, Cesarani recalls, "but Polo, the sport of kings,
kept coming up." After Polo started, Cesarani would sympathize when Ralph
complained about stores that wouldn't use his label, stores that wouldn't support
his move into shirts. "He'd get so upset!" Cesarani also lent a hand whenever
Ralph needed help, finding rugs and chests for the Fifty-fifth Street office, and
creating displays for line openings.

Sal had started his career at a women's coat company; he knew how to
sketch, cut, drape, and sew—all essential talents that the untrained Ralph
Lauren lacked. Having tested the water with his foray into women's shirts,
Lauren decided to launch a full women's sportswear line and, needing those
skills, hired Cesarani away from Paul Stuart in late 1970. Sal began work on a

women's pilot program. The next spring, department stores like I. Magnin and Neiman Marcus took a look at the line and agreed to carry it. But they wouldn't be the only outlets. It was also going to be launched in the first free-standing Polo by Ralph Lauren store, a three-thousand-square-foot space in Beverly Hills.

The store was not being opened by Eric Ross, even though it had held the exclusive on Polo for Beverly Hills since 1967. Eric Ross was the hottest store in Beverly Hills, but its owner, Berny Schwartz, wouldn't buy the collection the way Ralph wanted it bought, or present it the way Ralph thought it should be shown. He'd committed the sin of being more interested in Eric Ross than in Polo.

On a visit to New York in spring 1971, Jerry Magnin, an Eric Ross competitor, had spent hours with Joe Barrato, begging for the chance to open an all-Polo boutique adjacent to his eponymous Rodeo Drive men's specialty store, which was another of the best stores in Beverly Hills. Magnin already owned an Yves Saint Laurent boutique and was one of the pioneers of designer-name retailing. The great-grandson of the founder of I. Magnin, he had a name, a retailing heritage, a track record. "For three hours, I denied him," recalls Barrato. It didn't matter that Barrato thought Magnin was a great merchant; Eric Ross had the exclusive. So Magnin went to Lauren. "What if I created a shop for you?" Magnin asked, pointing out that it would be the first-ever freestanding boutique for an American designer. Eric Ross and Berny Schwartz didn't stand a chance after that. Within a week, the deal was done, sealed with dinner at the elegant La Caravelle.

"The frightful thing was, no one had the nerve to tell Berny Schwartz," says Barrato. "He found out"—finally—"and challenged us about it." To no avail, of course. Magnin had given Ralph what he wanted—complete control. He'd even hired the store designer Ralph wanted, the manager Ralph wanted, a male model whose look Ralph liked, and the salesmen Ralph wanted, including Joel Horowitz, a college dropout whose father, Sidney, a Lowbeer family friend and experienced tie man, was Polo's production manager.

That September, Polo by Ralph Lauren opened on Rodeo Drive in Beverly Hills. Ralph brought an entourage to the opening, including Buffy Birrittella; Michael Farina, who illustrated the ads announcing the shop; tailor Leo Lozzi; and Joe Barrato. They all joined him when he inspected the store—nit-picking the design every step of the way. The store didn't do very well at first—Polo was still having problems getting goods delivered—but Jerry Magnin would remain in the Ralph Lauren business until 1998 when he sold the store, by then relocated in larger, more luxurious quarters, to Polo. Berny Schwartz would end up back in the fold, too. Now in his seventies, he's a salesman at the Polo store in Short Hills, New Jersey.

It was a good thing Ralph now had friends around him because along with his rapid, if not overnight, success had come his first enemies. Chief among them was Roland Meledandri. He and Ralph had found themselves increasingly at odds as Lauren emerged from anonymity. Ralph would still go by his store, but he'd take someone with him like the imposing Anthony Edgeworth. "Walk in in front of me," he'd tell Edgeworth, hoping Meledandri wouldn't see him.

Still, Meledandri and his wife, Risha, invited Ralph and Ricky to their apartment on Madison Avenue just before Ralph started his women's line. Ralph was awed by its Bauhaus feel, high ceilings, floor-to-ceiling walnut shutters, parquet floors, paintings, and Mies van der Rohe furniture. Meledandri was starting a women's line, too, "and we showed them all our designs, everything," Risha says. It was the most time they'd ever spent together.

Then, Ralph's first full women's line debuted in May 1972. "I did a fashion show," Ralph says. "I did menswear—tailored clothes—for women. Bloomingdale's loved it. They gave me a shop right next to Yves Saint Laurent. Shirts, blazers, tweed jackets, pleated pants, chinos, sportswear for women. For the times, that was totally brand new."

Roland Meledandri didn't think so—and would curse Ralph Lauren for the rest of his life. Ralph seemed to be moving in on him on all fronts—Meledandri had been the first designer line sold at Jerry Magnin's store. Now the upstart Lauren had gotten Magnin to give him the first freestanding designer store in the United States. And Magnin was stocking it with clothes that Meledandri felt looked suspiciously like his. The charge that Ralph Lauren didn't design—that he adapted and put his name on work created by others—started there, and has never gone away.

"He knocked off everything we'd done," declares Risha Meledandri. "Roland did shaped English suits and hacking jackets. He did linen Norfolk suits and weekender suits and fitted reefers. He didn't just put his name on things. He actually designed them. Ralph is not a designer, but he created an image and a marketing thing that's beyond compare."

And nothing was going to get in his way. Not his lack of training and experience. And certainly not the now-nearly-forgotten Berny Schwartz or Roland Meledandri.

35

obert Stock, born Robert Fegelstock, had been a teenage salesman at Alvin Murray, the Brooks Brothers of the Bronx, when he first met Ralph Lauren selling Zizanie cologne. In 1971, Stock was running a successful jeans line when Ralph called to offer him a job. Lauren's men's clothes had proved so popular they, too, were being knocked off at lower prices—and even though this was standard operating procedure in the garment business, and something of a compliment, Ralph was furious. He wanted to open a new division of Polo with its own name and identity to sell the sort of inexpensive clothes you find on the main floor of department stores—commodities like khaki pants—that work as a collection but can stand by themselves, sweaters in a sweater department, pants in a pants department, all in Ralph's style. And he wanted Stock to run it for him.

"I know nothing about running a company or anything other than picking swatches and designing nice trousers, but at the time I didn't think about that," Stock says. Ralph offered him 20 percent of the new company (at first he called it Rugby Enterprises, but somebody already owned that name, so the division was rekindled Chaps), a big salary, and enough money to hire a staff. Stock jumped at the chance.

Ralph rented another apartment at 40 West Fiftieth Street, just across the hall from Polo, for Chaps. But it was a distinction without a difference. There weren't that many good ideas in the traditional clothing lexicon, so when Stock came up with a new one, Ralph usually took it for Polo. "If we both had a herringbone pant, he'd say don't do it, even though our fabrics were not as nice," Stock says.

As with Banks and Cesarani, Stock's life became entwined with Ralph's. He baby-sat for sons Andrew and David, and took Ralph to see the Rolling Stones in 1972. In return for his devotion, Ralph bought Stock presents—like a sterling silver chain-link belt from Gucci—and took Stock to Jimmy Palazzo for custom-made suits. "He'd order six, I'd order one," says Stock, who nonetheless ended up with more. "Ralph would find something wrong with his. One shoulder was

always off and Ralph would give it to me. The jackets were a little short on me."

Stock, a good designer, is the first to admit he didn't really know how to run a company. Chaps bought too much fabric, made too much clothing, expanded out of pants, its strength, and ended up with unsold inventory, then had to close out too many goods—sell them to liquidators, which meant losing money instead of making it. So after a couple seasons, things were dire. Polo was growing and needed capital. None of its new lines were making money like the ties did, and Chaps was a serious drain on dwindling resources.

Sidney Horowitz, Ralph's production manager, had been running the business with the help of a bookkeeper. But Polo had outgrown him, and Ralph had realized he needed a controller. No one else knew things were getting tight; Ralph never revealed how thinly capitalized he was. "He was dead broke, and he was able to keep it from us," says Gil Truedsson. Raises were meager, but Ralph was generous with gifts, and if you flew with him, you went first class and stayed in the best hotels. Though he spent like a drunken sailor, Ralph, like many rich men, never carried money. Someone else always had to pay for his taxis, or the vacant limousines he loved flagging down. "Joe," he told Barrato when he did that, "I'll have [a limousine] of my own one day." Never mind that, for now, he was broke.

36

Michael Bernstein was a Bronx boy, one year younger than Ralph. He'd gone to J.H.S. 80 and DeWitt Clinton, and had played basketball with the Sparks in the same night leagues as the Comets. He and Ralph didn't get to know each other, though, until Ralph was just getting started in business. Bernstein was by then a partner in a certified public accounting firm, with a clientele that ranged over technology, real estate, and apparel, including firms that financed clothing companies like Polo.

In 1970, Ralph called Bernstein and presented him with a problem. Norman Hilton controlled Polo's finances; its books were kept by Hilton's accountants. Ralph wanted to buy out Hilton, and he figured his first step should be to hire an accountant of his own.

Intrigued by Polo's prospects, Bernstein met with Hilton and got the okay to take over accounting and auditing for Polo. For the next year, whenever they got together to go over the books, Ralph badgered Bernstein to join Polo—and help him get rid of Hilton altogether. Bernstein looked at Ralph as an instinctive entrepreneur and saw an opportunity, but he was an equity partner at his CPA firm and didn't want to give up his ownership position. Ralph saw an opportunity, too, and finally offered Bernstein an option to buy 10 percent of Polo. "Ralph is a very shrewd user of people," Bernstein says.

In July 1971, Bernstein became Polo's treasurer and chief financial officer. "I walk in the door the first day, and I get a call from the First National Bank of Boston," he says. First National of Boston was Polo's factor, and it was not only doing the standard factor job of advancing Polo money against its orders to finance ongoing production, but also extending what are called "overadvances," or unsecured loans, in order to build up Polo's inventories, assuming that those goods would eventually be sold, yielding cash to pay off the loans. To date, those unsecured loans totaled $300,000.

But First National of Boston was losing its faith, in large part because factors also keep track of "chargebacks"—returns of late, damaged, or even improperly ticketed clothing. When goods are returned, stores refuse to pay for them and loans remain unpaid. Polo—which couldn't deliver on time, and when it could, often delivered goods that didn't fit—was taking twice as many returns as the factor was comfortable with. First National wanted to discuss that with Polo's new CFO—and they wanted to do it fast.

The rest of Bernstein's first day was no better. "There is no money for payroll that week," he realized to his horror. "No money in the bank. Can't pay bills. The bookkeeper is holding a substantial amount of checks. The business is out of control."

Polo was selling to accounts that couldn't or wouldn't pay for goods; some bigger stores were double-dipping chargebacks, claiming them against Hilton *and* Polo; Hilton wasn't paying all the royalties it owed to Ralph; the growing creative team was spending money like water, and Chaps was underwater. "Basically what I try to bring is corporate discipline to an apparel environment that doesn't reward discipline," Bernstein says, "by saying what have you bought, why did you buy it, why did you think you could sell it, does it fit into a rational budget that a bank will buy into?"

Bernstein battered Buffy, Barrato, and Sid Horowitz with memos requesting businesslike projections, reviewing job responsibilities, asking about production and deliveries, and setting deadlines for responses. "Not that it's widget manu-facturing," he says, but "you couldn't be a laboratory." By insisting on manufac-

turing women's shirts that didn't fit and were returned (as they were, in large numbers, by stores that didn't have a fashion victim clientele like Bloomingdale's), Polo was digging itself into a hole so deep, it would never climb out. Even a switch of lenders to Bankers Trust—which gave Polo more credit based on Ralph's and Bernstein's promises ("Ralph was an excellent salesman," Bernstein says) and their personal loan guarantees—couldn't change that.

Bernstein had enough faith in Lauren to sign that loan guarantee, but he couldn't do much about Ralph's need for perfection, his indecisiveness, his penchant for last-minute tinkering. Like the time he went to his shirt factory and stopped production in midstream to make a collar longer. "You couldn't control it," Bernstein admits. "He was the business, and he still is today." It's not that Ralph didn't know—Bernstein carbon-copied every memo to him. *Ralph didn't want to know.* "I tried to bring a toughness and a financial discipline that nobody wanted to adhere to," Bernstein says.

Part of the problem was that, at the same time, Bernstein was telling employees like Stock that financially things were okay. "Everything wasn't okay," says Stock. "There was constant cash flow pressure from overexpansion" into "tons of categories. Ralph was striving all the time. Ralph never came out and said it, but you could see him driving to make Polo a household name. He made everyone crazy. More business, more business, more business. Whatever you could put a polo player on."

37

Ralph had just begun making the products that would turn Polo into a household name. He'd realized that certain iconic items of clothing—the tweed jacket, the chambray shirt, the Shetland sweater, the chino pant—were no longer made with care. He'd bought a Levi's denim shirt in the late fifties, but when he went back to get another, he discovered it wasn't made anymore. So he revived the style—adding the Polo logo.

Ralph and Gil Truedsson both claim credit for the idea that grew into Polo's most reliable and best-selling item, a commodity that still mints money and still fuels Lauren's business: the Polo knit shirt. For years, a company called Izod had

marketed a version of the piqué knit shirt worn by tennis champ René "the Crocodile" Lacoste in 1933. Through the sixties, the Lacoste shirt, adorned with a little crocodile (some thought it was an alligator) over the breast, had ruled the market as a casual status symbol. "I wanted to get a Lacoste shirt, and they had three colors in polyester cotton," Ralph says. Where were the colors, he wondered? The natural fibers? Where was the chic of yesteryear?

"It was *my* idea to go after Lacoste, to build a business within a business," says Truedsson, who went to work developing what he hoped would be the best knit shirt in the world. Like Ralph's Oxford-cloth shirt, modeled on the Brooks Brothers original, and his Shetland sweaters, modeled on the British originals, the new Polo shirt also featured the little embroidered polo player logo that first appeared on his women's shirts — usually in a carefully chosen contrasting color like turquoise on orange or blue on pale pink. In years to come, it would prove the key that would unlock Ralph's wildest dreams. "The fashion gets the press and excitement," observes Marvin Traub. "The way one makes money is to have, season after season, basic items in a great range of colors. That's what's at the core." What jeans and underwear would be for Calvin Klein, those shirts would be for Ralph Lauren.

But they weren't yet and by mid-1972, instead of seeing improvement with Polo's finances, Michael Bernstein was facing more money problems. Interest rates were sky-high, and Polo's delivery and fit problems hadn't improved. Louis of Boston, a men's specialty store, had just ordered five hundred sport coats that came in too small and had to be returned. And like Chaps, the new women's business was a drain on resources. "There was no business plan," says Jeffrey Banks. "It was all about what Ralph desired. You went into a business because that was what Ralph was besotted with that year."

Bernstein had yet to fulfill his primary objective — getting rid of Norman Hilton. That was Ralph's obsession. "He didn't think he needed us as partners," says Peter Strom. The negotiation finally began at a meeting with Ralph. "He said he wanted to buy me out," says Hilton, who didn't want to sell. "I was in it for the long haul. He said, 'It's torture being partners with somebody you don't want.' First he took his clothes out of the factory, now this. I was crestfallen."

Once Ralph delivered that blow to his backer, Bernstein took over and asked Hilton how much money he wanted for his Polo stock. "Long, bitter arguments" ensued, Hilton says. There wasn't much to base a price on. Hilton's original loan had long since been repaid. "It was a great investment," says Strom. "For a thousand dollars he owned half the company."

Hilton seemed to have Ralph over a barrel. But then, Hilton says, "I remember thinking to myself, his office is under his hat. If I get too tough, he'll walk

out. So I was at a disadvantage." Hilton started out asking $900,000 but soon came down to $750,000. He thought Ralph was "a very, very greedy person," but acknowledges, "all businessmen are greedy, and he was a tough, smart, sharp businessman." Ralph finally paid $633,000, with $150,000 down and the rest to follow in $100,000 annual payments, plus interest on the outstanding balance. He paid by certified check. "I remember putting it in my pocket and showing it to a friend on the train home," Hilton says. "I said, 'Look at what I just got.'"

Hilton came away with hard feelings about Lauren, but he still admits, "He was an absolute gentleman. I never thought I'd ever get the rest of the money, but I got every goddamn cent of it." With the proceeds, Hilton bought a house in Sea Island, Georgia, where he later retired. He joked about naming it the Polo Grounds and tries to be gracious when friends find out how he got it—and tell him that based on Ralph's Polo knit shirts alone, it should be a lot bigger.

Be careful what you wish for, the saying goes. Buying out Hilton "was the best deal Ralph ever did," says Michael Bernstein, "but he did not understand that doing it would make the company very tight." Especially given that Polo's "contractors would ship late," Bernstein says, "the merchandise was ill-fitting and of bad quality," and it was being returned, leading to chargebacks. And Ralph wasn't helping. He insisted on selling stores that were good for his image but bad for his bank balance; he was owed more than half a million dollars he would likely never see. So Bankers Trust refused to lend Ralph the $150,000 he needed for the down payment to Hilton; the bank had already paid out $135,000 to cover bad checks for Polo.

Polo couldn't have even paid its contractors or its withholding taxes had Bernstein not pulled a new factor out of his hat in January 1973. John P. Maguire, Inc., a company devoted to factoring, bought the outstanding debt owed Bankers Trust, and took over as Lauren's lender despite all the risk that entailed, after Bernstein worked out projections with Ralph and the production and sales staffs that, on paper at least, seemed plausible. Polo's suppliers continued to sell fabrics and other raw materials the company based on those numbers.

But quickly, Maguire's account executive, Dave Goldberg, came to suspect that the financial statement "wasn't a valid picture of the financial condition of the company," he says. "They showed a sizable net worth but no cash." The day Maguire took over Polo's debt, "Bankers Trust threw a party," Goldberg continues. "That's how bad they thought the loan was. Polo couldn't meet its obligations." And the value of its assets was dubious at best. Polo's inventory was out of fashion—nearly worthless.

Goldberg didn't like the Hilton buyout either. "It would have been against my religion," he says, "using all that precious cash to pay out a shareholder." But

Goldberg and Maguire were willing to bet that some further overadvances at the start of 1973 would begin paying off when the fall goods they financed hit stores nine months later.

It wasn't a sucker's bet. Out in the world, Polo was seen as a hot new label. *Men's Wear* magazine had just put Ralph and Ricky on its cover. And Ralph certainly acted like a success; he was just as critical of the press as he was with his tailors. *Men's Wear*'s editor Mort Gordon worried that Ricky Lauren looked like Daisy Mae, the *L'il Abner* cartoon character, in the cover photo, but trusted his art director to fix it. But when the magazine came out Ralph "was livid," says the editor, "screaming, furious. 'What did you do to her?' "

Sadly, good press didn't stop the returns from coming in, and soon, Polo stopped paying its bills again. "I should have suspected something," says Joe Barrato, but Ralph was still spending money. He bought another car. And when Ricky got pregnant again (their last child, a daughter they named Dylan, would be born in May 1974), they moved into a three-bedroom apartment. When Ralph took a weekend trip to Philadelphia, he bought a suite of expensive Gucci luggage, just for appearance's sake. "There were no indications of problems with the business," says Barrato, "only delivery problems."

One thing led to another. When a factory Polo owed money to refused to release any more goods until Polo paid for them, Bernstein and Polo's lawyer thought a solution might be found in a private debt placement. But the investment bank they approached, Drexel Burnham Lambert, said no, the company was still too tenuous for that. Then Ralph asked Bernstein for $108,000 — the percentage of net sales that the company owed him under his contract. Bernstein insisted the money stay on Polo's books, and a special board meeting was called, at which Ralph was told bluntly that he couldn't take the money.

A few days later, J. P. Maguire made further financing contingent on Polo's meeting five demands. Ralph had to turn over his personal passbook savings account, which held $80,000, as collateral. He had to renegotiate some of his outstanding debts, so any new money Maguire put in wouldn't be used "to finance old sins," says Goldberg. Ralph also had to renegotiate the terms of his buyout with Norman Hilton, and license out both Chaps and his fledgling women's wear division (i.e., rent his name to others, who would produce and market those products and pay Lauren a royalty on net sales).

Finally, Goldberg told Ralph to ask for prepayments from big accounts like Bloomingdale's, because their orders for Polo goods were growing so large they would require huge seasonal overadvances that were too risky under the circumstances. If Polo collapsed from the burden of its sudden growth spurt, Maguire didn't want to be left holding the bag. "It was a very risky loan, and we

knew it," says Goldberg. "Ralph, in certain respects, was a fuckup. Michael Bernstein's role was to cover for Ralph."

Goldberg had lost confidence. But still, he wouldn't give up. "Ralph wasn't a technical designer," he says. "He was a stylist with a taste level, and he knew how to build a brand, and brands were just coming into their own as things department stores could hang their hats on. We talked to people in the stores. We did our homework. I sold Maguire's management on my belief that if stores were sold on the brand, we could help Ralph correct what was wrong with the business. He was not equipped to wrestle with these issues, and it would have been a tremendous waste of his talents."

Factors often did field examinations of clients' books. Now, Goldberg moved into Polo after hours. He didn't like what he found. Goldberg wondered if the books were cooked. "My belief is that Ralph wasn't smart enough to do that." Never a math student, "Ralph was at sea with financial information." Goldberg felt sure that Bernstein's motives were good: "His mission was to keep Polo alive." But no matter how you looked at it, Polo was near death. Had a big creditor demanded repayment, it would have spelled bankruptcy.

Goldberg showed Lauren a new financial statement he'd drawn up. Despite sales increases, the company had no cash, and debts of more than half a million dollars.

"That's not possible," Ralph replied. "I don't believe it. Michael wouldn't have done this to me." Goldberg suggested Ralph hire a third party to decide who was telling him the truth.*

"I remember the look on his face," Goldberg says. "I told him how close he was to losing everything—including his personal assets. It was like telling him he had cancer. He went pale. He was like a deer in the headlights."

* Bernstein refutes Goldberg's recollection of these events. "Whatever [numbers] he had was given to him by me," Bernstein says. "He got all the bad. In fact, I hired a guy who did nothing but work with the factor."

38

His dream going up in smoke, Ralph went to Michael Bernstein and demanded to know how this had happened. Unhappy with the answers he got, he realized he'd have to fix things himself. "That was the moment," he said. "It wasn't bankruptcy, but it was scary. I had to reorganize the company. I was living in the middle of a panic and I was in pain. But somehow I felt I wasn't going out of business and that it was going to be all right."

Ralph turned to his eldest brother. Lenny Lifshitz had been working for his wife's father, running a division of a company that manufactured watch crystals and jewelry boxes and displays. Lenny was the family's big success at that point. Ralph told him things had gone wrong, very wrong; he didn't understand what was happening, and he was so worried, he'd developed a bleeding ulcer. "Come help me," he begged. Lenny not only agreed, and became Polo's corporate vice president, he even—finally—changed his name to Lauren.

Lenny knew how to hondle. "I told contractors the truth. I said we'll pay in thirty days, sixty days, bear with us; and every one went along. I was like a fireman."

But Dave Goldberg was unhappy about Lenny's appearance on the scene. "In my view, this was getting too big to be the Original Amateur Hour," he says. "Ralph brought in Lenny to have someone he trusted instead of someone competent. You start with competence."

Bernstein professes not to have noticed or cared about Lenny's arrival. "Nice guy," he says, "very nice. Had nothing to do with me." Bernstein still believed in Ralph, and in Polo, and believes to this day that he helped Polo survive the early seventies. And as far as he was concerned, Ralph agreed. Early in April, they'd signed a new two-year employment contract, and a new stock option agreement that contained one small change. In the event he was fired, it said, he would have to sell Polo his stock. Ten days later, Lauren handed over the shares at a 70 percent discount off the share price he'd had to pay Hilton.

But just then, Bernstein found he was no longer being invited to important

meetings about Polo's finances. He'd be the first, but hardly the last who would suddenly and brutally fall out of favor. "The hotter it is, the faster it's over," says one favorite-gone-sour. Sometimes the darling of the moment would be a yes-man. Sometimes, they'd be inspirations—people whose looks or style Lauren liked. Sometimes, they'd remain in the company. Sometimes they'd be gone the next day. Often, they'd be like Bernstein, who thought he knew better than Ralph.

In later years, employees would equate Lauren with cult leader Jim Jones, who induced his followers to kill themselves by drinking poisoned Kool-Aid. "Ralph mixed a helluva Kool-Aid cocktail," one retailer jokes. Though he believed as much as anyone, Bernstein didn't drink the Kool-Aid. "That was the problem," Bernstein says. "I fired people that did and Ralph rehired them. Ralph was drinking the Kool-Aid, too."

But Ralph was listening to new people now. Lots of them. Steve Bell had married the daughter of a banker and sent Ralph to his father-in-law for advice. The banker told him to declare bankruptcy and start all over. Not what Ralph wanted to hear. Dave Goldberg sent him to see Arnold Cohen, an accountant who'd run the financial side of a huge garment company and was known for his integrity and acumen. "And if anybody needed that, it was Ralph," Goldberg says.

After Cohen took a look at Polo's books, and explained what he'd found, Ralph fired Bernstein. "I don't know what was in his mind," Bernstein says today, because Lauren offered no explanation. "You're fired," was all he said.

A few weeks later, in August 1973, Michael Bernstein sued Polo and Ralph, claiming that he'd been fired without cause, that Lauren took excessive compensation and expense reimbursements out of the company, that he'd failed to supervise his business, failed to research the potential of licenses before signing them, hired incompetents, and sold to stores that had bad credit. As a result, Bernstein said, he'd been denied more than $100,000 in salary, denied his stock in the company, and feared he might still be liable for his personal loan guarantees to the factor. He wanted indemnification for those guarantees, his salary, and $1.2 million for the return of his (at that point quite possibly worthless) stock. In a subsequent amended complaint, he also claimed that Ralph feathered his own nest with Polo money—using it to decorate his apartment—put his father and his maid on the payroll, and used corporate funds for personal gifts and trips. Back came a countercomplaint alleging that Bernstein had used Polo money to buy a car and pay premiums on his life insurance policies. The case would eventually be settled with a payment to Bernstein of $175,000.

Lauren doesn't downplay his near-miss with bankruptcy. "I just grew too fast

and was doing too many things at once and my cash flow was tight, and it was
bad planning, bad organization, and there was a period when a recession hit," he
says. "My business was great in stores but financially, it was tight." He blames
Bernstein for failing to supervise properly the wild expansion that preceded the
crisis. "We did too many things all at once," Ralph says. "He was in charge of it.
He had the financial role and I trusted him. I'd say, 'Can I do this?' He'd say,
'Yeah.' He was over his head and he didn't tell me."

Today, Bernstein is a managing partner of a consulting and CPA firm. At the
close of an interview in the firm's offices, just across the street from
Bloomingdale's, Bernstein refuses to address the question of why he was fired, or
talk about the settled lawsuit, or offer a personal appraisal of the man who was his
partner for two years. Instead, he points to a photocopy of an item from Page Six,
New York's best-read gossip column, that refers to him as a scapegoat. "I think
that's important to read," he says. "I have no ill feelings. I respect what he's done."

"I bet you wish you had that ten percent of Polo," I joke.

"There's no doubt about it," he replies, unsmiling.

39

Jerry Lauren joined Polo as vice president of design, a new post, just after
Michael Bernstein was fired. Ralph's middle brother had most recently been
design director at Rob Roy, a boy's clothing brand, for four and a half years.
Though he and Ralph talked a couple times a day, Jerry had kept his dis-
tance from both the brother and the company he'd named. "We couldn't be
together at the beginning because we were so close," Jerry says. "Then Ralph
reached a moment where he felt, it's time. He got somewhat burned. Typical
Ralph, he learned a lesson; he got stronger. He was looking for solid people who
he felt he could trust, who had similar sensibilities."

Initially, Jerry's primary responsibility would be Chaps. Stock had resigned.
Ralph had stopped paying the percentage Stock was owed and finally admitted
he couldn't afford their deal anymore—and was going to license out the Chaps
name. He asked Stock to forget about his cut and become an employee. "I said
I preferred the money," says Stock, who got his cash and remains an admirer.

"He always walked a straight line; he never veered. He had tremendous vision and always stuck to it, right from when we met. It was obvious he was very good. He could zero in on a look on the street immediately. He looked good dressed up; he looked good dressed down, unshaven, in ripped fatigues, a bare-threaded leather jacket and worn boots. He was a student and professor of cloth, a great fashion package."

Sure that Jerry Lauren would soon steal his job, Gil Truedsson found a new one and quit. Ralph had his usual reaction. "He felt I was deserting the ship," Truedsson says. "I wasn't articulate enough to tell him what I saw insofar as the goals of one brother and the incompetence of the other—Lenny was sweet, a slap-on-the-back well-meaning guy, but he was a square peg in a round hole."

Sal Cesarani was the next to go. When he wasn't running to the several factories that now made Polo's goods, Sal had worked at a folding table in a hallway, and stored his things on a shelf in Buffy Birrittella's office. Buffy had gotten between Ralph and Sal. "She was his eyes, ears, and mouth," Cesarani says. "There was always a sort of tension."

"Ralph's not going to like that," she'd tell him. But Ralph often did. "We had great rapport," says Cesarani. "I really loved him. If he said jump to the Moon, I would. He'd make me crazy, but he was right." Cesarani was good, too. His women's designs reflected well on Ralph.

Ralph was good to Sal in return. On April 30, 1973, Ralph bought tickets to the Film Society of Lincoln Center's gala tribute to Fred Astaire at Philharmonic Hall for himself, Banks, and Cesarani. Together, they watched a two-and-a-half-hour film of Astaire's thirty favorite dance numbers. And afterward, at Ralph's urging, they crashed the champagne reception for Ralph's idol. As Count Basie and his Orchestra played, Ralph wormed his way into a handshake and photo with Astaire, while his assistants hovered nearby.

Cesarani had watched as Lauren expanded his design vocabulary from ties to suits to casual clothes for both sexes. They'd drive around in his Mercedes on Saturdays and talk fashion. "He always thought of the wealthy and the kind of clothing they wore when they took time away from Wall Street," Sal says. "The WASPy goyim guy he designed for went to a ranch. Those were things to which Ralph aspired. He looked at pictures of the Vanderbilts; he loved houses on Fifth Avenue."

Not long before, Ralph had talked about his ideal female customer with *Women's Wear Daily*. She was, he said, "the kind of woman who could afford to go to Europe several times a year and whose families kept horses and owned houses with lots of grounds around them. . . . They wore cashmeres, camel's hair and suede and leather." And their skin never touched an unnatural fiber. Ralph

had absorbed his personal ambition into his business to create the image of the Polo person and allow him to become that image, too.

Ralph always wanted more, though. More money, more products, more attention. "It was too much," says Cesarani. "He demanded so much. He is all-encompassing. I was being controlled. I needed peace and to do one thing and do it well and do it for me." After Ralph won a second Coty Award for men's fashion in 1973, and had a grand party afterwards at a private club on Gramercy Park, word went around that Sal Cesarani had a lot to do with it. But Cesarani didn't want the credit. "He designed it all," Cesarani says. "He may not have sketched, but he knew exactly what he wanted."

Regardless, the phone started ringing, and soon, Sal was offered a new job, at $40,000 a year; Ralph was paying him only $25,000. "I said yes and I went to tell Ralph." Lauren was getting into a limousine in front of the office at the time and asked Sal to join him. Ralph didn't like what he heard. He browbeat his young designer, cajoled, threatened.

"You can leave at the end of the day, and I can't," Cesarani complained.

"You can't do this," Ralph said. "You just can't."

But he could, and he did. "I could breathe," Cesarani says. "I was released."

Years later, Cesarani still seems wounded by his Polo experience. "I've carried a huge cross," he says. "Everyone felt, Sal's doing Ralph, but it was really Ralph." He doesn't say it outright, but it's clear that Lauren came to resent him for that. "I don't have hang-ups about it," Cesarani says. "It's okay, it's okay, it's okay, it's okay. It really is. Ralph has acquired enormous wealth because he has controlled every aspect of it. Competition is everywhere. He doesn't want to see anyone else succeed more than him. Of course, you sacrifice something. You can't allow people in your way. You have to be better than them. I was such minor competition, but that's the psyche. He constantly needs to win."

Jeffrey Banks left that fall, too, and he, too, was wounded by the experience. "It was like a son sticking a dagger into his father," Banks says. "I couldn't make him understand it had to do with school, not him." Banks had transferred to Parsons, a different fashion college, and found he couldn't wear two hats anymore. School and work both suffered. Finally, after losing thirty-five pounds, he quit. "Ralph yelled," he recalls. "I started to cry."

Banks had hoped Ralph would hold his job open for a year and give it back to him. Ralph said the only valid reason to continue his studies was to get a glorious job—and he already had one. Then, Ralph stuck his finger in Banks's face, and the design assistant knew it was over. "He did that, he pointed at you," Banks says, the memory still painful. "I was being cast out."

On Banks's last day at Polo, Lauren was nowhere to be found. "It was true to form," Banks says. "He did not take leave-taking well. We were a family. You were leaving the family. It was difficult for him to understand that we did have lives outside of Polo. In every other company, it's a job and then you go home and have a life. For Ralph, it's all his job. You were never shocked to get a phone call in the middle of the night from Ralph, talking about a shade of blue. His narrow vision made him a success, but it doesn't make for the best understanding of other's people's situations. It's a little sad."

Gil Truedsson last saw Ralph Lauren on the day in 1978 when Jeffrey Banks debuted his own name brand at his first men's fashion show. Truedsson and Dave Pensky, the co-owner of Britches of Georgetown, went with Ralph in his Bentley. "I was stunned," says Truedsson; Lauren had been cool to him ever since he'd left Polo. "Out of nowhere, he said 'Dave, Gil was really and truly Polo.' It was the greatest compliment he could give me." Then the car stopped, and Ralph became his old competitive self again. "I'm sure I'm gonna see myself," he said of Banks. Years later, Truedsson called Lauren. "He wouldn't take my calls," Truedsson says. "He didn't respond to notes. But it wasn't just him. I don't have a lot of time for the industry."

Jeffrey Banks's last encounter with his professional father was both similar and even more disturbing. In the mid-nineties, a designer named John Varvatos, who'd once assisted Banks, was working under Jerry Lauren; his burden was so heavy, he was in the office from five A.M. until midnight, so he asked Banks to return to help him.

Banks was willing to work as a consultant, but he wanted to keep his own small business. After nine months of talking, Banks was told to see Ralph, but the meeting kept being postponed. Finally, an eleven A.M. appointment was confirmed, Banks put on a pin-striped suit, arrived at the scheduled hour—and was left cooling his heels in Ralph's waiting room. "I later heard Ralph never starts his day before eleven-thirty," Banks says.

Lauren finally arrived, wearing fatigue pants, a green T-shirt, dog tags, and a baseball cap. "You've met my son?" he asked as he took Banks on a tour of the office. Finally, back in his office, Lauren said, "So what do you like about what I do?" And they proceeded to talk about all of Lauren's lines. At the end of the chat, Lauren told him to see his brother the next day and work out a salary; he'd start the following Monday. The next day, Banks met with Jerry, who told him, "The money you asked for, we don't pay anybody that much. We just can't. It's not going to work. "

Back at his office, Banks spent several days composing a letter to Ralph. He

signed it, "Your son," and had it hand-delivered. There was no response until five weeks later, when they met at a board meeting of a fashion trade group. "It was cold shoulder in a strapless dress with the refrigerator door open," Banks says. As they left the meeting, though, Lauren turned and asked, "What happened? Why didn't I hear from you?" He said he'd never gotten Banks's letter. Banks called the Polo mailroom the next day, confirmed that his original letter had gone to Lauren's office, and then sent another copy. "I never heard another word," he says.

The last of the first Polo employees, Joe Barrato didn't quit; he was shoved aside. Jerry wanted Joe to stick to sales and stay out of design. Barrato had already felt slighted when Bob Stock was given a piece of the Chaps business. "I was resentful," says Barrato. "I felt I'd lost my soul brother. It was a deep pain for me." Ralph's first reaction when Barrato quit was to ask him if he intended to become a competitor. "I still believe he resents the fact that I left him," Barrato says.

When Barrato's next venture, in retail, failed, he came back to work for Chaps, which by then had been licensed to the conglomerate that also made Polo's men's suits. Barrato was paid by the licensee but worked for Ralph and Jerry, a relationship that would be repeated with many members of Ralph's design staff over the years. The problems Barrato had would be repeated, too. The licensee "had rules, deadlines, timing issues," Barrato says. "Ralph was very particular, and he couldn't make decisions." Barrato quit after a year.

Before he left, he saw Ralph being very tough on his older brother Jerry. He would be tough on Lenny, too, now that the brothers' roles were reversed. It all reminded Barrato of the time he brought his two sons to the office, one with a beautiful face, the other more rugged than good-looking. Ralph pointed to the less attractive child. "Watch that one," he advised Barrato. "The other one will overwhelm him."

Of his inner circle, only Buffy Birrittella survived the mid-seventies. Her devotion to Ralph was boundless. No one would overwhelm him when she was around. "She was always there," Stock marvels. "She did everything. She was like a protective agency, his buffer, Buffy the buffer, with that WASPy name and that reckless WASPy look about her."

40

n mid-1973, Ralph began meeting J. P. Maguire's demands to straighten out his finances, turning over his savings passbook, renegotiating deals, and licensing lines, but he couldn't get the advance payments Maguire had also demanded he arrange without a lot of help from his friends. Bloomingdale's had been giving Ralph special treatment all along; he was *their* designer, after all. And they were using him as much as he was using them. "We built our reputation on a WASP image," says Jack Schultz, the Bloomingdale's executive. Macy's sold brands. Saks sold fast fashion. Bloomingdale's aped Brooks Brothers, but added color and pizzazz. "Ralph did it for us. We built the business together." So when Ralph bought too much fabric, the store would buy it from him and make private label clothes with it; it was good business for all concerned.

But on a dark, rainy day that June, the morning after his second Coty was announced, Ralph had to run home to change out of jeans and into a suit, because he was going to lunch with Marvin Traub to ask for something unprecedented, something unlikely even for Bloomingdale's pet designer: an advance payment for goods the store had ordered for fall. Without that, he wouldn't be able to buy piece goods to produce them—or make his payroll. Jeffrey Banks knew what was wrong; that morning, Bernstein had told him they'd run out of money. When Ralph asked Banks to join him in a cab, he assumed he was about to get fired. "But all he talked about was the Coty," says Banks. "'I want you to do clothing for the awards show [that fall]. I want you to come up with a concept.' How could he be thinking months in the future? It was either courage or idiocy." Banks suggested they do black and white clothes in thirties style. "Great," Ralph said. "Do it."

"Then he changes his clothes, and I drop him off at Bloomingdale's," says Banks. A few hours later, Ralph was back on Fifty-fifth Street all smiles. On hearing Lauren's lament, Traub had gone immediately to his boss, the store's CFO, who agreed to the unprecedented arrangement and cut Polo a check. "It's the only time I can remember that I ever did that," Traub says. "Merchants do that. Financial people do not."

Bloomingdale's was not alone. The late Stanley Marcus was a great merchant, too. When Ralph flew to Texas to get a Neiman Marcus Award around that same time, Neal Fox made sure Ralph sat down with the store's owner and Neiman Marcus agreed to make advance payments, too. So did Britches of Georgetown. "We felt we had a partnership, not a vendor relationship," says co-owner Dave Pensky. "We really kept him afloat."

Simultaneously, Goldberg renegotiated the deal Michael Bernstein had made for the Hilton buyout. Ralph still owed Hilton a quarter of the price he'd agreed to pay for his Polo shares. Maguire argued that Hilton should accept less, if it was paid sooner. "Hilton knew what was happening" and agreed to the deal, says Goldberg, whose bosses wondered why he was trying so hard to save Polo. "It was probably a mistake," Goldberg says, "but I was young enough and stupid enough to be confident." He also turned out to be right. Polo's sales that fall "turned out terrific," he says.

"Ralph was special in spite of himself," says Gil Truedsson. "He was bankrupt, yet he had such great taste, people kept letting him go on."

The stage was set for the last piece of the Polo puzzle—professional management—to fall into place. In September 1973, Ralph hired Harvey Hellman, who'd been the treasurer and chief financial officer of a big jeans company, to replace Michael Bernstein. "Mess was not even the word" for what he found when he arrived, Hellman says. "He had a negative equity of about $3 million. He had no money, he can't deal with stores, he can't deal with fabric houses. It's impossible."

Hellman hired Arnold Cohen as Polo's new accountant soon after he started work in Polo's back office, located in a loft in an industrial district light-years away from Ralph's relatively chic Fifty-fifth Street offices. Hellman was shocked to find people working in hallways filled with boxes of clothes, shipping clerks working beneath cutting tables—"people just scrambling all over each other and no structure whatsoever," he says. "There were no financial statements, nobody knew what the loan balances were. It was a candy store, the desk drawers were filled with chargebacks and disputes and piles of paper." Then, in an eerie echo of Michael Bernstein's first days at Polo, Dave Goldberg's boss at John P. Maguire gave Hellman sixty days' notice; he'd decided to cut off Polo's funding in spite of its recent turnaround. Its business plan entailed far more risk than Maguire was willing to bear.

Suddenly, Ralph's deal with Norman Hilton was in doubt—the last payment hadn't been made yet, and the possibility existed that Hilton could seek to take over Polo—and even oust Lauren. So Ralph, Hellman, and Cohen had to visit

Hilton again and ask for a moratorium while they worked out Polo's financing. "Norman was tough," says Hellman. "It was a 'He's Ralph Lauren, he just won a Coty, who's he kidding?' kind of thing. Ralph had to beg. He walked out of there with his tail between his legs thinking there was no way there was gonna be a deal and Norman Hilton was going to take over his name." Finally, after more meetings, Hilton gave them a one-year reprieve; Hellman found yet another factor to take them on, made a license deal for Chaps, and went to work on another license, this one for Ralph's troubled women's line.

Ralph was almost out of the woods. Says Buffy Birrittella, "It was a rite of passage. He realized how fragile and ephemeral this business is, and he's never closed his eyes to anything from that point on."

41

Oddly, Polo Ralph Lauren was about to become a hot property beyond the insular world of fashion. In March 1973, just after showing his latest men's collection, Ralph had eagerly announced his first film commission, to "design" men's clothes for a new movie version of F. Scott Fitzgerald's novel, *The Great Gatsby*. The job began in controversy—a spokesman for Paramount promptly denied that a deal had been done. It would end in controversy, too—and engender ill feelings that have lasted thirty years.

Sal Cesarani had set the commission in motion before quitting. He'd met costume designer Theoni V. Aldredge when she was dressing Sam Waterston in the play *Much Ado About Nothing*. While shopping at Bloomingdale's, Aldredge saw some Polo clothes she liked and Cesarani arranged for her to get them. When he heard that her next job would be *Gatsby*, he wrote her a note and invited her up to see more.

"We presented ideas, concepts, fabrics, colors, directions," says Gil Truedsson, and Aldredge loved everything she saw; she asked that certain items be remade to her specifications. "Her ideas were only a small part of what was going on there," says Truedsson, but she chose fabrics according to the script, and Lauren got so excited by her choices that he incorporated some of the

wardrobe items into his next line. He was also excited by the fact that he'd been chosen, and started telling the world. Jay Gatsby was right up his alley, "a self-made man, and he was all about looking glamorous and wealthy and mysterious," Ralph says. The fashion press, always eager to boost its new star subjects, designers, quickly hopped on the bandwagon. But Ralph had made an error that would haunt him.

Credit is the coin of the realm of Hollywood, and under Hollywood rules, Aldredge was the costume *designer*—Lauren was merely executing the men's clothes she designed. The distinction was crucial. Aldredge explained it to him in one of their early meetings, when he asked her if he could win an Oscar. But Ralph ignored her—and still does, continuing to take the position that he designed the men's clothes. Twenty-eight years later, his website would say that he clothed the *Gatsby* cast in his then-current line.

Ralph was happy to escape to the Fantasyland of Hollywood on April 15, 1973, for fittings with the film's Gatsby, Robert Redford, then at the peak of his career. Lauren would tell anyone who asked that he saw the *Gatsby* job as a peak in his career as well. "I've always designed things with the look of old money," he told *Men's Wear* magazine, explaining that the film was a validation of his design sensibility. As the movie inched toward its 1974 release, Lauren rode the publicity it generated. He wasn't going to miss his chance to hitch his wagon to a Hollywood star vehicle. Indeed, he got more out of it than did the movie, which never lived up to its blockbuster hype. And Theoni Aldredge ended up "upset to say the least," says Sal Cesarani. "Infuriated."

"Manufacturers want to be involved for publicity, and we get [the clothes] for nothing," Aldredge says, explaining how such deals get made. She admits she liked Lauren's taste in fabrics and picked out some shirts and ties for the cast. She also let Ralph make a couple of suits for Robert Redford. But Redford also wore evening clothes, bathrobes, and bathing suits made by others. "I was there at five A.M.," Aldredge says, "making sure everything was right, outfitting the atmosphere people. I did ballroom scenes with sixty men, cooks, gardeners. And where was Ralph Lauren when Mr. Redford said, 'I don't want to wear that shirt'?

"I wouldn't have minded if Ralph Lauren said he manufactured some clothes. I minded that he said he designed the men's clothing. He thought he should have won an Academy Award for loaning me a dozen shirts!"

Just before *Gatsby* opened, Aldredge called the studio and demanded they take Lauren's men's wardrobe credit off the picture if he kept grabbing her limelight. Studio executives talked her out of it. She said she'd sue. They talked her

out of that, too. But she got her revenge when she won the only Oscar The Great Gatsby garnered, thanking her director and producer, but pointedly not Ralph Lauren.

"I was angry," Aldredge says, laughing. And now? "He has six houses, twenty-two cars, and a partridge in a pear tree. And we are all very happy for him."

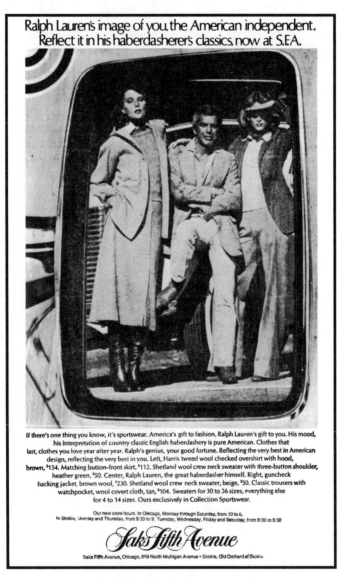

Lauren's advertising debut, 1975. *(Courtesy of Saks Fifth Avenue)*

Incaution:
From Bust to Boom

I'm tough. I built this thing. I'm tough. You know, I'm not weak. I'm tough.

—Ralph Lauren

42

S tuart Kreisler was just like Ralph, a kid from the outer boroughs of New York City who'd made it young in Manhattan's *schmatta* business. Kreisler was as audacious a dress salesman as Ralph was a tie designer. They'd met after Kreisler bought himself one of Ralph's first ties, loved it, and sought an introduction to the designer.

Kreisler had rag-trade roots; his father was a dress salesman from Sheepshead Bay, Brooklyn. In high school, Stuart started selling at a textile company and then enrolled at FIT, the fashion college. A year later, Kreisler joined his father at a dress house called Rembrandt Frocks. Sent to *Vogue* magazine one day to deliver some dresses, he bumped into Hubert de Givenchy, the imposing French couturier — "the most handsome man I ever saw," Kreisler says, "and that was my first introduction to the designer business."

Stuart moved to a bigger dress company, where he became the head of a division. The chubby, boyish salesman lied about his age — he was only twenty — not to get the job, but to get more money. "They didn't want to pay you," he says, "so I made myself five years older." When he hit thirty-five, he stayed that age for five years and then began admitting the truth.

Kreisler's next job was as a sales manager for a designer, Oscar de la Renta, whose business partner, a garment center legend named Ben Shaw, was a pioneer of American designer clothing. Shaw hired Kreisler to sell a new, lower-priced de la Renta line.

Kreisler bristles when told he's been described as a pinky-ringed *garmento*. "I never wore a pinky ring," he huffs. "Neither a star sapphire, or a family crest." He saw himself as a Young Turk on Seventh Avenue and expected to be made a partner in de la Renta's company, along with the designer and Shaw, but when the company was sold, "I saw all of that go out the window," he says. In its place came a thought. De la Renta made $3 million in sales a year, but the company had sold for $6 million. "There was something going on here," Kreisler says.

Lacking capital to back a designer himself, he decided to mimic the sports agent Mark McCormack, who'd begun building an empire by selling the names

of his clients, champion golfers, to product manufacturers. Kreisler opened a company to guide fashion designers to licensing deals. Working with them, and with the artist Peter Max, who put his psychedelic paintings on fake furs and belts, Kreisler made a name for himself but not a lot of money. Soon, he was back in the deal market, where he met a young venture capitalist, Louis F. "Bo" Polk, who offered to put him into business as a manufacturer himself.

Bo Polk, a wealthy midwesterner, had worked as a top executive at General Mills in Minneapolis and as the CEO of Metro-Goldwyn-Mayer before he became an investor in toy, game, and limousine companies and a man about town, living in a sprawling apartment in one of Manhattan's most prestigious buildings, River House. It had an eighty-foot drawing room and a hot tub built for ten. Henry Kissinger lived across the hall. The former secretary of state once threatened to fire a bodyguard who prevented the model Cheryl Tiegs from mischievously ringing Kissinger's doorbell when she left a Polk party at four A.M.

Polk agreed to back a new company, the Kreisler Group, in manufacturing clothes by a stable of designers. For every three designers who went into business, one succeeded. Kreisler spread his bet and backed three, figuring the odds were that one would make it. He offered to pay royalties and all the expenses for their design studios and to handle their sales and marketing, and he made factory owners partners instead of subcontractors, so they'd finance their own production for a piece of the profits. Polk, who put up $67,000, owned half the business until his financial adviser, a Princeton-educated, former MGM finance officer, Alan Ginsberg, joined Kreisler Group, too, and was given a piece of the action.*

"I was in the middle controlling everything," Kreisler boasts.

He signed designers Clovis Ruffin and John Kloss and moved into the most prestigious office building on Seventh Avenue, No. 550. But he was still on the lookout for a star designer. He'd stayed in touch with Ralph, worn his earliest suits, and though he turned down Ralph's offer to partner in the Lauren women's line, he'd advised Ralph throughout its brief life.

Lauren wanted to be a one-man brand controlling every product that bore his name. "I introduced him to the concept of licensing," Kreisler claims. Licensing was free money combined with brand-building on other people's money: Ralph would get paid for designing certain types of clothes and products for specific geographic areas. The licensees would do—and pay for—everything else; he'd have approval of everything and collect royalties on sales. But Ralph

* When Kreisler signed his license with Polo, Polk hoped to get free suits and was disappointed to learn that Polo still expected him to pay.

wouldn't license to just anyone. He'd been approached by a midprice manufacturer who sold in stores like Macy's and Gimbel's. "Ralph didn't want to go that route," remembers *Men's Wear* editor Mort Gordon. "He felt it would take down his prestige."

Kreisler, an unabashed fan, longed for the chance to make fashion magic with Ralph's name. "When we were just starting out, we used to go to the Plaza for breakfast," Kreisler says. "I used to feel like we were playing Cary Grant grown up." They both wore gray flannel suits. Once, Ralph accessorized his with a silk tie, white shirt, and a yellow sweater handknit by Ricky. "Rather than be in fashion, Ralph was a fashion," Stuart says. "It's something very difficult to achieve; only the greats have achieved it; he did, Coco Chanel did. I felt that Ralph was one of the great opportunities of all time."

This was music to Ralph's ears, especially now that licensing was a necessity. So in October 1973, he signed a ten-year deal for women's clothing with Kreisler. Ralph was required to deliver sketches and samples designed by him or others under his supervision for four collections a year—spring, summer, fall, and "resort," the last sold in early winter and consisting mostly of clothes for warm-weather holidays—all "to be prepared and delivered promptly." For that, Polo would receive 7 percent of commission sales. Kreisler took another 13 percent, out of which he paid overhead, including rent for a floor of offices at 550 Seventh Avenue, a prestigious building full of top designers. Polo would also collect half the revenues from foreign licenses Kreisler might arrange. And Kreisler promised that his quality would equal that of Polo's men's lines, and that Ralph could approve all merchandise, packaging, and presentation—and any change in the management of the Kreisler Group. If annual sales dropped below $2 million, or if Kreisler failed to ship 75 percent of booked orders, Polo could even cancel the deal.

The agreement would be modified three years later when Kreisler added a new line. He would continue to produce Ralph's highest-priced, high-design women's line, which was known as Collection, and would now add a new line of sporty styles called Active—it began with a suite of all-black tennis clothes. That second license also gave Lauren use of a late-model car of Ralph's choice and a driver to be paid $15,000 a year, credited against Polo's royalties. With the car came a chauffeur named Carrington; before that he'd driven for the owner of a company Kreisler had acquired.

Kreisler's former boss Ben Shaw, who'd approached Lauren before Kreisler did, wasn't entirely pleased at his protégé's success. "He's not a groundbreaker," Shaw said. "He's following my routine and my ideas." That routine was important to Ralph. "He understood that notoriety came through women's design," says Kreisler.

For now, though, his women's line was "so new, no one had it, and no one really recognized it," Ralph said. He was doing tiny vignette fashion presentations in his office for the handful of fashion editors who cared. "None of the magazines wrote about it, and [the women's fashion trade newspaper] *WWD* never even came up to see my show," he says. "I didn't even know who they were."

Ralph gave the press that did care the best spin he could on his loss of control, predicting his women's wear would quickly reach $10 million in annual volume. "Can you believe it? I'm going to get seven percent of everything they sell!" he bubbled to Shelly Geller, a salesman he'd known since he worked at Rivetz. "He was like a thirteen-year-old with a new baseball glove," Geller says. But what was really important was the check Ralph got from Kreisler as an advance on royalties and design fees: $250,000.

Kreisler got that money through some fancy financing. His factor, Chase Manhattan, which was making a big play for garment business, advanced the cash against a complex guarantee from a Pennsylvania clothing factory. Alan Ginsberg, Kreisler's partner, was instrumental to the deal; he'd been a Chase investment officer. Stuart got the check on the eve of Yom Kippur, the holiest Jewish holiday, and Kreisler, a devout Jew, couldn't travel after the sun set, so he chartered a small plane to get home and, when he landed at Westchester County Airport, called Ralph.

" 'Ralph," he said, "I got it. I got money! I got money!"

Ralph didn't get to keep it long. "I gave it to the bank," he said, a little glumly.

43

Polo's credit had been restored. Ralph Lauren would never have to beg for piece goods again. "Whatever he wanted, Stuart said yes to," says a Kreisler Group employee. "Stuart had the money and the expertise. Ralph had carte blanche." Kreisler even paid for real fashion shows, the first of which was held in May 1974, the same month that Ralph and Ricky's last child was born, a girl they named Dylan, after another diminutive Jewish genius who'd changed his last name.

That summer, there was enough money to rent a beach house in one of the best neighborhoods of East Hampton, on a compound of rental houses on Further Lane, where the main house was rented by Anna and Rupert Murdoch, another by Marlo Thomas. Ricky and the kids stayed there all summer while Ralph worked. The Jersey Shore was a distant memory. Ralph bought an old Jeep, painted it white, and rode around in it when he made it to the beach. Driving was his favorite relaxation. The car collection would keep growing.

That June, Ralph's third Coty Award, this one for women's clothes, was announced. More than another notch on his belt, it marked his arrival into the fashion pantheon. Men's clothes were easy. Years later, Ralph would even call them "dumb." Women's fashion was the test of champions with its frequent seasons, its shorter production schedules, and its only constant being change.

That fall, Ralph even talked Peter Strom into coming to Polo to run the business while he concentrated on design. Strom had left Norman Hilton and was about to go to work for a carpet company. All through Ralph's time of troubles, they'd kept in touch. People who knew them would see them huddling in odd places, like a Papaya King hot-dog stand. "But it's hard to give advice about a business you're not intimately involved with," Strom says. "I tried, but I wasn't confident."

Strom felt that Michael Bernstein had made "a terrible mess" of things, but that it wasn't beyond repair. He knew the trick would be finding a business structure in which Ralph could work. The man Strom replaced, an experienced garment executive, had wanted Ralph to do it his way, and had lasted only three months in the job. So, over the objections of Polo's factor and several big accounts, Strom was dubbed Polo's new vice president in charge of everything Ralph didn't want to do. Said Strom, "He designs, he does advertising, public relations; I do the rest." They had a father-son relationship; Strom could either get things done or talk Ralph out of them. For that, he insisted on getting the same 10 percent of Polo that he'd had when he worked for Hilton. Ralph agreed—and promised him Bernstein's stock.

Strom's first priority was retail. Ralph felt Jerry Magnin's Polo store in Beverly Hills was the only place where his clothes were shown well, and he wanted to duplicate it elsewhere. "As soon as you paint a clear picture, the retailers get on it," Lauren says. "You can explain a hundred times, but [they have to] see it."

"I can't take credit for that idea, but I knew how to go out and get it," Strom says. First, he limited distribution so Polo wouldn't lose its aura of exclusivity. "They'd sold a little bit to a lot of people, and you don't mean anything to a retailer when six other guys in town have the line," Strom says, "so we lopped off a huge number of accounts, picked the best in each town, and asked for better

presentation." Strom also demanded that Paul Stuart start putting the Polo label in the goods it sold. The store dropped Polo instead.

Meanwhile, Polo's CFO Harvey Hellman was in the loft on the edge of Manhattan, running finances, warehousing, and distribution. "We're starting to see orders, we're starting to see growth, royalties from Stuart were starting to come in, we started to show some profits," says Hellman, who decided Polo needed a better back office. Hellman found 26,000 square feet in a warehouse in North Bergen, New Jersey.

On West Fifty-fifth Street, Lenny Lauren still thought he was "overseeing, making changes." But now, there were too many hands reaching for the levers of control. "Peter and Lenny are battling; Peter is winning, and there was a meeting [to decide] whether or not Lenny had a place at the company," Hellman says. "Ralph did not want to let him go. But nobody could say what he did except walk around and dress very well." What were they going to do with Lenny? And could they afford his salary atop Ralph's and Jerry's and Hellman's and Strom's?

Strom decided to send Lenny to New Jersey to learn about production. Lenny wasn't happy, but he went—and picked out the nicest office in the place for himself. Strom visited and said, 'What's Lenny doing in this office?' " Next thing Harvey Hellman knew, Lenny Lauren was ordered out and Hellman was told to move in.

"Lenny didn't know where he was anymore," Hellman says.

Ralph says he told his brother to go back to the jewelry box business. "I needed stronger help," Ralph says. Once, Lenny took issue with that version of events. "Ralph didn't have the sensitivity to talk to me himself," but had Strom do it, Lenny grumbled to Ralph's biographer Jeffrey Trachtenberg. Strom says he doesn't remember firing Lenny, but adds, "He had to be disenchanted," so they had "a conversation about the future."

"I could have stayed," Lenny says now. "I wasn't fired. I like Peter to this day. I said, 'Peter is the guy.' I really didn't have enough experience. Ralph wanted me to be successful. I had to leave. I was going to leave anyway. I was happy for Ralph. I *am* so happy for him." Lenny pauses. "The little brother becomes the patriarch."

44

trom and Hellman were happy, too; Ralph finally seemed willing to stick to what he knew and delegate the rest to professionals. "If you feel it's necessary, do it," he told Hellman, who'd won Ralph's confidence by making magic for him. Ralph had found a new apartment he loved on tony Fifth Avenue, a ten-room duplex facing Central Park, with a view of the Reservoir. It was going to cost a lot, "X millions of dollars," Hellman recalls. "He said he wanted the apartment; can we afford it? I had to do some heavy-duty, not double-talk, but I had to do some real tap dancing."

Hellman had developed a good relationship with Polo's latest factor, so he argued, "We were growing, we had orders, and the guy's got to have an image," Hellman recalls. "We can't stop him from having this. We should support this—and [do] whatever is necessary to do the apartment."

Whatever was necessary meant letting the Laurens live far beyond Ralph's means. Three years later, in 1980, they'd finally unveil their new, minimalist space in *Architectural Digest* and the *New York Times Magazine*. "When Ricky and I found the apartment, it had very little going for it," he told *Architectural Digest*. "So we plunged right in and gutted the place." The *Times* got a different story. "We didn't buy it just to tear it apart," Ricky said, but then Ralph had insisted on interviewing a slew of decorators, before choosing modernist Angelo Donghia, who ripped out the boiserie and dark-stained floors installed by the previous owners, and then built and rebuilt and rebuilt again.

"I drove [Donghia] crazy," Lauren admitted to design writer Marilyn Bethany, who observed that, as with his fashions, "Lauren thought of completed work as a rough draft, worth considering but not necessarily the final word." Lauren ripped the new floors up "ten times before he finally got the color he wanted," Harvey Hellman says. "Again and again."

The apartment wasn't all Ralph wanted. He wanted cars, too, especially rare, expensive cars. He still had his heart set on owning a Bentley or a Rolls-Royce Corniche. At their monthly board meetings, Polo's lawyer and accountant would sit at a conference table and go over the company's numbers with Strom and

Hellman, while Ralph fidgeted at his desk about ten feet away. "I know he heard what was going on," Hellman says, "but he couldn't focus on numbers. He'd be going through magazines, looking at automobiles."

Hellman was drafted to get him a new one. Hellman had already leased BMWs for himself and Strom from an outfit in New Jersey, when he called them again to say that Polo needed a Lamborghini. And Ralph had to pick the colors. Then, Ralph demanded the owner of the leasing company fly to Italy and bring the car back personally to ensure that it wasn't damaged en route. "He's a man of perfection," Hellman warned. "If he sees one scratch, it's going to flip him out." On arrival, Hellman inspected the car himself before putting it on a flatbed truck to East Hampton. "No one else is driving this car," Hellman said.

Lauren, of course, found a scratch despite all the precautions.

He couldn't complain about Hellman, though. Indeed, he would joke about him. He told a friend from Camp Roosevelt that he didn't know how much money he made and was on an allowance, but that he could spend what he wanted, thanks to Hellman. "I go to him if I need a million bucks," Ralph said. The friend assumed he was joking.

Hellman even managed to get him out of the hands of factors and set up a less costly credit line with a bank. After pulling off that coup, Hellman called in a promise he thought Lauren had made him when he'd asked for his new apartment. Hellman wanted equity, a piece of Polo just like Strom had. Lauren told him he'd be taken care of but he never was. "I was not aggressive enough," Hellman admits. "I never pursued it. I just stayed on."

Ralph could afford his indulgences now. Polo built its licensing business rapidly, adding a Japanese line, boys' clothes (a deal inspired by Ricky's inability to find quality clothes for their growing brood), scarves, glasses, furs, and the like, in the process building up the equity in the company. Polo's men's clothing business, with its suits, jackets, and trousers, was still its heart and soul, and the only segment of his growing business that Ralph owned himself; everything else was licensed out and manufactured by others. But men's was "never going to do a tremendous amount of business," in Harvey Hellman's words. And in the short term, it was actually costing Ralph money. Ralph had pulled his production from Leo Lozzi's factory in Lanham, Massachusetts, in 1974, but after making his clothes elsewhere for a year, closed a deal to buy the factory. Now, he was spending his profits and more to reengineer it to his specifications, which cost a fortune.

Though he was selling about $8 million worth of men's clothes and Kreisler was doing another $2.5 million in women's a year, Ralph's profit margins were

"very, very tight," Hellman says. So the income from licenses was crucial to create the cash flow to service Polo's debt and keep growing. Of them all, Kreisler's license was more crucial than the rest, more crucial even than the men's clothing on which the whole edifice rested.

The heights of fashion were reached only by dressing women.

Jerry Lauren seemed able to handle both menswear design and Ralph's occasional tantrum about it. "Anyone could do men's for Ralph," says a men's design staffer. "You know what he loves." Ralph's intense focus would henceforth be reserved for women's wear. And, for the time being, he would be teamed in that effort with Kreisler, who quickly learned to balance Ralph's demands (he insisted on using menswear techniques on women's clothes) with business realities. "I had to change the fit," Kreisler says frankly.

Once he did, Ralph became his meal ticket, though his other designers remained. The Kreisler Group was doing $7 million a year in volume when Ralph arrived and would triple that by 1978—with most of the increase in Ralph Lauren product. Kreisler moved up in the world in tandem with Lauren. In 1976, Stuart moved his family from Riverdale, a bedroom community in the Bronx, to an estate in Greenwich, Connecticut. His partner Alan Ginsberg followed a year later. Greenwich was where they belonged; in 1974, they'd even begun buying other companies. They were becoming fashion industrialists.

Ralph was becoming a fashion celebrity—and he acted the part. "He became very cocky," says Ed Brandau. "He had an ego that was unbelievable." Then, he was invited to the White House to dress First Lady Betty Ford. "A phenomenal thing," Ralph raved. And it was made even better when he picked up an in-flight magazine on the way down and found himself mentioned a few pages away from Mickey Mantle. "It's like, you catch up to your heroes in a way," he said.

His latest colonial and military styles for women were getting nice write-ups, and he found a perfect backdrop for his men's collection in March 1975, when he showed army/navy looks and Abercrombie & Fitch–style luxury outdoor clothes at the Explorer's Club, providing his own narration. He dubbed his new look "roughwear," and pronounced it all "special and important, which makes it special," according to a DNR report. It was the sort of "non-fashion, authentic, equipment-type merchandise" that Ralph says he wore "as a kid, before it got popular, and I think one of the things I loved about it was the way real hunters wore it, not as a complete outfit so that it became a costume, but all mixed together so that it was something they were comfortable in." It is testimony to Lauren's influence on fashion that that statement seems as obvious now as it was clumsy then; his ideas really were original and influential.

Ralph began to flex his muscles. In 1975, Polo started selling to New York stores that competed with Bloomingdale's. Bergdorf Goodman opened two Lauren boutiques in its Fifth Avenue location, and, steps away, Ralph got a women's shop at the outré Henri Bendel—where there were no women's clothes larger than size 10. Henri Bendel went all out, furnishing its Lauren boutique with old hat boxes and counters covered with green baize from an old Brooks Brothers branch in Boston. After a small start in 1974, in mid-1976, it expanded into semi-couture "country"-style jackets, skirts, and pants, available only by special order. They would fit only "a particular kind of girl, a lanky long-legged girl," says Jean Rosenberg, Bendel's merchandising vice president. She says that Kreisler's denials notwithstanding, Lauren's problems with women's fit continued. "I'd complain," she says. "He cuts flat—a man's cut—and I'd fuss. I thought they should be a little rounder. I still think that, but look where he is."

Ralph wasn't ungrateful for the role Bloomingdale's had played in launching Polo—most of his new product introductions in decades to come would be exclusive to the store. But he also pushed them around when he needed to. Bloomingdale's executives—and their counterparts in the other divisions of its parent, Federated Department Stores, most of which carried Polo—were aware of Lauren's power at the cash register.

So upon losing its exclusive, Bloomingdale's renovated its Polo boutique. And when Ralph announced he was going to sell to Saks Fifth Avenue (where, previously, Polo goods carried Saks labels), there was little Bloomingdale's could say. Marvin Traub recalls "rather unpleasant conversations" about Polo's moves.

The bottom line: Bloomingdale's "couldn't do without Ralph," says store executive Jack Schultz, but Bloomingdale's couldn't give him everything he wanted, either. "Bloomingdale's was nouveau riche. Saks could sell better clothing, and we couldn't." And Saks gave Ralph something else Bloomingdale's hadn't: his picture in a full-page advertisement in the *New York Times*. Ralph is shown leaning against the hood of an old pickup truck, flanked by two models, one in Harris tweed, the other in a gun-check hacking jacket, Shetland sweater, and covert slacks. Lauren, now perpetually tan, sits arms crossed in a wide-lapel tweed jacket with leather elbow patches, a denim shirt, and cowboy boots. A careful observer will note that Lauren's stacked heels are both off the ground, one on the truck's bumper, the other foot *en point*. He insisted on perching that way to enhance his height, says the photographer Jacques Malignon. "He never wants to stand near models."

The ad "became a big hit," Lauren said. "People started to know what I look like, and started to relate to me somehow." Years later, a friend of decades' duration would point to the day that ad ran as the moment Ralph Lifshitz—the shy,

sleepy-eyed, lisping, duck-walking Bronx yeshiva *bochur*—ceased to exit, replaced by the suave Ralph Lauren.

45

Ricky Lauren was Ralph's first muse. Virginia Witbeck—Jennifer to friends—was his second. In 1976, Ralph and Peter Strom were eating lunch at J. G. Melon's, the hamburger joint near Lauren's apartment, when Ralph spotted the shapely, patrician brunette across the restaurant and sent a waiter over to ask if she'd have a word with him. His eye was sharp: she was a descendant of a Dutch family that first settled in colonial New York in the 1640s.

"He thought she was original," says Jim Rushton, a new Polo salesman. Witbeck was in a man's jacket, old men's corduroy pants cinched at the waist, a pair of boots, and a ratty old fur with its sleeves ripped off and its lining ripped out, worn inside out. Everyone at her table turned to watch as Lauren got up, red-faced, and approached. "I couldn't help but notice you," he said. "Are you a model? What do you do?"

She was a gofer at a commercial production house, but she said, "I'm in the film business." He asked if she was an actress. Her tablemates wondered if he was trying to pick her up—until he told her who he was and asked if she'd work for him: he needed people with style. She said she had no fashion experience. "We have people who do that," Lauren told her. She asked for his business card, and he seemed to bristle. Strom came up with one.

A few days later, Witbeck got the treatment that would become familiar to female applicants for jobs at Polo Ralph Lauren. Interviews often seemed to be half flirtation, half interrogation. Salesmen drifted past Lauren's office, checking out the new talent, while he engaged in pointed social chitchat: Where did they go to school? How did people dress there? Where did their families vacation?

"It was all about being a WASP," one applicant recalls. "I grew up a WASP. I didn't think it was special. I didn't know it was something you could market. Every ex-Ralphette has the same story. We were handpicked because we looked a certain way." The WASP sorority atmosphere of the studio was played up by

Buffy Birrittella, who gave every woman who worked there a nickname ending in the letter *y*—Witbeck became Jenny.

Job applicants didn't have to be very observant to get what the Polo game was: the evidence was on the walls of Lauren's office, which were full of photographs of Ralph living the lifestyles he dreamed about—even a picture of him sitting on a polo pony holding a mallet, just like his logo. It had been taken on a visit to Neiman Marcus in Texas, where one of the Marcus brothers propped him up on a horse he couldn't ride. To his credit, he was the first to admit that. "He said it was a fake," a visitor recalls. "I thought it was good he was so up-front about it, but how goofy! He was like a kid on a pony, only he was an adult. He's an adult marketing kid fantasies." He was thirty-seven years old in 1976.

But now his business had outgrown his fantasies and he needed outside stimulation. With Jerry Lauren ensconced in men's design, Ralph had turned his attention to what didn't come naturally—women's fashions. Lauren's confidence when dealing with men's clothing was mirrored by the insecurity he felt designing for women. "He was learning it," says Marvin Traub. "He was growing and developing" but also had "a feeling of being tested." Witbeck became the first of many who'd be hired simply to inspire him. Henceforth there would always be someone like her, someone empowered to ignore the company rule that everyone had to wear clothes from the Ralph Lauren collection, someone who got to wear her own clothes—which then became the *next* Lauren collection.

Witbeck mixed men's clothes with feminine frills: she'd wear a rough tweed jacket with an antique lace blouse—all finds from a flea market. For the next four years, her style would be the animating spark behind the Kreisler Group's Ralph Lauren women's wear line. "She did a lot of it," says salesman Jim Rushton.

The women's design team was tiny then. There was Witbeck; Buffy; two fit models, Tasha Bauer (whose real name was Sandra) and Lynn Yeager; a Scottish-born sketch artist who was the only trained designer on the staff; an assistant, Nancy Vignola; and another patrician beauty named Kelly Rector, who worked as a gofer—and would, in less than a decade, transfer her affections, both professional and personal, to Ralph's bitter rival, Calvin Klein. She'd be the first, but not the last, close associate to defect to Klein's camp.

Born in Detroit in 1957, Rector had grown up in Westport, Connecticut, the child of a broken home. Rector's first romance, begun when she was still a teenager, was with Sam Edelman, whose family had owned a company that sold alligator, crocodile, and lizard skin. The couple lived with his parents in Bedford, "like husband and wife, while Kelly was still in high school" and later, studying at the Fashion Institute of Technology.

Edelman, who then held the Ralph Lauren shoe license, introduced his model-pretty girlfriend to Ralph shortly after she graduated from FIT. "Ralph loved Kelly because she was cute and horsey and Connecticut-looking, and we could throw clothes on her if we didn't have a model," says a staffer.

Kelly went to work for Kreisler as a summer receptionist and then in Lauren's design studio, where everyone worked together in a big room; only Buffy had a private office. They would all sit around talking ideas, which would be sketched, then show them to Birrittella, who'd become Ralph's eyes and ears. Beneath Buffy, the staff was split between worker bees who got the nitty gritty work done, and the imaginative style mavens who were there for their looks and panache, like Witbeck and Rector. Witbeck actually tried to come up with ideas. Rector didn't do much besides look good in jeans and white shirts. "It was hard to motivate her, although everyone adored her," says a Lauren executive. "She'd stare into space at meetings with Ralph. It would be like, 'Kelly? Come back.'"

Kelly soon deserted Ralph physically, too. Edelman heard there was a design assistant job open at Calvin Klein and called Jeffrey Banks, who'd gone to work there. Banks set up an interview. Klein wasn't impressed. "The last thing I need is another pretty face with an opinion," he said. But he hired her anyway, and by 1984, they'd be romantically linked; they married in 1986.

"Ralph hated her because she went to work for Calvin," says salesman Jim Rushton.

46

That bicentennial summer in East Hampton, Ralph's next-door neighbor in the Tyson compound was David Horowitz, who worked at Warner Communications, the glamorous entertainment conglomerate built by the one-time parking-lot magnate Steve Ross. Horowitz, one of three key executives under chairman Ross, ran Warner's three record companies and its fledgling cable television operation (which later developed MTV). Horowitz was soft-spoken and private, just like his summer neighbor, and they were drawn to each other.

Over the years, several fragrance companies had sniffed around Polo (Ralph

had registered the name for a fragrance): Charles of the Ritz, Estée Lauder, Helena Rubenstein, and CBS chairman William Paley's son-in-law, Tony Mortimer, who was starting a perfume company. Fragrance was a pure image business, a bottle of eau de cologne an impulse purchase, and as designers since Coco Chanel had learned, it was a relatively inexpensive entry point for shoppers into a designer's world of fantasy, and an extraordinary promotional tool for a designer's other products, as well as a source of big volume and windfall profits. Ralph wanted to be in that business. Designers make their biggest income from fragrance.

Ralph romanced Horowitz. He said that he wanted to market fragrances because they were a critical way to capitalize on a fashion brand. "And it's a much higher margin business than clothing," Horowitz says. Ralph wasn't thinking small. "He wasn't talking one fragrance, he was talking a family," Horowitz continues. But Lauren had already grown wary of licensing. He didn't want to just sell his name to a company like a Revlon, because he knew that first impressions were all-important, and if his first scent didn't make it, it would be a small loss for a multibrand company, but the end of the game for him.

Ralph proposed that Warner become his partner in a new company that would own the fragrance license, "because we had no competing products and we sold dreams just like a fragrance company does," Horowitz says. "On the face of it, it was an off-the-wall idea. Warner had never been in that business. But we talked and talked and the more we talked, the more interested I became."

Ralph brought this news to George Friedman, an executive at Estée Lauder, the cosmetics giant. Friedman ran Aramis, a division of Lauder, and the world's best-selling men's fragrance. They'd been friends for years—introduced by Neal Fox of Neiman Marcus—and lunched regularly, eating hot dogs in Central Park, talking about old movies, style, and Ralph's encounters with fragrance moguls.

"I'd grown up poor in Brooklyn," says Friedman. "I understood that his name was a remarkable one for a men's fragrance." Leonard Lauder, whose mother had founded the company, wanted another "position" in men's fragrances that would complement Aramis, and, at one point, Friedman suggested it be Lauren. But Estée Lauder wasn't interested in a second "name" brand, let alone one so close to her own.

Friedman didn't give up, though; he did all he could to discourage Ralph from signing with anyone else, even telling him he could demand his own sales force and a huge advertising budget. This was what Ralph wanted to hear, but also an offer he was unlikely to get from the multibrand firms pursuing him.

Friedman swore they'd do a scent together one day. "You'll never leave Lauder," Ralph scoffed. But he didn't sign with anyone else.

Now, Ralph introduced Friedman to David Horowitz, who sent a memo to his boss Steve Ross, and other top Warner executives. Intrigued, they met with Friedman, who spun a vision of a company that could sell a Superman fragrance in a cardboard phone booth and a Barbra Streisand scent as well as Ralph Lauren perfumes and colognes. By August, Friedman was hard at work on a business plan. He was sitting at his kitchen table in Bridgehampton, a town away from Ralph and Horowitz, when Bob Ruttenberg, a former Lauder colleague, stopped by to drop his son off for a play date.

"Why are you working on a weekend?" Ruttenberg asked him.

Ruttenberg and Friedman had both come out of advertising agencies, where Ruttenberg supervised a hair color account, and Friedman hawked cosmetics. They'd worked together again at Lauder in the late sixties, until Ruttenberg quit and went to Revlon, where he managed a wildly popular scent, Charlie. Ruttenberg knew the women's business; Friedman, who stayed at Lauder, knew men's. The next morning, Ruttenberg called Friedman to tell him the dream he'd had that night. They were going to introduce men's and women's fragrances simultaneously. It had never been done. Fragrance launches in stores—and the attendant hoopla—lasted two strictly scheduled weeks. By doing two launches at once, they could get a month of noise. Freidman loved it.

But when they told Ralph, he worried that his name didn't mean enough in the women's business yet—couldn't they wait? Ralph won that point when Lauder reminded Friedman of his contract: if he left, he couldn't launch a competing men's scent for a year. "Ralph wasn't in a hurry," says Ruttenberg. "He wanted to do it right. He'd grown too fast. He learned. He's a quick study."

"Wait," Ralph said. "You only launch once."

Ralph also demanded equity in the deal. In exchange for more than $6 million in loans and capitalization, Warner would own 75 percent of the company, which was called Warner/Lauren Ltd.; Friedman got 15 percent, Ruttenberg and Ralph 5 percent each. Ralph also got a 5 percent royalty, much of which was paid to him personally, not to Polo.

Ralph relished his new position in the charmed Warner circle. He had the use of its corporate jets and helicopters and dined out and partied with Ross and the many stars he controlled. Ross was a world-class shmoozer. "He charmed Ralph as he charmed me," Ruttenberg said. "It was a very small piece of a huge

company when it began," says Horowitz, "but it got disproportionate attention from Steve. He was very interested in the company. He liked the association with Ralph." Ross even promised he wouldn't interfere, although of course, he did. When he learned the Polo logo wouldn't be on the men's fragrance bottle, Ross balked, "and he was right," says Ruttenberg.

The deal was announced in fall 1976 with a party at the '21' Club. Ralph was complimentary to his new partners. "Warner's isn't a monster chewing everybody up," he said. "They aren't sticking us in a division, but creating a company. Warner can relate to artistic people and I feel I'll be able to make a statement."

During the year preceding the launch, Ruttenberg and Friedman traveled the country, visiting every major department store, talking up their idea and the counter impact the double launch would have, showing off their bottle designs (the women's fragrance would come in a bottle based on one of Ralph's Victorian inkwells, the men's in one shaped like an antique flask), and boasting of their plans to launch with heavy advertising. The buyers they met confirmed one of the truths of the fragrance business: the sizzle matters more than the steak itself. "Only one person asked what the fragrance would smell like," Friedman says. "The key was the look and feel of the product and the crucial contributions were made by Ralph. The bottles were his concept. It all had to pass through Ralph."

Friedman came up with "Polo," the men's fragrance, easily, and everybody liked it. It was a scent he'd wanted to do for years, "based on certain woodsy notes I happened to love," he says. Notes are the olfactory elements of a fragrance, created from flowers and natural oils as well as synthetics. "Noses"—the people who develop scents—use all sorts of comparisons to explain what they do. Friedman says one note in "Polo" vaguely reminded him of a cleaning liquid the janitors used when they mopped the halls of the elementary school he'd attended as a boy—a scent he'd loved.

The women's fragrance, "Lauren," wasn't so easy to create. Jill Resnick, a tall young woman who'd later earn the nickname "The Nose," was hired to help find a scent. "We knew it had to be classic but different; otherwise, who'd buy it?" she says. "It was difficult to get Ralph to understand; he was only comfortable with notes that were familiar."

Ralph had a hard time with Resnick, who was taller than he, and was sure of herself and of her command of her job. "He was God there," says Resnick. "All I wanted to do was find something he liked." But they had "a horrible episode"—she won't talk about it—and were eventually kept apart.

Finally, Resnick, Friedman, and Ruttenberg settled on a scent developed

by International Flavors & Fragrances, or IFF. It was a fruity floral, the first such scent in the business, with sweet crisp notes of apple and melon. "It was very different and because it was different it was scary," says Resnick. Ricky Lauren didn't like it; Ralph didn't either.

But Ruttenberg had picked up a trick from Charles Revson, his boss at Revlon, who taught him that if fragrances were put in anonymous bottles, women couldn't choose their own. So Ruttenberg got a list of women from Ross, Ralph, and others on the Warner board—forty-five in all—and not one was able to recognize her own fragrance in an array that also included the proposed scent for "Lauren." But half thought "Lauren" *was* their favorite.

With the two scents in place, it was Ralph's turn to teach his partners a lesson. The packaging they'd developed was both unusual and expensive—the bottles were made of deeply colored glass, the packages echoed those colors, and the bottle caps were ornate. So Friedman and Ruttenberg set prices high. Ralph demanded they go even higher. "It's what Ralph Lauren is about," he argued. "People will pay for quality." They eventually hedged their bet by offering an accessibly priced three-ounce cologne spray at the bottom of the line. Launched in March 1978, the scents were immediately successful. Warner/Lauren rang up $7.5 million in sales its first year, $28 million the second (when it expanded into broader distribution with Chaps, a lower-priced drugstore-brand fragrance) and $75 million in 1980.

Ironically, the scent that became "Lauren" had actually been developed for Ralph's rival, Calvin Klein. Six months after Lauren signed his deal with Warner, Klein hired another Revlon executive, Stanley Kohlenberg, to develop a scent for him. But Klein hated everything Kohlenberg came up with except musk. So IFF was asked to develop a scent, but Klein rejected that one, too. With Kohlenberg's permission, IFF then offered it to Jill Resnick, without telling Warner/Lauren its provenance.

Klein and his business partner, another kid from Mosholu Parkway named Barry Schwartz, finally found a fragrance they liked, and wanted it out at the same time as Lauren's. When Bloomingdale's told Klein he couldn't launch until a week after "Lauren" and "Polo," he took his scent to Saks instead, and the two boys from the Bronx went head to head in Manhattan early in 1978. Klein's scent didn't sell well, though, and the volatile Schwartz was soon screaming at Kohlenberg: "Lauren" was doing much better.

"Have you smelled it?" Kohlenberg replied. "We turned it down."

Though it wasn't a straight trade, a design assistant for a scent, that was the net result of the first professional battles between Calvin and Ralph—and Ralph had clearly won the upper hand over his younger competitor. Calvin

and Kelly Klein would eventually separate (although they remain married). "Lauren," on the other hand, has become a classic scent like Chanel No. 5, still selling well twenty-five years after its introduction.

47

Ralph hoped for more from his deal with Warner than fragrances. "He loves the entertainment business," says David Horowitz. "There's no question that's what made it appealing." Ralph wasn't shy in suggesting that he hoped to finally realize his thus-far-frustrated Hollywood dreams.

Ralph's second run-in with the movies had been a repeat of his first. Woody Allen's 1977 comedy *Annie Hall* told the story of a love affair between a comedian played by Allen, and the title character, a singer portrayed by Diane Keaton. Not only did Keaton's ditzy Annie capture the imagination of moviegoers, her wardrobe—a whimsical, layered mélange of oversized men's pants, shirts, vests, ties, and floppy felt hats—became a fashion fad.

A few months after the film's release, Buffy Birrittella called Nina Hyde, a fashion reporter for the *Washington Post*, "to say a credit is due for all the clothes in the Woody Allen film, on and off stage, as well as the latest things in Diane Keaton's closet," Hyde wrote. "The Keaton clothes for the flick were a mix of new Lauren designs and Keaton's old favorites from the back of her closet." Henceforth, Lauren would often be credited as the creator of what became known as "the Annie Hall look."

Unfortunately, as with *The Great Gatsby*, a costume designer, Ruth Morley, worked on *Annie Hall*, and Lauren's authorship claims infuriated her. "It was an issue for many years," says her daughter Emily Hacker. Morley even considered suing Lauren over his credit grab.

In fact, if anyone deserves credit for the look, it is Diane Keaton, says Woody Allen; the clothes in the film came from his and Keaton's own closets. "I wore his clothes in life and hence on film," Allen says. "Same is true of Keaton. The Annie Hall look was the exact way Keaton dressed in life. I used it on screen because she was a great natural stylist. Ms. Morley was often very much against Keaton's choices and wanted me to tell her not to wear such outré fashions. I

opted to let Keaton wear what she wanted." In case that isn't clear, Allen adds, "Ralph Lauren was in no way involved in costuming the film."

Lauren did give clothes to Keaton, however, and she returned the favor by attending several of his late-seventies fashion shows, along with Joel Schumacher, a former window dresser at Henri Bendel, who'd been hired to costume Allen's next film, *Interiors* (and would go on to become a top director himself); Anthony Perkins and his wife, Berry (a granddaughter of Parisian couturier Elsa Schiaparelli); and Candice Bergen. Ralph cherished these cinematic connections. But he hoped for even more from Steve Ross. Although Amanda Burden, who was married to Ross at that time, says that Ross and Ralph didn't really spend much time together, that didn't stop Ralph from dreaming. Hadn't his whole career been based on the premise that dreams come true?

And they did. Ross introduced him to his childhood favorite, Frank Sinatra, at Warner/Lauren's first anniversary party, held in the chairman's Fifth Avenue triplex (and catered by an unknown named Martha Stewart), early in 1979. "Sinatra came and I was sitting with him all night at the table," Ralph raved. "I was singing, holding the microphone for him." It wasn't just Sinatra. "Cary Grant picks me up, takes me down to the track out in California, isn't that unbelievable?" Ralph continued in that same conversation. "They're just people, you know? What you think he should be like is exactly what he is like." Yet describing his encounters with the debonair Grant on another occasion, Lauren would note that while his favorite star "looked like he was playing himself, he really wasn't the guy in the movies. You thought he was. And he became it. It's not about being fake." To Ralph, the star's ability to be larger than life was the essence of life itself.

Ralph's dreaming had taught him that he could be whatever he wanted to be. So just after his first fragrances were released, in several interviews with *WWD*, he revealed his desire to star in or direct or produce movies. "I know I couldn't become an Al Pacino in three weeks, but those are the types of roles I'd like to play—action packed," he said, adding that he'd discussed acting with his Warner partners. "Now it's a question of something coming up. I'm looking for a new challenge. If the right opportunity came along, I'd grab it."

A few months later, he expanded in an article *WWD* called "Restless and Reaching." What roles would he play? the reporter wondered. "I don't think it matters as long as I ride a horse," he said, adding that he'd finally learned how. "I relate to people who are my size, like Humphrey Bogart and Al Pacino. I can do anything I want. That is a fabulous feeling."

Ricky Lauren, who was in the room at the time, chimed in. Her idea of a role for Ralph? "God, in *The Ten Commandments*," she said.

Ralph was sent to Joan Hyler, a talent agent at ICM, by mutual friends for "a looky-loo," Hyler says, though she downplays the approach. "He was checking out his options, seeing if there was something he could do," she says. But at the time, Hyler dined out on the story of how she'd asked him what ICM could do for him. Then, she imitated the lisping wanna-be's hopeless reply: "I want to be a movie *thtar*."

48

L ate in 1978, Ralph took reporter Lisa Anderson on a spin through East Hampton in his latest ride, a custom-made Porsche Turbo Carrera. This was a new Ralph Lauren—not the shy Anglophile but, Anderson implied, an overreaching egomaniac whose chrome-free car in shiny "Darth Vader black"—the first *Star Wars* movie had just been released—matched his bicycle and a just-designed new luggage line. She described Ralph as, "Slightly rugged, extremely confident and moderately macho, he wears a got-it-made aura like a label."

The Force was surely with him. Polo Ralph Lauren's wholesale revenues were approaching $75 million a year,* and as the number of individual items he sold, called SKUs or stock keeping units (a blue Polo shirt was one SKU, an orange one another) neared one hundred thousand annually, Ralph got proportionately larger than life. Bloomingdale's had hired a new buyer for his women's line, Milly Graves, who'd hung with him on Mosholu Parkway as a girl. They went to lunch, and he told her his vision. "A world of Ralph Lauren," she says. "He wanted it to be grand. People have pipe dreams. He actually implemented it." After lunch, he drove her back to work in an antique Bentley.

Ralph had started branching out sartorially after meeting Robert Redford, who dressed like a cowboy and owned a huge parcel of ranch land in Sundance, Utah. "Ralph never wore jeans and boots until he came under the influence of

*The $75 million figure represents wholesale orders. Retail prices in fashion are generally twice the wholesale price. But Polo wasn't necessarily selling $150 million worth of clothes. Some of them would be returned, others sold at marked-down prices. Those factors make valuing any fashion house a slippery business.

Redford," says a fashion editor who watched the transformation that was captured in that Saks ad in which Ralph mixed English tweeds and American denim.

Some of Ralph's competitors thought his much-touted relationship with Redford was actually more competitive than friendly. Redford had begun a relationship with Buffy Birrittella, who encouraged her friends and design studio colleagues to believe it was romantic.

It wasn't a secret. "Buffy was totally besotted with Redford before they ever met," remembers Jeffrey Banks. "She was like a teenager." Birrittella arranged her vacation time to coincide with the *Gatsby* shoot in Newport, Banks continues, "and she'd be there every day." Afterward, Redford started visiting 40 West Fifty-fifth Street, always in disguise—a tweed cap pulled down low over a pair of dark glasses—to pick out clothes for himself. He even had a code name: RR. "He'd come up for fittings and hang out," says a staffer. "He felt safe in the studio." That was because Poloroids protected their own. They were a breed apart, just like movie stars.

Opinions differ on whether Redford felt the same way toward Buffy that she did toward him. "He strung her along in his younger days," says someone who worked for her. "She'd talk about seeing him on the weekend and then he'd never call. She'd sit in the office all day waiting. Then, when he did call, she'd come no matter where she was." A former Polo vice president concurs. "Everyone believed she was Redford's girlfriend," she says. "Ralph believes it. She believes it. Trust me, it didn't happen. At best, it was a drunken fling. I heard Redford got wind of what she was saying and got very annoyed."

Studio yentas wondered if Redford was using her. But others thought it was Buffy using the movie star to make Ralph jealous—either as payback for his moving her out of design when Virgina Witbeck arrived, or as manipulation to ensure her survival in whatever job he gave her next. "Buffy has maintained a position no one else has," says a design studio insider. "It's like playing chess." While others came and went, Birrittella chose to be a pawn when necessary, a knight when needed, a queen when she could. "Buffy was running the show," says the underling. "There wasn't a detail she didn't pay attention to. She had a hand in virtually everything. Dysfunctional as they were, Ralph and Buffy [were] a team." He was brilliant. "She was cagier, more articulate, more intelligent than Ralph. She could complete his sentences."

At first, Lauren luxuriated in Redford's reflected glow. But the more Buffy doted on him, the less Ralph liked it. "He was jealous all the time," says Jim Rushton, the salesman. "The girls told us Ralph hated Redford because he wore the clothes but didn't tell people they were Ralph's."

More than once, Redford's special orders—shepherded by Buffy—arrived at 40 West Fifty-fifth Street before Ralph's own clothes did. Since they wore the same size, Lauren sometimes thought they were his. Once, he was about to take some shirts when he was told they were Redford's. "Where are mine?" he snapped. "Where's Buffy?"

The rumors of Birrittella's connection to Redford continued for years, particularly after she bought a condo near him in Utah. The end of the relationship may have come when Ralph decided Redford had betrayed him. In 1989, Redford issued the first Sundance Catalog, offering the same handicrafts and clothes he'd sold since 1970 in his Sundance General Store via mail order. Redford spoke to Lauren about partnering on the project. "Ralph got nervous and pulled out," says Buffy's subordinate. "Redford did it anyway and it looked like Ralph Lauren, but a really cheap, tacky version." Through an assistant at his production company, Redford declines to comment on Ralph or Buffy.

Regardless of the tenor of those relationships, Redford had a positive influence—he helped transform Ralph into fashion's Mr. America. Under Redford's spell, Birrittella began wearing cowboy boots, concha belts, and turquoise jewelry; and she began collecting Native American arts and crafts. If the ultimate Ralphette liked it, others would, too, so Lauren's next women's collection was full of cowboy imagery. Like a child bred of Horatio Alger and Hopalong Cassidy, he'd gone and imagined a new, luxurious frontier, one on which women wore shearling coats, suede fringed jackets, silver-buckled cowgirl belts, and luxe chamois blouses.

Flush with free money from his many licenses, Lauren cemented his image as he slowly began creating advertising. Until then, the only ads for his products had been produced and placed by stores that sold his products. The first Polo-made promotion had appeared the previous spring: a self-produced catalog that was mailed to customers of the stores that sold his products. But this time, he controlled it. It pinned his dreams down on paper for the first time.

Les Goldberg, the photographer, had met Ralph at Jerry Magnin's stores in Beverly Hills, where Goldberg supervised displays. After he shot a promotional brochure for Magnin, Goldberg decided to move to New York with his wife, a model, and become a fashion photographer. A few months later, he approached Lauren and Peter Strom with an idea: a mail-order catalog distributed by Polo retailers to their customers. If each agreed to buy a batch, specially imprinted with the store's name, all the costs of the production would be paid for, "and Polo might even make a profit," Goldberg says. "I walked out the door with a check that day." It didn't hurt that Goldberg told Lauren that he wanted the cat-

alog to look like stills from one of Lauren's all-time favorite films, *The Thomas Crown Affair*, the 1968 movie with Steve McQueen as a glamorous, polo-playing businessman-thief.

"*That* was a hero," says Goldberg. "That was a look."

Ralph had designed a white dinner jacket, and suggested that to avoid men's fashion clichés, Goldberg shoot it on a model sitting in a Jeep. Goldberg took the Jeep, which belonged to Ralph's new pal, Joel Schumacher, into some California woods, got it nice and muddy, and put a male model wearing the dinner jacket in the backseat, behind a liveried chauffeur. Buffy Birrittella penned the copy that accompanied the photo—and prefigured most Ralph Lauren ads to come: "We believe in style, not fashion."

Back in New York, Goldberg ventured out to East Hampton to shoot more of the catalog, this time using Ralph as a model. They continued the McQueen motif by blasting Michel Legrand's *Thomas Crown* sound track as they shot over several days. Goldberg suggested showing the clothes in lifestyle, as opposed to real-life, situations. The distinction made an impression on Lauren. "I'm living the dream, and I'm putting it out there—which has nothing to do with reality," Goldberg explains. "I don't know if he'd articulated that yet, but the pictures came back and you saw him living his own life in his own stuff."

The idea that a lifestyle fantasy could become reality through the medium of fashion would be the foundation upon which Ralph's empire—and, more broadly, all of fashion's appeal—grew. Lauren would refine and amplify the idea, coloring it in with his Everyman fantasies, but the basics wouldn't change. "Where do you start?" he says. "It starts with a season. Spring. What happens in spring? What are you doing? They've finished with fall. They've finished with skiing." Out with one lifestyle, in with another. "People think about beach houses. Country. Out of the city. So nautical, boating, beach houses, it's always been a classic with me, one of the repertoire of things I've always loved. I don't design to design. I design into living. I was the guy walking into the store. My wife was the girl. My kids were the kids. Everything I did had to do with how I see things and what I'd be looking for. It wasn't industry. It was very personal. The industry generally didn't care. They didn't have it."

That Ralph wore his own stuff in those first ads was thanks to Pam Branstetter, a friend of Goldberg's who'd also worked at Jerry Magnin and had come along to help on the shoot. When the team pulled up to Lauren's house, he came out to greet them in a pair of old jeans "and a Steve McQueen hat," Branstetter says. She frowned, and when Lauren asked why, she said, "I have a problem with the fact that you're not wearing your own clothes." Shooting her an approving look, Lauren turned on his heel and reemerged shortly afterward

in a Polo chambray shirt, a bomber jacket, "and different jeans with not so many holes in them," she says. "He kept the hat."

Later, they shot Ralph in Polo tennis clothes on his tennis court. "He couldn't play," she observes; he was too busy playing for bigger stakes. "I have a dream," he told her as he posed, "of stores with my name all over the world carrying every product category. My partner thinks I'm crazy. What do you think?"

It was a test, and Branstetter passed; she loved the idea. "Would you like a job?" he asked. She said no. "I don't care," he said. "I want you to work for me." And, of course, he got his way. Branstetter was named director of public relations for Ralph Lauren Women's Wear. "Stuart Kreisler didn't like that so much," she says, "but Ralph said, 'She's hired. Take her.'"

49

Pam Branstetter was more than a PR woman. She was also Lauren's eyes and ears at the Kreisler Group. "Pam was his person, hired on Kreisler's money, reporting to Ralph behind Stuart's back, like if they switched a fabric without telling him," someone close to her says. "Stuart would say, 'I don't care if Ralph wants it; no black cashmere!'" She was also a salesperson and an image watchdog, checking on every installation of Lauren windows at Henri Bendel, for example. "I had to make sure everything looked the way Ralph put it together," she says. "Every marcasite pin! I had to say 'No! Ralph wants it *this* way.'"

Branstetter entered the Polo inner sanctum at 40 West Fifty-fifth Street, where Ralph and Peter Strom, who'd been promoted to president in 1978, shared a two-bedroom apartment as their executive office. Polo had taken over—and transformed—much of the building. "You got off the elevator on the third floor," Branstetter says, "and you knew you weren't on Seventh Avenue anymore." It wasn't Oz, but it was close. "It was Ralph Lauren world; everything was perfection." The walls were Polo green, the floors covered in sisal. Plants, leather, and mahogany were everywhere.

Branstetter started coming uptown for fittings ("He wanted my opinion," she says, "I was ninety pounds, blonde, and wore his clothes"), and ended up a full-

fledged member of the Polo elite. She was in awe of Ralph, who'd refined the magnetic personality he'd first revealed at yeshiva. "He never raised his voice," she says. "I don't know how, but he created an aura. He had a mystique I've never encountered again in my lifetime, ever."

Though their offices were within a few feet of each other, and Ralph had to walk through Strom's to use the bathroom, the partners' worlds rarely intersected. Strom had hired a group of macho salesmen—many of them southerners—and when they were all in town for sales meetings, they'd gather in his office as soon as Strom's office bar opened, just after five P.M. "They taught me to drink," Branstetter says. "They taught me about life."

They all lived large. "It was a promiscuous, macho, heterosexual company where people slept with each other a lot," says an executive. Ralph, who didn't drink, wasn't really a part of it, but the women on his design team—even Buffy Birrittella—were considered fair game by the salesmen. "The world of Ralph Lauren was filled with wispy, gorgeous girls," says one. "Everyone was sleeping with everyone else." The annual Christmas party became a game "of who was going home with whom," says a one-time vice president. Strom didn't discourage it—indeed, the vice president thinks he liked it that way. "Do you think Ralph is handsome?" Strom would ask Polo women. "What about Jerry?" Whether it was done consciously or not, office romances linked employees even more tightly to Polo. "It was a way of life, not a job," Branstetter says. "We were unto ourselves. It wasn't about the money. You worked because you loved it. You never went out to lunch. No one wanted to leave. You ate it, breathed it, and slept it."

Strom's sales team, which handled the men's clothes, included Rushton, in charge of the Midwest; Joseph Abboud, who handled New England; Bill Joseph, aka "Billy Joe Trouble," a one-time salesman at Norman Hilton, who handled the West. John Hubauer had the Northeast, and Edwin Lewis, the South. A motor-mouthed tie salesman in his twenties, Lewis had been the first to come on board. Based in Atlanta, he was as hard a partier as he was a hard seller. His interview with Strom lasted a couple of hours and "a couple of drinks," at the end of which he was offered a job as Polo's southern head of sales. Back home, Lewis checked around and learned that "people hated the attitude of the company," he says. "They were nasty and the shipping was bad, but everybody had a love of the product."

Though he couldn't fix the shipping problems, or the fit problems ("Ralph has a fit, and it doesn't fit everybody," says Lewis. "That doesn't make it wrong, it makes it his."), Strom changed Polo's attitude. "It became a nice place," says Lewis. "People had fun there." And it wasn't a typical fashion house. Since his women's clothes grew out of his men's, and both were designed in-house, the

border between the men's and women's lines, which for other designers was typically impenetrable, was totally porous at Polo.

In most designer salons—suffused with the high anxiety and hissy fits common to the high-end women's fashion business—the air could seem too precious to breathe. But the good ol' boys at Polo drank life like cold beer, and sowed wild oats like wild men. "There was a lot of fucking going on up there," Rushton admits. Ralph, who was seen as a bit of a prig, didn't quite fit in. "He was not a man's man," says Rushton. "He felt ill at ease around us." Ralph was often defensive—after all, would a *real* man care about men's clothes, let alone women's? But it was okay with him if Strom's salesmen gave his offices a manly aura unique in the upper reaches of fashion. Especially when his rival, Calvin Klein, was becoming king of the bisexual party scene at Studio 54.

Calvin's dream couldn't have been more different from Ralph's.

50

Peter Strom's salesmen were the real-life equivalent of the fantasy men who began to appear in Lauren's ads. Les Goldberg's second Polo catalog, for fall 1978, was the model on which future Polo advertising would be based. Goldberg used the Princeton crew team as models and created what he describes as the "style—not fashion" closing page. It showed a male model walking a horse through the Laurentian Mountains outside Montreal, wearing a shearling steamer coat over jeans and a dinner jacket, and a cowboy hat that belonged to Ralph. "The hat had some history," Goldberg thinks. "It was a prop off some John Wayne movie." That shot became Polo's first magazine ad.

Advertising was about to become integral to Polo presentation, in large part thanks to Warner/Lauren. The launch of the fragrances was accompanied by Ralph's first national print ads and two television commercials, paid for by Warner. Those ads are a testament to Lauren's belief that style outlives fashion. Images from them, featuring a polo match, are still in use today.

The commercials were made by an agency called Ammarati Puris AvRutick. It was not the first agency the Warner/Lauren team approached. They'd started with a hot shop called Rosenfeld, Sirowitz and Lawson, where one of the part-

ners, Leonard Sirowitz, had gone to school with Lenny and Jerry Lifshitz. Sirowitz, who ran the pitch to Lauren's team, thinks several things led to his losing the account. "Our research department had come back with some silly conclusions," he says. "We informed Ralph it would better if we didn't use his photo. I don't think he wanted to hear that." Sirowitz also noted that he'd known Ralph as a Lifshitz. "That may have contributed," he allows a little glumly. "I don't know."

Julian AvRutick, an old friend of George Friedman's, got the business instead. But since Ralph had approval of all advertising, he was the client that counted. "And he was a tough one," AvRutick says. "He had to be satisfied." Ralph showed up at their first meeting with "a phalanx," AvRutick continues. He soon realized that the only ones who counted were Ralph and Buffy Birrittella. "They had no experience with advertising, but they knew what they liked," he continues. "They were learning. They went to school on us."

They were strictly visual people. "They used the name and a picture, and the picture had to do it all," AvRutick recalls. "Everything was an association. They haven't got much to say, so they borrow. It's a safety issue." They would only agree to use a still photographer who already had a reputation. So AvRutick recommended that the print ads be shot by photojournalist Slim Aarons, who'd just published A Wonderful Time, a book of sumptuous, nuanced photos of socialites.

Aarons lived in Bedford, New York, where Lauren would later buy a house, and had taken some of his best-known photos in the Round Hill, Jamaica, villa of William and Babe Paley, which Lauren would also later buy. Neither AvRutick nor Aarons recalls whether Ralph already knew of Aarons's work, but it would henceforth be a touchstone for him.

Aarons's pictures have long been copied by advertising agencies, which frequently use what are called "swipes"—photos ripped from books and magazines—as creative "inspirations" for future photo sessions. "They hired me to rip myself off!" Aarons roars when asked how he got involved with Polo. Summoned to a meeting with the ad team and Lauren, he learned they wanted him to reshoot a 1955 photo of polo player Laddie Sanford, sitting in a director's chair next to a station wagon at a polo club in Delray, Florida, a tweed jacket draped over the back of the chair, a spaniel sniffing at his feet.

"Put Ralph in the chair," Aarons told them. "Ralph didn't say anything," he continues. "They said, 'We don't use clients in our ads.' He never forgot that." Aarons shot some pictures of models posing as polo players, instead. "They didn't like them," he says. "How you gonna beat a real polo player?" Then they showed him their TV commercials and told him how hard they'd been to shoot: the models on the sidelines were afraid of the rampaging polo ponies. So Aarons

asked them to let him try it on his own, and photographed what became the ad: a local Bedford woman at her own stable, pulling a pony wagon holding two children of a friend—"pure WASP kids, if you know what I mean," Aarons says—each wearing a little polo cap and toting a child's polo mallet.

Lauren remained involved throughout the entire process, "as involved as any client gets," AvRutick says, "not only in terms of articulating his views but in terms of approving any material we created. He knew this was important. It was his first big national exposure." In the process, AvRutick admits, he had moments when he thought Lauren a pain. "But time having passed," he adds, "you see the success. It was his business, his life, his image, his name, however he came by it. He was tough, but he was smart. He was extraordinarily good at figuring out what was best for him. And it was all part of this mosaic he was making."

Slim Aarons never shot for Polo again. "I wasn't an advertising photographer," he says. "They hire you for what you do, then tell you how to do it. I was doing the pictures they were all copying." And what of those who say Lauren and his advertising team copies him to this day? "Why should I be upset?" he laughs. "Everybody knows it." And Lauren is still a good customer, it turns out. "He's bought hundreds of copies of my book," Aarons says, adding that it is so rare, they now go for $1,500. "He buys my pictures all the time and puts them on the walls of his stores all over the world."

51

Ralph's fragrance business had expanded, but it wasn't the only magic happening at Polo in 1978. Six years after their introduction—in twenty-four colors in 1972—Ralph's knit Polo shirts had become one of the most important items of status clothing in the world. Polo's CFO Harvey Hellman recalls a meeting with Ralph, Jerry, and Peter Strom, in the late seventies, when Polo goods were still sold only in a relative handful of better specialty and department stores. "You could not open up your distribution unless you had some item you could get into a lot of stores and make some real heavy margin," says Hellman. They were discussing how to do that when someone

said, "Maybe we could take over Izod's business." Lacoste shirts were still holding their own, but Polo's image was better and stronger than Izod's, and its shirts were better made, with better stitching, and used pearlized buttons instead of plastic.

The brilliantly successful shirt had many fathers. "I don't think Ralph would ever admit to this," says salesman Edwin Lewis, "but [the Polo knit shirt] was a collaboration." Gil Truedsson had come up with idea. And Lewis turned it into a phenomenon. His biggest account was Neiman Marcus, and that year, he suggested that the store put the shirt in its famous mail-order catalog in every one of the dozens of colors Polo offered. "And it takes off," Lewis says. "And it was insane."

Thanks to that Polo shirt, and its embroidered cousins, the Shetland sweater and Oxford dress shirt, suddenly, everyone wanted Polo. Polo's tailored clothing remained a hard sell, but the sportswear and shirts were blowing out of stores. With the addition of a solid women's business and Warner/Lauren's cash-cow fragrances and national advertising, a critical mass had been achieved.

"Now, Ralph's feeling some fat on his bones," says Lewis, whose star rose along with Polo's volume. "I'm twenty-five years old, I'm making six figures, I'm riding around in a BMW 3.0 Bavaria, working for probably the hottest name in America, loved the fun, loved the women, and then Peter called and said, 'Pack your bags, I need you in New York.'" Though it would be a few more years before he moved North for good, Lewis was on a fast track that would bring him within a nose of Strom's job—and then cause him to lose his own.

Ralph's business was great, but the American economy soured in the late seventies and many stores were hurt, even big ones like Britches of Georgetown, which had grown into a fourteen-store chain. So when Polo announced that it was going to start selling to Britches' competitors in Washington—discount stores among them—Britches co-owner Rick Hinden unloaded on the *Washington Post*, griping that Polo's suits were badly made.

"It was a terrible incident that I regret," says Hinden's partner, Dave Pensky, adding nonetheless that Lauren's "deliveries were bad," and that Polo "made it impossible for us to maintain our exclusivity." Ralph had changed, Pensky felt. He was no longer loyal to his early supporters. "Our friendship ceased, I'm sorry to say. We've had no contact since, and I feel very badly about that."

Ralph's women's clothes faltered, too. Though orders for the line rose 30 percent to $18 million for the fall 1978 season, Stuart Kreisler did much better selling them to stores than stores did selling to customers. Early in 1979, the *New York Times* ran an article singling out Lauren as a label suffering from overpen-

etration. It included Kreisler's admission that the line still suffered fit problems. "We could never ship groups," says a Kreisler Group saleswoman. "Stores would get a pant in June and the jacket that went with it in August. The design team would change their minds a lot."

That January, Polo was reorganized, and given a structure for the first time. Buffy Birrittella was eased out of design entirely and put in charge of advertising and publicity. Nancy Vignola, an assistant, and Tasha Bauer, until then Ralph's fit model, took over women's design. With Tasha in place, Ralph could focus more on expansion. In February 1979, his fragrances were launched in England with a bizarre London party. Ricky was the only woman wearing a Lauren outfit at the dinner for one hundred, hosted by a decorator. The Laurens was thrilled to dine with guests like Lady Duff-Gordon; Mary, Princess of Pless; Lord Duncan Sandys, the Marchioness of Cholmondeley, and the Earl of Gainsborough, even though they didn't seem to know who Ralph was, according to a tart party report in WWD.

John Fairchild, who owned WWD and DNR, was an Anglophile, too, but also a notorious snob. He thought Lauren was a pretender and over the years took every opportunity to cut him down. Ralph complained to one of Fairchild's editors that he felt persecuted by WWD. As every journalist who ever covered him quickly found out, Lauren, who wore his insecurities on his sleeve, made a tantalizingly easy target. He felt safe only within the world he controlled, where he could approve every button at his own speed. "That's what made him great," says a designer who worked there at the time, "but as you grow, you have to del-egate, and he had problems with both delegating and with giving credit. It was amazing how threatened he could feel, so you had to play the game of letting everything be his idea."

Ralph's insecurity, combined with Tasha Bauer's ascendance, put the design-er's relationship with his muse Jenny Witbeck in a vise. "She didn't think he was just the dreamiest thing," says a Poloroid of the period. Witbeck was appalled, for example, when Lauren whipped off his shirt to show a physique honed by jog-ging and weekend basketball games with old friends like Steve Bell. WWD even ran a page-one photo of such a moment: Lauren—in cowboy boots, silver-tipped belt, big sports watch, and Ray-Bans—is shown removing an Oxford shirt and using it to accessorize a burlap dress, as his design assistants look on. "Aren't I handsome?" he would ask at moments like that. "Don't I look great?"

Peter Strom thinks Lauren's questions weren't needy, but were designed to heighten people's sensitivity to the subtleties of apparel. "In all the years I knew him," Strom says, "I don't think he ever wore the exact same outfit twice." But many who worked with him saw it differently. "He was a major egomaniac," says

the Poloroid, "and for a straight man, it was amazing how neurotic he was about what he wore. He'd wear his Cary Grant outfit—silver suit, gray tie, and horn-rims—and he doesn't wear glasses! He was always put together like he'd studied every outfit for weeks. People with style just put clothes on." Not only did the effort show, he was constantly looking for approval. "Do these shoes go with these socks?" "What do you think, girls?"

Tasha knew how to handle him: "*Ohhh*, Ralph . . . ," she'd sigh.

The flip side of his insecurity was bossiness. It was displayed when his wife ordered her clothes each season. Though the outside world was told that Ricky was Polo's ultimate arbiter of women's fashion, "when she came in, he wouldn't let her approve a stickpin," the staffer continues. "Design had to okay every detail of every outfit." And sometimes that wasn't enough, "Ralph didn't want me to have this," Ricky would say when, as often happened, the clothes were returned. "That's what a neurotic control freak he was," says the Poloroid. "The image consciousness is *beyond*." Beyond anything anyone had ever seen before, that is. And it has remained so. Twenty years later, this same design staffer says, Ralph, Ricky, and the Jerry Laurens would arrive at Vico, a restaurant near Ralph's apartment, in a stretch limousine one rainy night and emerge in coordinated suedes.

Tasha's rise was Witbeck's fall. "Tasha wanted all of it," someone close to Witbeck says. "Tasha was older, and she got things done. Jenny's job had no structure; it was ideas. Executing is a lot harder." Tasha was smart, focused, and willing to do grunt work like photocopying. "Whatever it took," says one of her admirers.

As Ralph's long-time fit model, Tasha had an especially intimate relationship with him. Though most agree her relationship with Ralph never went further than flirtation, studio gossips wondered, at least until Tasha married and began calling herself Tasha Polizzi in 1980. Right around that time, Witbeck decided that Tasha was meeting with Ralph alone, claiming Witbeck's ideas, and undermining her. After Tasha was promoted to merchandising director, and then, in 1981, to director of women's and girls' design, Witbeck quit. So did Ralph's sketch artist. "They didn't want to work for Tasha," says the studio hand. But in the looking-glass world of Polo, Tasha's strength would eventually prove to be her undoing.

52

R alph had just showed his 1978 western collection when he and Donald Fisher, president of the Gap, the jeans retailer, announced a co-venture, a new department store brand called Polo Western Wear. Though it was another licensed line, and not his own, Ralph was finally going to have a blue jeans business.

The contract with the Gap included a separate design agreement with Ralph as an individual doing business as the Ralph Lauren Design Studio, based in his Fifth Avenue apartment. It was set up as a separate entity that allowed him to hire any assistants he felt were necessary and appropriate. The Gap paid him a design fee of $160,000, with annual raises of $40,000 a year. An amendment guaranteed a $400,000 budget for the first year's advertising.

"Ralph's like a surfer," says one of his designers. "He's very quiet and intuitive, he surrounds himself with people with taste, and he watches. There was a wave of western interest, and he caught the wave." But Ralph's competitive instincts had also been aroused. Though he was besting Calvin Klein in the fragrance arena, Calvin had already launched his famous five-pocket jean, and sold two hundred thousand pairs the first week they were on sale. Ralph was as envious as his plan to compete was ambitious: he was going to sell an enormous range of merchandise—from hand-tooled cowboy boots to bandanas—all western-themed to cash in on the emerging urban cowboy craze.

"I made Western wear very important," Lauren would boast. "I pioneered it." Never mind that there was a West before him. Never mind, too, that in a legal document at the time, Polo admitted that the western, utility, and surplus styles the new company would sell would be "of the type traditionally sold by L.L. Bean of Freeport, Maine."

Instead of positioning his products as costly designer jeans à la Calvin, Lauren and the Gap planned a midpriced, mass-market approach, just as Warner/Lauren would do in 1980 with its Chaps fragrance (released in a box belted with leather straps and a silver buckle). "I have never believed in fashion," Ralph explained. But that's what it was. And what the Gap thought it was, too.

Despite Lauren's protests that the line wasn't fashion, the Gap exerted huge pressure to get it designed and on sale before other manufacturers jumped on the trend. Fisher hoped that after Western Wear gained traction in department stores, he'd be able to offer it as a fashion addition to the Gap's basic merchandise.

"It was a very trendy idea, and everybody got carried away, thinking it would be a way of life," says Norman Grossman, the veteran fashion executive who was named Polo Western Wear's president. "But it really wasn't. How many western shirts does a man own?"

Still, in the months building up to the launch, hopes were high—and so were the Gap's expenses. Polo Western Wear's new showroom on Fifty-fourth Street—symbolically far from the garment center—was decorated with boulders trucked in from the Southwest, sand-blasted floors, custom-made pony pillows, suede furniture, and hand-cut plank tables. The salespeople were ordered to wear cowboy boots.

Again, Ralph used Ricky Lauren as his fit model. "Not really what the American woman was about," a salesperson sighs. "We all tried on the pants. They didn't look good on anyone who wasn't long-legged and thin." When the jeans didn't sell, Ralph sent Ricky to the showroom to put a pair on and show the sales staff how great they looked. Marvin Traub says Bloomingdale's had no fit problems with the jeans. "They may have been engineered for our customers," he admits. But away from the East Side of Manhattan, things were different. Says the Gap exec, "His jeans didn't fit the asses of the masses." The Gap was producing them and could never work out fit specifications with the Polo design team. The bottom line was, Ralph didn't want to know who his customer was. And no one would tell him. "No one wanted to say no to a designer then," says the executive.

Western Wear was sold as if it were a preordained success. The demands made on retailers were Draconian, especially as no store was given exclusivity. Lauren insisted that it have its own departments—decorated with antique wagons, barrels, and whisky crates. Minimum orders were mandatory, had to include the entire concept, and had to go into every single store in a retail chain. The launch hype was equally spectacular, the reality less so. After it hit stores early in 1979, WWD reported that some retailers felt sales were hurt by "deplorable" deliveries ("We shipped two out of ten items," admits the salesperson) and the "impossible" fit of the jeans. Even Marvin Traub was heard to complain about it. Though WWD quoted Lauren denying he was suffering from "high-handed egotism," the paper made that case plainly. A life-size cardboard cutout of Ralph, in cowboy boots and string tie, stood at the entrance to the

Bloomingdale's Western Wear boutique. It was the kind of tacky, revealing touch WWD loved; the paper ran a prominent photo of it.

By the end of the year, wholesale orders had hit $50 million, but only about half those goods were ever produced and delivered. What was sat unsold in stores. Ralph and the Gap were fighting all the time ("not unusual in Ralph's relationships with licensees," the Gap executive chuckles) and soon, the unromantic Fisher had had enough—and began trying to sell the trademark. Western wear had proved less than a bonanza.

Finally, the partners in the venture wanted different things. The Gap wanted a mass-market wholesale line with huge volume "out of the box," says Norman Grossman. Lauren wanted high volume, and high profits, too, but without sacrificing quality or diluting his high-end image. It was a gap that couldn't be bridged. "We ended up doing it Ralph's way," Grossman says. "The Gap didn't have the right taste in its mouth to get through the growing phase. Nobody had the stomach for it."

Polo blamed the Gap. "The Gap ran it and they didn't know how to do it," Ralph says. "I met Don Fisher later, and I said I guess this was the one thing we each did that wasn't successful, and he said 'It was my fault.'" Norman Grossman didn't think so; he blamed Ralph's perfectionism and his rodeo-look concept: "If he'd made it weekend wear, rugged sportswear, it might've had a better life." Others say Fisher was flabbergasted—"He'd never been confronted with anybody like Ralph," says the Gap executive.

The Polo Western Wear sales staff sobbed when the Gap announced it was closing the business in February 1980. "But we were always late and we were never shipping," says the salesperson, "so we shouldn't have been surprised." The lavish showroom was sublet and inventories liquidated (clothing worth $25 million at wholesale was disposed of for about $10 million). A few months later, the Gap announced a $5.8 million write-off against 1979 earnings because of the failure of the line—"a bloodbath," says the Gap executive.

It was the first, but not the last, time that Ralph would fail with blue jeans. The one clothing item that should have been an easy layup for him would prove instead an unfailing source of foul-ups. His jeans always flopped, but he would keep trying. "This is an unbelievably tenacious individual," says Peter Strom.

53

As Polo Western Wear was being consumed by the hubris attendant to its birth, another portentous cloud was darkening the wide open spaces of Ralph's dreams. The Kreisler Group, which held the Lauren women's wear license, was hurtling toward insolvency.

Still spreading its bets as Stuart Kreisler had since he started, only now on a larger scale, the Kreisler Group had diversified and bought two other "designer name" brands. But neither shone like Ralph's, both proved to be money losers, and in December 1977, the thinly capitalized Kreisler Group had to borrow $1.75 million from its friends at Chase Manhattan Bank. "We were a stellar account, one of their young, growing companies," Kreisler says. And Kreisler's partner, Alan Ginsberg, had worked for Chase. But that only mattered in good times; the Kreisler Group lost $5 million over the next eighteen months. The fall 1978 dip in Ralph Lauren retail sales hurt; Kreisler now denies it, but Alan Ginsberg admitted at the time that the Lauren license was losing money. And financing Lauren's ever-growing inventory was increasingly expensive.

The company had bitten off more designers and debt than it could chew. "The interest rates were killing me," Kreisler says. "They were creeping up to 21 percent.* Profitability wasn't where it should have been," he admits. "We went on what they called credit watch, and then it becomes a snowfall." Which turns into a snowball as it rolls inexorably downhill.

In March 1979, Kreisler signed an agreement that gave Chase a lien on all the company's assets, including its contract rights to Ralph Lauren's name. Kreisler and Ginsberg also gave Chase personal loan guarantees. Until then, their problems had stayed secret. But in July 1979, one of the Kreisler Group's original designers, Clovis Ruffin, tried to pull out of his deal after it canceled his next collection. Kreisler's woes became public and his loan officers suggested he ought to close his business. "Maybe because I was very young, maybe because I

* In fact, the prime rate was creeping up, but still under 10 percent when Kreisler stopped paying its bills and its credit lines were cut.

was dumb, I wasn't going to do it," Kreisler says. He went to Ralph and Peter Strom and suggested a new partnership to make only Lauren women's clothes. They said no. Kreisler isn't sure whether Polo lacked the money, the leverage with creditors, or the will to pull him out of the mess he'd gotten himself into.

It turned out Kreisler's mess was only a small part of a larger disaster in the making at Chase. Dave Goldberg, Polo's old factor, who was asked to take over Chase's factoring business at the time, says Chase had put more than $25 million into Kreisler. "And it wasn't just Kreisler," says Goldberg, who had to deal with fifty-two troubled factoring accounts. "Chase was badly overextended all over the place. It took three years to clean it up."

In September 1979, when Kreisler stopped paying his 156 employees, Chase Manhattan was about to attach the company's assets, including the only one that mattered, the four remaining years of the Lauren license. But a few days earlier, Polo had sent a notice of default—first step in an attempt to cancel the license—claiming Kreisler had failed to pay commissions and maintain complete and accurate books, and demanding money it was owed. Kreisler sent Polo a bad check. Strom responded with a letter terminating the license.

Kreisler's business was totally dependent on Lauren. Not only were Ralph's sales far higher than Kreisler's other designers, but under the license Strom was trying to end, the Kreisler Group also collected a big chunk of the income—anything earned by women's clothing—from Polo's licenses with Butterick Patterns, the Gap, and Polo's Japanese licensee. So Kreisler went to Sidney Kimmel, a garment center fixture who'd taken over Jerry Lauren's former employer, Jones New York, and made a deal for him to rescue the Lauren business—with Kreisler continuing to run it. But Kimmel wasn't the only game in town.

Ralph Lauren had always been afraid of licensing because it inevitably meant a loss of the control that he cherished beyond anything else. Ralph had controlled Stuart Kreisler, but Kreisler had lost control of his business—and was on the verge of going bankrupt. And so Ralph's women's line, the diadem of his fashion dream, was about to become a crown of thorns.

Short, pugnacious, and a bit unkempt, Maurice Bidermann was born Maurice Zilberberg, half Jewish, half Argentine, and the half brother of the disco queen Regine. As a young man in Paris, he got to know a Madame Bidermann, whose husband owned a garment business fallen on hard times. "Just to make things easier," he says a bit mysteriously, "we'll say he was an uncle." By age twenty, Maurice had taken over the business and taken on his "aunt's" last name. The pattern of his career was set, taking over businesses and using other people's names to sell clothing.

In the sixties, Bidermann acquired more ailing clothing and uniform factories. Then he signed a menswear license with Pierre Cardin, the couturier who'd pioneered licensing. When Cardin quit Bidermann's factories in a dispute in the seventies, the apparel magnate promptly signed up Yves Saint Laurent, and didn't even miss a season's business. All he did was "switch the labels," he says. Such was the licensing business.

By 1979, Bidermann had signed up lots of designers, including Daniel Hechter and Calvin Klein, and was a force to be reckoned with in men's fashion. That year, his French company grossed $560 million and employed thirteen thousand people in thirty-four factories all over the world. To grow more, Bidermann needed to get into the women's business.

Late that summer, Bidermann learned that Kreisler was in trouble and that Lauren couldn't afford to buy back his license. Although Bidermann had heard that Kreisler was an extravagant spender, he nonetheless called to offer his help.

Wary of Bidermann's menswear pedigree, Kreisler preferred to deal with Sidney Kimmel. But Lauren rejected the proposed deal with Kimmel—perhaps because Kimmel had just turned down an offer to take over the Gap's interest in Polo Western Wear, but more likely because Jones then made "moderate" sportswear, several notches below "designer" goods in the fashion food chain. Lauren considered Kimmel a *garmento*—one of the lower order of garment businessmen. So Kreisler brought Bidermann's more acceptable offer—which included an immediate infusion of $1 million in working capital—to Chase, and a deal was made. But it came unmade within days after New York State tax officials examined Kreisler's books and presented the company with a bill for back sales taxes.

Kreisler blames the press for driving him into bankruptcy. He says he didn't owe any taxes and denies his company engaged in the common garment center practice called Sunday selling, in which wholesale companies make tax-free retail sales from their showrooms. He claims the state tax officials came around only "because there was a lot of notoriety, a lot of press—*Women's Wear Daily* had about eleven front-page stories on me and they forced it." Describing Susan Alai and Nancy Josephson, the writers of those *WWD* stories, as "vicious, vicious girls," Kreisler claims they, not his creditors, forced him into "a fast [bankruptcy] filing . . . to be sure everything is clean and *glatt kosher.*"

But a Kreisler Group employee says that the company's namesake had been worried sick all that summer, and although Alai and Josephson's front-page stories in *WWD* on Kreisler's troubles—of which there were precisely eleven—began in August 1979, none hinted at financial improprieties until after the

bankruptcy filing. A combination of circumstances—and his inability to control them—actually forced Kreisler's hand.

Handed lemons, he made lemonade.

The Kreisler Group filed for protection under Chapter 11 of the U.S. bankruptcy laws on September 20, 1979—and was approved as a debtor in possession. As he discusses the bankruptcy, Stuart Kreisler seeks to downplay it. At first, he calls it "a technical bankruptcy." Later, he insists, "That was not a bankruptcy that needed to happen. We had only one creditor: the bank." But the bankruptcy filing includes outstanding bills from 229 other creditors, including lawyers (Philips Nizer was owed almost $40,000), a fashion photographer, WWD, the Hearst Corporation, publicist Eleanor Lambert, five model agencies, the Hotel Pierre, Surrey Limousine Service, the UJA-Federation of Jewish Philanthropies (which was owed $22,500), the Italian fabric house Ratti (which was owed almost $250,000) and Kurtz & Tarlow, the advertising agency that took over the Polo account when Julian AvRutick left Ammarati, Puris, as well as embroidery, label and trim makers, truckers, warehouses, and a press clipping service.

By far, the biggest debt was owed to Chase, which was out $9,397,398 from various factoring agreements, loans, letters of credit, and other guarantees it had issued. Kreisler had only $1,782 in the bank. His most significant asset was $1.7 million in inventory—including both finished and unfinished goods. All concerned recognized that a hiccup in production of the Lauren line could bring down the whole house of cards. So seven days after Kreisler filed for bankruptcy, Chase loaned the company almost $1.3 million more to keep going. Chase appeared to be in the driver's seat—and like Kreisler, Ralph was going along for a bumpy ride. "We couldn't get our license back," says Peter Strom. "The creditors had it, and we went through hell. We wanted to not have a tremendous eruption." Letting Bidermann take over the license, Strom continues, "appeared to be the smoothest way." In fact, it was the only way.

Bidermann created a new subsidiary, Ralph Lauren Women's Wear, and the bankruptcy court agreed to let it sell Kreisler's inventory and take over paying the Lauren operation's salaries and expenses. The new company was also given a temporary license to produce Lauren's resort line, due in stores in just a few months. Chase loaned Bidermann another $700,000 to facilitate the deal.

In exchange for letting Bidermann take the license, Chase was allowed to collect all of Kreisler's outstanding bills for the fall goods it had already produced and begun shipping to stores, and apply the proceeds to Kreisler's debt. Chase was also reimbursed for a payment of $58,000 it had made to Polo to cover Kreisler's bounced check. Polo and Chase both signed off on the deal, and the

bankruptcy filing was accepted in October. The Lauren women's business was saved.

One creditor, a Hong Kong factory, objected, however, and filed a lawsuit that would drag on for years. The suit charged that the court had, in effect, allowed the very people who'd driven the company into insolvency to profit from its bankruptcy. The suit alleged that under the cover of a Chapter 11 reorganization, which is the kinder, gentler form of bankruptcy, the court had really approved a prepackaged liquidation and sale of the assets of the Kreisler Group—which, according to bankruptcy law, should have been accomplished under the far more onerous provisions of a Chapter 7 bankruptcy. But a Chapter 7 filing would have assured disruption to the continuity of the Lauren business and threatened Chase Manhattan's ability to collect the money owed to Kreisler.

Had Kreisler not continued running the company, says Dave Goldberg of Chase, the stores Kreisler sold clothes to "would have lodged every complaint known to man to try not to pay" for the fall goods they'd received but not yet paid for. "When people smell bankruptcy," Kreisler agrees, "nobody pays. The bank had to play along." And what the bank wanted, the bankruptcy court wanted, too. The only way to play, though, was to give Ralph Lauren something, too—and once it became clear that he couldn't get his license back, he'd decided he wanted his license transferred to—as one witness claims Ralph put it at the time—"that nice French gentleman, Mr. Bidermann."

The court was told the Kreisler Group would survive, reorganized as a sales and marketing organization, but, in fact, Kreisler became an employee of Bidermann, albeit the president of Ralph Lauren Women's Wear. Bidermann took Kreisler on, despite his tarnished track record, because Kreisler knew the women's business, and because Lauren still supported him. So Kreisler gave up his other businesses, and three of the four floors he'd occupied in 550 Seventh Avenue, and set up shop on the remaining floor, where Lauren's women's business operates to this day. "Everybody got paid," Kreisler says. But he's exaggerating. Bidermann eventually paid the Kreisler Group's remaining creditors 15 percent of what was owed them—or twelve cents on the dollar—without interest.

"Kreisler was a solid bullshitter," says Polo salesman Jim Rushton. "You never could tell when he was telling the truth." He wasn't telling much of anything when he appeared in bankruptcy court in May 1980, for a hearing on that outraged creditor's lawsuit. Asked what his salary was (the security agreement with Chase had limited it to $150,000 a year), he said, "I would have to check." He dodged and weaved some more when asked how many cars the company leased (they included a late-model Mercedes, a BMW, and a Firebird—his Porsche was on a personal lease). Wasn't there also a late-model Cadillac limousine? "I

think the company may have had one," Kreisler said. Was it used for personal reasons? "I'm not sure." He went on to testify that he wasn't familiar with his company's checking account, would not have known if the company was insolvent, and couldn't say if it was true that the preceding spring, its accounts had often been overdrawn by as much as $100,000.

Then, the litigating lawyer, whose name was Martin Klein, got to the point he really wanted to make. Had Kreisler borrowed $61,000 from the company? Maybe, Kreisler answered. Kreisler and his partner Ginsberg had "used this corporation for their own personal benefit—constantly," the lawyer sputtered. Not only had the Kreisler Group bought them both $2.25 million life insurance policies, the lawyer alleged, but it had also paid for a doctor, hotel bills, and a landscaper, and, he continued, "your wife used the company account maintained at Bergdorf Goodman to furnish her personal residence." Kreisler calmly replied that if, indeed, the company had loaned him money, it was all properly accounted for in a loan account. Thundered Klein in response, "All this at a time the company was insolvent and showing a $5 million loss!"

Martin Klein wasn't the only one who thought Stuart Kreisler was living a little *too* large. WWD, fascinated with the Kreisler Group's bankruptcy, reported on the shoddy record keeping of the Kreisler Group, on Kreisler's Porthault linens, his gardener, his maid, his chauffeur, his kids' horseback riding lessons, and his and Ginsberg's black Porsches, just like Ralph's—Kreisler's Turbo was a $30,000 car, Ginsberg's Targa cost $16,000.

Kreisler remains unapologetic, and even blames Chase for its loss, which was $1.7 million according to Kreisler, the only one involved who is willing to offer a figure. "The bank took a haircut," he allows. "And the only reason was the way they played out the hand. If they'd left the business intact and hadn't forced the sale," he insists, "they wouldn't have lost anything."

How does Chase think it got stung? Its bankers decided to keep the money flowing in order to protect their investment. "Do I roll forward or shut 'em down?" asks David Kantes, who ran the Chase lending operation. "We guessed wrong." The Chase officers were aware of how well Kreisler and Ginsberg lived, but believed they were good enough businessmen to conquer the world without capital—just as Ralph Lauren had done.

With the benefit of hindsight, Dave Goldberg scoffs at that. "Obviously, Chase or any other factor does not provide funds for personal use," he says, "but you have to exercise control over those funds, and Chase wasn't exactly skilled in that endeavor."

A Chase officer involved with the troubled Kreisler loans agrees to explain on condition he is not quoted by name. "The point of doing business is taking risk,"

he says. "In that case, we got stuck. They did borrow. They did live very well. They bought things with mirrors and didn't have the wherewithal to support what they bought." Did they use corporate funds for personal purposes? "They all do," the officer says. "But they didn't steal. Nothing could be proved."

Why didn't the bankruptcy court give the workout more scrutiny? After all, had Kreisler been forced into a Chapter 7 proceeding, a trustee would have been appointed to investigate what actually went wrong. But that might have been even more embarrassing to the major creditors like Chase than to Kreisler and Ginsberg. "Nobody wanted that," says lawyer Martin Klein. So instead, "the people who caused the problem continued to run the company and paid themselves handsomely, too," Klein says. "Kreisler got the best of the deal, and that just seemed wrong."*

Which leaves the question of why Ralph Lauren stepped in to save Stuart Kreisler. Without doubt, Kreisler understood how to romance Ralph's products and merchandise his attitude. "Stuart never hurt the name," Peter Strom says. "He always believed in the brand and the man. He tried hard. He was just misguided." But the Kreisler saleswoman says Strom and Kreisler were always at odds. "Peter always thought he was up to something," she says. "I don't want to say shady, but Stuart was not as professional as he should have been."

Some who know him speculate that with Kreisler now in *his* debt, Lauren thought he could use him to watch and control Bidermann, just as he'd used Pamela Branstetter at the Kreisler Group. Lauren insists it wasn't that at all. "Stuart was very good to me when I needed help, and I stayed with Stuart," he says. His payback for that loyalty would be fifteen years of grief, ending in a return to bankruptcy court. Mr. Bidermann, it would emerge, wasn't the gentleman Ralph hoped he'd be.

* Kreisler calls Klein "a terrible guy" who was "trying to make a name for himself."

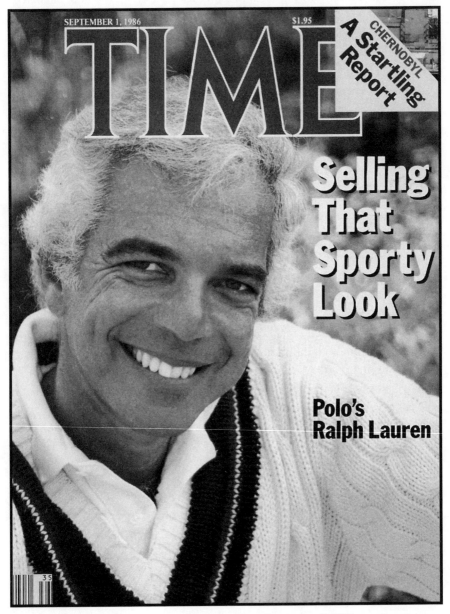

SEPTEMBER 1, 1986

$1.95

TIME

CHERNOBYL
A Startling
Report

Selling That Sporty Look

Polo's Ralph Lauren

The turning point; *Time* magazine, September 1, 1986.

Ascension: From Man to Myth

I became, like, a cult.

—Ralph Lauren

54

I t was the summer of 1985. In a video studio in midtown Manhattan, the two faces of the designer decade were displayed on editing machines. One was an in-store video for Calvin Klein, the other a series of black-and-white Ralph Lauren commercials introducing his third stab at marketing dungarees. He was still trying.

Klein's provocative video was about a boy's introduction to desire and jealousy. The males in it all looked as fey as James Dean as the only female in the video toyed with all of them. Lauren's evocative commercials were country to Klein's urban jazz. Rodeo photographer Louise Bogan sang "Home on the Range." A farm boy talked about playing baseball, a blonde girl about moving to Paris.

The two videos couldn't have been more different, yet they shared a crucial element: both were made by the burly, bearish fellow shuttling between the two editing rooms. He wore a scraggly, graying beard, a rumpled black jacket, and a wrinkled white cotton shirt, buttoned to the neck and stretched taut over an impressive belly; a cheap scarf was knotted over his balding head. Bruce Weber, then thirty-nine, was an unlikely, unglamorous fashion photographer. But his just-so sloppiness, an image he clings to today, is meant to dissemble. "In this business, everything we do is about creating an image," Calvin Klein admits. As Lauren and Klein's primary photographer, the uncredited "auteur" of America's two best-selling designer images, Weber was the manufacturer of their most important product.

"Ralph had the vision, but Bruce was able to visualize and communicate it," says a former Polo executive. "His aspirational imagery was the real key to our success. He created a world people wanted to be part of. The advertising drove the business."

Weber replaced Les Goldberg as Polo's catalog photographer in 1978, shooting his first photos for Ralph that year on Shelter Island, a remote summer colony off the eastern end of Long Island, not far from Lauren's rented home in East Hampton. Weber's appearance in Ralph Lauren's life was as much a water-

shed as Polo's wide ties had been eleven years before. By the mid-eighties, the multipage advertisements he shot for Ralph—huge location productions running as long as twenty pages in glossy magazines—would be widely recognized as the ideal form for the presentation of fashion "lifestyle" and the products that created it. "Ralph saturated magazines that never covered him the way he wanted to be covered and told consumers who he was," says the Polo executive. Though they were more commercial allusion than compelling narrative, the ads were often compared to movies.

By 1985, Weber had been shooting for Lauren and Klein for years. By then, he'd won a provocative reputation, for both the overtly ambisexual pictures he took for Klein, and for the more covert and freighted photos he made for Polo. "He puts you face-to-face with a reality convention has always hidden," the late Condé Nast editorial director Alexander Liberman said. "The existence of male sexuality is tangible." For all their differences, Klein's and Lauren's images shared that similarity: their men were as much sex objects as their women, only it wasn't always easy to say who was objectifying who. As advertising critic Barbara Lippert put it, Weber's distant, yet emotionally charged photos for Lauren seemed to capture the moment just after a man has told a woman he's homosexual. Whether that was the intention or not, they certainly got your attention.

Weber came along at a crucial moment for Lauren and Klein, the dueling designers from the Bronx. As the eighties began, they were like rockets that had lifted off Earth but needed a bit of extra power to escape gravity. Weber, and the way he visualized their brands, was their booster rocket. As surely as Klein's jeans and Lauren's Polo shirts were the vehicles that put the two designers a world apart from their fashion fellows, Weber took a form—the fashion photograph— that had long existed in a realm apart from everyday existence, and gave it a natural, wholly American look in tune with the moment, a look so successful it was quickly copied everywhere from Italy to Japan.

Weber plundered the visual past for Klein, in form studies inspired by Edward Weston, and for Lauren, in scenes evoking the films of Nicholas Ray, John Ford, and Preston Sturges. Weber rummaged through our image attic for the archetypes of American boyhood: the cowboy, the athlete, the preppy, the rock star. His was an all-American willingness to venture into the unknown. And, though they sometimes took their clothes off, his pioneer-gypsy shoot team, a traveling repertory company of stylists, editors, assistants, and models, had an eager, Andy Hardy–esque, "C'mon, kids, let's make fashion" innocence that came through in every frame.

For that, Weber was paid $10,000 a day. It covered his fee, overhead, salaries

for a staff of three, and an agent's commission. Expenses—always substantial—were extra. And rights to use Weber's photographs cost thousands more, depending on how often and where they were used. A year's use of one picture cost as much as $15,000. Buyouts—in which the client purchased all rights to a photo—paid up to $100,000. In 1984, Polo spent $3 million (including expenses) for Bruce Weber photo sessions. Weber's estimated earnings that year were about $1.5 million.

The money bought Weber his "personal" projects: typically homoerotic portfolios of men together. Some of the rest was spent to finance a Lauren-esque lifestyle: a river-view loft in Tribeca, a rustic compound with a pool in Bellport, Long Island, and Longwood, an eleven-acre eighteen-building camp on Spitfire Lake in the remote Adirondacks Forest Preserve; an extensive collection of photographs, and, again like Ralph, a car collection that included a 1963 Porsche 90, a 1963 Mercedes convertible, two pickups, and a Jeep.

Unlike Buffy Birrittella, who functioned as the chief facilitator of Lauren's vision, Weber was a collaborator, even a co-creator—and that inevitably led to tensions with a client for whom the exercise of control was as vital as the air he breathed. Weber was just as notoriously difficult as Ralph. His battles with fashion magazines were legendary. He constantly complained about clients killing his work or choosing the wrong pictures. He often tried delivering finished layouts instead of photographs.

Weber got away with it because he was a camera chameleon, able to shoot for very different—indeed rival—designer customers: Klein, Lauren, Valentino, Matsuda, Versace, Jeffrey Banks, Perry Ellis, Azzedine Alaia, James Galanos, Karl Lagerfeld, Comme des Garcons. He gave each their own image, yet the photos were just as distinctly his. His seminude ménages for Klein's then-new underwear and relaunched fragrances went as far as ads ever had and unsaddled the Marlboro Man as America's best-performing commercial images. His value to Lauren was amply demonstrated every time Polo gave him another assignment.

It wasn't easy, though. Back in the editing room that day in 1985, Weber was viewing some final Polo commercials when he learned that on his own, Lauren had cut the vignettes into a voiceless montage over music. It was the second time Weber had done commercials for Ralph; the first set had never run. Now he was told Lauren feared these new ones too closely resembled Calvin Klein ads. And Louise Bogan looked too masculine and wrinkly. Weber wanted to use her in a print ad, and Lauren rejected that idea, too.

But for Weber, whose stock in trade was creating selling imagery from the raw material of high-end fantasy, this was par for the course. "I think people are really

frightened," he says, "not so much by the sexuality in pictures as by a confrontation. Things they might have to answer for themselves. I think people are really embarrassed if you say, 'Did you ever fantasize about that? Did you ever dream about that?' If you went around and asked people those questions they'd be really frightened of you." If, on the other hand, you made their desires manifest, as Weber did for Ralph, they'd be *both* frightened of and dependent upon you.

Like homoeroticism, fear was something new in fashion pictures. Before the seventies, the greats had generally taken pictures of women in garments. When Irving Penn wanted to make self-conscious art, he photographed cigarette butts. Richard Avedon's nonfashion portraits captured power, death, and ugliness. But Weber stood apart, a stylistic cross between "heroic" photographers of the 1930s such as Alexander Rodchenko and Leni Riefensthal and glamour photographers Horst P. Horst, George Hoyningen-Huene, George Hurrell, Andre de Dienes, and Roger Corbeau. His iconic imagery made him far more commercial than others who worked the margins like Helmut Newton and Guy Bourdin.

Weber was a workaholic who would, without complaining, kneel on rocks in the freezing cold Pacific for six hours to get the picture. He'd shoot twenty-five rolls waiting for the right gesture. He would edit film 'til dawn the night after photo sessions. Even on vacations, he accepted commissions. He was a perfectionist, known to turn down work if the client had already picked the location or models. While he discussed approaches and models with his clients, "we never get specific," he says. He let his shoots take their own shape, trying to capture fantasies on film. "And sometimes they're not mine," he adds.

Inspiration came from his models. The male amateurs he often used "don't fall into clichéd responses," says graphic designer Milton Glaser. "Their awkwardness makes his pictures dissonant and consequently more interesting."

Weber searched for the telling moment. Even when his models were off-duty, he'd snap them. "I'm constantly staring at them. I'm watching who they talk to, I'm watching how they handle themselves, what they say, the relationship with the other people at the table," he says. One of Calvin Klein's early underwear ads pictured a model feeling ill, who'd lain down in the grass. Klein's sexually charged Obsession perfume ads featured models skinny-dipping after a shoot. "It was so warm in the pool," Weber said. "We were just doing what we were doing."

Lauren and Weber shared an outsider's fascination with the good life, and Klein connected with Weber's voyeurism. Lauren says that when he and Weber did those ads, he would present the photographer with a mood dictated by the season's clothes. "Bruce will then shoot it as he sees it."

"I started working for those guys in a totally unbusinesslike, totally unconventional way," Weber says. "When I work for Ralph Lauren, I draw upon experiences I had in boarding school, trips, family, things I've read." Calvin Klein photos "were always about skin," he continues. "Ralph is thematic. Ralph loved a lot of the same clothes that I loved from antique stores. *Rebel Without a Cause* is very much Calvin. When I work for them, I'm really interpreting what's happening for them at the moment, and I don't just mean in clothes. I mean in their feelings." Ad critic Lippert called the results "distinct" and "mythic." "For Lauren, it's perfect breeding," she wrote. "For Klein, it's threatening eroticism." For some, though, Klein's eroticism was merely titillating; it was Lauren's breeding that was threatening.

Weber calls fashion "completely schizophrenic," but adds, "I was used to that kind of emotion." The source of his chameleon-like empathy lies in his troubled, solitary boyhood in a small mining town outside Pittsburgh. "Part of why I do what I do today is because my family was so crazy, like really insane," he says. They could not have been less like the Lifshitzes: Weber's parents drank heavily, had affairs, and traveled constantly. Left at home, young Bruce lost himself in the snapshots they brought back. "My world was centered about visual things and the way people looked and the way they dressed," he says. In school, he was a water boy, not an athlete. "I had an enormous fantasy life and really wanted to be as athletic or as handsome or as muscular as the people in my pictures."

Weber moved to New York University to study theater and film in 1966 and became, he says, "slightly a little bit of a party boy." That summer, he decided to earn extra money modeling. Roddy McDowall, the actor, took his test photos. Bruce looked like many of the models he photographs today—young, clean-cut, fresh-looking, with rosy cheeks. "I was completely dizzy, never on time," Weber says. Modeling didn't last long.

By 1969, Weber was in Paris, trying to become a photographer. Back in New York a year later, he began shooting press parties for record companies and rock magazines and taking head shots for actors, learning how to coax the best from insecure people unused to being photographed. He started shooting fashion for *Men's Wear* magazine in 1973. "I was totally infatuated," he remembers. The model Mike Edwards, who later dated Priscilla Presley, "was the kind of guy girls really dream about meeting. I thought, I really want to photograph this and give women, and other men if they want, something to look at in men."

Weber felt people of both sexes were "starved for a way to look at men. It was something I had a sensibility about. I knew it was a way for me to start. I took something that was very, very, very easy for me to do in the sense that my feelings about men were very clear to me and I just photographed what I knew." Ralph

was attracted by Weber's taste in men. Before Weber, male models had either been swarthy, European, and gigolo-ish, or else overtly homosexual. Weber scoured America's school yards, picked through college yearbook team photos, hung around gyms and sports fields, even crouched in dunes with binoculars, trying to spot new faces on beaches. He had a taste for heterosexual men with a clean-cut American look. It was a taste others shared. Some of his finds, like surfer Buzzy Kirbox, ended up with Ralph Lauren contracts.

Ralph hired his first contract model, a porcelain-skinned brunette named Kristin Holby, who modeled under her middle name, Clotilde, to introduce "Lauren" perfume in 1978. They'd met when she shot a Saks ad with Ralph and a raft of models and he picked her out of the crowd and asked if she'd appear in his fashion show a few days later. Then he booked her to pose in an ad for Stuart Kreisler's line—choosing her precisely because she was not one of the classic blondes he'd long favored, Ricky Lauren look-alikes like Jane Gill and Bonnie Pfeiffer.

When photographer Patrick Demarchelier's photos of Holby appeared, presenting her fresh-faced and almost makeup-free, the clothes she was wearing "apparently sold like crazy," Holby says, and she was offered the chance to be Lauren's fragrance "image" model. The ads were such a hit that Holby was sent on the road to represent Ralph in stores across America, signing autographs and answering makeup and fashion questions.

In 1979, Kurtz & Tarlow took over the Warner/Lauren account, just before the Chaps fragrance launch. Ralph and Buffy bonded with Sandy Carlson, an art director who was both a partner in the agency and the wife of its co-owner, Dick Tarlow, and hired them to do Polo's clothing ads, too. Years later, Carlson would recall her first meeting with Lauren in a birthday remembrance. "You were interviewing Dick and me as the team to introduce Chaps cologne," she wrote. "You were wearing cowboy clothes—jeans, a fancy belt, silver-tipped boots—and Buffy was dressed like an Indian. I thought, 'Boy, this is really advertising as it should be. Imagine, they came dressed like this just for the presentation.' I came to realize later that you always dressed that way. I came to realize much later that you were hoping to be cast as the lead."

Lauren decided to hire Weber after seeing some of his photos in *L'Uomo Vogue*. Weber's work was everywhere in 1978: he shot his first spread for the *Soho Weekly News*, a sort of underground newspaper, featuring twelve-year-old Brooke Shields in menswear, and an entire issue of *GQ*. A set of pictures of Jeff Aquilon, a Pepperdine University water polo player, on a rumpled bed with his hands down his underwear, won Weber a job shooting Calvin Klein's first men's

jeans ads (one of which became a Times Square billboard) and a landmark twenty-seven-page advertising portfolio.

Calvin had leapt ahead of Ralph, but not for long. Soon, Lauren ordered up multipage ads, too, paid for in large part by his licensees. Each of them was now required to put a small percentage of sales into the kitty that paid for Polo Ralph Lauren's advertising. In exchange, the Lauren goods the licensees made were featured. Until then, whenever designer licensees ran ads, their names always shared the spotlight with the designers's, and sometimes ran even larger; the designers were the supporting players, the licensees the stars. But Ralph changed the rules of that game. He told each of them that though they would still have to pay their share, his would be the only name in the ads, and they would have no say over what the ads looked like. He wanted to ensure that the brand-building impact of the ads would not be diluted. "Of all the things he did, we did, that was the most important," says Peter Strom. "Everyone takes it for granted today. It came from his mind."

Sandy Carlson kept the Polo account when her husband sold his agency to a larger one, Geers Gross, in 1982. She's never left Ralph's side since—she proved that valuable. "Ralph would describe a situation, an elegant dinner party and how the clothes fit into an environment," says a member of the ad team. "He'd describe it in broken non-English, a conversational murmur, soundbites very few people could understand, words that meant nothing and contradicted each other, and Sandy would say, 'I know what you mean,' and out of this would come a campaign."

Of Weber, Carlson says, "You'd never give Bruce a location, a sketch and a model and say, 'Do this.' He's very eager to do what you need and surprise you, but when he gets behind that camera, it suddenly becomes Bruce's world. Most of the models are people Bruce knows, loves, or discovers. Bruce contributes a lot to the clothes, too. It might be just the way he undid your tie or rolled up your sleeves. I know Ralph has been influenced by his eye." Many on Carlson's staff thought Weber's influence went even further. "He was the one with all the ideas," one of them says.

Weber would do two major location shoots a year, lasting several weeks each, then minor ones in between. After Weber did an edit of the film, Carlson would do another. Then Buffy Birrittella, Lauren's aesthetic Praetorian, would review the film; only then would it be shown to Ralph. They always strived for the effect Les Goldberg had achieved in his first Polo catalog, illustrating a lifestyle more than a series of products. Though Calvin Klein got there first, Carlson takes credit for Lauren's multipage ad portfolios. She suggested "we gather money and not run a spread here and a spread there," she says.

Model Kristin Holby describes what a Weber shoot was like: "It was the Ralph girl with her boyfriend, her sisters and brothers and her father-in-law. Cast of hundreds, men, women, children, animals, twenty models paid to sit around, caviar served to us on the beach, no other client had a budget like that. They treated us like princes and princesses because they wanted us to feel wealthy. That's how they created the romance of it."

They'd go to Barbados or Hawaii or Scotland, find cricket fields, rent yachts. "They'd bring in old Jeeps; they flew a zebra from L.A. to Hawaii," says Holby, for a safari themed set of ads. Whether in tandem or in competition, Lauren and Klein spearheaded a new form of advertising, spending millions to buy multiple pages in magazines for Weber's pictures. As Lauren puts it on his website today, "with little or no text, and more importantly, a sweeping cinematic scope," he and Weber "created a pageant of seamless worlds and fascinating characters that consumers could relate to, follow and admire." It was display unprecedented for any fashion photographer. Which made Weber a power in his own right.

Who authored Lauren's image? That remains both obscure and a source of silent tension between Weber and Ralph. Regardless, Weber played a crucial role. "Close your eyes and think of Ralph Lauren and you think of Bruce Weber images," says an early Polo employee. So criticisms leveled at Weber can just as easily be made of Ralph Lauren. "He makes magnificent scenes, moods, and places and conveys a sense of lost times," a photo editor said of Weber in 1986, "but reality is not transcended. You can taste the dust, but it never happened."

55

Weber's ever more lavish productions were paid for by a business that minted money at mach speed. Initially, at least. The Kreisler Group's bankruptcy appeared to be the best thing that could have happened to Ralph Lauren. Ralph's talents, but also his foibles, flourished, fed by the fabulous amounts of cash that now poured in from Bidermann, USA.

Stuart Kreisler had told his staff nothing would change, but things had— immediately. Bidermann computerized Kreisler's messy records within days of

the takeover. At first, Kreisler wasn't allowed to sign checks, and his colleagues watched warily as his marriage crumbled, and his Porsche was repossessed, but, eventually, he won the trust of his new bosses, using his personal relationships to ensure there was no blip in the Lauren business, and his responsibilities increased. His skills complemented those of his boss, Michel Zelnik, the president of Bidermann in America. "Michel has a hot temper," says one of Zelnik's intimates. "Stuart kept him in check. Michel was a dealmaker. Stuart was good at managing people day to day. And there's no question, Stuart was way up Ralph's butt. To keep Ralph controlled and working and approving things was no small matter."

At first, Kreisler was seen as Ralph's guy, "but he became part of us," says a Bidermann colleague. That's because Bidermann was good for him, too. Surrounded by production experts, he could concentrate on what he did best — selling. As a result, "we all did very well," the Bidermann exec chuckles. "A new marble bathroom every year."

It was all about the basics. Bidermann executives had noticed that Calvin Clothing, the infelicitously named firm that held the license for Polo's boys' wear, was selling a lot of simple items like shorts and T-shirts to women — and decided they needed to take that business back from the boys' licensee by lowering prices of their women's clothes and offering more commodity items like basic shirts and khaki pants.

Zelnik quickly moved production of the most important of those basics, notably women's versions of Polo's knit shirt, to Hong Kong. Although Chinese manufacturing was still considered second-rate, Zelnik knew better; he'd made goods for Calvin Klein and Yves Saint Laurent there. Zelnik showed Ralph samples of knit shirts made in China, and Ralph couldn't tell the difference between them and ones made in Maine. Lower production costs led to lower prices and higher volume. "Ralph would still be a losing proposition if Michel hadn't gone to Hong Kong with the Polo pony to get the gross margins," a fashion friend of Zelnik's says. "Overnight, you blinked, and there was a big company there."

Zelnik claims that in the next three years he raised Lauren's women's volume from $9 million to $119 million annually. Such figures are often exaggerated, but there's no denying the benefit of moving knit shirt production to China. "That one product helps turn around the whole business," says Marvin Traub of Bloomingdale's, which also profited.

Offshore manufacturing was a big hurdle for Ralph to get over. "One thing we both agreed on — and his thoughts about it were filled with passion — was that all licensees be top quality," says Peter Strom. "We were not in it for a quick dollar. The licensees always wanted more more more volume. We kept them doing

high quality, expensive merchandise, and that was one of the things that built the name."

But Lauren and Strom proved flexible. Strom, Polo CFO Harvey Hellman, and a production executive soon flew to Hong Kong to scout out factories that could make knit shirts for men. "We saw what they could ramp up to," Hellman says. Polo's men's knit shirt business soon leapt from $5 million to $50 million in a year. The knit shirt "was over 50 percent of the business," says Edwin Lewis. And suddenly, Polo's New Jersey warehouse wasn't big enough for the business, and Hellman had to build a new one—this time, Polo owned all seventy-five thousand square feet of it. Two and a half years later he would build another of equal size, connected to the first by a tunnel, and employing about 150 people. "Ralph didn't know the location of the building," says Hellman. "If someone said to him, find the building that you own with your big horse and polo player in front, he couldn't find it."*

By the end of 1980, flush with royalties from Bidermann, Polo began expanding again. After Peter Strom's attempts to resurrect Polo Western Wear faltered, Lauren announced yet another stab at jeans— a new denim and casual sportswear line called Roughwear made by Bidermann to be launched in fall 1981. Polo also enrolled in Polo University, a new line aimed at young men and manufactured by the licensee that produced Chaps.

These were all lower-priced lines. Lauren's high-end products were not as successful—and that would henceforth be Polo Ralph Lauren's dirty little secret. Though it was positioned as a manufacturer of luxury products, they produced pennies compared to the big money minted by Polo's more plebian goods. Bidermann's success helped stabilize Lauren's women's Collection, and pay to advertise it, but that high-end line never achieved revenues above $20 million a year.

This is the essential subterfuge of the high fashion business: the products that make people stand up and take notice rarely if ever sell well. They are vital to the DNA of the business, however. "In a perfect relationship, the runway collection is a laboratory," says a Bidermann executive. "It may be insignificant [financially] but by using the runway and the press it generates, the manufacturer hopes to build volume and a real business."

The runway was Ralph's job. In women's wear Zelnik (whose hold over the American end of the business increased in September 1982, when reverses at

* Until he eventually made an appearance at a Christmas party there, the only involvement Lauren had with the Jersey warehouse was choosing fabric swatches and paint colors. However, his current Bentley bears New Jersey plates, indicating that its formal residence is one of four locations Polo now maintains in New Jersey.

the French parent company forced Maurice Bidermann to relinquish management, although not ownership, of his business) took care of the rest. Stuart Kreisler was the buffer between them, building the image by hiring the right people and selling to the right stores.

It wasn't long before that buffer started breaking down. Lauren started complaining within two years of joining Bidermann. He even ripped down a sign pointing to Bidermann's seats at one of his fashion shows. Ralph was constantly complaining about the high-priced, high-design Collection line. It wasn't selling enough. It wasn't made well enough. Bidermann was getting a free ride on his hard work. "We make a $23 million profit," Maurice Bidermann says, mocking Ralph's complaints, "and on this he makes *only* $8 million royalty."

Bidermann's leaders weren't thrilled with Ralph, either. "It's the same with every designer," says an executive. "They have to be flexible. They have to be responsible to the realities of budgets and timetables. They have to understand that in a perfect world, it ain't perfect." Ralph Lauren couldn't cope with any of that. And he was a pain to boot. "Everything was late because of Ralph," says a studio insider. "You'd sign off on something, and he'd come in the next day and say, 'I don't love it.' It's a dream come true if you want to work around fabulousness, but you can't run a business that way."

Ralph had begun designing by appointment, spending his day moving from meeting to meeting, switching gears from men's to children's to accessories as needed. Strom had set up the system of scheduled meetings to allow Ralph to micromanage the design process. Ralph's assistant would take him from one meeting to the next. But the system created problems as often as it solved them. If an idea occurred to him late in the game, Ralph would want to do the fashion equivalent of stopping the presses. "It happened almost every season," says one of his design directors. "Ralph was just a person going from meeting to meeting, and he was not as aware of the boundaries of what was possible as we were."

It was a mark of its importance that the last thing finished every season was the women's Collection. On the Friday before his big fashion show, which was always held on a Wednesday, everything else would stop and Lauren and his constantly growing design jury would adjourn to 550 Seventh Avenue, where every item he was considering for that season had been made up into samples in every color and fabric he was considering using. The waste was as extraordinary as it was necessary to Ralph's way of doing things.

Others had designed the actual garments, but Lauren designed the Collection, and in his mind, he did it like a writer, trying to tell a story—and he needed an unabridged dictionary if he was going to do it right. He was a visionary, but a

literal one. He didn't get ideas without visual aids. "So we'd make a million sam-
ples," says the insider. "He was extravagant with everything. Nothing was ever
enough. It could always be better. Poor Stuart was trying to show a profit. And
Bidermann would charge insane markups to pay for it all." About 20 percent of
the samples would end up in the show; the rest ended up on discard racks. "The
racks could fill a boutique," says a woman who watched the process over many
years. "The sample costs alone would have put most businesses under. You got
the sense that nobody ever said no to Ralph." Most designers second-guess
themselves and make last-minute changes, but none on the scale that Ralph
Lauren did.

So in those final design meetings, his staff hung on every twitch of his lips—
every smile, every frown. "He'd look at the colors, mix things, blend them," says
a design staffer. "That's what the meetings were about—seeing plays of pattern
and proportion. He'd run the fittings, but he didn't know or care about darts and
shoulder seams and sleeve caps." He couldn't say what would be right, but as his
growing cadre of designers scurried about, putting looks together, he always
knew what was wrong when he saw it. "I want it narrower," he'd say. "Do we
need a crocodile pump?"

It was in these meetings that new Ralph favorites found and lost their lime-
light. "When Ralph took a fancy to you, especially when you were new, every-
one knew you were the flavor of the month," says one. "The veterans all went
along because they saw the bigger picture." Ralph fed on fresh sources of inspi-
ration, and, given the chance, he'd suck them dry. Employees who were strong
would see what was happening and leave. Weaklings "inevitably become trailing
sycophants," says the former favorite. "Ralph knew and he didn't respect that.
He's more inclined to ask a total stranger's opinion than a yes-person. He's able
to see beneath the veneer, even of characters he helped create."

The process could be excruciating. "He'd single someone out who was keep-
ing quiet and say, 'You don't like this. Why not?' He'll push, push, push when he
senses people aren't giving their all. Work, rework, overwork, then go back and
max it out. That's his strong suit."

Ralph didn't miss a trick. Even his show music had to have the same pro-
duction values the clothes did: "expensive and richly done," says an earwitness to
the process. "And he stayed with sure winners." But he was never *really* sure.
Ralph never decided what he'd actually show, says an executive, "until the last,
terrifying moment."

56

I n the early eighties, Ralph Lauren had no reason to be reasonable, or to pay attention to formalities like budgets and timetables; he was riding high. His relationship with Peter Strom was perfect. "He got comfortable with me and confident in my abilities and relied on me," Strom said. "We're a perfect combination of CEO and COO. We talk about policy, he makes the final decision and I execute it. In a way I'm happy it's not fifty-fifty because there's never a deadlock. I don't brood if it doesn't go my way." Like Buffy Birrittella, Strom's loyalty was absolute. "Peter was a crusader," says Polo salesman Joseph Abboud. "He was vigilant about protecting Ralph." Holding up a black notebook, Abboud continues, "If Ralph said, 'This is the best green I've ever seen,' Peter would agree."

With Strom's skills giving Ralph the freedom to be his best, everything fell into place. In April 1981, he showed the Collection that cemented his reputation at a lavish runway presentation in the ballroom of New York's Pierre Hotel. The show had three acts. First there were Lauren's signature, mannish tweedy and tailored pieces. Then came a group of Hollywood siren gowns and Marlene Dietrich–style evening suits. Then came a group of looks people still remember, and even wear, today: Inspired by a family vacation in Santa Fe, New Mexico, Lauren's new clothes evoked the prairie, the plains, and the pueblos of an idealized frontier where never was heard a discouraging word and luxe leather and silver were worn all day.

Lauren was on a winning streak with women's wear, making clothes that not only whet the appetites of fashion editors, who are ever on the lookout for the sort of graphic, individual—and often unwearable—clothes that make for punchy magazine pictures, but they also appealed to just plain folk, for whom fashion must be wearable as well as *want*-able. He was having similar success in the men's field where he was nominated as men's designer of the year by the Council of Fashion Designers of America, a trade organization best known for its CFDA Awards, which that year replaced the Coty Awards as the Oscars of fashion.

Joseph Abboud moved from sales to men's design in 1982. He worked under Jerry Lauren. "Jerry was the fierce defender of the faith," says Abboud. "If there was a certain green that was Polo, Jerry knew it instinctively, or had learned it." The relationship between the brothers was fraught with complexity, even though Jerry was "blindly devoted, deferential, and supportive" of his younger brother, says Abboud, who wonders if that dynamic isn't "a private hell" for Jerry. "He can't stand up to his brother," another Polo executive says of Jerry. "He's a visionary about menswear, but he can't be his own man."

The Polo design process was simple and, at least in the early stages, was the same for men's and women's clothes. Sometimes Ralph would give the designers a theme to work with, issuing his vague instructions, or describing what he'd been thinking about, what he'd been listening to. These musings were typically neither eloquent nor precise, but rather, broad brushstrokes they would have to refine. And more often, Jerry and Abboud would come up with design concepts themselves and present them to Ralph. "An entire season could turn on a swatch," says Abboud. "Ralph would bless it or not. It had to look like Ralph Lauren." If his women's designers had a good idea, Ralph would show it to the men's team, and vice versa. In later years, one season's advertising campaign might even drive the next's designs.

But Ralph only parachuted into the process, he was no longer involved every step of the way. "Call it the actor syndrome," says Polo CFO Harvey Hellman. "He definitely becomes more aloof. He only allows certain people into his world. He sees himself as above."

Ralph's inaccessibility was increasingly a problem. Whether he designed them or not, Ralph had always presented his lines to his salesmen every season—bantering with them about what would sell and what wouldn't, and sometimes even listening when they told him how unlikely it was that heavy winter tweeds would ever sell in the South. Now, though, often as not, Buffy Birrittella presented the line and Ralph made a cameo appearance. "He'd come in from the Hamptons on Monday night and leave town on Thursday night," says another salesman. "You were dying for him and you got three days." Even when Ralph was around, his mind was often elsewhere. "He was always working the mirror behind us," the salesman says. "Looking at himself. We'd spend forty-five minutes in a meeting on whether or not he needed a haircut. And we were under huge pressure." With much of Polo's production moved offshore, the sales force had to predict with some accuracy, far in advance, how many units of each style they'd be able to sell, so that commitments could be made for piece goods and factory time. But with limited access to Lauren, they were often on their own.

"Jerry used to get frustrated," says Abboud. "We didn't get enough Ralph.

Ralph was dealing with celebrities, dealing with women's [fashion]. He was more enamored with women's. It was more creative, more intuitive. It had the glamour, the press, an excitement men's doesn't have." But women's wear was also his bête noire, his biggest challenge, his biggest source of insecurity.

In early 1982, it became a source of controversy as well. Beginning in the late seventies, Lauren and his staff had made it known throughout the antiques business that they were on the lookout for "accent pieces" for the Polo shops, says Marilyn Kowaleski, whose antiques shop in Lancaster County, Pennsylvania, was one of their regular stops. "His network knew what he was looking for and did the footwork. His buyers were always coming through. Someone would come every week." What had previously been seen as dusty junk, like old suitcases covered in decals and ancient painted croquet sets, took on a new luster when Ralph Lauren lusted for them.

They also bought some antique clothing. "They copied a lot," says Kowaleski. "When they did prairie, I sold them western Pennsylvania farm dresses, and he reproduced the detail and fabric. He did shirts with calico copied from original prints. Anything western, you could sell him. I sold a ton of Indian blankets."

No one but fashion purists cared about that borrowing. But the collection Ralph showed in April 1982 caused a tempest in the folk-art world. It was inspired by Shari Sant, a blue-eyed blonde who looked a bit like Ricky Lauren, who'd joined Polo as a fit model early that year. "I was willing to work for practically nothing, and I was a perfect size eight," Sant says. Tasha Polizzi hired her, Sant continues, so "she wouldn't have to try clothes on anymore." Sant asked Polizzi whether she should wear Santa Fe styles to her interview with Ralph. "I don't want to see what we're doing," Tasha replied. "I want to see where we're going." Sant showed up in a petticoat skirt sewn together from scraps of chintz under a suede prairie skirt, and gave Lauren the idea for his next Collection.

Ralph's minions spent that winter cornering the market on antique patchwork quilts. "They'd cut them up into jackets, vests, and skirts," says Kowaleski, then a major quilt dealer. But Ralph didn't realize how strongly people felt about quilts and the need to preserve them. Though dealers like Kowaleski convinced him to buy quilts that had problems, even that caused controversy. A museum textile conservator told the *New York Times* that Lauren's use of them "not only smacks of commercialism, it is cannibalizing a historic object." One quilter ripped up a Lauren shirt and some feed sacks and turned them into a patchwork quilt decorated with messages to the designer like, "Ralph Lauren, you are an old sew-and-sew!"

Lauren's response was dismissive: "How many quilts can you put on a bed?"

But still, his next few women's Collections stuck to safer ground. The spring Collection he showed in October 1982 was heavy on feminine white linens, pastel blazers, and black silk crepe evening pants. And his April 1983 Collection also lacked surprise, at least according to WWD's reviewer. That fall, too, he stayed true to form, showing safari styles.

Yet even as he veered from quilts to conventional clothes to echoes of colonial England, Ralph's cult of customers grew. He might have been the ultimate wanna-be, but, people found a sort of reassurance in his shuffling of the identity deck. And though he was often clumsy expressing why he did it, he was also perfectly consistent. "It started out with things I saw in the movies or magazines, or old books," he said. "It was a style that I thought was prince-like, dream-like. It was not about the 'big time,' or being rich. It was more like an unreal kind of living that I thought was very romantic. What I wanted to do was capture the essence and return it."

"What I do is not apart from what I am," he said on another occasion. "I was the guy looking at the magazines and movies, saying, 'Wow, that's where I'd like to be.' It's not just the car, it's where you're going in that car. I'm trying to paint a wonderful world. Maybe I'm redefining a life we lost. That's my movie. What is yours?"

57

All of Ralph's yearning had been leading to this moment when his desires merged with the world's. Anglo-Americanism would always remain the stiff backbone of his style, but he'd fleshed it out with all sorts of other beautifully edited and art-directed dreams of good living—all drawn from the same well. He'd constructed his own vocabulary of visual signifiers (because words just didn't cut it) that were in balance with his gyroscopic sense of what was right and what was now. "I went and did something which I love," Ralph said. "It was my insides, how they came together. It's a very emotional thing that goes through you. I want to wear it. I want to be that."

Lauren was inspired by heroes, by fantasies, by things that were quintessentially American, even though they hailed from all over the world. After all, his

country was founded by Englishmen, and they'd come here with an agglomeration of things—things that came from everywhere from Persia to Peking. They'd conquered a continent and its Native Americans and become Americans themselves. So the children of immigrants who followed over the next two centuries had lots of dreams to choose from, lifestyles from Davy Crockett's to the Duke of Windsor's they could fantasize about as they led their own lives, humdrum or haute. "America is about dreams," Lauren says. And barons dream of log cabins as surely as beachcombers build castles of sand.

Ralph's dreams were hardly his alone. He was surrounded by people who shared them—at Polo and beyond. "Everything he did or said was right for me," says Joe Barrato. "He could be difficult, he could batter you psychologically, but his concept, his vision, the way he dressed, he was so great, you overlooked the bad stuff, you overlooked his moods."

"I compared it to a religious experience," says another ex-employee. "You worship in the house of Lauren." Lauren's staff began to resemble a cult, "a lifestyle cult," according to one member, "that seduced from within and permeated out"—winning orders from retailers, attention from the press, devotion from consumers. Ralph's fantasy was real to them, "and everything else is trendy or of the moment or inelegant but not classic," says a true believer. "They're all striving to achieve what he's got."

Doing that—becoming a Poloroid—meant drinking deep draughts of that Kool-Aid the people at Polo were always joking about. "Or were we eating M&Ms?" asks Joseph Abboud, recalling the dishes of the candy that were everywhere at Polo. "But it *was* very much like a cult. You wanted to be part of it. Ralph was our hero. We believed the myth; we dressed the myth. We were the legions. It was all-consuming, and you were sucked into it. It was a beautiful place to be. Tweeds and stripes and tartans and beautiful women and conspicuous consumption and the office was a beehive of energy flying.

"Was there something in those M&Ms?"

Lauren indoctrinated employees by surrounding them with the best of everything. "The people who worked there were the best and the brightest in fashion," says Marty Staff, who'd joined Polo as a sales executive in 1981. "It was the coolest clothes, and Ralph was setting his own rules. He was the best instinctive merchant I've ever known. He was unstoppable. So we were sort of chosen, everyone in sales was earning more money than they'd ever dreamed of." Once, when Staff and Strom missed a commercial flight, Strom just booked a charter to get them home. "I mean, that was how we lived!" Staff says.

They were thoroughbreds wearing blinders that kept them focused on the race, so dedicated to winning for Polo that they sacrificed their own lives and, in

the most extreme cases, never realized their own potential. "We didn't work around the clock because we had to," another former Polo executive agrees. "You wanted to. People thought alike, they dressed alike, they worked on the same things all week and they went antiquing together on weekends." Though Polo's mostly single young staffers began getting married and having kids in the mid-eighties, most followed Tasha Polizzi's lead when she became a mother. "She had it on Friday and she was back to work on Monday," says a co-worker. The baby came along in a basket. Tasha would leave it in the PR office.

"I would've jumped out of a window if he'd asked me to," says another studio staffer. "It was like, hypnotic. He had a mesmerizing effect. It's a gift. He wasn't tall as a kid, so he had to fall back on charm." Barrato thought Ralph cultivated devotion through the exercise of control. He'd keep everyone waiting for a meeting for hours, then once he finally got there, keep everyone waiting some more while he stared into a mirror, brushing his hair. "Don't I look beautiful," he'd say. The smart employees would agree.

"Then Ricky would call," says Barrato. "He'd say 'You coming tomorrow? Wear a denim dress. Not the one with white buttons, the one with snaps,' and wear your hair this way. He molded her into the vision of what he wanted his women's line to look like."

"It was always, you had to ask Ralph, you had to please Ralph," says the studio staffer. "You don't get it," Ralph would whisper in a tone that mixed sadness with sneer if you didn't get it. "You don't *belong* here." The target of that quiet tirade would do anything to get back in his favor. "The way he said 'That's not Polo, that's not me,' taught me about branding," says Mike Toth, who designed catalogs, hang tags, and the like for Polo licensees. "He stood for something."

His religion was good taste and excellence. Who'd turn down the chance to join that church? "He'd cut you down and you'd want to give him more," the staffer continues. "You lived for his approval. He was difficult but he was always right. He'd find a weakness and go for it, and it filtered down through Buffy." Buffy was the high priestess. "She became him. She adored him. She gave up her life for him. She'd read the paper to him in the morning. She put herself there; she had nothing else. People say she had no outside life, but she did: Ralph. And it was a very full life. She traveled; she met amazing people and saw incredible things. They were consumed. They became the brand. You can't separate *it* from *them*. Nothing could happen in that company if it wasn't the way she said Ralph wanted it."

Ralph was so controlling that, if someone who worked for him wore something he liked, he'd even demand they turn it over. "He's possessive in everything," recalls designer Sal Cesarani. "If he touches something, it's his." One day

Ralph pointed at *DNR*'s Michael Farina jeans. "I want those," he demanded. He did that a lot. "He says 'Mine,' " another designer recalls. "Which means take it off your back and give it to him." Sometimes, Buffy Birrittella would be his messenger. "Ralph likes that," she'd say—pointing at an item Lauren coveted. "He wants it."

"He owned your whole fucking life," says one staffer who lost a piece of treasured clothing that way. "He wanted to control everything in everyone's life," thinks the studio hand. Ralph threatened to fire one staffer because he didn't like her boyfriend. Tasha Polizzi never talked about her husband. Ralph's possessiveness even extended to the styles he championed. "He started believing he created the WASP look," an employee scoffs. But it wasn't that, precisely. It was rather that he felt that if he dressed the part, he could be it. Lauren loved playing dress-up. He had outfits for meeting bankers, others for visiting mills, still others, equally thought out, for relaxing. He'd once wandered London in a black Barbour jacket, black wide-wale corduroy jodhpurs, and black high-heeled boots. His costumes let him occupy the dream milieus in his mind—and everyone at Polo joined in the dress-up party. "We're all part of a dream world," he said. He'd known it ever since he exchanged his yarmulke for a potato pot hat back on Steuben Avenue.

The intensity of his belief in the power of clothes was easy to mock. "You get up in the morning and say, 'Today, I'm a cowboy.' Boots, jeans, a western shirt," says Robert Stock. "He lived the roles. He'd wake up and say, 'Today, I'm Cary Grant.' The collections followed." And the collections gave Ralph that sense of ownership over the looks he adopted and adapted. One day, Stock was walking down Fifty-fifth Street in jeans, boots, a baseball cap, and a herringbone tweed jacket when someone stopped him and said, "You have the Ralph Lauren look."

"Yeah," Stock replied. "He invented horses, also."

58

S
uccess made Ralph Lauren a target. As his wealth, influence, and advertising presence increased, so did the attacks on him turn into a deluge of abuse. It began with that groundbreaking Santa Fe collection. When it hit stores in August 1982, Susan Lydon wrote a story entitled "Come off it, Ralph: Stop Selling Us Thrift Shops Classics at Designer Prices" in the *Village Voice*. She accused Lauren of "plundering the nation's treasures for his own personal gain. . . . Lauren doesn't merely adapt or revive," she wrote, "he appropriates whole looks and passes them off as his own invention. . . . The personal taste he claims credit for derives precisely from the anti-fashion philosophy espoused in the anti-consumer attitude of the counterculture. . . . The other major component of the Lauren style was stolen intact from the preppies, who also buy clothing one piece at a time for a lifetime wardrobe. . . . Lauren's specialty, it would appear, is the addition of the label and the markup."

That first salvo was followed by a barrage. Two months later, England's BBC aired an exposé knocking Lauren for running a sweatshop operation, selling $400 sweaters made by British hand-knitters earning a mere $10 to $20 a garment.

"I don't get into that," Lauren sulked about the charge.

In spring 1985, Polo introduced a "weathered," i.e., pre-aged, Polo shirt and earned a diss on the *New York Times* editorial page: "His new old shirt implies that the buyer had that good taste 2 or 10 years ago and is no upwardly mobile arriviste, having long since arrived. This shirt conveys the very antithesis of nouveau riche," wrote Jack Rosenthal, who compared it to clothing he'd actually worn for years. "Let Mr. Lauren sell his weathered look; this one is better. It's not bought, but earned."

Ralph didn't make things easier on himself. His lust for credit often seemed like overreaching. In a press handout that year, Polo claimed that "his ties fomented the 'wide tie revolution' "—forgetting all about London's Mr. Fish and his "kipper" ties. It also claimed that Lauren had "established the 'preppy look.' " That last usurpation led to vilification.

"Imagine you are a former stroke for the Harvard crew sitting on the beach at, oh, Lyford Cay," the acerbic social critic and novelist Michael M. Thomas would sneer in the *New York Observer*. "Suddenly you notice that the vile fellow sitting a few yards away, a palpable penny-stock salesman from Blinder, Robinson only days out of Lompoc, is wearing a crew shirt beribboned at the neck with the same colors you puked your guts out to win at Henley 20 years earlier. Save that on the bosom of his shirt, like a leper's mark, is a tiny appliquéd polo pony. Your likely reaction is to become apoplectic."

Fifteen years after he wrote those words, Thomas is unapologetic, though he does reveal that he was an early Polo customer, buying a pair of green flannel pants with a light blue silk lining at Eric Ross, "when I had typical early seventies taste," he laughs, "i.e., none at all.

"But you have to admire someone who took the 1959 L.L. Bean catalog and a pad of tracing paper and turned it into the best part of a billion dollars," Thomas says. "Lauren understands from the inside the yearning of people who didn't go to Ivy colleges. And his timing was exquisite. The old WASP hegemony was breaking up; retail in America was tired; and he saw a way to appropriate WASP culture and rebrand that image to his own."

Thomas is hardly alone in his disapproval. "He cheapened things that were secrets," fumes an old Palm Beach preppy—and Lauren acquaintance. "He went into Angier Biddle Duke's closet and got all the goyim clothes he could to imitate boys who went to St. Paul's School, a school he could not have attended. I mean, he sold to every impressionable person in the world. Ralph ruined things for me. He doesn't play squash, he doesn't play tennis, he doesn't play golf, he doesn't want to be in any of those clubs. So he has nothing to lose!"

By 1986, Lauren had the right to feel besieged. That year, the *Washington Post* joined the chorus, with a story entitled "King Lauren, Conferring Nobility." "Millions of Americans," wrote Jonathan Yardley, "want to be something they are not and are prepared to spend ludicrous amounts of money in the hope of transforming themselves. . . . [Lauren's] primary market is among the arrivistes." To Yardley, Lauren's accomplishment was marred by its "furtive desperation" and "essential fraudulence."

"Beneath the argyled veneer beats an insecure pulse," he continued. "The only thing genuine about it is the money required to swathe oneself in it. . . . The money is what really counts; the only difference between a *parvenu* in a sharkskin suit and a *parvenu* in a Lauren blazer is that the latter has pretensions."

In response, Lauren argued that in a supposedly democratic society, everyone is entitled to the pursuit of the best that life has to offer. "People think that if you have good taste and a nice style that you somehow invented yourself," he said.

"But what does that mean? This is America. We were all born somewhere else. And people think that because you're successful that you shouldn't care when a columnist writes, 'Ralph invented himself.' You don't see these things. But I do, and they sort of hurt."

Why was he under attack for the very things he was once praised for? He was for good taste and against rules that said who could have it. "I'm very anti-rules," he said. Still, all the sniping made old scars itch, old wants gnaw, and suspicions of anti-Semitism rise. "I read articles saying 'This is WASP-y clothes, who does he think he is?'" Ralph said. "This comes from non-Jews. It comes from people who don't like the idea that I'm designing clothes that they might relate to. The kids that went to [Harvard and Yale and Princeton] were very well bred, educated kids, parents were more worldly, more exposed to things. I happen to have liked that. I did like New England. I did like blazers. I don't know what Jews dress like or not like, but my look was more classical, more traditional. That's not a matter of a lie, it's a matter of what you love."

Ralph loved the Traditional look—and if the Michael Thomases of the world didn't like it, that was their problem. "If you buy Brooks Brothers, are you leaving your origins?" Ralph demanded. "What's preppy? Preppy means not Jewish. Why is that? Jews don't go to Harvard?" And then there were those to the manner born who didn't appreciate their birthright. "Sometimes people have something and because they live with it all the time, they don't know they have it," Ralph observed.

He cherished what Brooks types took for granted. "For me both England and the West are the places where people valued wornness, naturalness, the feel of things gradually gaining a place in your heart. I am not talking about coziness versus modernity. I love newness, but I want the sensation that new things, too, will be able to linger in time." Obviously, his romantic pitch struck a chord with far more people than Ralph struck as a phony.

59

erhaps Ralph's utter self-absorption was just a defensive reaction to all the criticism, but it appears to have deeper roots. One of his longtime executives describes Lauren as a pathological narcissist. In Greek mythology, Narcissus was a beautiful boy who fell in love with his own image in a pool and died there, fixated. Psychologists say narcissism, a personality trait, is caused by a parent, usually a mother, who lacks empathy for her child. The narcissist is left feeling empty, unloved, even hateful—and enraged by the failure to gain the mother's love. "A child who feels so gravely threatened by his own aggressive feelings attempts to compensate," wrote Christopher Lasch in *The Culture of Narcissism*, "with fantasies of wealth, beauty and omnipotence."

Narcissists exhibit unusual self-reference and an inflated yet fragile self-importance, a grandiose sense of their own uniqueness, an inordinate need to be admired, a sense of entitlement, an expectation of special treatment, fantasies of omniscience and omnipotence, and a tendency to idealize both themselves and their mothers. They grow up into toxic cocktails of self-love and self-hatred, desperately needing to be perfect and powerful. Since that isn't always possible, the narcissist ends up restless, unsatisfied, obsessed with superficiality, fame, and celebrity, and with an engorged sense of self-importance that expresses itself in outward rage and inward humiliation when his or her needs are not given precedence. Charming and charismatic, they learn to manipulate others to give them what they need.

The checklist of narcissistic personality traits seems to fit Lauren like a bespoke suit. Frieda Lifshitz's expectation that her son become a rabbi, or at least a devout Jew, left him feeling imperfect. The child's defiance—Ralph's desire to attend public school, his discarding of the name Lifshitz—is experienced as a victory over the unloving parent. By demanding what she wanted, and not listening to his desires, Frieda turned him into the furthest thing from a rabbi—a faux WASP. Yet the gnawing doubt, the sense of imperfection, remains.

Stuck in the cycle of disappointment and rebellion, Ralph idealizes Frieda as a perfect parent, and reinvents her, too, constructing his company as a perfect

Jewish mother, figuring out what employees need and giving it to them so they not only depend on him but can be counted upon always to tell him how wonderful he is, to give him unquestioning approval. "Oh yes, Ralph, you're brilliant, Ralph, you're so right," mimics design staffer Bonnie Young. He wasn't just a Jewish prince. "He was God, the king. "

At Polo, at least, whatever Ralph wants comes first. And he wants most of all to be loved. "His neediness is compulsive and out of control," says a Polo executive. "He'd come in late and start rambling, and people were so happy to finally have him, they went along with it and everything would get pushed back even further," says another executive. They called it Polo time, those moments when the company seemed to grind to a halt, as people queued up to give Ralph affirmation. "If Ralph has a chance to talk about himself," says an ex-executive, "entire meetings stop."

It wasn't enough, though. Success was stealing Ralph's joie de vivre. "He became a celebrity and he liked that, and he built a wall around himself to protect himself," says Jack Schultz of Bloomingdale's. "He became isolated, remote, defensive." Where once, he'd come to the store alone in his Morgan to mingle, now he turned up in a stretch limousine buffered by his entourage. "It was more than he'd bargained for," says Milly Graves, his Bloomingdale's buyer. "The dream became a difficult task." Graves thinks that's why her old friend circled his wagons, limiting his contacts to an inner circle of true believers, his partner Strom and devotees like Buffy Birrittella. "They understand him and protect him," Graves says, "and they implement what he wants."

That was all important. "He knew what he wanted and went after it," says Chaps founder Robert Stock. "His dream was to create an empire and as it expanded he got more into it." Most people who become rich and successful start to breathe easier, Stock thinks. "But it hasn't taken the fire out of him. He wanted to be known as the best. He fought every day to do that, and he still fights. He is the most competitive person you'll ever meet. "

One way of keeping score was money. By 1982, it was clear that Ralph Lauren was one of life's big winners. That April, WWD estimated Lauren's overall retail volume at $90 million and Polo's pretax profits at $20 million. Ralph's various licenses were printing money, too. With Bidermann claiming $80 million volume from women's wear, Warner/Lauren another $40 million from fragrance, and the licensee that made the Chaps and Polo University brands raking in $15 million, WWD figured Ralph was personally making about $12 million a year, even after overhead was deducted from royalties.

That year, Lauren acquired a new $6.5 million nine-seat Hawker Siddeley jet, and redesigned it, changing the upholstery five times. "It was for his image," says CFO Harvey Hellman. He needed it to jet between the houses he'd started collecting—also for his image, in places "where the top guys were," Hellman says. In a burst, he bought a huge parcel of ranch land in Colorado, 115 acres on Lost Lake in Pound Ridge, New York, and a stone-and-wood beach house in Montauk designed by Frank Lloyd Wright assistant Edgar Tafel (that had previously been rented by Barbra Streisand, Diana Ross, Leonard Bernstein, and John Lennon).

Low-slung and hidden from the road, the Montauk house is unassumingly decorated with white canvas furniture, a stone fireplace, stone floors, zebra rugs, raw wood walls and ceilings, piles of books, artfully placed straw hats and baskets filled with coral and raffia slippers, ship models, telescopes trained on the ocean, and scores of family photos and travel shots taken by Ricky. The grounds are quietly spectacular. With a pool set into a grotto, hidden groves, gardens tamed and raw, terraced lawns and trails, it is a perfect place for Lauren to indulge his penchant for going off alone and dreaming. He never even spoke to his next-door neighbor, playwright Edward Albee.

Not satisfied, Lauren also bought High Rock, a house in the Round Hill colony on Jamaica; built by the financier Clarence Dillon, it sits two hundred feet above the sea. "It's private, it's beautiful and I've earned it," Ralph said.

He had indeed, but once again he'd turned to accountant Arnold Cohen and Polo CFO Hellman to get the money to buy it all; they changed Polo from a type C to a type S, or small business, corporation. As a C-corp Polo paid tax on its profits and then Lauren and Strom paid more taxes personally. As an S-corp, Polo paid all the taxes. Lauren "loved the idea of an S-corp, yeah," says Hellman. At the end of the year, he'd write a big check to Strom and a very big check to Ralph.

There was no financial distinction between Ralph and his business: it was he. "Everything was paid for," Hellman says, "groceries, anything, everything, Ralph never had to reach into his pocket. If you walk down the street with Ralph Lauren and you want to grab a soda, you have to pay for it because he doesn't have twenty-five cents."

Ralph didn't pay for his jet, either; it belonged to Polo. Lauren had told Hellman he wanted it: "Do whatever you have to do," he said. So Hellman went to Manufacturers Hanover Trust, Polo's latest lender, and got 100 percent financing for the jet. The pilots were on the Polo payroll, too, although not only for Ralph's convenience. They also flew Strom and Hellman around. But Hellman admits, "It never made sense. We thought he went overboard, sure. But he could

afford it. And the banks were satisfied. They could care less whether or not he wanted three planes." All that mattered was that $30 million in equity remain in the company at the end of every year. It did. Ralph had earned it.

His money didn't assuage the gnawing concern that it could all disappear in an instant. When his April 1983 Collection, filled with Sun Valley–style ski sweaters, coat dresses, and argyle evening knits, was panned by fashion critics for overreaching—he showed in an armory in which his huge Collection was dwarfed—Ralph flew off alone to Jamaica in a snit.

No matter how successful he was, he was never satisfied. "He would go to Bloomingdale's less to be proud of what he'd achieved than to snoop into every other bit of apparel on the floor," says Polo sales director Marty Staff, "just to be sure that no one was doing something better than him. If they were, he had to do it for himself, immediately." Staff remembers meeting after meeting about casual pants, a business other designers did better than Polo. "He brought in every casual pant and dissected it," Staff says. "It stemmed from his feeling that there was something he was missing. That's how he made all of his decisions. He would buy a Porsche 969 versus a Porsche 911 not because it was a better car but because he wanted a car no one else had."

Ralph's obsession with cars had only grown over the years. By the 1990s, he would own dozens. He kept them in a second house he bought across the street from his place in Montauk. For day-to-day use, he alternated between a 1956 black Porsche, a vintage Woody station wagon, a Mercedes 220, and a Land Rover Defender 110, which he refloored in sisal and repainted three times to get the right shade of tan ("like the old desert guys"). But mostly he drove an old Ford Country Squire station wagon. "I can go anywhere in that and I don't have to lock the doors," he said.

Lauren also owns and has painstakingly restored a yellow 1937 Alfa Romeo ("the Ferrari of its time"); an even earlier Alfa designed by Enzo Ferrari before he founded his own firm; a 1929 "Blower" Bentley race car ("major—it was owned by one of the Bentley Boys, glamorous, flamboyant men who loved action and excitement"); a pack of wartime Jeeps; a passel of Porsches, Jaguars, and Ferraris, including several early Testarosas ("moving art—the sound is thrilling"), a convertible used in *The Thomas Crown Affair*; a stripped-down 1962 GTO that won at LeMans; a green Morgan ("wind in the hair, a rugged, hippy English guy"); a silver Gullwing Mercedes; and a red Maserati once raced by Juan Fangio.

He spared no expense in pursuing his obsession. "Ralph always paid top dollar," says a Polo executive. "Most designers negotiate. He pays asking price. Sellers thought he was crazy." Once, on an advertising shoot, Ralph spent an

entire weekend agonizing over whether to buy a group of rare cars that included one of only four 1938 Bugatti Type 57SC Atlantics, with a magnesium alloy body held together by a prominent riveted spine, along with another Bugatti and an Alfa Romeo. Lauren called the black Bugatti "my personal rocket ship—there are two [left] in the world and one was hit by a train in Paris and restored, so it's not original," he said. "Bugatti was a very elegant guy. He walked around in jodhpurs and sold to kings. If he didn't like you, he wouldn't sell to you." Lauren patted the car like the thoroughbred it is, cooing, "Look at the details. The dashboard, the pedals, the tooling."

Buying it was terrifying. "Ralph asked Bruce Weber's assistants, who made $100 a day, if he should buy the cars for $13 million," says the executive. "He had his personal masseur drive out to the shoot in East Hampton with all his car books to help him decide."

But no matter how many houses and cars he bought, none of it assuaged Ralph's insecurity. Gary Goldberg, a classmate from Salanter Yeshiva, got back in touch with Lauren in the early eighties; he'd found his Salanter autograph book and sent Lauren a copy of the page on which he'd written Ralph Lifshitz under the rubric "Best Chum." Lauren called and invited Goldberg to lunch at the swank La Caravelle, across the street from his office. Goldberg had become a financial adviser and was constructing tax shelters at the time, so Ralph put him in touch with Arnold Cohen. "But a good part of our conversation was about our lack of security, how easily you can lose what you've accomplished," Goldberg says, "how insecure you can be as an adult, coming from the background we came from. We were poor. Some of us achieved security and success, but we were never sure it would stick to our bones. You wonder, why me?"

60

Ralph's solution to his constant unease was constant innovation. In March 1982, Polo gave the latest of its twenty licenses, for home products, to J. P. Stevens, the sheets and towels giant. Lauren had been approached to put his name on sheets before, but, as usual, he saw a bigger opportunity. With advice from Marvin Traub, who'd started his career in home furnishings,

Ralph developed an unprecedented yet classic concept. J. P. Stevens agreed to lead an ambitious move into home furnishings, manufacturing Lauren-designed sheets, pillowcases, and towels (all in natural fibers, of course), and licensing others to make furniture, china, glassware, ceramics, flatware, kitchen utensils, wall coverings, light fixtures, and closet accessories. "They were willing to spend the dollars Ralph wanted in order to create a major image," says Harvey Hellman. "Floors were built in the J. P. Stevens building."

Name brands had never been sold in the home market before. Home, as the line was called, was a brand-new idea, conceived as an attempt instantly to duplicate Polo's success in apparel in what was perhaps the only field where his concept of affordable luxury could be transplanted on a massive scale. The target market was "people who use their homes to make a statement about who they are, people who want to control their environment," Buffy Birrittella told the *Washington Post*.

Initially, retailers were supportive. But when the launch was delayed from May to October 1983, and the terms of the endeavor became widely known, some said Lauren was overreaching. "They will buy it right or else they're not buying it," Ralph responded. "That's not arrogance, it's my belief in what I'm doing." Retailers had to commit to establish Home departments; buy at least three of the four lifestyle themes in the launch—Log Cabin, Colonial Jamaica, Hunt/Thoroughbred, and Connecticut/New England—and commit up to $1 million per store in inventory and real estate, and more for shop décor and sales staff training. Stores got no advertising allowances and were barred from holding comparison sales or white sales (which composed 85 percent of the sheet business at the time). And Ralph Lauren Home boasted the highest prices in the business: Log Cabin blankets would sell for $300, Colonial-theme linen sheets for $475.

When the initial two thousand SKUs began trickling into stores, the line of future heirlooms was plagued by Polo's usual problems: late deliveries, lots of irregular merchandise, and, as a result, empty store shelves. The material Ralph insisted on for silverware melted in dishwashers. Lauren's high-thread-count sheets slowed down the mills. J. P. Stevens and Lauren executives were at each other's throats. Strom called it a disaster. "We saw that it wasn't right, and we changed it," Lauren says. It was that simple. And almost that fast.

In July 1984, Polo took over management of Home. Cheryl Sterling, a former Bloomingdale's executive who'd been in charge of production for Polo menswear, was named president, reporting to Strom instead of the J. P. Stevens executive who'd run the show 'til then. John Idol, a young J. P. Stevens salesman, was put in charge of sales and marketing. And Nancy Vignola, who'd run women's wear with Tasha Polizzi, took over design. Charged with turning Home

around, Vignola and Sterling, a Strom protégé, would enter the inner circle of Polo executives, where they remain to this day.

Strom exuded confidence as Sterling canceled SKUs, hired an in-house sales force responsible for the entire line, and, with Ralph's acquiescence, allowed products like towels to be sold in towel departments as well as dedicated Polo shops. Idol and Sterling also introduced nonthemed merchandise and agreed to allow annual sales of irregular items. Although Home didn't turn a profit for another half dozen years, they turned the business into the pride of Polo and confirmed its status as a powerhouse; Marvin Traub estimates that following the Home launch, about 10 percent of Bloomingdale's volume came from Polo Ralph Lauren products.

By 1988, when Polo teamed with Williams-Sonoma to open its first free-standing Home collection shops, retail sales of the line would be close to $50 million annually. And even that figure understates Ralph's impact, since knockoffs of Lauren's Home line were estimated to be doing another couple hundred million dollars in annual volume. Lauren had rewritten the rules of the home furnishings market and created a new, higher standard.

61

After years as the head buyer of boys' clothing at Bloomingdale's, Marty Staff had joined Polo in 1981 with Marvin Traub's blessing. As vice president of sales, he was charged with building Polo's department store business—and positioned to become Peter Strom's successor. "Peter needed someone to help him run the business," says salesman Edwin Lewis, who'd been promoted to southeast regional sales manager. But nothing was simple at Polo. Soon, Lewis came north and emerged as Staff's corporate rival.

Lewis told Strom that Staff, despite his big-store experience, wasn't handling Polo's department store business well. All the big stores wanted was the logo merchandise: the Polo shirt, the Oxford shirt, and the Shetland sweater—and they were used to getting their way. Lewis felt that Polo could gain the upper hand when dealing with the Goliaths of retailing by leveraging the stores' desire for those Polo logo products, and got Strom's okay to hire regional merchandise

coordinators to watch over Polo's in-store departments, to create special fixtures that would hold shirts and sweaters in them, and to insist that stores accept both. The stores proved so desperate for a piece of Polo "that it was sick what they would do," Lewis says. "The seas would part" because Polo goods "immediately elevated their image."

Emboldened by this gambit, Lewis proposed another. Polo was selling ten thousand pairs of its Roughwear pants—basic khakis—every season, at about $60 per. Lewis proposed dropping the price to $39—and guaranteed that the price cut would quadruple Polo's khaki business. "Do what you want to do," Strom told him, "but if you fuck it up, I'm firing you."

Lewis bet Polo's production man $500 that he'd sell one hundred thousand pairs a season. Then he went to his salesmen and told them that, henceforth, stores would have to order a pair of pants for every four knit shirts they wanted. To win his bet, though, Lewis had to convince Lauren "to improve the design," he says, and Ralph was "fighting the whole way." Finally, Strom convinced him and Lewis sold 110,000 pairs of pants and won his wager. But Ralph couldn't savor his success. He despised the stores that were giving it to him. When Staff tried to take him into a Macy's West branch in San Francisco, Lauren stopped between its two sets of doors and announced, "I hate this, I'm leaving."

Soon, Lauren and Strom decreed that Polo had to stop selling department stores, or at least department stores that didn't live up to the standard set by Bloomingdale's Fifty-ninth Street flagship. "Edwin and I were given the job," says Staff. "We made a list and realized it would cost us $50 million—a third of our volume. Ralph got cold feet then. He realized that the people he hated minute to minute were his bread and butter."

The man was becoming the brand.

Marty Staff was smart, but Polo's sales staff didn't like him. "Marty tried hard," says Edwin Lewis, "and Ralph had this vision of this important Harvard MBA in horn-rim glasses. Knows not shit about the business, but that image, that's [Staff]. The whiz kid."

"He was never one of us," Jim Rushton agrees. "We put up with him. He was such a goober." But then, Rushton didn't like the business anymore. It had shifted out of the specialty stores that treated Polo as a gem, into department stores that thought of it as a staple. The little stores were dying out—and with them, a breed of merchant. "It was not as much fun," says Rushton. "You'd think just the opposite." After all, profits were soaring. "But it became drudgery. It wasn't a quaint little company anymore."

In May 1983, Edwin Lewis was promoted to head of sales at Polo, effectively

Strom's No. 2, and Marty Staff was moved to a new post overseeing marketing and licensing; both of them thrived in their new jobs. "Edwin sells like nobody else," says a Polo executive. "He'd fly up and down the East Coast in his own plane and make sales at the airports. The stores loved him and believed in him. He was the rainmaker."

Staff, it turned out, was better off working with manufacturers, as he'd done at Bloomingdale's. "I dealt with them for Ralph, and with Ralph for them," he says. But Polo's relationship with Bidermann, its women's wear licensee, continued to be problematic. As its volume grew, so did Ralph's unhappiness. "Ralph Lauren only want [sic] one thing," says Maurice Bidermann. "More advertising, more advertising, more advertising." Ralph thought his women's licensee was "greedy, opportunistic, and without a lot of integrity," says Staff. "That was his starting point." His relationship with Stuart Kreisler was more complex. Ralph felt that Kreisler was greedy, opportunistic, and lacking integrity, too, but also felt a certain loyalty to him. He could complain about Kreisler, but no one else was allowed to. And, of course, Ralph was a big part of the problem. "Ralph was excessive," says Staff, and insisted on hiring and firing "based on appearance, not competence."

Retailers worried about the tensions with Bidermann. "Stuart hurt Ralph and he hurt us," says Jack Schultz of Bloomingdale's. "Ralph would do the line the night before the show, which was too late for Stuart to buy piece goods. Ralph wanted exotic, unusual, high-end, exciting, and Stuart couldn't make that work." It was, of course, easier to blame Kreisler than Ralph; Ralph was the star. "But Stuart was not a good manager," Schultz says.

Not all licensees were problems. Polo's relationship with the maker of Chaps and Polo University Club couldn't have been more different. Lauren no longer cared as much as he once had about those midpriced goods. "They were permitted to present designs to Ralph instead of vice versa," Staff says. The designs could make Ralph crazy, but Strom diverted him.

Though it wasn't where he made his money, Ralph's happiness depended on the high end of the business; Strom had to keep both Ralph and his bottom line buoyant. So the terms of engagement with the big stores soon changed again. "They didn't want tailored clothes or ties," says Joseph Abboud, "so the game was, you ain't getting the meat and potatoes without the spinach and broccoli." Department stores were forced to carry Polo suits and sport coats (as well as the most expensive women's fashions)—albeit in small numbers—just to keep the commodities. Polo's high-end business would never mean much to the stores that sold most of its goods. But as long as Ralph didn't know that, he was happy.

62

Sustaining Ralph's illusions became all-important. Polo had backed into a way to do that while simultaneously replacing the cachet of the vanishing specialty stores, and guarding against the inevitable maturation of the department store business: more Polo boutiques like Jerry Magnin's.

Polo was set to open one of the very first on Madison Avenue in New York, in partnership with Louis of Boston, a big specialty store, but then its opening was abruptly canceled. The press was told that the landlord had suddenly demanded exorbitant rent, but Joseph Abboud, who'd worked for Louis before joining Lauren, says there was actually a clash of cultures between Ralph and Louis's owner. It killed the joint venture even though Abboud had already ordered goods for the new store.

Peter Strom decided he'd be better off licensing individual stores to others, using other people's money to expand Polo's retail presence, and he got thirteen Polo Shops open in a year. The stores begin to proliferate in 1979. Says Polo CFO Harvey Hellman, "They were throwing off money from day one." By summer 1982 there were thirty shops. Some were owned by savvy retailers like Magnin, but most were owned by investors "with no experience," says Abboud. The Washington, D.C., Polo shop, for example, was owned by a retailer, an interior designer, and two mortgage investors.

As head of licensing, Staff ran the Polo shops, and pitched them as superior to department stores. "Polo shops clearly succeed because of service," he told a reporter in 1985. "That's a commodity you don't find in big stores like you used to. What we're selling is not a product. You don't buy a shirt; you buy a lifestyle. If you want to go hiking, you can buy the Roughwear jeans, the flannel shirt, the down vest, the socks, the hiking boots, all from the same salesperson in the same room. If you went to a big store, you'd have to go to six floors. We're not the kind of company that makes a million units of five products. In men's alone, we make forty thousand different styles a year. Let's show everything Ralph can do. What he believes in. A Polo shop can offer that breadth."

Lauren controlled the goods in the Polo shops, shipped to them first, at the

same time as important accounts like the Bloomingdale's and Saks flagships, and used them to distribute limited edition items like hand-knit sweaters and eighteen-karat gold cuff links. Buffy Birrittella controlled the way they looked—most featured bleached pine and brass. But Ralph rarely saw them and didn't much like them. "Buffy didn't know what she was approving," says Staff. "And [the store owners] would typically build cheaper than they told her they would."

Even when the licensees acquiesced to his demands, Polo didn't get royalties from the stores. But it did get guaranteed business; by the mid-eighties, Polo shops (which had spread to the Far East, Mexico, Canada, and Europe) accounted for 20 percent of Lauren's retail volume. Unfortunately, "most of them were not successful," says Hellman.

Luckily, full-price stores weren't Polo's only retail gambit. One day in 1982, Peter Strom announced that Polo was making too many suits in its Lawrence, Massachusetts, factory and turned half the building into a Polo outlet store, selling out-of-season, returned, and damaged goods at a discount. Not coincidentally, the store solved a problem: Lauren's intense disgust whenever he went into a Polo store, or a department store, and saw Polo goods marked down—literally cheapened.

Lauren says his first wholly-owned outlet store was opened because retailers were selling his stuff to deep-discount close-out chains like Syms—in cities where Polo's full-price business was strongest. "We were having trouble with outlets just putting our stuff on sale," he says. "Everyone has odds and ends. We had to control that to protect the stores that were selling us." But Harvey Hellman says Syms was actually buying direct from Polo. He and Strom had first tried selling old merchandise through the established Polo shops—but Lauren "would see the markdowns; he could kill us about that," Hellman says. "That merchandise was history, he wasn't interested. 'Get rid of it.' " Then came the likes of Syms, but Ralph liked that even less. So Strom decided to open discount outlets of their own—the first-ever bearing a designer's name, says Staff, who oversaw the operation.

The first outlet opened in mid-1982; the second, a year later, was provocatively placed right across the street from L.L. Bean, the original New England outfitter in Freeport, Maine. A third opened in Niagara Falls. They called them Polo Ralph Lauren Factory Stores. "We had no expectations," says Staff. "But we made $5 million the first year." So Strom assembled a team to expand them. They would go into tourist towns and find local developers who would buy land Polo chose and erect outlet centers, using Polo as an anchor tenant to attract others. The deal was so attractive that Polo had to pay only a small percentage of sales as rent. And in no time, Polo was also demanding cash to

decorate its stores so they "looked like a Polo shop," says Hellman. "The whole woodsy atmosphere."

The division was named Factory Outlets of America, as a way of separating it from Lauren, who didn't even like his full-price stores. "He hates dealing with customers," says another Polo retail executive. "He's genuinely shy, and, anyway, it shatters the dream because he sees it's not all models wearing his clothes." So the outlets were "Peter's little secret," Staff says. "I'm not aware Ralph knew how many we had. He had no idea what they looked like" until he showed up at one in Jackson, Wyoming, while on a skiing trip—and liked it.

"It was like dodging a bullet," Staff says.

63

T hen there was Europe. Parisian women's fashion was the *ne plus ultra*, and Italian tailoring its masculine equivalent. In fall 1980, Browns, a store on London's South Molton Street, opened the first freestanding boutique anywhere in Europe selling clothes by an American. Problem was, that American was Calvin Klein. Two months later, Ralph was in London for the launch of a new fragrance, "Tuxedo," and just happened to reveal that he, too, was talking about European boutiques. He was playing catch-up, but he'd soon surpass his rival.

Lauren had been visiting Europe regularly since the early seventies, and not surprisingly, given his particular fetish for things English, loved to poke around London, usually with a British guide. His latest was Serena Bass, now the owner of Serena's, a lounge in New York, then the wife of a British psychiatrist.* Bass would ferret out fine goods Ralph could remake in his favorite colors and brand with his name, and got a 5 percent commission on anything he ordered. But her favorite part of the job was taking Ralph shopping.

"He was fascinated with London," Bass says, "and we got on very well because I'm not very serious. Buffy was the only one who was business-like. Jerry

* Bass's husband, David Shaffer, would later marry and divorce Anna Wintour, the editor of British and then American *Vogue.*

was hysterical, kidding all the time. He'd go behind salesmen's back and make faces and Buffy would just continue her conversation, implacable. I moved to waterproof mascara the second day, Jerry made me laugh so. Ralph would pull himself together occasionally, but basically we were messing around all the time."

Driving around London, Ralph would follow whatever caught his eye — even a car on the street that he liked. Sometimes his wonder at the rare and well made got the better of him. Once, when Bass found a knitter who made special Fair Isle sweaters, Ralph wanted to order four hundred dozen and "got very upset when I explained that was completely impossible," Bass says. The sweaters, knitted by hand, "literally in front of fireplaces," took two weeks apiece to create.

"Don't they know who it's for?" Ralph demanded nonetheless.

Whether driving up and down Bond Street, stopping into Swaine Adeney Brigg, the leather goods purveyor on Piccadilly, or checking out special wool from tiny Scottish islands, Ralph proved "totally passionate about visual things," Bass says. He was particularly adept at repurposing, turning a hacking jacket into a bedspread, a watch into a plate, a blanket into a coat, a Swaine Adeney fisherman's basket into a handbag, or a spiked bulldog's collar into a belt. And he was childlike in his zeal for anything "intensely English and idiosyncratic," Bass says. "There must have been a previous life in which he was an English gentleman. I always thought he should sell little bags of Labrador hair to scatter on your sofa."

Only once did Bass see Lauren's other side — when her secretary failed to get a package of samples to America when Ralph wanted them. "He said if I didn't get them there by Friday night, 'You'll never work in this town again,'" Bass recalls. "It was a *Little Caesar* kind of remark, movie talk. I couldn't believe my ears, but he was bitterly serious. He wanted what he wanted when he wanted it."

What he wanted most in London was a Polo shop. He quickly got one from Joan and Sidney Burstein, the owners of Browns, who'd just opened London's Calvin Klein shop. In 1981, Joan Burstein fell in love with Lauren's Santa Fe collection, met Ralph through a London fashion editor, and asked him to let her open a London shop for him, too. Though the site she had in mind was slightly smaller than Calvin's, it was a stunning Regency-fronted storefront on New Bond Street that had previously housed a famous chemist, Savory & Moore Ltd. Lauren's response was humble — "He thought nobody knew him in London," says Burstein — but he was keen to sell coal to Newcastle. "I felt my things belonged there," he said. "My things, I've always thought, were in a lot of ways more English than the English."

The Bursteins had the store tricked out with $360,000 worth of Georgian oak fixtures and curios like old shoe trees from junk shops and auctions. But when it

opened that fall, its windows filled with haystacks and a leather saddle, it rang up only $23,000 in sales the first day, less than half what Calvin Klein had sold on his first U.K. day. "The English public are fickle," Mrs. Burstein says. "They started looking at prices." Then came the BBC and that sweatshop sweater scandal—customers couldn't understand "paying import prices for things coming down from Scotland." Sales went down, not up.

The Bursteins are gracious about the end of their brief affair with Polo. By late 1982, still sustaining losses, Sidney Burstein was getting offers for the lease and began thinking about selling it. Joan faxed Lauren and told him—but he didn't respond. He'd begun ignoring news he didn't want to hear. Finally, on a trip to New York, she warned, "It's going to be sold if you don't get going."

Lauren, typically, is a bit more blunt. "It wasn't working," he says. "Joan Burstein loved it, [but] she was never there. She gave it to someone to run, and they didn't have a great relationship. The husband was the businessman, the man behind the scenes, and he didn't love [it]. I bought the store because he wanted to close it."

The Bursteins sold Lauren the lease for about $350,000. "It wasn't worth the work," says Sidney Burstein. "It was good for him and good for me. He wants a huge business. I don't want to be big, I want to be happy."

The London deal was financed by a Danish businessman whose relationship with Lauren began, oddly enough, in Colorado. Peder Bertelsen had made a small fortune as an oil trader in the Middle East in the 1970s. In 1981, he bought a ranch outside Ridgway, Colorado, from a rancher named Charlie Hughes, who also worked as a local Realtor. Hughes sold Bertelsen his ranch after the Dane turned down the next-door spread, a huge property Hughes represented called the Blue Lakes Ranch. Bertelsen met Ralph after he hit town in the Warner jet (he didn't yet have his own) and bought Blue Lakes Ranch a few months after Bertelsen rejected it.

Ralph's new ranch had once been the homestead of Reverend J. H. Scott, a preacher. His granddaughter Marie started acquiring all the land around it at the age of twenty-two in 1918. A rough-hewn ninety-pound redhead who wore gaudy red skirts and cowboy hats that matched her well-rouged cheeks, Scott eventually became one of the largest private landowners in the American West; her holdings exceeded seventy thousand acres at their peak. When she died, it was split up and sold off.

Bertelsen's sixteen-hundred-acre ranch was once part of the Scott property, as was a separate four-hundred-acre parcel Bertelsen bought from other heirs, just across the road from Blue Lakes Ranch, on which sat Scott's house, a modest, wood-sided affair with a huge picture window.

It looked out on Lauren's new ranch, one of the most beautiful properties in Colorado. High in the San Juan Range of the Rocky Mountains, just beneath a towering fourteen-thousand-foot peak called Mount Sneffels and the Dallas Divide, a one-time flag stop for the Rio Grande Southern Railroad, Ralph's ranch was described in a sales brochure as forty-seven hundred acres of "incredible beauty and promise," the largest contiguous property ever offered for sale in that corner of Rockies, with three virgin streams providing water rights worth $1 million; its own 9,829-foot mountain, Old Baldy; sweeping irrigated alpine meadows full of sage, buckbrush, chokecherries, and wildflowers surrounded by spruce, ponderosa and pinion pine, aspen, oak, willow, cottonwood, juniper, and cedar trees, and the Uncompahgre National Forest as a next-door neighbor. Other neighbors included deer, elk, black bear, wild turkey, and grouse.

Though Scott's ranch—on which she'd raised cattle—was not as big as the famous King ranch of Texas, the largest private holding in America, "Marie owned prettier land," says Charlie Hughes. "She was much more selective," limiting her purchases to valley meadows with great views—precisely the sort of land that gentlemen ranchers wanted when they hit the Rockies in the seventies. "She loved property," says her ranch foreman, Mario Zadra. "It might've been a disease, but she loved land. There was never enough of it."

Like her, Lauren wasn't easily satisfied. Before he agreed to buy Blue Lakes Ranch, he made his purchase contingent on another deal. He wanted an adjacent five hundred acres that Marie Scott had willed to her foreman, in order to square off the property. Ralph was difficult, but he was also generous. Mario Zadra agreed to sell when Lauren offered him $3,000 an acre, $1,750 more per acre than he'd paid for the larger Blue Lakes Ranch.

That other four hundred acres of land on a ridge nearby—owned by Peder Bertelsen—overlooked Ralph's new ranch and he hoped to graze cattle there in summer, but it was fenced off. At first, Bertelsen wasn't willing to give him access. "He told Lauren to go piss up a rope," says Realtor Hughes. But then Ed Pastoucha, Bertelsen's New York lawyer, told the Dane who Lauren was and reminded Bertelsen that he also owned a bankrupt British uniform factory that might be useful to Polo. Pastoucha arranged a meeting where Lauren upped the ante. His offer was astonishing: if Bertelsen would give him grazing access, he'd give the Dane the right to open Polo shops throughout Europe. The offer wasn't totally mad—Bertelsen owned the Roman couturier Valentino's London boutique. But it was still like a bolt of lightning out of the blue.

After a meeting with the Italian investors who held the license to make and distribute Polo menswear in Italy and France, Bertelsen and Pastoucha made the deal, agreeing to help Ralph take over the Burstein's London shop, too. "He was

not going to let that store fail," says Pastoucha. And Ralph got more than access to the Dane's land: he and Bertelsen traded land, so Lauren owned his ridge. Then Bertelsen and his lawyer headed to Europe to scout out stores. "We didn't get any further," Bertelsen says. "I thought I was clever. I wasn't clever enough. Peter Strom had his own ideas."

Strom had let Lauren make his little land deal, but he was uncomfortable with Bertelsen, an outspoken maverick whose first mistake was telling the Italian licensees how to do business. Then, Bertelsen gave in to his penchant for peculiar public behavior—he loved to shock—and did a handstand in the middle of a Milanese hotel lobby. While some found this sort of thing amusing, when Strom heard about it, he declared that Ralph was uncomfortable with Bertelsen, the deal died, and Bidermann bought out Bertelsen and Pastoucha's share of the London store. Years later, Bertelsen (who went on to open a number of London boutiques, including Giorgio Armani's, and to back the avant-garde designer John Galliano) sold his Colorado ranch. Lauren, of course, ended up with it.

"So he has nobody next to him," Bertelsen says.

Ralph's European adventure was just beginning. After its roaring rookie years, Warner/Lauren Ltd., Ralph's fragrance company, had hit a sophomore slump. An ambitious Lauren makeup line, launched in 1981, was a huge money loser, as was a name-brand skin-care line introduced the following year. The "Lauren," "Polo" and "Chaps" fragrances continued selling well, but the company plowed a quarter of its revenues into advertising and promotional efforts, so it showed no profits until the company agreed to sign a license with Mohan Murjani, who owned the socialite Gloria Vanderbilt's name for a perfume. Vanderbilt, who'd helped start the designer jean craze, was hot, and Warner/Lauren needed more revenue to support its 130-man sales force.

Ralph objected strenuously. "He didn't want our resources focused on anyone but him," says George Friedman, his partner in Warner/Lauren. Especially not a real aristocrat who'd succeeded in the crucial arena—denim—where Ralph had failed. Like Polo Western Wear, Roughwear jeans had been less than a success. Ralph even asked Friedman and his partner Bob Ruttenberg to leave a company board meeting so he could make his case against Vanderbilt—and stopped talking to Friedman for a while when he lost. But he won by losing; Vanderbilt's scent, an immediate hit, finally put Warner/Lauren in the black.

The fragrance dramas weren't over, though. After a series of reverses for Warner Communications (notably, a disastrous investment in the computer game manufacturer, Atari), it was forced by its huge debts to divest its noncore businesses. In January 1984, Warner agreed to sell Warner/Lauren for $145 mil-

lion to Cosmair, the American subsidiary of the French cosmetics giant L'Oreal. Again, Ralph objected. This time, Warner chairman Steve Ross invited him to lunch and begged him to go along so Warner could raise cash. Having suffered reverses of his own, Lauren agreed, and made another bundle selling his equity share of the fragrance company. Which turned out to be a terrific deal for him in another way.

Warner/Lauren had done "at best okay" outside America, say Friedman and Bob Ruttenberg. L'Oreal had extraordinary international resources and the French company's plans to create a big Polo fragrance business in Europe affirmed "the importance of Ralph as a global brand," just at the moment he was pushing into Europe, says Marvin Traub. "The virtue was not the business the brand does but the amount of advertising L'Oreal put behind the brand, which has an umbrella effect."

The timing was perfect. Lawrence Stroll (born Strulovitch), son of a manufacturer who held the Polo boys' wear license for Canada, had just acquired the right to sell Polo clothing across western Europe. Stroll formed a licensee called Poloco, which began opening more Polo shops throughout England and in Paris and set up wholesale showrooms across Europe at the same time L'Oreal launched Ralph's fragrances there with a big push.

As with any other licensee, Ralph insisted on controlling Stroll, so Shari Sant, the former fit model and licensing policewoman, was given a new title— design director for special projects—and began traveling regularly to Europe, attempting to control this new Polo frontier. Stroll had hired a creative team in Europe, but Ralph and Buffy were reluctant to trust them. "So I had to do everything," Sant says. "I even had to find tumbleweed in the Bois de Boulogne."

64

In their game of chess, Lauren's European moves put him ahead of Calvin Klein. Then, a rangy South African model, Jose Borain, who arrived in New York in 1983, became the latest pawn in their game. Borain was represented by Click, a boutique model agency run by a former photographer's agent, Frances Grill. Bruce Weber was said to be one of Grill's investors, and Weber's

favorite Polo models, the Ricky Lauren look-alike Jane Gill, and surfer Buzzy Kirbox, were booked by Click. Grill believed her business was image creation, not photography. And she was delighted to play linchpin in the unique collaboration of Ralph and Bruce: "They were made for each other," she once told a reporter. They told "the same story; that's why it's so powerful. Bruce just took that WASPy, puritanical image, gave it a pinch of sex appeal, and it jumped."

Grill brought Borain to Lauren's attention in the summer of 1983, and after doing some fittings for him, Borain joined Weber's troupe, earning $52,000 in six months culminating in an eight-day Polo photo shoot that paid her $16,250.

That August, Click started negotiating an exclusive Polo contract for Borain. Though most designers avoid others' models like the plague, that's when Calvin Klein started using her, too. Click went along, hoping to use Klein's interest to goad Lauren into signing a deal. To keep Borain's commercial image pristine for Polo, Click kept her out of Klein's ads, only allowing her to pose in Klein's clothes for what are called "editorial shoots" in fashion magazines; designers are often allowed a measure of control over such pictures.

Klein wanted to snatch Borain away from Lauren, so he kept Click out of the loop when he took her to dinner and offered her a contract. For a month, Click talked to Polo while Borain talked to Calvin and, Click would later allege in a lawsuit the agency brought against them, posed for several off-limit ad jobs for Ralph's rival.

Final contract talks with Polo were scheduled—right after a fashion show in which Borain was booked to appear. But a day before the show, Borain canceled, telling Click she was leaving the country and telling a Polo executive that she was quitting modeling. Then, on September 25, 1983, Borain signed a contract to become the new Calvin Klein Girl—and Click promptly sued. Three years later, after her contract with Klein ended, Borain and Calvin Klein Industries settled by paying off Click. But the episode was the first public display of the simmering rivalry between Ralph and Calvin.

Employees theorized endlessly about the feud. The two never really went head to head in fashion—their styles were quite different—but they were both empire builders. "There was more jealousy on Ralph's part than on Calvin's," says someone who worked for both. "Calvin was a tall, handsome devil. Ralph had a short man's complex about him, and he verbalized it." Ralph would note with displeasure that in the constant two-way traffic between their design houses, it was more often Calvin hiring people from Ralph than vice versa. When Klein hired Kelly Rector, Ralph fumed, "I created her. She's mine!" He'd also stew over Calvin getting more attention from fashion magazines. "He'd get furious, he'd curse, he'd get them on the phone and threaten to pull his ads," says a

Lauren designer. Adds a Polo PR person, "If Calvin got a headline, it'd be a black day. He'd lecture us for hours about Calvin, ranting about what a terrible person he was."

Indeed, Ralph would disparage Klein at every opportunity, alluding to the open secret of his rival's bisexuality, his public displays in discos, his blatant courtship of influential editors, and the way his style blew with the winds of fashion, inspired at different times by different designers: this season, Saint Laurent, the next, Azzedine Alaia. "Calvin was such a chameleon," says a Polo executive. "Yet it was Ralph who they called a fake. And from a business point of view, Ralph was and is authentic. He's the most important men's designer in pretty much every store he sold. They banked on him."

Lauren *was* consistent. "Those goofy outfits he wore as a kid?" the executive says. "That's still Ralph." And though it wasn't glamorous, Polo made consistent profits selling sheets, towels, Polo shirts, and khakis week in, week out, whereas Klein's volume went up and down, this way and that, just like his designs. "What always upset me," Ralph says, "is that I went through this business really clean. I didn't copy Armani and I didn't copy Saint Laurent. I built my own thing. I didn't come from the women's business. I wasn't hyped by fashion magazines. I built myself. I didn't wine and dine anybody. I very rarely go out."

Lauren's eternal issues with the press were exacerbated by the free ride he felt Klein was getting. "Ralph was doing new things, and the papers wrote about people at Studio 54," says Marvin Traub. "Ralph's home life is not as exciting as that." Traub recalls nights at the Lauren home spent listening to music and watching the children dance—the youngest, Dylan, turned nine in December 1983; the oldest, Andrew, was then fourteen. Heartwarming as such family scenes were, they were no match for Calvin's divine decadence. And Ralph rarely allowed outsiders in, fiercely protecting his family from public scrutiny.

Jeffrey Banks, who has worked for both men, thinks the rivalry boils down to greed. "Wanting to have it all," he says, "the best people, the best houses. It's a total, total rivalry. They never talk about it, but it's obvious. The fact that I worked for Ralph made Calvin salivate for me." So close yet so far from each other, neither can abide the other. "If there's a CFDA board meeting," Banks says, "Ralph's office calls. If Calvin is coming, Ralph won't go."

"It's like a kid thing," says Milly Graves, who knew the two as kids in the Bronx and managed to buy both of their collections for Bloomingdale's in the eighties. She insists that the two really respect each other. "But they each don't want the other to be more important."

65

I n 1982, Wilkes Bashford, the leading men's specialty retailer in San Francisco, who'd been selling Ralph's wares in his eponymous Union Square store since 1967, opened the city's first freestanding Polo shop. Bashford's art director was Jeff Walker, whom Bashford had discovered a few years earlier when Walker moved to San Francisco from Minneapolis, where he'd designed window displays for Dayton's, the local department store. "He had the knack to make you look," Bashford says of Walker's windows. Only in his late twenties, Walker was already considered one of the best display artists of his generation. Other stores in San Francisco were constantly trying to hire him away.

The opening party for the Polo shop that September was an affair to remember. Bashford hired the Broadway choreographer Michael Bennett to stage a fashion show. Bennett brought in lighting and sound crews and built a three-level scaffold that he populated with sixty models. The guest list included local social figures like Charlotte Maillard and Denise and Prentis Cobb Hale, and California governor Jerry Brown. It was *the* party of the week in a town that loves its parties. Calvin Klein staged a luncheon fashion show at the nearby I. Magnin department store that same week, but the Polo party overshadowed it. When the night was over, Jeff Walker knew what his next job *had* to be.

In the months that followed, Walker barraged Buffy Birrittella with letters, telegrams, gifts, and ideas for Polo. "We were always laughing: Jeff's on the phone again," says a Poloroid. Finally, in spring 1983, Walker flew to New York and talked himself into a job. "There was an aura about Wilkes that was magnetic to Ralph, and Jeff embodied it," says Marty Staff. "Ralph collects people. So Ralph collected Jeff. Ralph sometimes fell in love with people because of their hair color, but Jeff was more than that. Jeff was uniquely talented."

It hurt to lose his wunderkind, but Bashford understood: "Ralph knew how good he was, and in those days, if somebody had talent, Ralph made room for them to exercise it." Promoted to director of creative services, charged with coordinating visuals in ads, showrooms, and stores, "Jeff became Ralph," says a Polo

designer. "He got into Ralph's head better than anyone except Bruce Weber." Indeed, only Weber had a greater influence on the Ralph Lauren the world knows today.

Back in the seventies, Sal Cesarani and Jeffrey Banks had started creating little vignettes in the showroom at 40 West Fifty-fifth Street—stage sets that evoked the mood of each season's collection to help sell Lauren's lines. Jeff Walker had a much broader stage to play on, decorating not only the ever-larger and more numerous Polo showrooms, but also showrooms all over New York where licensees sold Polo goods, as well as creating the look of Polo's ads, its shops, and Lauren's own homes. It all began with what Poloroids call rigs.

Rigging was a fashionable cousin of set design—and over time was used throughout the company, not only to sell clothes, but also to inspire the people who designed them. A rig could be as simple as a presentation on oak-tag boards or as complex as a whole building. Walker's rigs were environments that brought to life whatever themes Ralph had chosen for a season. To help the literal Lauren visualize, his designers had long built them using everything from photographs, sketches, and clippings torn from books and magazines, to pieces of clothing and fabric swatches—and then created collections that reflected them. Walker was a rigger on steroids. Once he got involved, a rig could include saddles, blankets, pieces of furniture, old suitcases, ivory-handled walking sticks, anything that harkened to the concept and helped set the right mood. Walker once cut a truck in half for a Roughwear showroom, and would buy out whole antiques stores to get what he needed. The rigs were built, then photographed, and, eventually, the pictures were distributed to all departments of Polo and catalogued in its library. Walker even created "rigging books," seasonal display guides for Polo's shops and its retail accounts.

Walker's influence quickly pervaded the corporation. He was even allowed to put his two cents in about clothing design, and a better Polo emerged from the exchange of information. "He had an unbelievable ability to capture what Ralph was thinking and make it inordinately better," says a Poloroid. "He ran around like a crazy person trying to be all places at all times. He really was a little star." Though Ralph would tweak, massage, and approve his rigs, "They were Jeff," says the creative services executive.

Soon, Walker was hiring staff, and his growing division was divided into teams: one handled Polo's various wholesale showrooms—both the company's own and those of its licensees—*and* New York store displays and windows; another handled Polo stores and off-price outlets around the country; and there

was a special projects team that worked for Lauren personally, redoing his homes on Fifth Avenue and, later, in Montauk, Jamaica, Colorado, and Bedford. Each team included designers, administrators, and "a slew of carpenters and builders," says an executive.

In 1984, Tasha Polizzi's fit model and Ralph's creative policewoman in Europe, Shari Sant, joined creative services, and created another new job description at Polo. She worked with Buffy Birrittella on ad shoots, in charge of coordinating accessories; and as the liaison between creative services, advertising, and design, charged with soldiering Polo's looks like Ralph had once soldiered ties at Brooks Brothers. Sant sat in on design meetings; worked with Walker on showroom installations, explaining where each line was going; and accompanied Walker and Weber on advertising shoots, ensuring that the themes, designs, and environments all meshed.

It was a magical time at Polo, as the anointed made magic in the sisal, leather, and pine beehive of 40 West Fifty-fifth Street. Though they were crammed, as one Poloroid put it, "879,000 to a room the size of a closet," they walked past palm trees on Oriental carpets, wore lavish Lauren wardrobes, and wrote letters on thick, creamy stationery topped by the Polo logo. Every season, the staff would pile into a showroom to view Walker's rigs and hear Lauren expound on the line. "It was intoxicating," says a recent hire. "We were on this incredible ride and he'd say that this beautiful stuff wasn't him, it was us—the most talented people in the world were in this room. We were young, good-looking, a winning team. God, you'd have to pinch yourself!"

Had anything ever been so perfect? "You did it perfectly or not at all," says an employee. Adds another, "It was a whole package—the Polosphere."

66

The Rhinelander mansion, the ultimate Polo shop, was the *dernier cri* in Ralph rigs. There were forty-four Polo shops at the end of 1984, when Lauren signed a twenty-year lease (with renewal options) on the Rhinelander and announced he'd open a shop there in a year—but none encompassed the breadth and depth of the Polosphere in all its magnificence. The Rhinelander was conceived to do that job, *and* be a laboratory, and a living advertisement for Ralph's total concept and the premier outlet for Polo's most expensive clothing, which (*shhhh*, for this was a secret) few retailers carried anymore.

The idea was to pull the Polo lifestyle together once and for all—and show Lauren's vision the way *he* wanted it seen, not the way some fashion magazine saw it. That meant it had to be, to borrow a phrase from Bloomingdale's, like no other store in the world. "A return to old time values," said Marty Staff. "Greet you when you walk in. Bowl you over with an old English, clubby sense of abundance. Have wood cubbies and an armoire. And *don't* put in an acoustic tile ceiling and fluorescent lighting." But first, they had to find exactly the right store in exactly the right location. And upper Madison Avenue was the only neighborhood clubby enough for Ralph Lauren.

Staff, still Polo's top marketing man, was assigned to find the perfect site for the store. He walked Madison Avenue with a real estate broker and a camera, and took pictures of twenty available and suitable buildings. The Rhinelander was the only one Ralph liked. It was full of tenants, but one of their leases had just expired, and the landlord paid several others to give up their leases—then recouped that money, plus interest, from Polo as part of its rent. Eli Zabar, founder of the famous delicatessen, got $4 million. Another tenant got half a million. The process of emptying the building took a year, and while it was going on, Polo was offered the building outright for $12 million. Staff advised Strom not to buy it. "One of my worst moves," he admits; the mansion was finally sold to a new owner in the mid-nineties for close to $50 million, causing the building's

taxes to quadruple. Under the terms of Polo's lease, it was responsible for all costs.

The interior designer Naomi Leff, another Bloomingdale's veteran who'd designed the J. P. Stevens Home collection showrooms and created a number of Polo stores, was in charge of the restoration of the mansion. Buffy Birrittella approved details like the color of the mahogany. But Jeff Walker was the real author of the Rhinelander, just as Weber was the author of Lauren's image. There were very few people who Ralph felt had taste equal to or better than his own: Walker was one. And he knew how to handle his boss, too. When Ralph couldn't decide whether he wanted a balustrade or paneling on a balcony, Walker had examples mocked up out of Styrofoam. "Jeff would overwhelm Ralph by doing it better than Ralph asked for," says a design staffer. "Jeff was born to be with Ralph Lauren. God put him on Earth to do that job."

As construction began, Walker planned what would go inside the mansion. Polo was already known in the antiques trade before Walker joined up—along with museums and libraries, Ralph's designers would routinely comb flea markets and antique shows like the one held twice a year in Brimfield, Massachussetts, for inspiration. But once Walker started rigging the Rhinelander mansion, antiquaires looked at Ralph in a new and hungry light. "The word would ripple out: 'The Ralph Lauren people are here,'" says Marilyn Kowaleski, the Pennsylvania dealer who'd sold Ralph patchwork quilts.

Until then, Polo's creative services team had more often been renters than buyers. Whether they were rigging showrooms, propping advertising shoots, or just seeking inspiration, they went to prop- and costume-rental houses like London's Angels & Burman, a four-floor warehouse organized by era. But for the Rhinelander, they needed more and bigger antiques—and needed to own them. So buyers spread out across the United States and England, seeking furniture, chandeliers, Persian and Aubusson carpets, vitrines and showcases with which to furnish the store. It didn't matter what period. "In a real family home, furniture is acquired over generations," Lauren said. "That's the effect we want."

The expenditures on the mansion were so great, Ralph's executives began to worry that the undertaking would impoverish the company. "We weren't swimming in cash," one says.* Lauren worried about more than that. Would his big retail clients like Bloomingdale's and Saks feel he was stealing their business? Might he lose those crucial accounts? After one of their regular lunches at the

* The store would be Marty Staff's Waterloo. He resigned in September 1986—just after the Rhinelander opened. "Everything good with the store, Ralph did, and everything bad, I did," says Staff. Staff's job was to control spending on the store, but that meant controlling Ralph, and that was impossible. Staff took the blame for the cost overruns.

pricey Four Seasons restaurant, Ralph took Marvin Traub up Madison Avenue in his stretch limo to see the mansion. "Isn't this marvelous?" he asked his most important friend in retail. "I'm going to build a store that's unique."

"Ralph," the shocked Traub replied, "you're twelve blocks from Bloomingdale's." Lauren says Traub offered him a bigger, better shop inside Bloomingdale's if he'd only change his mind. Lauren insisted, "as Ralph is wont to do," Traub says. He was sure the mansion would help, not hurt, Bloomingdale's. Faced with the irresistible force of Lauren's will, Traub did an about-face and offered to refurbish Ralph's Bloomingdales's boutiques, "to build our business and not run away from it," he says.

What incentive could Bloomingdale's have had to take that leap of faith? Traub's reply is vague. Certain financial arrangements were made. "Leave it at that," Traub says. "It helped Ralph to be able to say Bloomingdale's feels they can make it work."

The two-year gut job on the Rhinelander mansion broke Lauren's $5 million construction budget (he would eventually pin the final cost at $14 million; Staff says it was closer to $35 million). To complete the massive undertaking, Ralph employed sculptors, wood-, brass-, and stoneworkers, and battalions of display artists. "The expenses were out of control," says an executive. "At the end, crews were working around the clock."

The attention to detail was as astonishing as the expense of giving Ralph whatever he wanted. "Ralph had to have a dumbwaiter installed so he could serve lunch wherever he wanted at any time," says Staff. Lots of little air conditioners were put in because a big system would have eaten up too much ceiling height. A tack shop full of equestrian gear was pursued for months but then abandoned. Even the back offices—which would be bare-bones in most stores— were tricked out with mahogany fittings. And then the sales staff had to be put through a three-month boot camp.

A press blitz preceded the opening. There was a lavish profile in W in January, a Forbes cover story in April, and articles in newspapers across the country. There were paid notices, too, including an eighteen-page advertising portfolio in the New York Times Magazine that cost $450,000, and featured photos of the mustachioed husband of a top men's fashion editor, a drawing of the Rhinelander, scenes from a Polo match, a gang of racquet-toting blue bloods, a black-tie party, and some beachy photos that looked as if they were taken at Ralph's Jamaican retreat, all "carefully calculated," Forbes wrote, "to assure the insecure."

The store opened with a big champagne party on April 21, 1986, and was described, without apparent irony, by the *New York Times*, as Lauren's "ultimate ancestral dream home." The next morning, the public poured in for the first time, and a couple hours later, Marvin Traub called Ralph to ask how it was doing—and demonstrated that his friend still had a lot to learn about retailing. Traub had to explain that the cash system kept a running total of sales. So Ralph asked his manager how much they'd made: $40,000 so far. "Is that good?" Ralph asked. Traub assured him it was terrific.

That evening, it was Lauren's turn to call Traub. Once the doors closed, Ralph had asked his manager for the final first-day sales. Traub thought Ralph sounded like a little boy as he reported the mansion had made lots more since he'd first asked that morning, for a total of just under $100,000. First week sales would come close to $1 million. Ralph was vindicated. And overjoyed.

"He had a new toy," Traub says.

Visiting the store became Lauren's favorite pastime. "He was there all the time, by himself and with his family," says a salesman. A special locked room in the mansion's basement was filled with clothes in Ralph's size, 37 short, just for those occasions. A tip-off would come from his office when he was headed uptown—and a panicked scramble would ensue. "Does everyone look good?" the salesman recounts. "Are the cutest girls up front at the cashmere bar and the antiques counter? Salesgirls were told to change into current merchandise. Then Ralph would come in like a visiting king, and everybody would fold sweaters, trying to act natural." You knew you'd arrived when he asked for a piece of your clothing and handed it to someone in his retinue with orders to take it to design.

It was the same in Polo shops around the country. "You got a day's notice if you were lucky," says the salesman. "Mobilize! Change the windows! Fluff the store! Pull the collection from Dallas and get it to Beverly Hills." Women's clothes in Ricky's size were flown in, so she would always find merchandise to buy. "People would be outside with toothbrushes, polishing brass," says a store manager. Sale merchandise would be removed from the fronts of departments. SWAT teams were even known to fly in from New York, to redress the staff and fill the stores with orchids.

"Ralph was not to know," says another salesman, "but it was all about pleasing him."

At the Rhinelander, a five-person creative services tactical squad, working under Jeff Walker, was responsible for keeping Ralph happy by maintaining the

mansion's perfection. They worked out of a tiny room, each assigned to a floor. "Keeping it up required an amazing amount of hours," says a member of the team, Mark Matszak. "It meant getting there at seven A.M. when the flowers were coming in. It all had to look perfect and serene. You had five dresses on the floor and five hundred more in storage around a corner. No one could push; no one could sell. It was retail, but the illusion was that it wasn't."

Even the mansion's sales staff was rigged. All new employees were given an indoctrination about the mansion and the company, and told they had to look a certain way. "We'd get speeches about being actors on Ralph Lauren's stage," says a salesman. So would reporters. "This isn't retail, it's theater," Charles Fagan, who started out selling sweaters and ended up managing the store, told a journalist. "We present our clothes in lifestyle. They're all little movies. At the mansion, you can get lost in different worlds."

Lauren loved hiring the children of socialites, and for them, the need to buy head-to-toe Polo ensembles wasn't a burden; they even got big discounts. Managers not only got a 60 percent discount, but also seasonal wardrobe allowances. Salespeople who didn't have independent wealth, and earned an average $24,000 a year, sometimes tried to cut corners. That's when orders came down that everyone's outfits would be photographed each season—even stock-room employees—their looks would be approved, and no deviations would be allowed. "In interviews, you were told you couldn't wear red nail polish and asked if that would bother you," a salesperson says. Wardrobing seminars were organized; haircuts and tanning sessions would be prescribed by managers. It was rumored that a socialite's daughter quit, threatened to sue, and got a hush-hush settlement after a manager "suggested" she needed breast reduction surgery.

As time went on, things spiraled. The mansion's manager, who'd run Polo shops in Texas, was "brilliant, but excessive," says Staff. "Lost money wherever he went." But never this much. Then there was Walker. "Jeff always wanted bigger and better," says Mark Matszak, who worked for him. "The money! The expense!" The window displays grew ever-more elaborate. The creative staff would work all day, running around to antiques stores for the perfect prop to create a facsimile vignette of, say, the Duke of Windsor's world. Then, when the store closed at night, creative services would move in like pixie stevedores and make magic. Which meant moving furniture and walls and pulling up rugs as trucks pulled up and disgorged antiques.

The Home department was renovated every season. "You'd walk out of the South of France on Saturday night," says Charles Fagan, "and come in Monday to a Russian salon." Bill Sofield, then a kid on the creative services staff, is now

a top retail designer himself. "Cutting your teeth at Polo makes you so fierce," he says. "Jeff raised the bar. Never say no. Sod the whole fourth floor! It wasn't, 'You're insane.' It was, 'How do you prevent leaks?' The trick was to execute the equivalent of a six-month construction project—elaborate perspectival trellises, limestone floors, antique windows—after store hours. And not only was Jeff tyrannical, relentless, and fastidious, he showed up at four A.M. unannounced because that's when we had to do the sueded plaster finish so the walls would be ready for the next step."

Needing more room to plan its Rhinelander productions, creative services took over a big, white warehouselike space a few blocks north at 980 Madison Avenue, across the street from the Carlyle Hotel, in the former home of Sotheby's auction house. Lauren and Strom had actually rented the space as a new headquarters; Strom had been begging Ralph to leave Fifty-fifth Street for years. "We could hardly operate," he says. "We had people all over town." Then he had to wait until Ralph found just the right block and building. But with Polo experiencing exponential growth, the space, once found and leased, proved insufficient. It was, however, just large enough so that new installations for the Rhinelander could be worked out there, built like movie sets—"only they weren't movie illusions; everything had to be perfect," says Matszak. It was all done in advance so the rigs could be moved into the store overnight. Walker would create walls horizontally on the floors, which he'd marked out to size with masking tape. He'd sandpaper and distress velvet, burn bedclothes with cigarettes because that's what the character he imagined lived in the store that season would have done. He had very definite ideas. "God forbid anyone use a mannequin with a head on it," says an employee.

It was all about creating a brilliant, seductive illusion. Shopping at the Rhinelander made you feel like a member of an elite club, a participant in the Polo way of life. Your purchases let you take a piece of that idealized fantasy with you and incorporate it into your quotidian existence. "It wasn't the real thing," says a creative services staffer, "but the thing it should have been. And it seduced you into the lifestyle."

The numbers proved Jeff Walker's magic wasn't *all* illusion. On its first anniversary, Lauren said that the store's $30 million first-year volume was triple Polo's projections (even though the venture wasn't profitable). And area department stores confirmed that the competition from Polo hadn't cannibalized their business. Indeed, some retailers said they thought the Rhinelander experience had helped their businesses *and* given Polo a new appreciation of their problems. A Polo executive agrees. "Before the Rhinelander, Ralph thought retailers were sleazy scumbags," he says. "That was the turning point."

The Rhinelander was a watershed in all sorts of ways. But, most of all, it was a personal triumph for Ralph. And thanks to its astonishing and vastly influential success, not only did fashion retailing change all over the world, but Ralph himself reached what many consider the pinnacle of American achievement, appearing in a Polo shirt and white cable knit cotton sweater on the cover of *Time* magazine's September 1, 1986, issue.

He wasn't yet forty-seven years old. On the cover, he smiled like someone blessed.

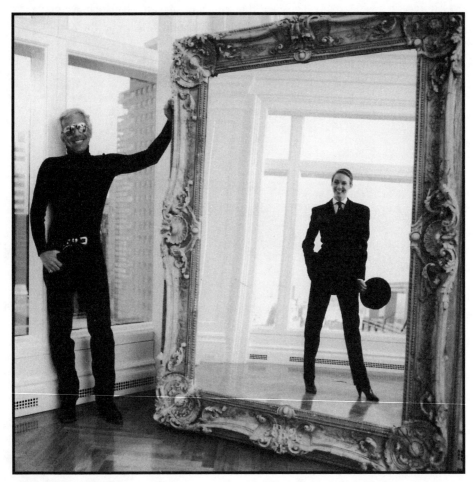

The "only mistake I ever made"—Kim Nye and Ralph Lauren; April 1992. *(George Lange)*

Disruption:
From Illness to Infidelity

I am not an angel, I am not.

—RALPH LAUREN

67

With Tasha Polizzi firmly in charge of women's design, Buffy Birrittella's role as Ralph Lauren's alter ego became her full-time job in 1983. Anne Marie Rozelle, daughter of the National Football League commissioner Pete Rozelle, was hired to take over many of Buffy's publicity duties, including Ralph's personal press relations.

One of Rozelle's first acts was to advise Lauren to become involved with a cause. He'd recently given a fund-raiser for Colorado senator Gary Hart, who was running for president, but after Hart was broken in a sex scandal, Ralph never wanted to play politics again. So Rozelle suggested he adopt a cause he cared about. One possibility was a disease. Lauren had suffered from tinnitus—a ringing in his ears—since 1977. As far as he knew, it was the only health issue in his family, but it was hardly a billboard-size cause.

Instead, he ended up sponsoring something closer to his heart: Man and the Horse, an exhibition of equestrian clothing worn by Rockefellers, Mellons, Rothschilds, and Phippses, as well as Buffalo Bill, at the Costume Institute of the Metropolitan Museum of Art, New York's fashion museum. Inevitably, he was attacked for breaching the wall between culture and commerce, between historical truth and commercial facsimile. "It was," wrote the *Nation*, "a barefaced commemoration of the Old Money look and a spur to the would-be-horsey set. It was also a splendid advertising opportunity for Ralph Lauren, the show's only corporate sponsor. In return for $350,000 from Lauren, the Met affixed his name and his Polo logo to all publicity associated with the exhibit, even to the walls of the galleries." In his defense, Ralph told Bernadine Morris of the *New York Times* that "there isn't a blazer of mine in [the show]." But then, he showed jodhpurs that season.

The noise of his critics competed with the noise in his head; after years of ignoring and denying it, it was driving him crazy. Yet nobody figured out what was causing the problem until August 1986, when Ralph's doctor rushed him home from Colorado for a CAT scan and diagnosed a benign brain tumor.

Ralph's *Time* cover had just hit newsstands when he found out. "It was the

accomplishment of my life and I couldn't enjoy it," he told an interviewer. "Envision this: it's a beautiful day and I'm sitting in a hospital, isolated . . . out of the world . . . out of the loop. That's hard to deal with if you're as excited by life as I am." At first, he told only Ricky. Then he told Strom. "He was very, very concerned," Strom says. "He was very nervous."

Ralph procrastinated about surgery, as he did over so much else. He had so much on his plate. His father had had prostate surgery that January, a heart attack in September, bypass surgery a month later, and then had broken his hip. Jerry Lauren had just suffered an aneurysm. And on the business front, there were pressing new problems with Ralph's women's wear licensee Bidermann, which had gone into a sudden decline. Though Bidermann's sales volume was over $250 million, the company was barely profitable.

Calvin Klein bought back his menswear license from Bidermann at the end of that year, infuriating Lauren, who wanted *his* license back, too. But Lauren Women's Wear was Bidermann's only bright spot, earning $2.6 million profit on sales of $42 million—and the company needed those revenues. As a result of business reverses at the French parent company, Maurice Bidermann had been forced to reliniquish control of his company to a three-man team in 1982. But after four years, he'd returned and was making it clear that his managers in America, primarily Michel Zelnik, the man who'd made Ralph a fortune by moving Polo shirt production to China, had fallen out of his favor.

Word was out that Zelnik and the president of Bidermann's women's wear division, Ralph's old friend Stuart Kreisler, were proposing to buy the Lauren license—which had three years left to run. But instead, in January 1987, Bidermann announced plans to expand its Lauren business and aggressively pursue more in-store boutiques, while downsizing all its other business, even those of big names like Yves Saint Laurent. Bidermann also committed to spend a six-figure sum so that Ralph could present his April fashion show twice in one day at the St. Regis Hotel. That represented a major statement of support of Ralph, and would be a major statement by him, as well.

Lauren decided that the tumor surgery would have to wait until after that fashion show. But as the show date grew closer, his symptoms worsened. Marvin Traub guessed something was wrong when they met for lunch early in 1987 and Lauren confessed. Traub was sympathetic; his daughter had been treated for a brain tumor, as well. The severity of the situation became clear when Lauren grabbed Traub's arm and said he'd gotten a sudden, piercing headache. They rushed across the street before eating—and Traub called New York Hospital for an emergency appointment. He bundled Ralph into a car and took him to the hospital where he finally agreed to schedule the surgery—for a few days after his April show.

As that show approached, things seemed normal to most of Lauren's staff, with the women's design team locked into the workrooms at 550 Seventh Avenue until the wee hours of the morning. Ralph hated doing shows; "These damn things take the life out of me," he'd complain. This time, though, he was preparing for surgery as well as a show—and, unsure how much life he had left, he was trying to create beauty beneath a cloak of gloom.

Lauren's show at the St. Regis Roof stuck to his classic theme of opulent, vaguely equestrian fashion. Wrote Bernadine Morris, "It's the look of old money, and it has the kind of enduring charm that won't be made obsolete." Not exactly a rave review. But for once, it wasn't the press that caused the backstage pall. Lauren had finally told key staffers—although not his partners at Bidermann—that he was going into the hospital the next day. "He thought it was curtains," one says. As he took his curtain call, many of his employees, who were his closest friends, fought back tears. No one knew what the next few days would bring. Would this be Ralph Lauren's last stand?

The following Monday, Ralph underwent surgery to remove the benign meningioma pressing into his brain. Though the lump wasn't cancerous, the operation was dangerous, so the fact of it wasn't announced until three days later, when his doctors were certain they'd succeeded and their patient was out of danger.

The announcement was an attempt to alleviate concern, and not just because meningiomas can recurr. "The 'Calvin thing' worried everybody," says a Lauren executive. The "Calvin thing" was the then-pervasive rumor that Lauren's arch rival had contracted AIDS. While it didn't visibly harm Klein's business—indeed, it was in a perverse kind of synch with Klein's image of polymorphous sexuality—it was nonetheless a severe distraction. Lauren was concerned that his enemies real and imaged would use his illness to harm Polo.

Shortly after the operation, *Esquire* magazine asked Ralph if he would pose for the cover of its fall fashion issue. Lauren was very thin, had a scar over his skull from ear to ear, and his hair, shaved off for the operation, had not yet fully grown in. But as always, those closest to him kept telling him how great he looked, and so he decided—against the advice of others ("He did not look as fabulous as he should have," says one)—to pose for the cover. It was an act of bravado, but Ralph knew how the fashion world worked, how bitchy it could be, and how fragile a business like his really was. If people thought he was anything less than 100 percent, then the excised tumor would be the least of his problems.

The resulting photo showed Ralph hidden behind dark aviator glasses, wearing a Marine Corps baseball hat and a denim jacket made by Lee, not Lauren. He'd taken refuge behind one of his favorite alter egos; he was dressed exactly

like Steve McQueen as Thomas Crown in a dramatic sequence from Ralph's favorite film, *The Thomas Crown Affair*, in which the star had piloted a glider, swooping through the skies like the king of the world. But despite Ralph's bravado, and his macho pose, the *Esquire* photo didn't quell the rumors that he was off his game, so in October, he gave an interview to *WWD*, admitting that his purpose was to assure people that he was indeed "on his feet and working."

Lauren had spent six days in the hospital, worked from home through the spring, then spent the summer recuperating in Colorado. "I actually had time to think," he said. He'd earned a new appreciation of life, and felt exhilarated, energized, and joyful. He vowed to change, to make more time for his family, to avoid stress, and to be more sensitive to others. Back at work, he announced that "life was really important," Shari Sant recalls. "He said, 'Go home to your husbands.' That lasted about a week."

As it turned out, Ralph spent *more* time at the office now, not less. "I've always been sensitive about life and am grateful for what I've had, but when I came out of the hospital I was more scared than when I went in—maybe because it dawned on me that anything could happen to me, just like that," he said. "I went back to work with a much greater fury. . . . I don't take anything for granted." Not even the skill and loyalty of his closest staff.

68

In July 1987, Ralph announced that Elizabeth Tilberis, a fashion editor at British *Vogue* who'd worked closely with Bruce Weber, would be joining his design team. Tilberis was following in the footsteps of her colleague, Grace Coddington, who'd been the fashion director of the same magazine before becoming design director at Calvin Klein earlier that year. When Klein heard about Lauren's offer, he, too, made a run at Tilberis; she took Klein's offer to Ralph, who matched it, and Tilberis accepted a $250,000-a-year job.

Coddington didn't last long at Calvin. Tilberis never made it to Ralph, even after she'd sold her house, packed her belongings in containers, and was about to move her family to America. British *Vogue*'s then-editor Anna Wintour was moved to *House & Garden*, another title in the Condé Nast magazine stable,

and ten days later, Tilberis was named her replacement. It was an offer she couldn't refuse: British *Vogue*'s influence and access were as great as its circulation was small.

It was never made clear if Tilberis was meant to replace, or merely complement Ralph's chief women's wear designer, Tasha Polizzi. Regardless, Tasha left five months later, in December 1987. The official announcment said she'd resigned. She was actually fired. Back from his convalescence, Ralph had to prove he was in charge again.

Tasha had had a good run without much interference. When the former fit model was named head of design in 1980, Ralph had cleared the way for her. "Buffy stopped coming to design meetings," says a studio hand. "She only came when Ralph did. In Buffy's mind, Buffy was still above Tasha, but Tasha reported directly to Ralph." And that clearly irked Buffy. Her revenge, when it came, would be cold, but sweet.

Tasha was smart—and tough. "Good fit models have to be political and Tasha was," says a design staffer. "They have to have opinions, to say 'This pocket is too high.' And if their opinions sell, they become irreplaceable." Tasha was also political; she'd been known to fiercely defend her primacy among Lauren's models at his shows, scaring the wits out of anyone who challenged her prerogatives. "Tasha was great," says the Kreisler saleswoman. "She was reasonable and accessible and realistic, and she got things done. Our whole team loved her."

Tasha wasn't intimidated by Ralph. "She had a strong sense of self," says a co-worker. But that was a weakness as well as a strength. "Tasha was not a team player," says an executive. "She was a cold fish. In the men's studio, everyone got along. They laughed. The vibe in women's was uptight." Still, Tasha was good, she was very well paid, she'd recently been promoted, and she seemed to know her place; when Lauren offered her the chance to take a bow after one of his shows, she wisely refused. "Tasha was involved with everything," says Jennifer Houser, who'd been a backup fit model at Polo for years before replacing Polizzi as the lead in-house clothes horse. "The final product was Ralph, but Tasha edited out what he didn't need to see. He needed that. There was so much to do; it was impossible."

As he'd grown comfortable with Tasha, Ralph began staying away until just before shows, when it was time to put Collection together. Tasha was given so much control that "it was hard to go back" when Ralph returned after his convalescence, says one of her assistants.

Unhappiness permeated the design studio. "People would say how horrible it was," says a competing designer who interviewed several Poloroids seeking to

flee. "It was a chaotic mess. It was all backstabbing and catfighting, and Tasha was dictating to Ralph and he said, 'Wait a minute, *I'm* the boss.' "

Lauren told people he felt undermined when he'd give orders in design meetings and the staff looked at Tasha for approval. Then Lauren ordered Tasha to eliminate certain items from the Collection shown to be that fall, and when she didn't, there was a confrontation. "When you start to think you are greater than God, you get thrown out of paradise," says Joseph Abboud. "We might have been archangels, but we couldn't replace Him."

Polizzi disappeared overnight. "It was really weird; none of us really knew why," says Shari Sant. "We never saw her again." Sant suspects someone did Tasha in. "He'd get paranoiac about people who were close to him," she says. "People would plant seeds in his mind." Indeed, Ralph would often ask staffers to criticize each other. "What do you think of so-and-so?" an executive recalls his asking. "It's very Tudor; there's a lot of mumbling behind the tapestries. If your opinion matched his, he'd say you were right. If it didn't, he'd say, 'Why do you think that?' Then he'd give his opinion. 'I don't think she shares our taste level.' He'd plant seeds and influence your opinion."

Design staffers thought Buffy Birrittella was planting seeds in Ralph's mind, stabbing Tasha in the back. "There was a lot of animosity there," says Polo CFO Harvey Hellman, who resigned just before Polizzi was fired. "Jealousy and envy." Tasha and Buffy had been competing for Ralph's attention since 1979, both dressing up in white jodhpurs, for instance, to catch his eye. It was a natural conflict. They were two women of great style, about the same age, both close to Ralph, both long-term Poloroids. Ralph enjoyed watching them compete, and he got better design out of it, too. Co-workers believed Birrittella had lain in wait, chosen her moment, and given Polizzi a shove. Buffy was put back in charge of women's design. Says Joseph Abboud, "Buffy never let her guard down." Except once. "It's very hard to be a woman in this business," she confessed one night. "The only way to get the job done is to be a ruthless bitch."

Tasha Polizzi won't discuss her time at Polo. "I don't want to defend myself," she says. "I shoot from the hip. That offends people. Some can take it; some can't." After leaving Polo, she joined the Polo-like Ruff Hewn, left within weeks for the Polo-like Banana Republic, stayed there a year, then spent eighteen months designing for Polo's polar opposite, Calvin Klein, before founding a small company of her own, where she makes clothes quite similar to those she designed for Ralph. "There's no one in our industry more amazing that Ralph Lauren," she says. "He's changed everything we do."

In Polizzi's wake, Lauren remade his design team. He hired Nick Gamarello, a fine artist who'd made some money in fashion by painting the backs of flight

jackets, and had become a designer of clothes rather like Polo's. The two met when Ralph visited Gamarello's New Jersey home; he'd heard Gamarello was a good painter. Gamarello, who, like Ralph, collected military gear, antique clothes, and flea market Americana, liked Lauren's designs, although he felt they lacked the purity of vintage clothing.

Lauren walked through Gamarello's house—noting the knotty pine 1939 British Air Force ready hut Gamarello had installed and the closets full of vintage clothing—and immediately offered him a job. The painter said no, but they stayed in touch; months later, he had an interview with Jerry Lauren. They took an instant dislike to each other; Gamarello thought Jerry "really fruity, rude, and insecure." So when Jerry asked him what salary he was looking for, he answered $650,000 a year. "He actually choked," Gamarello recalls. "I said I wasn't looking for a job, and asked him, 'If you weren't Ralph's brother, would you be paid what you are?'" When Gamarello then told Ralph what had happened, he continues, "Ralph started laughing. He said we'd talk further."

A month later, Ralph called to say Polizzi had been fired—and he wanted Gamarello to design for Roughwear, which had evolved into a subbrand of both Polo men's and the licensed women's business. After meeting Buffy Birrittella and Peter Strom, Gamarello moved into an office in the women's design department at 40 West Fifty-fifth Street He didn't know it yet, but he was Ralph's new favorite on the design team. "You'll come to meetings with me, sit, listen and join in," Lauren told him. Gamarello came to think of himself as "a Ping-Pong ball, bouncing around" the company, doing skirts one day, gloves the next, sometimes designing wallpaper, sometimes drawing logos, even painting a T-shirt for a summer staff outing: "Polo Pictures Presents Ralph Lauren as the Colorado Kid," it said.

Simultaneously, Tasha Polizzi was replaced by her predecessor, Jenny Witbeck, who'd gone to work in the interim at Calvin Klein. Ralph, of course, had resented that. "It was like she'd cheated on him," says a design staffer who was close to Witbeck. Ralph wanted her back, if only to take her away from his rival. And he had to "pay her a lot more, as much as Calvin paid her," in order to do it.

Witbeck flew to Europe on the Concorde the day after she was rehired. The design staff was all there, waiting for her. As they told her about the Collection they'd begun under Tasha, Witbeck was unimpressed. "She said toss it and start all over," says the staffer. "She thought Ralph had no vision, that he'd lost it along the way. Ralph found it very frightening. He started canceling fittings, canceling meetings, everything was getting later and later. Nothing could be

approved without him." Witbeck realized Polo was the same way it had always been but worse. Ralph had changed, all right, but not for the better.

69

After Ralph's brain surgery, new wrinkles had been added to an already complex personality. He seemed more serious, more obsessive, harder to know, even quicker to anger, even more ruthless and egomaniacal than he'd been before.

He'd always liked an entourage, but now it had grown and become a constant; he was never without a buffer of Buffys and Bitsys and Pollys. "Masses of them," says a Poloroid. "Not just the girls in the stretch like in the old days. It was like, what do these people do? There was so much unhappiness. All the assistants were crying every day, working until eleven at night." They had reason to cry.

Ralph's peculiarities had multiplied. Where once he'd ignored the ringing in his ears, now he developed hypochondria. There was the day he regaled an advertising meeting with the story of how he'd had his jet land halfway home from Jamaica because he thought he was having a heart attack that turned out to be heartburn. And the time a nurse with a stethoscope and blood pressure machine appeared at a meeting: Ralph's chest felt tight.

Ralph's talent for destructive criticism also flowered. "You had to come up with ideas or he'd yell, but if you had one of your own, he'd shoot it down," says a Poloroid. "If you fought and won, you'd lose. If you acquiesced, you'd lose. It was lose-lose-lose." Even admirers were wounded in the process. "Anyone who gets close to him is left reeling by the assaults on their self-esteem, his need to diminish people and make them feel helpless, infantile and inept in his presence," says one who suffered the treatment. "He cripples people to keep them dependent. He has no tolerance of independence. I always wondered what huge hurt he'd suffered in his childhood to make him act that way."

It was scarier when something *really* went wrong. "He'd carry his rage from meeting to meeting," says a vice president. "You lived in fear of his moods. I don't work there anymore, yet I *still* feel like I shouldn't be saying this. He has this terrible dark side to him."

It wasn't only employees who felt Ralph's wrath. "He's not the most pleasant guy in the best of times," a Polo executive says. "Twenty-five percent of the time, he hates you, he hates his coffee, his hates the world." Once when Michael Ovitz, then the head of Creative Artists Agency, failed to get a star to turn up at a party for Lauren, as promised, "Ralph called him and harangued," says a witness. "Just streams of abuse! He wants people to be scared of him and to think he's tough." Serena Bass, Ralph's British liaison, had once compared him to Little Caesar, the Hollywood gangster. Now, a fleeting personality trait was becoming a defining one.

The problems at Bidermann didn't help. The head of production, who'd done all he could to give Ralph whatever he wanted, had died of a heart attack within weeks of Lauren's brain surgery, and "nobody was running the ship," says a Poloroid. "Jenny would tell Ralph what was going on; he didn't want to hear it." Then Witbeck broke her arm carrying a garment bag. "I think she realized she was in the wrong place," says the Poloroid, to whom Witbeck confided her plan to quit right after Lauren's April 1988 fashion show.

But the end came before that, in a fitting, in front of about three dozen Ralphettes, and it seemed like a snapshot of the post-op Polosphere. Lauren was tearing into an assistant for a delay that many in the room felt was really *his* fault. Witbeck raised her hand like a schoolgirl; reminded Ralph that he'd canceled about five fittings in a row, and told him things couldn't be finished if he wouldn't approve them. Ralph went ballistic, "enraged, shaking, pointing," says a witness. "Get out!" he screamed as the staff watched, cowering. Flushed, Witbeck stalked to the elevator, never to return. The next day, Lauren started calling design staffers he thought close to Witbeck into his office, one by one. "Why do you believe in her?" he asked them. "Why are you loyal to her?" He demanded they never speak to her again. "He was trying to deprogram them," the Poloroid says.

Lauren was happy nonetheless, or at least seemed so, in April 1988, when he literally danced down the runway at his first fall show since his brain surgery. In a season of restraint—the stock market had crashed the preceding fall, deflating both the hot-air balloon of the Reagan era and the poufy fashions that symbolized its excesses—Ralph seemed to be celebrating life, even if his show was full of sober and subdued, if luxurious styles—cashmere knit dresses, wide pants, cropped jackets, and camel's hair swing coats, most in neutral colors.

But now that he was back in the saddle, he was looking to collect some more scalps. The first one he wanted was Stuart Kreisler's. Lauren had realized that Kreisler, once his biggest booster, had gone over to the enemy—his colleagues at

Bidermann. "Stuart saw an opportunity to make more money being [Bidermann CEO] Michel Zelnik's new best friend," says a Bidermann executive. Adds another, "Stuart didn't want to work, he wanted to guide [the Lauren license] along. He figured, Why go into virgin territory?"

The annual volume of Bidermann's licensed Lauren women's wear line was by then about $120 million, but Polo men's, wholly owned by Ralph and Peter Strom, was three to four times larger. By creating a commodities business—those khakis and knit shirts and T-shirts—Kreisler and Zelnik had grown the business by a factor of ten, but Ralph wasn't satisfied. "They wanted to make the most bucks for the least cost," says a Polo executive. "If Ralph designed cashmere jackets, they wouldn't make their margins, so they wouldn't produce them."

Ralph wanted more volume, which would pay him more royalties, while the Bidermann boys wanted high margins, even at the expense of volume. "[Ralph] thought more was better," Kreisler would later say, "but it was not the way that I was interested in managing the business, because it impacted profits."

Throughout Kreisler's reign, Bidermann had managed to make nice, consistent money, with earnings before taxes and interest never falling below $12 million, and rising as high as $20 million in 1983. But the money came from those generic, lesser-priced items. Collection—the high-end line that for most large-scale women's wear designers gets the most attention but has the smallest sales—was a consistent loser, draining $2 million to $3 million a year. "When you spend $1 million on three shows a year and you only sell $12 million, that doesn't leave much," says Zelnik, "even if you're very lucky." Edwin Lewis, then Polo's head of sales, estimates that Collection represented 7 percent of the women's business, but 80 percent of its expenses. The only way to give Ralph what he wanted financially and still make profits was by entering a lower-priced fashion arena.

A brief lesson in the fashion business comes in handy here. Only in its topsy-turvy universe is better worse. The terms fashion uses to describe its price levels are as absurd as fashion itself can sometimes appear. Big stores are segmented by price point to make shopping easier. Like-priced goods are typically sold near one another. While most shoppers think in terms of casual, career, and evening clothes, stores divide them differently, with couture or made-to-measure clothes at the top of the pyramid, mass-manufactured "designer" lines like Lauren's Collection one notch below, and then, in descending order, bridge (bridging the gap between designer and cheaper clothes), contemporary (fashionable sportswear), better (generic career clothes), moderate (items, not outfits, and the staple of most department stores), main floor (commodities like one-pocket T-shirts) and budget (think K-Mart).

To get the volume he craved, Ralph had to go into the "moderate" business

in a bigger way. But Maurice Bidermann felt his company wasn't equipped to make a move into that market. "We have not the habitude," says Bidermann. "Zelnik and Kreisler were not capable." They could run a hundred-million-dollar company, he thought, but not one five times that size. Kreisler, Bidermann says, was "a small man with small ambition." Indeed, Kreisler felt the growth Ralph was demanding simply couldn't be achieved. "I didn't think it was conceivable unless Ralph's standards dropped," he says. Really, it was a failing on both sides. Which doesn't mean Lauren and Strom stopped asking for more volume. "The meetings were horrible," says a Bidermann executive. They argued constantly about the size of the business, and Ralph's dissatisfaction with Collection.

Polo men's business, while huge, wasn't as profitable as it could have been had Ralph cut corners. Bidermann cut corners. Lauren would make samples in one fabric and Bidermann would switch to a cheaper one for goods that went into stores. "I never subbed a fabric on Ralph," Stuart Kreisler insists, but design staffers sniffed about Bidermann's "disposable cashmere." Ralph would see a Bidermann-produced item at Bloomingdale's and start haranguing Buffy: "Where did this come from? I didn't approve this."

"Ralph," she once replied, "it's tagged, it's on the rack, it's for sale."

"Never happened," says Kreisler. Didn't matter to Ralph. "He wanted to take [women's wear] over," says a staffer. "He wanted it to be his." But when an attempt to buy back the license failed, Strom and Ralph decided to replace Kreisler with Edwin Lewis, the southern salesman who'd grown the Polo menswear business by leaps and bounds. "Ralph comes in the office one day, and he is irate," Lewis recalls. Kriesler had failed to do something Ralph wanted. "He says, 'I've fucking had it with Stuart Kreisler. He's full of shit, he's a liar, I'm tearing my heart out and he's not thinking about the business, I want him out, it's over. Work it out, Peter.' He had a serious hard-on for the guy."

Lewis had become a star player at Polo because he had the uncanny knack to get stores to do things his way. But his explosive personality had made him enemies inside the company. So putting Lewis into Bidermann seemed like a win-win proposition for Lauren. If Lewis succeeded, Ralph would be richer. If Lewis failed, he'd be gone. Either way, he'd be off the Polo payroll, and at a safe distance.

Michel Zelnik couldn't protect Kreisler's job; he'd left Bidermann in summer 1987. A year later, Kreisler resigned, or at least, that's what he told WWD— and says today: "I wasn't fired by Ralph Lauren," he insists. "Whoever said I was fired by Ralph Lauren?" Kreisler did, in fact, in a federal court a few years later, when he testified that Lauren had told Bidermann to fire him. "I was asked to

leave," Kreisler said under oath. "I was pushed out of the company." Edwin
Lewis took his place, at Polo's request.

Strom was pleased. Succession was an issue for him—and Lewis was his
favorite. "Peter trained Edwin to take his place," says a Polo executive who was
close to Strom. "They called them Pete and re-Pete. Peter pushed Kreisler out of
Bidermann for Edwin." And Lewis looked like just what the women's business
needed. A sales-making machine, he was terrifying. But Edwin terrified Ralph,
too, and that would be his undoing. "He was having too much fun," says one of
Lewis's intimates. "And Ralph was jealous of Edwin's relationship with Peter
Strom. Ralph has to have all the attention."

There were shake-ups in the design studio, too. Just after that joyous April 1988
fashion show, Lauren asked Jennifer Houser, who'd replaced Tasha Polizzi as his
fit model, to replace Jenny Witbeck, and become a top designer of his women's
Collection. When she asked when he wanted her to start, he said, "Yesterday."
Houser was intoxicated with Lauren. "He was magical," she says, "a dreamer. He
always allowed himself to swim against the stream." When she came back from
a research trip to New Orleans with antique uniforms she'd found there, he
based his next Collection around them.

But after Houser designed two Collections, another designer appeared. Gale
Parker had been a fashion editor, a muse to the Italian designer Valentino, and a
peripheral member of Andy Warhol's seventies Factory set. After she met Ralph
through a mutual friend, he offered her a job alongside Houser.

Chaos followed, as Houser and Parker fought for control and Ralph toyed
with them both. "Gale wanted my job," says Houser, who thought Parker untal-
ented and insubordinate. Ralph brushed Houser's complaints away. "It was very
upsetting because I adored Ralph and she was his favorite," says Houser, who
decided that Lauren, overwhelmed by success, had lost his bearing and was hav-
ing a midlife crisis. He'd survived a brain tumor. He was about to turn fifty. His
kids were heading to college, and he was asking himself, "What else can I have?
What else do I need?" Houser says. "He could have anything he wanted. That
can be as frustrating as not having money."

Annoyed with Ralph for pitting her against Parker, Houser quit when she
learned she was pregnant. Looking back on her Polo years, she finds it funny and
sad that despite all his talent and all his money, Lauren saw himself as a loser.
He'd once told her how he'd watched his foe Calvin Klein work a party, unable
to do so himself. "He never felt he was good enough," Houser says. "He's still
this shy little petrified boy."

Shy, but not reticent. Ralph always had a temper, but after his surgery, he could turn volatile in an instant. "You'd see a flush," says a P.R. staffer who came to dread those moments. He'd control his anger in public. Behind closed doors, things were different. Especially when it came to the press.

"Ralph was never happy with his coverage," says a PR person. "He always had a problem. Why didn't he get more press? You'd say, 'You're not that trendy.'" And that flush would rise.

Ralph and Buffy micromanaged everything concerning the press. The seating chart for shows was constantly being erased and redone. And so was every piece of paper that emerged from the press office. There were rules: Words like timeless and elegant always passed muster, but others were forbidden. "It's not a pant, it's a trouser," a PR recites. "Maroon is not a Ralph Lauren word."

He wanted to control the press, too—as he had all the way back in the sixties, when he turned down an interview because other designers were going to be quoted. Now, he'd flare whenever anyone pointed out he'd once been a Lifshitz. That was one of several supersensitivities. "He hates being called Jewish; it drives him crazy," says one of his flacks. It was the same way when anyone mentioned his height.

"What's that have to do with anything?" he'd demand. "Why is this coming up?"

Lauren cared desperately about how he was perceived as a designer, yet would never be photographed in the act of designing. He hated reading reviews of his shows—yet a press package was placed on his desk every morning, mentions of him marked with a highlighting pen. He also insisted on controlling how his collections were shown in fashion magazines. He'd get incensed when one of his garments was used to illustrate a seasonal theme that wasn't his, if a riding jacket was used in a spread on the color red, instead of one on equestrian clothes, for example. He began insisting that magazines be allowed to borrow his samples only if they shot head-to-toe looks, without so much as an accessory from another label. "You had to support us if you wanted our support," says a Polo flack.

His arguments with the press became louder and more frequent. "The temper was phenomenal and in total conflict with his public persona," says another flack. After a ranting phone call, one fashion editor called the PR person and said, "He's a madman." Ralph went apopleptic over Jeffrey Trachtenberg's 1988 biography, demanding that the subtitle be changed from "King of Marketing," and furious over quotes attributed to his brother Lenny about his departure from Polo years before, quotes Lenny now longs to disown.

Ralph liked a few reporters. He loved Nina Hyde of the *Washington Post*, who loved him back and gave him great reviews. He returned the compliment when she came to him in 1988 and asked him to host a party to raise funds to establish the Nina Hyde Center for Breast Cancer at Georgetown University Medical Center. He adopted breast cancer as his cause—and would later sell pink Polo-logo T-shirts (conceived of by Strom) and Polo bears for its benefit, putting Polo power behind the search for a cure.*

As opposed to newspapers, which tended to honor journalism's time-honored tradition of separating journalism (or "church") from the business of publishing (or "state"), most fashion magazines kowtowed to major advertisers like Ralph, informally trading editorial coverage for ad pages. But the maverick trade paper WWD and its owner, John Fairchild, were another story. Even though Fairchild also published W, a high-end lifestyle magazine as obsessed with wealth as Ralph was, and as dependent on advertising as any other fashion magazine, Fairchild's coverage was often barbed. So when Lauren was seating his fashion shows, the question was always, where to put Fairchild? Trustworthy fans had to be placed on either side of the puckish fashion pasha. In years to come, Lauren would even hire two of Fairchild's children, James and Stephen, to work for Polo.

As with so many other Polo hires, Ralph seemed drawn to PR people who somehow impressed him or seemed particularly useful to him. Alexander Vreeland, who did Polo's in-house press in the eighties, was a grandson of the legendary *Vogue* editor, Diana Vreeland. In November 1988, Dolores Barrett, whose husband, Ed Klein, had been the editor of the *New York Times Magazine*, was hired to work alongside Vreeland.

Only days before Barrett was hired, Ralph had suffered one of the little indignities from which he expected his flacks to protect him. The Council of Fashion Designers of America considered naming Lauren its designer of the year, but then reversed itself. It emerged that there had been arguments on the fifteen-person award jury—Ralph was too big to ignore, but his clothes were too popular, too generic for some of the judges. Donna Karan, then a relative newcomer to name-brand fashion and a darling of the fashion flock, ran neck and neck with Ralph. The vote was close. Too close. So Ralph's detractors flexed their muscles, and it was determined that no designer of the year award would be given at the ceremony in January 1989. A CFDA insider says that "someone naughty"—then he names the fashion director of a department store—called WWD and blamed Bernadine Morris of the *New York Times*, who had chaired the meeting.

* Lauren has also practiced charity on a private and individual scale, reportedly paying for the college educations of the children of the doormen in his apartment building.

Morris and Lauren had been at odds for years. She admits she'd written "snotty" reviews of his work, and found him obsessive and controlling when he tried to dictate which garments she would photograph. "The problem is, he's not a designer," says Morris. WWD had blamed Morris for the award switcheroo, but Lauren blamed Alexander Vreeland. "Ralph wanted to be recognized as the best designer in the fashion world and as something bigger, a leader, one of the pre-eminent people in the world," says a Poloroid who watched what happened. By spring 1989, Vreeland was gone, and Barrett, the first Polo PR person to come from the world of corporate marketing, was put in charge of the department.

Lauren wanted to be wanted; he didn't want his press people to have to pitch him, but of course they did. One of Barrett's first coups was a cover story in *Manhattan Inc.*, a brief-lived but highly visible business magazine of the Reagan-Bush years. Lauren had been furious the year before when it had run an excerpt from the Trachtenberg biography. Barrett convinced the magazine to do another story on the tremendous success of Lauren's Home line—and put him on the cover. But *Manhattan Inc.*'s editor, Clay Felker, didn't play along.

The story, though quite positive, elicited a complaining phone call from Barrett. "She was quite exercised," says the author, journalist James Kaplan. "He was incensed that I paid him the service of quoting him word for word. She was hurt that we hadn't put gauze over the lens."

In fact, it wasn't so much the story as the visuals Lauren was incensed about. Barrett had arranged a photo session with one of Lauren's favorite photographers, but Felker wanted to put an illustration on the cover and hired a painter to reproduce a John Singleton Copley portrait of the silversmith and American revolutionary Paul Revere contemplating one of his teapots, with Lauren as Revere. Lauren's PR people made it clear he wouldn't be happy with an illustration, and even picked out a picture from the photo session that they knew Ralph would like, but Felker insisted on the right to edit his own magazine.

Lauren and Felker ran into each other next in the president's box at a football game at Duke University. Felker was a Duke graduate; Lauren was there accompanying his seventeen-year-old son David, who'd come for an admissions interview. "Ralph started raising hell," says Felker, who was taken aback. "He went on and on about how his hair was too gray in the painting, and how it was bad for his business."

Over the years, journalists and editors would regularly have such experiences. "He was *always* complaining," says Carolyn Gottfried, the WWD editor who covered Ralph in the early seventies. When GQ did a special western clothing issue in the early eighties and failed to include any Lauren designs, he refused to loan them samples for more than a year. He complained so often about his cov-

erage in the *New York Times Magazine*, where Polo was a top advertiser, that its editors were loath to run even positive stories about him. *Vogue's* all-powerful editor Anna Wintour felt his wrath, too. Lauren has "read her the riot act" several times, say former employees of Polo's public relations department, most recently about one word in what was otherwise a valentine about his purchase of a second home in Jamaica; Lauren went ballistic because *Vogue* called his hair frizzy.

Ralph's control fetish went beyond the press. His inability to bend the world outside the Polosphere to his will had always made him something of a hermit — and his isolation increased as time went on. He'd regularly drive his PR staff crazy, vacillating over whether to attend events, even ones at which he was being honored. He had reason. In 1992, Ralph would make a rare public appearance to accept a Woolmark Award for lifetime achievement. The MC, comedienne Sandra Bernhard, referred to him as Ralph Lifshitz several times, and then, as he returned to his seat next to Ricky after getting his award, quipped, "There he goes, the Jewish cowboy, off into the sunset. I sure do like your sheets, Mr. Lifshitz."

Lauren cringed, says a tablemate. "It was everything he'd worked so hard to have people forget." The next day, he whipped off letters of protest, promptly leaked to the gossip column Page Six, addressed to the chairmen of the evening, and top retailers and magazine editors, calling the event undignified and a bad reflection on fashion.

That advanced state of crankiness began as the eighties ended, and Ralph's midlife crisis seemed to deepen. Employees thought him unhappy and detached. "He'd sit in his office, looking at magazines and making phone calls all day," says an executive. "Sometimes, he didn't come in at all." His secretary would photocopy his daily schedule regardless — "with every minute taken up, no downtime," says one who saw it. Not that he'd stick to it. But everyone knew there was one appointment he'd keep. Ralph had realized something was wrong and started seeing a psychiatrist, Toksoz Byram Karasu, chairman of the department of psychiatry at Albert Einstein College of Medicine, and an expert on depression, every other morning. "The whole company knew it," via those photocopied schedules, says a creative services executive. "Everybody talked about it."

Meanwhile, menswear, the wholly-owned engine that drove Lauren's business, had stalled. Giorgio Armani's power suits had defined the middle of the decade; now sober new styles were emerging from young designers like Romeo Gigli. "Polo didn't mean anything," says Ed Glantz, the one-time Meledandri salesman, who'd moved to Milan to work for Armani. "Ralph was concentrating on

women's and on licensing, and Polo went stale. The eighties were a clothing period. Ralph never sold clothing. His ads always looked great, but I didn't know anybody who wore it."

Nonetheless, Lauren was selling so many basics—Polo shirts and khakis and sheets and towels—that he held on to his image of fashion dominance, even as he sat alone on his throne, flipping through magazines. In May 1989, *Life* magazine profiled him and revealed that Polo's retail volume had reached $2 billion a year. The article caused exultation inside Polo. "Nobody had added it all up before," says an executive. "The industry shuddered; it had no idea we were that strong. Everybody thought it was just a bunch of nice little businesses, but we were more powerful than the stores were. The little fish in the bowl had become an ocean liner in their backyard." But instead of being thrilled, Ralph was enraged; he'd lost the cover of *Life* to First Lady Barbara Bush and her dog Millie, who'd just had puppies.

Five months later, Ralph turned fifty years old. He looked dreadful at his spring fashion show, held just after that October 1989 milestone. The rumors about Calvin Klein and AIDS were still on his mind. A few months earlier, he'd begun dieting and exercising and had lost twelve pounds. That, combined with the worry and frenzy of the preshow build-up, had left him depleted. So Lauren gave an interview to journalist Lisa Lockwood, and insisted he was healthy and happy, too—happy as he'd ever been, in fact. "I dreaded my fiftieth birthday and wanted to look as great as I can," he told her.

Jerry Lauren saw Ralph's sudden self-improvement binge as a good sign. "Ralph never, never rests," he said a few years later. "He's always moving on." But he never gives up what he loves. "Ralph just wants perfection. That's played a strong part in all our lives." So when he turned fifty, Jerry continued, "typical of Ralph, he wouldn't fall into, 'Gee, I'm not a kid anymore.' He wants to be in shape. We say, 'I haven't got time.' He said, 'I'm going to make time.' There was no reason he couldn't get in great shape. It's still about showing people how to wear clothing. People who are in shape look better in everything. There's no reason a guy in his fifties has to say, 'That's for younger guys.' "

Indeed, cool clothes weren't the only younger guy thing Ralph craved. When they turn fifty, many driven men end up seeking whatever it is they feel they've missed in life. Some change jobs, but Ralph was the boss. Some buy red sports cars, but Ralph already had more cars than he knew what to do with. So he indulged himself in a different, though equally obvious cliché, and dove headlong into a blatantly public affair with a much younger woman.

70

K im Nye, a fine-featured blonde with legs that went on for days, strode into the Polosphere as a runway model and ran off with Ralph Lauren's heart. In three brief years, she became the fit model for Lauren's Collection, signed a contract to star in a huge ad campaign, and then disappeared after it became widely known that she and Lauren had been having an affair that nearly broke up Ralph and Ricky Lauren's marriage. It was the talk of the fashion world, the first time Ralph was publicly accused of infidelity. But inside Polo, Nye was seen as just the latest in a long string of blondes.

"There are rumors Ralph had affairs with just about everyone who worked there," says Shari Sant.

As early as 1978, Lauren's indiscretions were whispered about widely enough that WWD asked about them and Lauren was forced to defend himself. "People can say anything they want," he told the paper. "Ricky does not have too much competition—it's not as if I have a dog at home and no one sees her. When I am away, what Ricky is worrying about is not whom I'm with but how I am." Ricky chimed in, defending her choice of motherhood as a career. "It's like a fairy tale," she said of her life.

Speculation about Ralph's alleged indiscretions begin with Buffy Birrittella. "She was the first," says the Kreisler saleswoman. "Buffy has been in love with Ralph her entire life, and she never fell out of love with him." Certainly they shared an intimate bond. "They could go on for six hours about the detail on a button," says a Birrittella underling. But there are as many Poloroids who insist the two were never intimate as there are who think they were.

Indeed, some say that like Buffy's affair with Robert Redford, Ralph's alleged escapades are either his fantasies or the fictions of others—particularly those who knew him early in his career. "Ralph is the shyest human being in life," says former Chaps designer Robert Stock. "I'd take bets he never had an affair. He was too smart to do anything stupid."

"Impossible," agrees ex-design assistant Gil Truedsson of the rumors about Birrittella. "He was such a devout family person. He absolutely worshipped the

ground Ricky walked on. He was a—voyeur isn't the word, but it's close—watching from the outside, appreciating beauty and chic." Model Lauren Hutton would come by to try on clothes, and Ralph would just stare in awe.

"I don't think he's a sexual person," says another longtime male employee. "He lives in a fantasy world, an internal world. He's like a mouse popping out of a little hole." Lauren's social shyness—some think of it as ineptitude—is legend. "He doesn't entertain, he doesn't have guests, he doesn't like anybody, he doesn't see anybody," says a PR executive. "He invites his staff to his birthday parties. He doesn't have a life. It's lonely and sad."

Yet the chatter about Lauren's sex life extends to both sexes. Joe Barrato acknowledges he was the first man with whom Ralph supposedly had sex. His relationship with Jeff Walker, who *was* gay, was intense, though likely not sexual.

Other stylish men would follow Walker in Lauren's affections, but the only evidence of a homosexual streak is how often he points out his heterosexuality. There's a school of thought that says that since an interest in clothes was a little suspect, when Ralph was young, he began to overcompensate. Some believe he has issues with men as authority figures, or else puts men on a pedestal, where Lenny, Jerry, and the better playground athletes were for him as a boy. "Ralph envies guys intensely," thinks a gay ex-employee. "I don't think it's sexual. He envies creativity, panache, prowess, and ease." Another says he just loves style, so he falls in love with stylish men as easily as women in a profound but nonsexual way. "It was all about the taste level," he says.

In the beginning, when he was supposedly sleeping with Buffy Birrittella, Ralph and Ricky were "inseparable," says Stock. "He was there when his family needed him." But, still, Stock adds, "He had to be in the office all the time. There were always late nights." Which was more than enough to fuel the rumor that he was having an affair with Birrittella. A design staffer from the late seventies believes they'd had a fling, at the least: "Buffy was definitely in love with him. As a woman, you can tell."

The cattiest gossips theorize that Birrittella's well-known personality quirks are a result of the frustration that went hand in hand with her devotion to Lauren. "You could get ripped to shreds," says a freelancer who worked with her. "She was allowed to be a bitch but she's just Ralph's puppet. She's so angry because her life never went beyond Polo. Pathetic. Sad."

Birrittella's reaction to Lauren's possessiveness fueled the rumors. "She gave up several serious boyfriends because Ralph was jealous," says the seventies staffer. "He was jealous of all the women who worked for him. A lot of us wouldn't let our boyfriends come by. He was either your possessive father or

your jealous lover. I preferred the father; the other was too sick. Buffy allowed it."

"I looked at Buffy and said, 'I don't want to be that,' " says Shari Sant. "I want a life." Yet Ralph gave Birrittella status and a certain power. She was quoted in newspapers and photographed for magazines. "Buffy is under the impression she is Ralph Lauren," says one of her ex-assistants. "She's his memory, his clone. She knows what he's going to like. People ignore her and second-guess her and think she's full of shit, but she's not. She's never wrong. In Ralph's mind, she's the quintessential Ralph girl, the be-all and end-all of American womanhood."

Whether Ralph ever made love with Birrittella or not, many of the women who've surrounded them since not only believe he did, but that she wasn't the last. "Ralph always had a girl or two," a seventies staffer says. "Most of them became kind of significant, and he'd make them rather public. He'd show up places with them, holding hands." But the speculations remained an in-house affair until the early eighties, when Ralph allegedly began what a British retailer describes as "a very nice affair."

The object of his affection was the beautiful blonde fashion editor, Ann Boyd. A Scot, Boyd "personified British peaches and cream," says Serena Bass. "Shiny hair, oval face, big eyes, tall, sweet, charming, and clever." When they met in 1978, Boyd was a fashion editor at London's *Observer* newspaper, in New York interviewing American designers.

They shared a distaste for conscious "fashion," and Lauren loved the fact that she wore a uniform of white T-shirts under denim shirts, jeans, a blazer, and pearls, and that she never wore makeup, only blush and Vaseline on her lips. In 1984, Ralph hired her as a press attaché and quickly promoted her to creative director for Europe. "She became a sounding board, someone who was valued," says a Polo executive. Adds a Polo advertising executive, "When she called, the office would be turned upside down, Buffy would genuflect and bow and scrape because she had Ralph's ear at the time. She was like the queen of England."

Few Poloroids got the chance to see them off duty. But Marty Staff, Polo's chief marketing executive, did in London. "I was at a dinner with Ralph when she and he had a screaming match about where she was going to sleep that night," he says. "I was mortified."

Now a London interior decorator, Boyd declines to discuss Ralph Lauren. "I just don't want to do anything that's going to upset him," she says in explanation. "I have a very long relationship with him." Indeed, it survived his affair with Kim Nye; Boyd remained a Polo employee, if not a lover, until mid-1994.

Lauren had always been a perfect gentleman around his models. "People in the company would say 'Ralph is so in love you,' but he never crossed the line, never even that twinkle," says his first contract model, Kristin 'Clotilde' Holby. Just before she signed her Polo contract, Ralph invited her to dinner at his beach house, and she wondered what she was getting into. But he leapt up from dinner three times to call Ricky. "He was so in love with her, I can't tell you," Holby says. He wanted Holby's opinion—not her body, she thought. "He was the only man in fashion who'd listen," she says. "He understands it's about how a woman feels, not the designer's crazy whim. If you opened your mouth at Yves Saint Laurent, you'd be fired."

In 1984, the model Isabelle Townsend, daughter of Royal Air Force group captain Peter Townsend, the star-crossed ex-lover of Britain's Princess Margaret, joined the Polo troupe when Holby got pregnant. Click Models sent Townsend to Bruce Weber who sent her to Buffy and Ralph. A week later, she was shooting with Weber, who promptly wrote Ralph a letter, explaining why he should give her a contract. Weber hadn't chosen Clotilde and was eager to get rid of her. "Bruce needed somebody he could work with, a face and a persona he could communicate with," says an art director at Polo's ad agency. "Bruce wanted to move on."

Townsend didn't get a contract quickly. "It took a while," she says, even though Weber's photos of her seemed to be everywhere instantly. "My agent said he couldn't get me other work. Everyone thought I had a contract." Frustrated, Townsend left for France. That did the trick. Three days later, Weber summoned her back to sign a two-year contract that stretched into a seven-year relationship. "I think who I was was part of it, to be honest," the well-born model admits. Lauren was a gentleman toward her, too. "We were both extremely shy," she says. "We were not pals."

Kim Nye, the daughter of a welder from Wiconisco, Pennsylvania, a coal-mining town, was a flutist and a chemistry student before she started modeling in

Cleveland. She'd been in Lauren's runway shows for several seasons when she caught his eye. "Isn't she great?" Ralph asked his fit model Jennifer Houser. Houser didn't think so. "I said she was very rough, she had bad posture, and she didn't walk very well," Houser recalls.

"We could fix her, right?" Ralph replied. He loved the shape of her head, the way she tipped her hat over her chin-length blonde bob, her big shoulders and small hips, and those legs that went on forever. "He was intrigued," says Pam Geiger, who did hair and makeup for the fit models, and became one of Nye's close friends. "Her face suggested somebody with a life; she had the trappings of a Ralph Lauren girl." Kim loved vintage clothes as much as Ralph did. And she'd talk about clothes, how they felt, how they should be worn. "She was a godsend," one of the designers says. "Anything that got Ralph going creatively was a plus."

In 1988, at what for models is the ripe old age of twenty-seven, Nye was summoned home from a trip to Paris; Lauren wanted her to be his new fit model, replacing Houser, who'd just moved into design. Ralph was in the mood for a 1930s-style girl like the African bush pilot Beryl Markham. His wife, Ricky, had gone to Nairobi on safari in 1983 and come home with photos that fascinated him. He'd decided to do something unprecedented and launch a theme across all his licenses: home, apparel, and fragrance. That theme, Lauren's fantasy of colonial life in Africa, would be unveiled at his November 1989 women's Collection show. The fragrance and clothes would hit stores the following March.

Ricky Lauren had inspired the biggest production yet from Polo's dream factory. "I'm the writer, director, producer and star," Ralph told writer Patricia Leigh Brown. His co-star would be Kim Nye.

Nye's ascension fixated the Polosphere. "Out of the clear blue, this dandyish girl appears," says a creative services executive. "She looked like a little boy." Overnight, she ascended to "numero uno," the executive continues. "She was the girl in the ads, the first girl out with every group in the fashion show. Her opinions were solicited." Ralph called her his little monkey face. He even sang her praises to reporters. "Everything we put on her looked fantastic," he told the *New York Times*. "She has a loose energy, an international look that is wonderfully rich and elegant." But "not WASP-y," he added, disingenuously. "That's a category that has never been part of my vernacular."

Ralph and Kim were soon spotted dallying at the bar of New York's Carlyle Hotel, in the Tuileries in Paris when Ralph was there on a business trip, and on Eastern Long Island, where Lauren's public profile rose after he opened a Polo

Country Store there in July 1989, selling Roughwear, furniture, and antiques. Page Six, the *New York Post*'s gossip column, got a tip that Lauren had been spotted "canoodling," in its vernacular, with the model in a vintage car pulled off the highway between his home and one she'd rented, conveniently nearby.

A Page Six reporter called Polo to get a comment on the report that "Ralph was having an affair with a look-alike of his wife, but much, much younger," says the reporter. Moments later, Ralph was on the phone. First he threatened, then he begged that the item be dropped. "He said that it wasn't true, we were going to ruin his marriage, that he loved his wife, that we'd damage his children," the reporter says. "He asked why anyone would say this about him. He said, 'You can't believe the damage this will cause.' We didn't doubt it was true, but he was obviously very anxious to keep up appearances." Richard Johnson, Page Six's editor, ran the item without Ralph's name.

Ralph wanted to see Nye in his ads. "Through her, he could live in his ads," says the Polo executive. "It wasn't fulfillment of libido, it was fulfillment of lifestyle." Donald Sterzin, who art directed Bruce Weber's ads, tried to prevent it—once Ralph left the room. "How can we shoot her?" he'd moan. "She has pimples, she has bags under her eyes, she has tits down to her ass." It was a losing battle. "Donald was being honest about her physical flaws," says an advertising executive, "but it didn't matter. Clearly, Ralph was having an affair with her."

Weber and Lauren had often disagreed about models. "Every job was a falling out," says a member of Weber's team. "Bruce really liked Kim, she had great style, but he wasn't crazy about shooting her," says Polo's Shari Sant. A showroom model, Nye had a different skill set that translated into bad habits on a photo shoot. Weber wasn't the only one who thought she wasn't up to Ralph's standards, although no one involved in creating the company's image confronted the boss directly about her; not only would that have been undiplomatic, but given Ralph's volatility in recent years, it might well have been career suicide. "Ralph saw more than a camera could get," says Sant. "Bruce likes to pick his own models, so it was hard for him. Sometimes it felt like Bruce was shooting her with a gun, not a camera."

Polo's advertising agency refereed disputes between Ralph and Weber over the years. Dick Tarlow, its owner, had retired, but his wife, Sandy Carlson, the creative director, kept the Polo account as she moved to another agency, and eventually, she and Tarlow opened a business of their own. Carlson & Partners, a one-client agency named for Sandy, was "set up to handle Ralph Lauren," said a Polo spokeswoman.

When Lauren announced the $23 million Safari campaign, which would kick off with an eleven-page *New York Times Magazine* ad portfolio and thirty- and sixty-second television spots, it was a bonanza for the new agency; they would rake in 15 percent of all placement buys plus production costs. But a fox snuck into the Polosphere and disrupted their plans. Les Goldberg, who'd shot Polo's first mail-order catalog and ads, had stayed in touch with Ralph in the years since he'd been replaced by Bruce Weber. A vintage clothing fan exactly Lauren's size, Goldberg would send great finds to Lauren and was sometimes invited to shoot his portrait.

In 1988, seeking to become a director, Goldberg had made a short film about a female assassin. Goldberg's ex-wife, who'd gone to work at Polo, showed it to Ralph, who liked it. When Goldberg heard Lauren was working on a new fragrance, and would be making television commercials to advertise it, Goldberg decided to shoot another film calculated to catch Ralph's eye and win the assign- ment to shoot the commercials. Cannily, he made Kim Nye its star.

Goldberg claims he had no idea she was Ralph's lover. But his producer, Gerald Dearing, knew exactly what was going on: Like Bruce Weber, L'Oreal, which now owned Lauren's fragrances, didn't like Kim Nye. "Ralph was hurt," Dearing says. "He saw her through the eyes of a man in love." So Dearing sug- gested taking advantage of the situation by shooting a film with Nye, and letting Ralph use it to prove how good she'd look. Ralph not only agreed, he financed the film test himself.

Goldberg decided to create a telegraphic love story, using both still photo- graphs and a series of filmed vignettes of Nye. Shari Sant went out to the Hamptons with the photographer, the producer, and the model. "We winged it," Sant says. "We wrote the script in our heads over a glass of wine." Nye wasn't much of an actress. When Goldberg asked her to laugh, she couldn't. So Dearing handed her a note that said, "You're not getting paid," she started to laugh and Goldberg filmed it. An editor cut the film and stills together with evocative footage borrowed from films set in Africa like *White Mischief* and *Out of Africa*, and Goldberg showed the result to Lauren.

Ralph cried when he saw it. Not only did it seal a deal with L'Oreal for Nye ("I want Kim," he told Sant. "I really see it"), he also used the film to convince Tarlow and Carlson that they should go for an epic *Out of Africa* feel—and hire Goldberg to get it. "So Tarlow hated Les," Dearing says. They'd outmaneuvered the ad agency. Ralph told a reporter he'd signed Nye to a contract, rather than one of the era's supermodels, because "It's more exciting to create your own look." Modeling people snickered. "Ralph had always chosen amazing girls,"

says an agency owner. "She's not a beautiful girl, yet she got a key position. It could only have happened in bed."

Dick Tarlow and his wife weren't happy about being bypassed, but he claims it wasn't really a problem. Neither was Lauren's signing Nye; Tarlow says he had no idea she and Ralph were lovers. The only issue was Les Goldberg's lack of experience. "But we always respected Ralph's eye, so if he had confidence in Les, okay," Tarlow says. "We went, hoping he'd be terrific." But once on the set, "everyone was rolling their eyes," he continues. "Les didn't know what he was doing." And not only that, Goldberg refused to shoot scenes the agency wanted. "We backed off and let him do what he wanted to do," Tarlow says.

Things went wrong from the first. Ralph had planned to join Kim on the shoot, "but Ricky threw a fit," Nye told her friend Pam Geiger, the hair and makeup artist. "Ricky said Ralph was never home and he didn't spend enough time with the kids. A woman in her position can't be all dumb!"

Sant and Goldberg went to Africa in advance to scout locations. "Then Buffy and Tarlow and a whole entourage show up. All these people insisted on coming," says Sant. "Dick Tarlow sabotaged the shoot. He treated Les like crap. Talk about tension!" Tarlow's attitude split the shoot team in two. "He had a separate table at dinner and he tried to make everyone from Polo sit with him," says Sant. Birrittella, who styled the shoot, walked the line between the camps, making it clear in the process that she knew all about the affair—and didn't care. Indeed, at one point, Nye was filmed sitting in a tent, writing in a journal, and Birrittella teased a romantic glance out of her by telling her to pretend Ralph was there.

Tarlow waited until the shoot was over, and then, as they were breaking down the set, he told Goldberg that a rough cut of the commercial had to be in New York in two days, and Goldberg had to use the agency's editor, not his own. Some of the footage had yet to be processed and New York was a seventeen-hour flight away. "It was impossible," Goldberg says.

Two days later, Tarlow and his wife had mixed feelings when they joined Ralph to view the rough cut. They were afraid Ralph would love it. They were also afraid he would hate it, Tarlow says, "because if he does, we're screwed; we need a commercial." Goldberg showed a grainy work print, three generations removed from the original negative. "It looked like shit," he admits. After the screening, Lauren was furious. "How could you do this?" Ralph demanded of Goldberg.

Now it was Tarlow's turn. "I'm trying to sell perfume and he wants to make movies," the ad man said, demanding Goldberg leave the room. Tarlow took the footage, "and we saved it," he says. Upset, humiliated, and sure he could do bet-

ter, Goldberg spent $10,000 of his own to recut the commercial and sent it to Lauren with a heartfelt letter. Ralph never answered — even though he continued to use photos Goldberg shot in 1978 and still does. But his relationship with Les Goldberg was over. He never replied to the letter and has never spoken to Goldberg again.

The final Safari commercial emphasized the girl, not the epic, as Tarlow and Carlson always wanted. But ironically, half of the footage used in it came from Goldberg's Long Island test shoot, "mostly because of the tension in Africa," says Sant, who was so stressed from the ordeal, she was hospitalized in Paris after it was over, and quit Polo soon thereafter.

Kim Nye may have been the only one thrilled with the results of their African adventure. "They have to notice me now," the delighted model told Pam Geiger. In fact, it seemed the whole world had noticed Kim Nye. "We realized what she was after the ads came out," says another Lauren model.

Dick Tarlow seems satisfied with the way things turned out, too. In 2000, he and his wife sold Carlson & Partners to Omnicom, a global advertising giant. The Polo account remains there, firmly in Sandy Carlson's hands. "It's interesting to see whose career went where," says Tarlow, in an obvious reference to Les Goldberg, who was nearly ruined by the experience. His photographic career never recovered; today, he works as an interior designer.

"I'm absolutely not blaming Ralph," says Goldberg, whose ex-wife still works for Polo. "It wasn't Ralph." Goldberg still takes pride in the fact that one of his first Polaroids of Nye, sitting in an antique truck, was used as the sepia-toned double-page ad that launched the Safari fragrance.

Ricky Lauren played a role, too, in the Safari circus. She self-published a lavish book of her Nairobi safari photographs to coincide with the perfume launch. The $150 volume had leather covers and gilded pages, and she donated proceeds of its sale to the World Wildlife Fund. Ralph gave a party at the Rhinelander for Ricky Lauren's *Safari*. Polo employees combed the mansion's first floor beforehand, removing every picture, all evidence, of Kim Nye. Nobody told them to do it. "We just knew," says Mark Matszak of creative services. "This is Ricky's night."

They all survived that evening, but Ralph's relationship with Nye kept causing ripples in the Polosphere. At fittings, he and Kim would disappear into a private room. "When those two were together, everyone else was eclipsed, and we all knew it," says a creative services executive, who recalls a symphony of revealing looks, gestures, and jokes. "It was bizarre," he says. "It was blatant."

It was made even more so when Nye moved into an apartment right around the corner from the Laurens' Fifth Avenue duplex—and Ralph had Polo's creative services department decorate it. He seemed no longer to care who knew about the affair. "Employees lived in the neighborhood and they'd see them picking up coffee," says an executive, who believes that Ralph's sons both knew about Nye, too. Indeed, Ralph was so blatant about the affair, it seemed inevitable that Ricky Lauren would find out about it.

Nye didn't help matters. She made friends in the company, sought out shoulders to cry on, and made no secret of her new status. She'd show up at the Rhinelander and sit around for hours as if she owned the place. She'd shop at the East Hampton Country Store and announce Ralph was footing her bill. "It certainly didn't establish family values," says a salesman who saw them together.

In fall 1990, the affair burst into public view. "Ralph Lauren After Hours," read the cover line on the November issue of *Spy*, the satire magazine that made a monthly meal of the rich and famous. An item in its "Usual Suspects" column reported a nocturnal sighting of Kim and Ralph at a restaurant near their apartments. "When the couple's food arrived," *Spy* wrote, "the statuesque model moved over to the boss's side of the table, more or less in his lap," dispensed with silverware, and started feeding him with her hands. A member of Polo's in-house legal department brought the item to Buffy Birrittella and she showed it to Ralph. "He put on this act," says a witness, "calling it bullshit, saying there was no affair. It was total denial."

Late in 1991, Lauren even started flaunting his affair in front of his wife. The couple was in Jamaica to shoot a cover story for the society magazine *Town & Country*. The shoot team, a writer from the magazine, a batch of Poloroids, and two models were there. Nye was one—posing naked, draped in a scarf on a wall overlooking the Caribbean. One afternoon, she and Ralph were in his swimming pool, when he turned to her and said, loud enough for others to hear, "I look at you and I see myself and that's why I love you." When the issue was published early the next year, the cover featured Ralph and Ricky, cheek to cheek.

72

The pressure to give great women's fashion shows had, if anything, increased since Ralph's operation. Speaking of those shows, Ralph says, "With all I do, this hovers over me all through the year. It's like your final at school. And it's not private. The danger makes it exciting and at the same time makes you, like, sick."

In 1989, Ralph's big fall fashion show was based on Navajo rug designs and Austrian jackets. The show was held in a large hotel ballroom and, as had happened before, when the reviews came in, Ralph decided his work was overwhelmed by being shown in such a huge space; he declared that in the future, he'd show his designs in the more intimate setting of his showroom at 550 Seventh Avenue. In order to accommodate all the viewers who would come, he had to have four or five shows a day. He would serve a lavish breakfast buffet and invite family as well as his Poloroid posse. Ricky and Ralph seemed the perfect couple, except to those who noticed Nye, standing with the other models, watching the Laurens.

In November 1991, Ralph showed men's suits restyled for women, then refined the concept for his show on April 8, 1992, his 25th Anniversary Collection. Just before that show, Nye went to see Frederic Fekkai, a French hair stylist who'd taken New York by storm. Lauren had "decided Kim would look great with short hair," says one of those who planned the show. Ralph even had his resident artist sketch a haircut inspired by the French gamine, Jean Seberg (who was actually American). "Then Kim pushed for it," says a design studio insider of the time. "Maybe she felt she was losing his attention."

When Nye showed up at Fekkai's salon, she announced she wanted to reinvent herself. Fekkai followed his instincts on the haircut—which turned out beautifully. But Ralph didn't like the result and insisted Kim cut it again before the show. "Ralph got Frederic in and said 'Try this, try that,'" Pam Geiger recalls. "He chopped the hell out of it, and it looked awful."

"Big smiles, big smiles," Lauren ordered as he sent his models out on the runway that morning. Nye opened the show in a long, black pinstripe jacket and black

cashmere leggings, her eyes filled with tears. Audience members gasped when they saw her; it was unclear if they were reacting to her haircut or her obvious distress. "Everyone knew something was going on," says a Bidermann executive who was in the audience. "It was very strange and sad."

Backstage afterward, asked why she'd cut her hair, Nye said, "The boss told me to." Ricky Lauren stood nearby, acting as if nothing was happening. But there was a melancholy air, "a realization things were coming to an end," says the studio insider. "Maybe he was just using the haircut as an excuse. It's got to take its toll, time after time, knowing your wife is in the audience and your girlfriend is on the runway."

The situation looked messy, and people talked, but Nye stayed on the payroll. That May, she made personal appearances for Safari and gave an interview to Becky Homan of the *St. Louis Dispatch*, claiming she'd cried from lack of sleep and preshow jitters that came to a head when the show began with a Barbra Streisand song. "I'm very happy with it," she said of the haircut. "He just wanted to change the image."

But Kim was getting antsy. "She was fed up with being a mistress," says a photo stylist, "she wanted to be a wife." Whether or not that's the case, she clearly wanted more from Ralph than she was getting. So, feeling ill, Nye called Lauren's house in the middle of the night. "Ralph got her checked into a hospital," says Pam Geiger, "but Ricky knew who was on the phone." Staffers assume that Ricky issued an ultimatum: Get rid of Kim or she'd divorce him. Says a Polo executive, "He was sweating, and he decided it wasn't worth it." But he seemed compelled to talk about it. "It was the worst personal trauma of his life," says the executive, "but he'd blab everything, even things you didn't want to know."

"I don't think Kim is worth trading Ricky for," Ralph told one employee, although others swear he was still in love with Nye. "Poor Ralph," sighs a friend of Kim's. "Ricky's very sweet, she's a good partner and a good mother, but there's no meeting of the minds." So Nye remained hopeful and under contract through the fall, thinking she'd be given a design job with Polo, based in Paris, "but Ricky forbade it," Geiger continues.

Nye moved from Ralph's neighborhood into a Beaux Arts apartment building ten blocks south. "Then Kim vanished," says the Bidermann executive. She disappeared from the design studio and was erased from the record of Polo as surely as some disgraced Kremlin commissar in the Soviet Union. "Her ads no longer appeared in retrospectives," says the creative services executive. "Every photo of her was taken off the walls."

Nye left for California to try to find work as an actress. She reconnected with an old high school sweetheart during that brief flirtation with Hollywood—but

her attempt to launch an acting career went nowhere. Lauren was heard to swear that if he had anything to do with it, she would never be in a movie, never have a public face again. And indeed, she does not. She lives year-round on Martha's Vineyard, where she owns a flea market in the town of Oak Bluffs.

73

The design staffers who love to gossip about Ralph don't have much to say about Ricky, who generally stayed home, out of the spotlight, along with the three Lauren children. "She was very shy and very quiet," says an employee, "or else she knew to stay out of his way. Some people didn't think she was very bright." Others thought her main skill was survival.

Eventually, Ricky found a life of her own, finishing college and hanging out a shingle as a psychologist. In a summer 1995 interview she offered a revealing comment: "I have a fantasy of myself as this perfect woman in a cozy chair—there she sits, totally elegant, refined—and all around her are the pieces of her life. There's nobody screaming in the background, there is no confusion. Everything is in its place and she is totally in control."

Ricky, clearly, was not. Her life was not a Polo ad. Though she dutifully appeared at Ralph's fashion shows, season after season, kissing her fella for the cameras, behind the scenes, the couple no longer played the perfect couple. "I was at the ranch once and they were fighting over who was going to ride which horse," says a Polo executive of the late nineties. "Ralph took hers. It was faster and better. She was really upset." Ralph's response was frigid. "If you're not careful, I'll give you the ranch," he warned, implying that he'd take everything else, says the executive, who adds, "I don't think he cares if she's with him or not."

It's unclear if the Kim Nye affair taught Ralph a lesson, as he's claimed. To this day, rumors persist that Lauren has had at least one lover since Nye.

"He has his pick," jokes a Poloroid who worked beside the alleged lover. "There's the flavor of the month, the flavor of the year, the flavor of the decade." And Ralph is comfortable enough with the subject of office romances that, not long ago, he appeared as himself on *Friends*, the television sitcom that features a character who works at Polo, played by Jennifer Aniston. Ralph was in an

episode that revolved around whether or not he'd kissed a woman other than his wife.

"You ride the waves," Ricky told an interviewer when she published *Safari*. "Both the crest and the trough. Just to exist is the thing. Marriage is not about the good parts or the bad parts. It's just participation."

74

There was one other significant woman in Ralph's life, the movie star and style icon Audrey Hepburn. Ralph adored her and would buy tickets to any event where he might see her. In October 1987, he and Ricky attended a tribute to her at the Museum of Modern Art and a year later, he was invited to sit at her table at a benefit for the Lighthouse for the Blind, where she was honored for her work with children. "They were not personal friends," says someone who knew Hepburn. "Although Ralph may have thought they were."

In 1989, the producer of *Gardens of the World*, a series of television specials starring Hepburn that was being planned by public television, asked if Ralph would fund the project. Like Anne Marie Rozelle before her, Dolores Barrett, Polo's latest head of PR, wanted Ralph to play the publicity game more—encouraging him to write notes to celebrities and journalists, and support useful causes; all basic techniques of social climbing and image enhancement that Lauren, to his credit, had always abjured. It was easier to get him involved with one of his screen idols, but Strom wouldn't pay for the show, even though Ralph wanted to. Barrett, whose job it was to say no gracefully, instead offered to dress Hepburn for the shows—and a relationship of sorts began.

Hepburn came to the Rhinelander after store hours for fittings. "They had tea and a chat, and he was very excited," says a witness, but when the time came to choose clothes, "she waved him away and said she didn't want to waste his time." Humiliated, he shrank away to let her shop by herself, but from then on, Polo's press office would send her runway photos after each of Ralph's women's shows so she could order what she wanted. Though she was faithful to the Parisian couturier Hubert de Givenchy, who'd always dressed her, and refused Ralph's regular show invitations and offers of evening clothes, she was more than

happy to take day clothes and special items made just for her, as well as clothes for her sons; Ralph gave them to her free. "She played Ralph like a fiddle," says her friend.

In April 1991, Hepburn was to be honored again, this time by the Film Society of Lincoln Center, the same group whose tribute to Fred Astaire Ralph had once crashed. Again, Polo was asked to underwrite the event, and this time he agreed to pay for part of it, but there were strings attached; Ralph would pay, he said, only if he could introduce Hepburn. Told that the event's chairman performed introductions, Lauren threatened to withdraw the offer, and his demand was met. Not only that, but Hepburn also accepted his invitation to spend a few days with him in Jamaica at his home in the Round Hill colony.

Hepburn's longtime companion, Robert Wolders, describes that idyll in Round Hill as relaxing and just what Hepburn needed. Others say she left early—in a huff. "Something happened that offended her," says the friend. "Ralph must've said something that upset her. She'd never visit again. She always got out of it."

Still, their relationship continued, and Lauren referred to that Round Hill visit in his speech at the tribute. "He came onstage in his glasses and his tan, looked up from the podium, and said, 'Audrey, I bet you thought I was Cary Grant,' " reports a guest who was at the gala. Then Ralph told how the sixty-year-old Hepburn had walked to the beach ahead of his son, David, who subsequently declared, 'I'd date her.' The joke fell flat; Polo staffers cringed; they knew he'd discarded prepared remarks in favor of the awkward anecdote.

Hepburn apparently didn't mind. In February 1992, when Lauren received the CFDA's Lifetime Achievement Award, he asked if she would present it (after first asking his staff if she was too old), and even offered to send his jet—Polo had traded up to a Gulfstream II in the late eighties—to pick her up. But what would she wear? It was a black tie event; this time, she couldn't possibly choose Givenchy, and "Ralph's new collection was very Audrey," says a Polo executive. "He kept sending gowns and she kept fudging; nothing was quite right." It emerged that Givenchy was furious, so the diplomatic Hepburn chose to wear Lauren day clothes—a navy wool crepe blazer she found in the Beverly Hills boutique.

Ralph was embarrassed, but nobody else knew; all that mattered was that she was there. Her speech that night was charming, gracious, and filled with praise of his consistency, integrity, gentleness, kindness, sincerity, and simplicity. As Ralph bounded up to the podium to join her, she stepped away, but he grabbed her and pulled her back next to him. "This is my night, Audrey said," he began. "And you wanna know the lifetime achievement?" Looking out at the audience,

he spoke directly to his oldest friend, Steve Bell. "Steve—remember when we went to the movies in the Bronx thirty years ago? Remember the princess? I got her!"

Ralph hugged Hepburn tightly, then seemed to ease her away as he studied the crowd and spoke again. "I see ya, Mom," he said, lifting his award and waggling it at the woman who'd raised him to be a rabbi. "Still want me to be a . . ." and then he paused, seemingly searching for the right word . . .

". . . a doctor?"

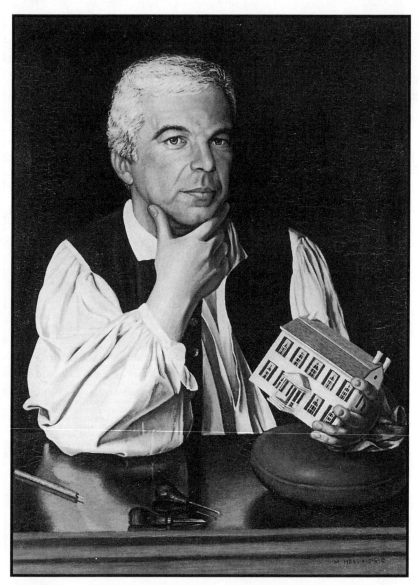

Ralph Lauren's Home, after John Singleton Copley's 1768 portrait of Paul Revere.

(Illustration by Mark Hess/hessdesignworks.com)

Presumption:
From Growing Gains to Growing Pains

I want to be a star . . . I want to be recognized but I want to be myself, too.
You must try not to lose yourself.

—RALPH LAUREN

75

To celebrate the holiday season in December 1991, Ralph Lauren sent out a card featuring a photo of himself with Jeff Walker, his arm slung over Walker's shoulder. Walker had fallen ill in 1990. "It was all vague," says creative services staffer Mark Matszak. "Jeff seemed fine. A little more distracted in meetings. Then we were on our own more. The company was growing, so it was hard to say if he was in other meetings or not feeling well." Others knew something was up; when Walker traveled, a ground-floor hotel room had to be arranged for him.

Walker died in March 1991, at age forty-one, in a Polo-rigged hospital room. "Everyone knew he had AIDS," says a Polo executive, but the cause of death was given as pulmonary hypertension. Before he died, Walker had been heard to complain that Ralph made him work even when he felt ill. "Ralph would drive poor Jeff," says a Polo executive.

Walker ended his life with bad feelings toward his boss. "Ralph had no loyalty to him after he wasn't of use anymore," says another executive. "The last weekend, everyone knew he was dying, but Ralph wouldn't visit him. Ralph had to be talked into having Jeff's memorial at the store."

Lauren spoke at that gathering, but he infuriated some of Walker's friends. His remarks "always came back to Ralph somehow," says one. "How Ralph was affected. What Jeff did for Ralph. Then Buffy turned to the crowd and said, 'I hate to see Ralph so upset.'"

Walker's absence was strongly felt by those he left behind. "He was a shooting star," says Wilkes Bashford. "People still use him as a benchmark." In fact, Walker still occupies an honored place in the Polosphere. He'd been cremated and his ashes were "buried" in the mantle of the mansion's second-floor fireplace.

"An odd resting place, to say the least," says a Polo retail executive. "I always wondered if it was a fuck you."

Around that time, Edwin Lewis, Polo's resident sales sensation and the latest leader of Ralph Lauren Women's Wear, began to wonder whether Ralph was

sending him the same message. He would end up sending it right back at Ralph. Shortly after he got to Bidermann, Lewis's boss, Ken Sitomer, the latest president of Bidermann's French parent company, announced he was leaving for a new job. But the Lauren license contained a "key man" clause that required that two of three executives—among them, both the previous CEO of Bidermann USA, Michel Zelnik, and his replacement—remain and that one of the two had to have that job or the license would revert to Ralph's control. If Sitomer left, Lauren would finally get his license back. Bidermann says that Lauren's lawyers, the famous Watergate scandal attorney Arthur Liman among them,* told him they would waive the key man provision, but a few days later, Lauren claimed Bidermann had defaulted on the license anyway.

Keeping Ralph was becoming expensive. Maurice Bidermann paid Sitomer $7 million, plus an additional $500,000 a month to stay on—"this man make me blackmail," Bidermann sputters—until December 1989. But that summer, with reports of Lauren buying back the license surfacing again, a new president of Bidermann was hired with Ralph's approval, and began to stabilize and rebuild the troubled operation. Two months later, Bidermann USA bought most of Cluett Peabody, which produced Arrow shirts and Gold Toe socks and held licenses for Burberry, Colours by Alexander Julian, and Christian Dior hosiery. To pay the $600 million purchase price, the company borrowed $150 million. That would prove an expensive mistake.

Edwin Lewis had been swimming upstream since he'd moved to 550 Seventh Avenue to run Lauren's Women's Wear company in mid-1988. "I get there and the place is a disaster," Lewis says. For all the talk of Stuart Kreisler's skill at handling retailers, "all the stores were complaining, the goods aren't retailing, the stores are having fits, and I'm in there selling miniskirts that fit Kim Nye, and if you're a size six, five foot ten, it's a wonderful product." But otherwise, the clothes were unwearable.

Even the owners of Polo shops, with their loyal, dedicated customers, were complaining about the women's collection. Lewis didn't have to listen to most of them—they were just flunkies—but David Hare was another story. In 1973, Hare and a partner, William Merriken, had bought Perkins-Shearer, a hundred-year-old Colorado specialty store, and had begun carrying Polo when they opened a Denver branch in 1975. Eight years later, they opened a Denver Polo shop, and were so successful, they began buying and opening more.

In the late eighties, when Polo began buying back weak retail properties,

* Liman also represented Steve Ross.

Peter Strom invited Hare and Merriken into a partnership. "The Polo licensees were becoming pains in the ass, no money, no vision, old, small stores," says Marty Staff. "Ralph always wanted to own and control his own retail, but he was nervous that Polo as a company did not have retail experience." Polo brought money to the table; Hare was an expert merchant. But Hare and Merriken declined. The other stores weren't very profitable. Operating costs were double what they should have been "because of the flowers, the interior redecorations," says a former retail executive. "Ralph would want wood paneling one season, suede walls the next, and therein lies a problem."

But in 1992, with Denver's petrochemical industry in decline, the 120-year-old Perkins-Shearer shut down and the company retooled as a Polo-only retailer. "Our future was Polo," says Merriken. "We knew the customer." So Strom and Lauren made them Polo's most-favored retail licensee; Perkins-Shearer became Polo Retail, joining forces with Polo to operate twenty-eight stores, including nine that had been owned by Perkins-Shearer and nineteen that had been bought back by Polo.* Hare knew better than anyone what Polo customers were buying, and what they were leaving on store racks.

Despite the chorus of complaints, Ralph foiled Edwin Lewis at every turn. Lewis had learned that women were buying Polo men's T-shirts because they were cheaper than the women's counterpart, but Lauren wouldn't let him lower prices. Lewis found a Hong Kong factory that made flannel jackets, skirts, and pants for Calvin Klein, "and Calvin's eating Ralph's lunch at the time in women's," Lewis says. So he brought back samples of items he could sell at good prices, but Ralph wouldn't even look at them and sent his emissary, Buffy, instead. Lewis hung the samples side by side with identical Polo garments. When Buffy criticized them mercilessly, Lewis asked her to point at the ones she didn't like. He says she chose the Polo garments, but killed the program anyway. Ralph refused even to discuss it.

Lewis also drew up schedules for the fall 1989 collection, in order to move the production process along more efficiently, met with Lauren to choose fabrics late in 1988, and ordered the cashmeres and woolens Ralph picked out. A few months later he got a call from women's design; they were ready to order fabrics for fall—all over again. Lewis moans, "It was not all Stuart Kreisler's fault that this business was a problem." Deliveries that season were horrendous. Lewis went to Strom. "I gave [Ralph] what he wanted and he told me I didn't know what I was doing," Lewis complained.

* Another thirty-seven stores in the United States and seventy-eight overseas remained in the hands of licensees.

"He's fucking you, flat out," Strom replied. Lewis would soon turn the tables.

In December 1990, on the same day a design studio underling told Lewis it didn't matter what he said since they would do things their way regardless, Polo's former European licensee Lawrence Stroll, who'd sold that business, called him to offer him a new job, running a company called Tommy Hilfiger. Hilfiger was a freelancer jeans designer from upstate New York when he went into business with Mohan Murjani, the manufacturer who'd made a fortune making Gloria Vanderbilt jeans. Murjani packaged Hilfiger as the new Ralph Lauren, selling preppy clothes at affordable prices, and launched the label with an audacious ad campaign that listed Hilfiger's name alongside those of Lauren, Calvin Klein, and Perry Ellis, as if they were peers. Next, he ran multipage ads that showed the Lacoste, Brooks Brothers, and Polo logos next to the newcomer Hilfiger's red, white, and blue flag symbol, making Ralph Lauren's ventures in hubris seem petty in comparison.

After a few years Murjani's business faltered, and in 1989, Stroll and Silas Chou, whose wealthy Hong Kong textile family had manufactured for Polo, teamed up with a Murjani executive, Joel Horowitz, to buy Hilfiger. Like Stroll, Horowitz, the son of Ralph's first production man, was a Polo veteran.

The trio started rebuilding Hilfiger into what Chaps should have been but never was. "The focus was on building a megabrand; not let's do Ralph," says Mindy Grossman, a Hilfiger executive, though she adds, "We felt Ralph had not acknowledged younger consumers as aggressively as he needed to." Hilfiger sales doubled in a year. But Lewis says Stroll and co-chairman Silas Chou "didn't know what they had." Hilfiger "was a joke."

Lewis felt the fashion market was ready for something new and decided to go to Hilfiger. Strom begged him not to accept the offer (which included 2 percent of Hilfiger's company) until he'd talked to Ralph. But Ralph dithered, claims Lewis, who resigned a few days later. Ralph later told his designer Jennifer Houser that Lewis had demanded equity in the business—and an immediate return to the men's business—before he'd agree to stay. Ralph refused what he saw as an attempt to strong-arm him by someone who'd failed him.

The consensus around Polo was that Lewis had tried to run the women's business the way a men's fashion label is run, making deals and selling the same basics season after season. Like Ralph, the thinking goes, Lewis didn't really have a feel for the fast-changing women's fashion trade. And in the end, he left Ralph Lauren Women's Wear a mess, with millions of dollars of unsold inventory on hand. "Ahh, terrible! I lost, we lost, a fortune!" says Maurice Bidermann.

But Ralph lost something more when Lewis departed. While it is not quite a zero-sum game, fashion is a pie that cuts into only so many slices. Tommy

Hilfiger, until then a nibbler, was about to start taking big bites out of Ralph's business. "Edwin knew the formula," says a Polo colleague, "and the formula works." Lewis turned out to be the missing piece of the Hilfiger equation, giving the new kid credibility with retailers. "He really put them on the map," Peter Strom admits.

As surely as Ralph had competed with Calvin Klein, he now began fighting Hilfiger. Ralph had watched warily since Hilfiger burst on the scene with those ads that associated his name with those of his betters. Ralph affected disinterest, as he always had with Calvin, but he revealed himself every time he said his latest rival's name, mispronouncing it, Hilfinger. Others had often tried to take market share away from him by copying what he'd done. J. Crew did it with khakis, the Gap with its "small-p" polo shirts. Now, sure enough, "anything Ralph did, Tommy did," says a Polo executive, only Hilfiger made what Ralph hadn't been able to make: "better" clothes. And his cheaper version of Polo hit the market just as the American economy began to wane. Though it was larger, Ralph's company was less nimble than the newcomer. Calvin Klein's business began waning, too, and Hilfiger replaced him as Ralph's pet hate.

Edwin Lewis quickly hired away several key Polo employees, angering Ralph even more, and began elaborating the Hilfiger formula. Tommy wasn't just Ralph, he became a younger, happier, friendly, approachable, accessible, inclusive Ralph. Instead of showing snooty-looking models in exclusive country club settings, Hilfiger ads showed clothes on kids with dreadlocks and tattoos. Tommy's models wandered Vermont in bathrobes, wore their pants around their ankles, swam while smoking cigars. "Tommy hit on the next thing," says Reed Krakoff, a designer who jumped from Polo to Hilfiger. "People said, 'That's me, I don't have to be on a yacht.' "

In 1992, Hilfiger's company went public, and by 1994, the stock price had tripled—and that was before Hilfiger stumbled onto the next big thing. When he splashed huge logos on clothes he'd designed for a Formula One race car team, hip-hop stars adopted them and Hilfiger aggressively pursued the connection, using the rapper Coolio in a fashion show years before other designers latched on to the new urban sound. Hilfiger's volume soared to $321 million in 1995, but in the process, he also replaced Ralph as a figure of contempt for the fashion set, the world's leading nondesigner designer. But that didn't make Ralph feel better. The new nondesigner drove the old one crazy. "Tommy Hilfiger hasn't anything new to say," Ralph fumed to the *Wall Street Journal*'s Terry Agins.

76

Tommy Hilfiger had also thrown a wrench into Peter Strom's exit strategy. Strom had had enough of Ralph Lauren. Enough of putting out the fires Ralph started. Enough of Ralph's reckless spending. By 1991, Strom's desire to leave was an open secret. "He'd developed all these tics and twitches," says an executive who was close to him. "Every six months, he and Ralph would have a fight. Ralph would find out something Peter had felt the need to do, knowing he'd get in trouble for it. Ralph would blow up at him, and there'd be no communication for two weeks. By six weeks, they'd be back to normal."

Strom had hoped to slide Edwin Lewis into his job; thanks to Hilfiger, that was no longer an option. "Edwin leaving bothered me; it didn't bother Ralph a bit," Strom admits. Still, Strom quit. Sort of. "I give three or four years' notice," he says. He told Ralph he didn't want to die at his desk. "I don't blame you," Ralph replied.

That left a gaping hole in Polo's future—and the next generation of Polo's management rose to fill it. Michael J. Newman, who'd replaced Harvey Hellman as Polo's CFO, had been promoted to executive vice president in 1989, replacing Edwin Lewis when he went to women's. "Peter was the right hand," says a creative services executive. "Mike was the other hand." Now, Newman rose to president and chief operating officer of the men's company; a restructuring had split Polo into two groups: men's, and retail and licensing.

Lance Isham, a shirt and tie salesman from Chicago who'd been brought to New York by Edwin Lewis, moved up the ladder, too, taking Newman's former title. Nonconfrontational and likable, neither was the threat to Ralph that Lewis had been. They also had a WASPy Wall Street demeanor that appealed to Lauren. He didn't like how Newman dressed, though, and asked one of his dapper store managers to take his new president in hand and teach him about style.

Isham and Newman worked on the sixth floor of Fifty-fifth Street with Ralph, Strom, and Buffy. But Polo had outgrown Ralph's homestead. The design department alone had grown to eighty-five people. In 1989, Lauren had signed

a lease for four floors of an office building at 650 Madison Avenue. It took two years to trick the space out to Ralph's exacting specifications. The new office would be a symbol both of Ralph's fabulous taste and his extraordinary extravagance. The china on which Ralph would serve visitors lunch was but one example. Creative services chose a blue spatter pattern, but Buffy Birrittella nixed it. "When Ralph has a meeting," she said, "he'll want the china to match what he's wearing."

Polo rented four floors, two basement levels, and twenty thousand square feet of penthouse offices for Lauren and Strom. It was "a sensitive transition," says Lee Mindel, the architect for the project. "We had to guard against the loss of the humility and intimacy of his beginnings. Ralph didn't want to lose the sense of family of the organization." Mindel decided to give Ralph what he'd missed in college, a campus.

Administrative offices were stacked on the north side of the building, showrooms faced east, and design studios south. It was all meant to convey the campus idea, with design quadrangles for Home, women's, and men's on separate floors, each consistent and quite unlike the beehive on Fifty-fifth Street. Mindel hoped to formalize what had always happened by accident in the stairwells and warrens of 40 West Fifty-fifth Street. That was where chance meetings happened, ideas flourished, and Ralph would sometimes grab members of his staff and make their day. "Do you like it here?" he'd ask. "Are you happy? You look so great. Don't ever leave."

But the end of the era of meetings in stairwells spelled the end of that collegiality. "People were more isolated," says an executive. Impressive though it was, the grand staircase at the center of the office—which echoed its counterpart in the Rhinelander mansion—just wasn't the same thing. Still, it was impressive. It led to the stunning mahogany reception area Mindel designed as the central quadrangle. The area, called the Reading Room, resembled a well-worn gentleman's club, decorated with a huge mural of top-hatted gentlemen, antique globes and silver championship cups in vitrines, and glass-fronted bookcases containing rows of books: Ultra Violet's *Famous for 15 Minutes, The Decline and Fall of the British Aristocracy*, and *System of Practical Therapeutics* among them.

The Reading Room "was the culmination of what we'd accomplished and reflected everything Ralph Lauren stood for," says Peter Strom, who calls his first sight of it the greatest moment of his career. "I've been in a lot of offices," he says, "but never one that beat that."

The company finally moved, seven months late, in June 1991. Some staffers didn't like the new offices. "You'd run up and down ten flights of stairs, twenty times a day," says one. "It was beautiful, but it took forever to get to menswear."

Ralph seemed to realize that he'd lost as much as he'd gained in the move. He and Strom never moved into their penthouse, with its marble-floored workout room, even though it had been completely decorated at considerable cost. "He felt he would have been isolated," says a creative services executive. "He realized he still wanted to be in the midst of everything. It sat empty for years." A symbol of Polo's empty grandeur.

77

haven't changed my clothes in two days," Ralph announced, late as usual for a meeting in October 1992. He hadn't shaved, either. He was in a hurry. There was only one thing he worried about as much as women's clothing: advertising. His ad meetings were held on the fifth floor of 650 Madison, where a montage of photos of the boss—driving a fabulous car, riding a horse, playing tennis, posing as an aviator, a cowboy, a country squire, a beach bum, and an English gentleman—greeted visitors. Ralph stormed past the photos that afternoon in a greenish waffle T-shirt, an antique motorcycle jacket, stained khaki pants rolled at the ankles, ski socks, a silver bracelet shaped like an eagle, wire-rim glasses, and a gold wedding ring.

Lauren's advertising team, a baker's dozen, almost all women, always dressed up in current Lauren outfits for their regular meetings, which were held in a tiny conference room. Carlson and Birrittella were wearing identical pinstripe suits. Carter and another woman wore the same tartan outfit. Usually, they had to wait for Ralph, so a huge spread of food—sandwiches, salsa and taco chips, lentil salad, fruit salad, cookies, and drinks—shared the conference table with stacks of photos and composites of print ads. Key personnel from the Carlson & Partners ad agency picked at the food as they waited along with Buffy Birrittella, Polo's head of advertising Mary Randolph Carter (known simply as "Carter"), their in-house ad team, and Ralph's latest favorites.

The group was demoralized. One of their number, a close collaborator of Bruce Weber's, had just died. And post–Kim Nye, the relationship with Weber was troubled. Though he still shot most of the pictures, Weber no longer set the tone: he was increasingly seen as too expensive and "too big for his britches,"

says a Carlson executive. "Ralph realized he couldn't rely on Bruce exclusively." Weber's fees had more than doubled over the years; he was now earning $25,000 a day, and expenses on his seasonal shoots ranged from $250,000 to $1 million. "Bruce would always have to rent a boat or two or three," the ad executive laughs.

In the face of the Tommy Hilfiger threat, Ralph was flailing, seeking a new direction for his ads. "He'd listen to anyone," gripes a Carlson & Partners executive, even his kids—Andrew was finishing college, David starting, daughter Dylan in high school. They periodically warned their father that he was losing his touch "and he'd panic," says a Carlson staffer. Ralph "had lost his confidence, and Tommy wasn't helping," says a Poloroid. "At first, he'd bat Tommy off like a fly, but he became the bane of Ralph's existence."

But Hilfiger was a goad, and ultimately a necessary one. The challenges to the Polo brand were everywhere. Even academics were attacking. In 1990, Michele Wallace, a black feminist educator and author of *Black Macho and the Myth of the Superwoman*, had given a lecture sponsored by the Smithsonian Institution, accusing Lauren, among others, of selling an elitist, Caucasian worldview that was out of step with the times. Change was in the air, and it was Ralph's job to reflect it. So, a month before the October meeting, Polo had run ads for its boys' line featuring a twelve-year-old black girl holding a book covered in kente cloth and a thirteen-year-old boy with a Gibson guitar wearing mixed tartans and checks. A handsome, brooding, long-haired paraplegic, Mitch Longley, had also begun appearing in Polo ads. They were all part of Ralph's first brush with multiculturalism. Advertising critics said it was a risk. To Lauren, it was a necessity.

It was Ralph's fifty-third birthday. Before their meeting started, his ad staff diverted him into a nearby office where a Polo bear piñata in a pinstripe suit hung from the ceiling. "This is not about bear abuse," someone said as Lauren stripped off his jacket and began whacking the bear with a bat. "Boy, am I taking out a lot of aggression," he said. "Can I do this every day?" After six swings, the bear burst open and, weirdly, Band-Aids and lollipops flew out. "Wait, where's the Rolex?" someone joked.

The ad team returned to the conference room, most sitting in cowhide-backed chairs around a big white table, while the rest perched on the windowsills. The first order of business was stroking Ralph's ego. Sandy Carlson, who sat near Ralph at the head of the table, pointed at his scrubby beard and cooed, "Oh, how cute." Ralph popped a lollipop in his mouth as they began discussing what ads they'd place in February magazines. "What do we have to say?"

he asked as photographs of wintry expedition-style clothes were passed around
the table. "We're scrambling to do ads but we have no plan. These are just pic-
tures. I don't have a story."

Gently, Birrittella reminded him that he hadn't yet finalized his spring
women's Collection, which would be shown in a month, so no one was willing
to venture a guess at what "story" they would be selling in spring 1993. Lauren
ignored the little poke—he was the boss, he could take as much time with
Collection as he wanted—put his lollipop down, and suggested using runway
photos from the October show in the ads; that way, he wouldn't have to decide,
wouldn't have to plan ahead, and wouldn't have to say what Collection would
be until he knew. Knowing that was a bad idea—runway photos are too plain,
too generic, too *not* Ralph—Carter wondered if they shouldn't advertise some-
thing other than Collection in February, and save their big message for March
magazines.

"Depends on how good Collection is," Lauren murmured with a small smile.
Birrittella plucked the lollipop stick off his sleeve where it had gotten stuck, rub-
bing his arm and murmuring, "Pops." No one stroked Ralph like Buffy.

"So let's wait until the show is over?" Carter asked, unsure.

"We have to make a stronger statement of our style," Lauren said, ignoring
her. "And we've also got to get another girl." They all stopped talking—in mid-
sentence—whenever Lauren spoke, but the silence that followed that remark
was freighted; no one dared acknowledge the reference to the gap Kim Nye had
so recently filled.

The meeting veered into the minutia of choosing which photos would run in
which magazines. Lauren, who micromanaged every insertion, instructed Sandy
Carlson that an ad in the *New York Times* fashion supplement had to run on
page two—or not at all. "The middle of a book is worthless," he said. "We're
wasting our time unless we put it in the right places."

The Poloroids nodded at their leader and seemed to avoid each other's eyes.
The meeting wasn't going well. "They were passive-aggressive, self-destructive,
insular sycophants—all disliking each other," says a Carlson executive. "Ralph
would be ten times bigger if he wasn't so loyal to them." But he could be hard
on them, too. Lauren told Carter she should come to his women's Collection fit-
tings at 550 Seventh Avenue. She protested, "We try hard to stay out of your
hair."

"I like an audience," Lauren shot back. "It makes me funnier." Well aware
what a waste of time it would be for Carter to attend the interminable fittings,
Sandy Carlson backed her up, telling Ralph the ad team felt his designers were
intimidated when he sought opinions. "You can hurt their feelings," Carlon said.

"Yeah, you can," Ralph replied. "But it's my show. If anyone's insulted, it should be me. When people say things after the show, I want to know, why didn't you say that before?" Staring at photos again—classic Bruce Weber shots of hunky, bare-chested men, cowboys, kayakers, and wet black Labrador retrievers—Ralph suggested an oddly exciting idea: that they run them in women's magazines. "It'll be a total surprise."

Now that Ralph had declared himself, Carlson jumped on the bandwagon. "It's authentic, but it's very romantic."

"Very timely," Lauren said, "very cool."

"It's like, hippy sportsman," Carter chimed in.

"Let me see more," a suddenly enthused Ralph said, and photos flew around the room. He paused over a picture of sky and water. "Doesn't this look religious?" he asked.

"*And Ralph said . . .*" Buffy intoned. "That's what so great about your pictures. They're so sexy and strong."

"More, more," Lauren said, beaming down the table. "You'll get a raise."

78

On an afternoon in summer 1993, Ricky Lauren welcomed a reporter to the Laurens' latest home, an extravagant stone manor near Bedford, New York. Ricky wore moccasins, a white linen shirt, a suede vest, and a pair of frayed jodhpurs hand-painted with African animals and the face of a Masai warrior. In the kitchen, her mother and Ralph's were baking apple pies. As they puttered, household staffers slid silently through the rooms, and a team from Lauren's Home collection design group—a few of his three thousand employees—created an impromptu rig on the lawn, steps, and stone benches of a mossy courtyard just out the kitchen window. They were there for a meeting, but it would have to wait. Ralph was taking the reporter on what turned into a two-hour tour of the mansion.

"Oatlands," as it was originally called, was staked out in 1924, and completed the following year by the architects Delano & Aldrich, as the residence of Robert Ludlow Fowler Jr., a banker and landscape architect who owned about

twenty-five hundred acres of land around it in Katonah, Mount Kisco, and Bedford, New York. Though he was best known for designing private gardens for clients like David Rockefeller and Averill Harriman, Fowler's greatest work was his own seventeen-bedroom home and grounds, situated just below the crest of a hill, reached by a road and granite stairs. Fowler's son Harry, the chairman of an investment bank, later inherited the house and lived there for a time with his second wife, whose son Carll Tucker commissioned another home on the property, designed by the modern architect Robert Venturi.

Despite its fine provenance and architectural distinction, by the late 1980s, the property had been sold and abandoned. Owned by a bank and in disrepair, it was split up: the main house and about two hundred acres around it were bought by a wealthy woman, who planned to restore and sell it. An additional two hundred acres was sold to developers, who hoped to subdivide and erect speculative "builder" houses.

Ever since he'd bought his empty property in nearby Pound Ridge in 1982, Lauren had been visiting it, trying to figure out what to do with it. He loved his spit of land that stuck out into Lost Lake, but it was too small for a house. So he looked at other properties nearby. Michael Farina, the former *DNR* illustrator, was building houses at the time, and told Lauren about Oatlands while Ralph was recovering from his brain surgery. It turned out Lauren had already seen the place—as a wreck. But with a remodeling job half done, and a new pool, kitchen, and circular driveway installed, he changed his mind; throughout 1987, he negotiated to buy it. As he had in Colorado, he made an offer contingent on his ability to buy the adjoining two hundred acres. In spring 1988, he agreed to pay $5.5 million for the house, $14.5 million for the additional land, and $2.5 million more for the original estate's gate and guest houses.

As usual, the line dividing Ralph's private and business lives was quite porous. Ralph's accountant, Arnold Cohen, who'd help restructure Polo in the 1970s, had become a sort of superconcierge, running the Laurens' private lives, as well. After the closing, Cohen handed Michael Farina the keys and said Ralph and Ricky wanted him to help rebuild the place. "Three years later, I was still here," says Farina, who is now Lauren's estate manager.

Every bit of Ralph's obsessive compulsion was to put work in his remodeling. Lauren rebuilt roads, resculpted and replanted the tranquil, open lawns and wooden rolling hills of the property, dynamited rocky outcrops, created a lake, filled in the new pool (which was visible from the driveway), and built a new one along with a pool house, which was then torn down and rebuilt when Lauren walked in for the first time and decided the ceiling was too low. He also hired Italian craftsmen to duplicate a courtyard he'd seen in Europe, then had it

ripped out and reinstalled. Balustrades and a tennis court with a basketball hoop were added and speakers were inserted into rocks around the property.

One of Lauren's neighbors, Carlo Vittorini, the president of *Parade* magazine, "watched wide-eyed as a parade of flatbed trucks full of mature trees pulled up the driveway over a period of months," says a Vittorini family friend. "They put up an avenue of trees." Hundreds more were planted, torn up, and replanted all around the property. Shortly thereafter, a man popped out of a hedge dividing the two properties, and said he worked for Lauren, who wanted to buy the Vittorini property because the house was in Ralph's new view. "A very generous deal was made," says the friend, "and as soon as they pulled out of their driveway, bulldozers came in, knocked everything down and filled in the pool. They landscaped over everything." The work was so extensive that when the broker who sold Ralph the place returned to see the final product, he couldn't find it.

Like the grounds, the interior of the main house was totally redone to make the place Ralph's own. He ripped up and reinstalled a diamond-patterned limestone and cabochon entry hall three times, had a molded ceiling crafted to fit another room in France, but tore it out when he didn't like it, and had cashmere curtains made up in three different colors before he decided which to use.

Bedford was to be the Lauren family's seat. "It's not us trying to be somebody else," the designer told W, preempting the obvious accusation. But not every sign of the past was obliterated. The initials of the first owner, Robert L. Fowler, were carved into the lead rain gutters of the house. "Lauren ground down the Fs," leaving only the letters RL, says Fowler's grandson Luke, who grew up in the house. "He made it look like he was always there." But hints of the real provenance remained: a Fowler family crest, sporting a limestone owl and the words "Watch and Pray" in Latin was still over the front door, and an iron grate bore the coat of arms of Robert Fowler's wife's family, the Winthrops—a hare jumping over a helmet.

Then there was Robert Venturi's Carll Tucker House. It was an architectural landmark, but Lauren apparently didn't know that when he "decided to take it down," Tucker says. "It was clear he didn't know who Venturi was." Only after the architecture critic Paul Goldberger and architect Philip Johnson intervened did Lauren decide to leave it standing, Tucker says, "and he now boasts that he has a Venturi house."

It was all about Ralph and all done by Ralph—according to Ralph. The estate "had great bones," he allowed as he took the visiting reporter around, "but it was worked on. It was the hardest thing I ever had to do in my life. You have to look for what your dream is. You're buying it; it's not like it's heirlooms, but you want it interesting, individual and special. I bought everything in this house. No

one bought it for me. Look around. This is close to my life." He didn't say how close as he pointed out portraits of Indian chiefs, French and English gentlemen, and exotic animals; Louis XV and George II furniture; animal heads, animal skin rugs; and even the shining pipes in his bathroom. "These details inspire me," he said. "The brass. The way it curves."

Lauren might have claimed he'd bought everything in the house himself, but, in fact, his team of elves had done it all for him. "Bedford was done by creative services down to what picture was on the frickin' tables. They created a life for him," says the creative services executive. "All he had to do was show up."

A creative services staffer named Bill Sofield had worked on the architectural renovation as well as decorative elements like a huge wall upholstered in tartan. "It was very difficult to achieve," he says. "It was enormous and every corner had to meet. The geometry was challenging. You do the math and employ incredible craftsmen and shim out the walls an eighth of an inch at a time."

Jeff Walker "chose every piece of furniture," says a Poloroid. "He spent days looking for dining room chairs. He found antique chairs with ripped leather, unbelievably expensive, like $20,000 apiece." After his death, Walker's successors finished the job, going on three-country buying sprees, shipping back containers full of booty. "Hundreds of thousands' of dollars worth," says one of their colleagues. "The money would be wired to the shipping company. All they had to do was point."

The house tour paused briefly to meet Ralph's and Ricky's mothers. "What do you think of my little son, my baby?" Frieda Lifshitz asked in a thick Yiddish accent, redolent of the Pale of Settlement. Frieda was tiny, stooped, dwarfed in the elegant entry hall. Then Ralph led the way upstairs, where every wall and surface was covered with books and drawings, equestrian, western and animal paintings, and Lauren's extraordinary collection of photographs—Noël Coward by Horst, a Maserati by Bruce Weber, dying tulips by Robert Mapplethorpe, a pair of bathers by George Hoyningen-Huene, and Garbo by Edward Steichen. There are pictures of his heroes and heroines too—Cary Grant ("he came to my house for lunch"), Gary Cooper, the young Sinatra, Humphrey Bogart, Katharine Hepburn, Marlon Brando, James Dean, Steve McQueen, Gene Kelly, and John, Jackie, and Robert Kennedy—all sharing wall space with Ralph and family.

Lauren didn't know that one picture showed Igor Stravinsky at his piano. "It doesn't matter who it was," he said. "The look, I love." Ask who painted or photographed one or another of the works, and Lauren doesn't know the answer. "I'm not name-conscious," he says. "Someone tells me a date, I don't care. I don't care about origins. I care what it feels like and what it says to me."

Then came the attic playroom complete with barroom; capacious, cracked leather armchairs; a pool table; two guest suites; and the children's bedrooms—tartan for David and Dylan, dark green for Andrew, who wanted a sophisticated room—and several bathrooms (one with two Frank Lifshitz–signed paintings), before reaching Ralph and Ricky's master suite, with its all-white bedroom with a bathtub smack in the middle of the room.

Off it was Lauren's study, full of little crocodile and tortoiseshell boxes and photos of Ricky and of Ralph with Ronald Reagan and Frank Sinatra. Then the tour ended in the couple's room-size closet. "What's mine is Ricky's and what's Ricky's is hers," Ralph jokes. It is filled with Polo products—khaki and corduroy pants; jeans; work shirts; blanket coats; worn riding boots; navy, green, gray, and American flag–emblazoned sweaters—and a touch of country luxury—eight pairs of velvet slippers, three monogrammed, and two embroidered with flying pheasants. "I have lot of clothes, but they're all sort of . . ." Lauren pauses and laughs ". . . the same."

He had a lot of furniture and furnishings, too. The excess purchases made for the Rhinelander, the public spaces at 650 Madison Avenue and Ralph's homes—and there were many—all ended up in storage. A few years later, Lauren's attorneys contacted Sotheby's and offered to sell some of it. A curator for the auction house, Larry Sirolli, walked through a back house in Bedford that contained 150 pieces of furniture, and Polo's New Jersey warehouse—half the length of a football field and twenty-five yards wide, filled with triple shelves that reached to near the ceiling—giving estimates, while wondering if he hadn't wandered into the set of the last scene of *Citizen Kane*, the huge warehouse where the megalomaniacal Charles Foster Kane stored the fruits of his spending sprees.

"It was typical Ralph Lauren," Sirolli says of the stored goods. "Leather furniture, canes, riding crops, Chinese vases. The sheer volume and range was amazing," although Sirolli adds that "most did not have great provenance. It wasn't from dukes or duchesses." Sotheby's finally took 350 pieces. "Not a sizable dent." But enough to raise $2.5 million for the Nina Hyde Center. Here was proof Ralph's celebrity had tangible value. The top bid, $290,000, was made for a Gobelin tapestry estimated to be worth $70,000.

That sale came at the very end of a retrenchment that was kicked off by the spending on the new offices at 650 Madison and the Bedford house, which came atop the troubles at Bidermann. But few knew that. In 1992, things looked great on the surface, as they always did at Polo, when Ralph kicked off a year-long orgy of self-congratulation—it was his twenty-fifth anniversary. Lauren's PR

people played the press like a symphony. He was everywhere that season, trumpeting his $3.1 billion volume and his take-home pay of $64 million. The *New York Times* hailed him in an Arts & Leisure feature as "the ultimate lifestyle purveyor." The CFDA was induced to give him its Lifetime Achievement Award, and he was on the cover of *Town & Country* and the subject of glorifying pieces in *Esquire, Mirabella, Forbes,* and *Vogue.*

"And it wasn't easy," says a Polo PR person. "He wasn't exactly news."

79

'll sit here," Ralph Lauren said as he entered a room to be interviewed in the early nineties, heading straight for a chair covered with a spotted animal skin. "I feel like a king." But he couldn't sit easy on his throne. Ralph's traditional image was becoming a prison in a time of radically changing attitudes toward clothes. Ralph Lauren Women's Wear had stalled at $100 million volume and Polo's menswear sales were slowing down. The Gap, J. Crew, and Ruff Hewn were muscling in on Polo's traditional business, and Nautica and Tommy Hilfiger were nipping at his younger market. Then there were the *real* counterfeits. Ralph had started suing fake artists in the seventies, and has continued litigating ever since, even getting into a tangle wth the United States Polo Association over its rights to put its name on clothing.

Employees would be drafted to give depositions and testify in court about Ralph and the polo pony and how it wasn't merely a logo but a symbol of dreams and one worthy of protection. "Obviously we realized we weren't the be-all, end-all of the sport," says one who did that, "but it was ours. There were counterfeit Polo shirts on the street, tainting our product."

As the number of Lauren lines had grown, the expense of designing and marketing them had grown apace. So on the ad shoots that seemed to be constantly occurring in the mid-nineties, Buffy Birrittella was always trying to get more bang for the buck, hoping to finish ten ads a day instead of five, stressing out her advertising team.

Already furious that Les Goldberg had snared the Safari assignment, Bruce Weber had stopped talking to Calvin Klein that year after another competitor,

Herb Ritts, was hired to shoot a TV spot for Klein's latest fragrance, Escape. So Weber needed Lauren to support his lifestyle. But just as the Poloroids were beginning to question him, behind the scenes, Weber complained constantly about Birrittella and Carter. He felt taken advantage of by "people who were very worried about their jobs," says one of his assistants. "None of them had any say-so, so they wanted a lot of options." Even if that meant driving Weber crazy.

"We've got to shoot this bag, Bruce," Carter would plead, noting how much money the licensee who made it had contributed to the ad budget. "But when you're Bruce Weber and you get into the mood, and you're looking at image, not product, it's frustrating to be told you have to do product shots," says Shari Sant, who'd left Polo but remained close to the Weber coterie. "There were too many demands on him, and it just got worse and worse and worse." Even when he was relieved of the less creative jobs—Weber didn't shoot the Home collection ads: that was done by interior and still-life photographers who, not coincidentally, worked for less money—money remained a sore point. Lauren would moan about how much Weber charged and beg him to throw in a day for free. "Bruce sometimes would," says an ad-team member. "But he always found a way to charge us." After all, it was his work that gave Polo its emotional life.

The fact is, Ralph Lauren and Bruce Weber were locked into mutual dependence. "As it became commodified, Ralph's product, like any fashion company's, was actually advertising," says ad critic Randall Rothenberg. "If you have people who are effective at communicating, you want to keep them around." And Bruce Weber communicated the Lauren message like no one else.

Lauren was a means to an end for Weber, too. "He was happy for the work and the visibility, but underneath it all, he hated Ralph," says a Carlson & Partners executive. "Ralph made impossible demands," demands that were always delivered by Polo's ad team, never by Ralph himself. "He would never confront Bruce. We were always softening the blows, commiserating; it was an inhuman task." You could never do enough for Ralph, who said of Weber, "If it wasn't for me, he'd be nowhere.'" Sometimes, Sandy Carlson would try to get them to talk to each other. But nothing much got said beyond, "Oh, Ralph, your clothes are so amazing." "Oh, Bruce, your pictures are so amazing."

The tense tango might have gone on forever had it not been for Spencer Birch, who'd first appeared at Polo at the end of the 1980s. He was still in high school then, but he came to the Polo office at 40 West Fifty-fifth Street to visit his brother, who worked there. Dressed in vintage clothes, with blond dread-locks and a sullen, fuck-you expression, Birch epitomized the generation with which Ralph was desperate to connect. He decided to reel Birch—the hippest

thing he'd seen in years—into Polo and gave the teenager a job on the men's design staff.

By the nineties, Birch had left school and gotten married. And he played a game of hard-to-get with Ralph, taking time off so he and his wife could go camping in Utah; Ralph always took him back. "They live the life Ralph dreams of," says an executive. "The more he pushes Ralph away, the more Ralph needs him. The weirder Spencer is, the more Ralph likes it."

For years, Lauren had been toying with an idea for a new line, Double RL, named after his Colorado ranch, but conceived of in Europe when he was looking for vintage Levi's in antique clothing stores and was dismayed to find that they were all being sent to Japan. He decided to re-create the vintage look, and developed new processes for weathering clothes.

At first, Double RL was to be "about America," Ralph said, "about college, about the '30s, the '40s, the '50s, the '60s, the '90s. It's a timeless spirit." But in 1992, with grunge, an anti-style spawned in the Seattle music underground, spreading across the county, even affecting the way his twenty-three-year-old son Andrew dressed, Ralph put the quintessentially of-his-moment Birch, now in his early twenties, too, in charge of developing the line. Though he'd repeatedly failed at making jeans, Ralph kept trying. Lauren's executives couldn't say no to him. "He could make grown men buckle and allow things to happen against their better judgment," says a creative services executive.

"I didn't build a company just to make Polo shirts," Ralph would insist. "We have to lead. I don't care what it takes. Make it happen."

Polo had just leased a modern building directly across Madison Avenue from the Rhinelander. At first, Ralph thought about moving his Home collection there; it had outgrown its space at the mansion. He also had a dream of opening a small restaurant. But the pressure to be cool kept the heat on him. He needed to bring another generation—the sons and daughters of his core customers—into the Polosphere.

All around him, designers were adapting to the new economic climate, developing cheaper, sporty lines like Giorgio Armani's AX, Calvin Klein's CK, and Donna Karan's DKNY. "I had a few babies that were growing," Ralph says, so he kept changing his mind about which would go into the new space.

Ralph had begun a cross-training program after he dumped Kim Nye, a grueling regimen that he hoped would keep him looking and feeling young—without leading to divorce court. He decided sports might be the key to updating his image. In 1989, he'd expanded his sports apparel business with a line of golf clothes and accessories; in 1990, he'd designed uniforms for the America's Cup team and off-field gear for a U.S. Olympics team, and in 1991, his winter

Collection for women included high-tech skiwear. "This is a time to go more contemporary," he decided. "Everyone says Ralph Lauren is traditional. I was going the other way but you couldn't see it. It got buried under the image."

Instead of keeping all his sports apparel submerged in the Rhinelander, he decided that it, too, should get its own line and began developing what he called Polo Sport. He wasn't worried about who would wear it. Although many weren't athletes, his customers would also be "people who go to matches or people on the street who want to look active," he said. And he dismissed the idea that moving away from his Anglo-American roots would be risky. "It's risky not to," he said. "And it's not like I'm dropping one for the other."

He ended up calling the new store Polo Sport, and that line was his next great success, but Double RL was where his heart was. It "has no limitations," he said. "I think it's going to go major. . . . I'm a jeans expert." Spencer Birch wasn't just the director of the division, he was the icon of the lifestyle. "Spencer was the inspiration, fine," gripes a Poloroid. "Ralph gave him full control, fine. He's running the show, fine. He had nothing to say, he's completely inarticulate, he wears a hat that looks like it was run over by a truck on the Jersey Turnpike and then slept in by rats, on top of dreads, fine. Ralph ate it up, couldn't get enough. Fine. But then, Ralph puts him in charge of the Double RL ad shoot." That wasn't fine.

Double RL was to be introduced with a series of teaser ads in fashion magazines in August and September 1993, to be followed by more ads showing clothes, coinciding with the opening of a Double RL boutique in the new Polo Sport store, thirty Double RL in-store boutiques, and a national college tour by a shiny eighteen-wheel truck Polo had decided to hire and turn into a store on wheels. Road-tripping from school to school, stuffed with Double RL merchandise, the truck was conceived of as a rolling, and possibly even profit-making, advertisement for the new line.

Accompanied by Andrew Lauren, Birch flew to Santa Barbara to shoot the ads with Bruce Weber. "Basically, it was a disaster," says a member of Mary Randolph Carter's ad team. "It was unfair to everyone, including Spencer. Millions of dollars were at stake, and Spencer couldn't give direction, he couldn't handle Bruce; it was one disaster after the next," all reported back to Birrittella by a humiliated Carter, whose "legs had been chopped off," the staffer says. The models Weber chose were pretty. Birch wanted real, instead. Weber's nerves, raw in the best of times, were worn bare—and not just by rainy weather that had them shooting knee-deep in mud for days.

"Ralph kept forcing stylists down Bruce's throat," says Shari Sant. "Spencer was really young and didn't understand: Bruce is like Ralph and you have to

treat him with respect. It's his show." But Ralph was paying for it. And when Buffy told the boss what was going on, a message went back to Weber to shoot photos of Birch himself. Birch put his wife in the pictures, too. "He had no respect for Bruce," says a member of the advertising team. "He thought, 'Bruce Weber is not the guy.' " Birch was; he was the apple of Ralph's eye.

Arnaldo Anaya-Lucca, one of Birch's colleagues in the Polo design studio, had made a study of Bruce Weber. A gay Puerto Rican in head-to-toe Polo, Anaya-Lucca had battered the Polo gates until he won a job as a salesman in the mansion in 1988. His adherence to Polo principles was so great, he was assigned to be the Lauren family's personal salesman—one of their favorite games of make-believe was shopping for Polo clothes. "What's cool?" Ralph would ask Anaya-Lucca. "What are *you* buying?"

Next, Ralph set him up with a men's design job. "Listen," Jerry Lauren told him. "You're born with an eye. Everything else, you can learn." Anaya-Lucca was soon doing research, creating rigs, and attending meetings as Ralph's latest favorite. "I became somebody he looked to," says Anaya-Lucca. "He always has an Arnaldo."

Anaya-Lucca heard all about the tempest on the Double RL shoot. Weber walked off the set "several times," Anaya-Lucca says. "Bruce was hurt and angry and feeling betrayed, but he came back and finished it." Still, the most important picture in the campaign, the September teaser, had to be reshot—and Weber wouldn't do it. Instead, Kurt Marcus, who specialized in photos of the West, created an iconic image of mustangs running free that also appeared on the side of the Double RL eighteen-wheeler, as it rolled from town to town.

Though Weber kept working for Lauren after the Double RL debacle, and still does, their relationship was damaged, and for a long time Weber no longer shot the all-important women's Collection pictures. Weber even flirted with Tommy Hilfiger, before taking up with a newly Ralph Laurenized Abercrombie & Fitch in 1995, blending his Lauren and Klein looks into a wholly new, wholesomely sexy image that, of course, drove Ralph Lauren crazy.

Ralph's campaigns, meanwhile, "always ended up a mishmash," says the advertising executive. What followed was "an endless search for the right picture and the right photographer."

The opening of Polo Sport was repeatedly delayed and the invitations reprinted multiple times. When Ralph couldn't visualize what the cherry and steel doors to the store would look like, "we had to mock up a true-to-life section so he would get it," says a creative services executive. "That cost a gajillion dollars." But finally, in September 1993, those expensive doors opened to the public. The

two-story Double RL boutique was located just south of the entrance, its floor made of old wood planks, its banister of iron, its ceiling of pressed tin studded with fans. Aged license plates and antique roadside signs shared wall space with frayed, old jeans hung as soft sculpture. Klieg lights, a black Indian motorcycle, broken-in work boots, trunks full of socks and decrepit crates stacked with new old things, jeans, T-shirts, and chambray shirts, filled the floor.

Grunge had died in the marketplace six months earlier, and the dreadlocked Spencer Birch was nowhere to be seen when Ralph showed the store off to a reporter. "This was meant to look like the kind of things you collect all your life that you love and you can't get any more of," Ralph said. "What I've done is put together what I love, what I've worn all my life. Things I've accumulated over thirty years. People used to say 'You look like a schmuck, Ralph. What are you wearing?' They didn't get it. All of a sudden they get it."

Then again, maybe not. The overpriced line, with its $150 flannel shirts, $78 worn jeans, and $950 leather coats, failed to ignite. Lauren seemed confused about who the Double RL customer was—college students buying off the back of a truck would never pay his prices for faux-vintage clothes—and once again, he had fit problems.

WWD reported Polo would take $10 million in returns rather than allow markdowns. Spencer Birch soon left Polo on a long hiatus. But there was one positive result from the Double RL experiment: Andrew Lauren, who'd left college and announced he was going to become an actor, made the International Best-Dressed List.

80

The mood in the Polosphere was grim at the dawn of 1994. "Sales are falling off, the numbers aren't there, he's pouring millions into Double RL," says an executive of the time. "The tone started to change. We better tighten our belts. It was the beginning of the end of the old Polo—and the start of the nervous nineties." Ralph seemed lost, suspended between "greed and creativity," the two forces that drive him, says a former top executive.

The failure of Double RL was symbolic of the dilemna Polo faced as it

neared its thirtieth birthday. Double RL was too pricey to be commercially successful, at least on the scale by which success is judged for companies as large as Polo. Ralph's name could still sell goods in significant numbers, indeed more than ever before, but they would have to be at the low-priced end of the fashion market. The profits cheaper goods generated could then be used to support the crucial illusion that Polo was still a luxury brand by, for instance, supporting dubious ventures like Double RL. That illusion, in turn, would sell more low-priced goods to customers who aspired to better and wore the Polo logo as a totem of their desires. Ralph's business was already moving in that direction. But Ralph wasn't there yet.

Marvin Traub was. Following his 1991 retirement from Bloomingdale's, Traub had joined the board of a company that owned outlet malls where brands like Polo have off-price shops. So Traub knew one of Polo's darkest secrets: that it had begun producing goods specifically for its outlet stores, goods that weren't seconds, weren't returns, weren't overstock, weren't unsold, but, rather, were made to be sold at a discount. And that was and remains a sensitive subject. In 1998, when a *New York Times* reporter called asking questions about those goods, Polo officials refused to comment.

Other former Polo retail executives say that's because the real story is even more dramatic: they claim that at century's end, goods manufactured specifically for the off-price stores represented a huge percentage of the inventory of the Polo Outlets. "It got to be an animal," says a former executive of the full-price stores. "Why pay full retail when you can drive to an outlet mall?"

In an effort to reverse that trend in the late 1990s, Polo began spending huge sums to renovate and refresh its full-price retail stores. Yet all that did was increase the importance of the outlets—which were contributing 80 percent of Polo Retail's volume, and were then responsible for its entire operating profit. Today, although "full price retail brings in about $150 million to $170 million a year," a former Polo Retail executive believes, "it loses $10 million a year because it eats up a disproportionate amount of operating expenses," thanks to the high cost of maintaining the clubby Polo retail image. The outlets pay for it. In 2002, according to Polo's own numbers, a $14.3 million decrease in sales in full-price Polo shops was offset by a $29.8 million increase in sales at the outlets.

Polo doesn't break out a lot of these figures in its annual reports. That may be because sunlight would pierce its all-important veil of illusion. The outlets make so much because they pay a wholesale price for their stock that's half what a full-price retailer has to pay—and they can charge a proportionately bigger markup while still undercutting full-retail price. So where a department store buys a shirt for $20 and sells it for $40, making $20, an outlet owned by the same company

that makes the shirt can buy it for $10 and sell it for $24.99, making only $15, but selling far more shirts by letting the customers think they're a bargain. Polo even has an off-price product development division dedicated to creating products for the outlets. It's the perfect fashion food chain; Lauren's cannibalization of his image helps keep that image strong.

Though its numbers were never reported publicly, Factory Outlets of America, or FOA, was a stand-alone operating company within Polo Retail. At the end of every season, the Polo shops and the various licensees—women's wear, shoes, scarves, and sheets, for instance—would sell remaining goods to FOA. Outlet sales volume rocketed from $80 million in 1992 to $500 million in 2000, and because they were considered the outlet mall version of loss leaders, FOA outlets usually paid low rent, or no rent at all, and were built to Polo's specifications, with entire outlet malls built around them. "Once Polo signed, forty others would line up behind us," the executive says. FOA's overhead was virtually nil.

Ralph knew about the explosive growth of his outlet business, and he "was supportive," says the executive. "He felt we were protecting him. We were controlling the distribution of excess product"—i.e., product that failed to sell at full price. "You're not going to talk about it, but at the end of the day it was very profitable." And even in the low-cost arena, Polo was an innovator, introducing customer service, merchandising, and a full assortment—and attracting former department store customers who'd been driven to look elsewhere by the bankruptcies that decimated the big-store universe in the early nineties.

Ralph had paid his debt to Marvin Traub when Bloomingdale's teetered on the brink of insolvency at that time by making sure goods were regularly shipped to Traub's stores. But those big-store bankruptcies hurt Polo, too—particularly its women's Collection. There were critically successful collections like Lauren's Russian-themed line shown in April 1993, but every success was balanced by a new problem with the licensee, Bidermann, where executives came and went as often as commuter trains at rush hour.

In the early nineties, the latest president of Ralph's women's line lowered prices on key items by 25 percent, which caused sales to rise 20 percent. But despite that, the license showed a loss for 1992. That year, Bidermann's latest CEO, Al Fuoco, told Strom that Collection would never make money because "the waste was astronomical," Fuoco says. When he argued against producing "image" items that wouldn't sell, Strom reported back that Lauren felt stifled. The CEO commissioned an analysis of the Lauren business and discovered that the commodities that had long supported the business weren't selling that well either, and could no longer support the cost of Ralph's creativity.

"Peter would bring in Buffy and Cheryl Sterling and I'd vent and they'd 'Yes, yes,' and then it would go right back to 'This is what Ralph wants,' " Fuoco recalls. The biggest problem was Lauren's refusal to make decisions about what items to actually produce until after his shows. "You can't finish the Collection the day of the show, price it the next day, sell the next and deliver on time," says one of Fuoco's predecessors, Michel Zelnik. "It's just not possible."

And always, Ralph was demanding more money be spent to advertise it, hoping he'd be such a pain Bidermann would sell him back his license. But Lauren was Bidermann's crown jewel. It was divesting other divisions to stem losses and build the Lauren line back up. That was a necessity. Otherwise, Ralph could cause *real* problems. In the most recent of its seemingly endless string of license renegotiations, triggered by the debt-driven fall in Bidermann's net worth, Polo had won the right to buy the license back at eight times its 1994 earnings. But it had lost $20.6 million in 1990, $6.5 million in 1992, and was going to lose another $3.1 million in the first half of 1993. Based on that formula, Lauren Women's Wear was worthless—and Ralph would be able to take it back for free.

In January 1993, the banks that held Bidermann's debt brought Michel Zelnik back as Bidermann's CEO. In March, Zelnik brought back Stuart Kreisler. "A designer like Ralph needs someone to fight him, a counterbalance," Zelnik says. "Stuart could say, I need more of this and less of that without Ralph going crazy." But hiring Kreisler as the division president required Lauren's approval. And Kreisler feared being pushed out by Ralph again. Lauren had to approve and could terminate an employee, but not a consultant. So Zelnik brought Kreisler back as a consultant.

Kreisler claims Lauren welcomed him back "with open arms," but Kreisler's faith was now in Zelnik, not Ralph. "I didn't care if Ralph was happy," says Zelnik. "I needed to fix the company. If I straightened it out, Ralph would be happy." Zelnik gave Kreisler a base fee of $500,000 and a guaranteed bonus of $250,000 paid weekly against 15 percent of earnings to help Zelnik maximize the value of the license, raise its value, and sell it. If Kreisler could bring earnings back to $20 million a year, the license would command $160 million. Kreisler decided to do that by selling more goods in fewer stores.

As long as Bidermann held the license, Ralph had to grit his teeth and work with them. "Ralph thinks Stuart's a lowlife, but so is everybody else," says a Bidermann executive. "Stuart built [the women's business], he ran it, he's very talented, and he understands Ralph profoundly." So, a few months later, they even introduced "Ralph," a younger line produced by Bidermann, together. Lauren opened that season's show with it—an important statement. But he still

couldn't describe it as what it was—a cheaper, younger collection—and he sounded as if he was still getting used to the idea himself.

"It's a new statement, a new concept, a new sensibility," he told Mary Randolph Carter in an advertising meeting. "You have to create a new thing. If it doesn't have newness, we've wasted our time." Incorporating bits of many of the lines Ralph had sold through the Kriesler Group and Bidermann in the past, among them Classifications, Sport, Roughwear, and Ralph Lauren Dungarees, Ralph-the-label soon represented 80 percent of Bidermann's Lauren volume. Kreisler also went through languishing inventory and retagged it, producing additional garments only in sizes that were underrepresented in the old stock, allowing him to sell it all as brand new. By the end of 1994, the division's profit was back to $11 million, and the license was worth $88 million.

Stuart Kreisler's gain was Ralph Lauren's pain.

81

That summer day in Bedford in 1993, Lauren joined his Home design staff on the lawn at six P.M. They'd brought along a bunch of garments to inspire him, just as he'd been inspired by clothes—both old and new— made by others throughout his career. This time, it was a brown oil-cloth winter coat that did it. "I had this exact jacket when I was fourteen years old and I hated it," Ralph told the group. But now, he felt differently. Even if it wasn't innovative or his own, he wanted it, and told the team to leave it behind when they were through.

Because this was an impromptu, alfresco meeting, instead of real rigs, the Home team had made piles of clothes, accessories, and bedding both vintage and Lauren, and other inspiring items on the lawn, each pile representing one of the themes Lauren was considering for his fall 1994 Home line: Wellington, Safari Modern, Pacific Northwest. As a lion-headed fountain gurgled against an ivy-covered wall, Ralph picked his way between tableaux of paisleys, plaids, and khakis, tossing them one atop another, and eyeing the resulting mixes. Some would call this "styling." For Ralph, it is designing.

One pile—Thoroughbred—rubbed him wrong. "This is not new enough,"

he said. "It's not happy. It's not rich. It's familiar." He tossed an oatmeal-colored sweater and a pair of muted brown-and-pink-plaid pants away, leaving an olive sweater, a dark plaid blanket, and a pair of olive corduroy pants. The head of Home, Nancy Vignola, hovered at Ralph's side with a fistful of rich ruby, purple, and plaid velvet swatches. He threw a few on the pile. "This has surprise," he said, brightening. "You could wear that."

"I look forward to it," Vignola smiled. Sucking up to the boss was so easy.

Lauren spotted a photo of a Persian rug pattern across the lawn, and added it to the pile. "Now I can see a woman saying 'I love that in my house.' But we're missing some leather." A voice said, "Like an old boot?" Lauren said saddle leather. Vignola fetched an old suitcase from the mansion's mud room. "House o' Props," someone muttered.

"I need something richer," Lauren said, stalking across the lawn and returning with a purple sheet, gun check and plaid blankets, and a cable-knit throw. "Very good," he said. "This is excellent, beautiful, glamorous, alive. Stop! That tweed is too masculine." A pause. "You know what we haven't done? A tweed sheet. I know, it feels scratchy when you look at it, but we did a wicker-print sheet." Notes were taken.

Lauren picked up a paisley swatch. "That makes it new," he declared. "Print that as a sheet. What do you guys think? You want to live in that room? I think we've got something magical. But we need one more thing."

Stymied, Lauren moved on to another tableau. "This is the mistress of an Oriental exporter in 1921," a staffer said as Ralph plucked a Chinese red shawl from the middle of the heap. "I need this sent to women's wear—immediately—tomorrow," he ordered. Vignola laughed. "Shanghai, here we come."

Thoroughbred kept nagging him. "Run up to my bedroom," Ralph ordered. "Open the closet. There's a shirt with suede elbow patches." Before it arrived, his eye was caught by the glint of a gilded frame corner, and he added it to the pile. "Antique gilt could be interesting. Take the tweediness out. Make it more romantic and rich. Gild the bed, then put the velvet, then the olive, then the Fair Isle. Suede-colored sheets and I think we've got it. The gilt solved the problem. Perfect. Perfect. This has the spirit of everything we do, right in one shot." He'd created a new old thing.

Just then, Ralph's middle child, David Lauren, arrived. Strolling into the courtyard, he picked up the gilded frame. "This would make a great bed," he muttered.

"Scary," someone said.

Ralph lit up with fatherly pride. It was right out of a movie.

"All right," the director said. "It's a wrap."

82

As 1994 dawned, Ralph Lauren, fifty-four, was learning that wealth and fame don't protect you from the depredations of middle age. He was dealing with his children leaving the nest, and with his partner, Peter Strom, who was desperate to quit; and caring for his father, who was dying by inches. Frank Lifshitz had developed anemia and kidney disease atop his heart condition. Near-comatose since 1991 and suffering from dementia, Frank was fed through a tube, needed blood transfusions, and endured frequent bouts of pneumonia. His wife, Frieda, was still vital, but Frank's needs were so great that by the end of 1990 he was getting round-the-clock nursing care, paid for by Ralph to the tune of more than $300,000 a year. Then suddenly, on the morning of February 1, 1994, Frieda Lifshitz had a heart attack and died. The family was shocked; no one had known that she, too, had heart disease. No one ever expected Frank to outlive her.

Ralph filed a petition seeking to be appointed his father's legal guardian so that Frank's bills could be paid and he could continue being cared for in his own apartment. Astonishingly, a few weeks later, a court-appointed evaluator recommended against the appointment. "I spoke repeatedly over several days to [Lauren's] counsel, his business office staff, his brother, his bookkeeper and his accountant," she wrote, "in order to secure a date and time when the petitioner would be available for an interview by telephone. The petitioner was never available." Ralph also refused to appear in open court.

Though the evaluator agreed that Frank needed a guardian, she wrote, "the choice of proposed guardian is not appropriate." Ralph withdrew his application and Lenny Lauren filed a new one, which was accepted in May. Frank Lifshitz died just before dawn on July 6, 1994. His estate, which totaled just over $400,000, was split equally among his four children.

Ralph really was busy when the evaluator tried to reach him. He'd come unglued by his mother's death. And nothing was working at Polo—thanks to the costly launch of Polo Sport, the dismal failure of Double RL, and the maturing of his high-end lines, all piled atop the losses generated by the Rhinelander, and

the extravagant spending on 650 Madison and Oatlands. Just when Ralph had hoped to be able to buy back his women's operation, his company was in money trouble again. Cash reserves were low, Strom says, and Polo was "highly leveraged"—deeply in debt. Ralph felt the pinch, and told employees how much it hurt him to experience that degree of failure. Set against his glorious but perilous success, his predicament had all the earmarks of Greek tragedy.

Late in 1993, Mike Newman, Polo's Mr. Nice Guy president, began cutting fat from the firm's operations; there was a lot to cut. There was a kitchen in every department at 650 Madison—ten in all. Lavish breakfasts, free Evian water, and flowers on birthdays were regular perks. "Nobody ever bought stamps," says a PR executive. "Everything went FedEx. Everyone had town cars; there would be lines of them outside 650 every day. The assistants had assistants. It was a great private company, run the way Ralph wanted it." But suddenly, fiscal discipline was as important as integrity.

Belt tightening alone didn't solve the problem, though. More drastic measures were called for and they came on Valentine's Day, 1994, when 15 percent of Polo's staff was kissed off. Though the layoffs were described publicly as a minor streamlining, "it was really awful," says an ex-employee. "So much was superfluous in the company, something had to give, and Mike did what he had to do to make Polo viable in a tough economy." That meant budgets and strict accountability. "We were told they were getting their house in order," says the creative services executive, "getting the numbers where they had to be to show they were grown-up enough for an IPO."

IPOs—taking companies public with stock offerings—were the new status symbol. At the head of a wildly successful public company, Ralph's new nemesis Tommy Hilfiger had done one and was now bragging that he made more money than Lauren. Ralph had always been the gold standard. Competition was his lifeblood. "He's never sat back and rested," Buffy Birrittella says. "He's always had tremendous drive and energy to constantly top himself. He can't rest on his laurels, and he doesn't. He's always hungry in the best sense of the word. Some people, when they achieve a success, say okay, I've done it. Great entrepreneurs are always looking for the next challenge. He challenges everyone around him to keep sharp and improve things because someone is out there, looking to top you—and you have to top yourself."

83

Ralph had been questioning Polo's future for years. "Where are we going? What will it take? How can I make this an institution?" an executive remembers his asking in the mid-eighties. That's when he started making lists of people and institutions that might play a role, and Robert Rubin's name landed near the top. Rubin headed Goldman Sachs, one of America's premier investment banks. After they met socially, Rubin put Ralph's name on a list, too, of target clients, and began an informal advisory relationship that both hoped would one day bear fruit. Ralph's relationship with Goldman Sachs survived Rubin's move to Washington to become treasury secretary in Bill Clinton's cabinet. It was 1993, and Polo's growth was still being financed by retained earnings—money that otherwise would have gone to Strom and Lauren—and costly bank loans. "It was a very heavy burden on [Ralph]," says Richard A. Friedman, a Goldman managing director. "He had to shoulder the full risk and reward, and he couldn't take the kind of risks he needed to take to grow the company."

Through all its ups and downs, Polo had remained a solid business. Ralph had built a bespoke men's fashion business that was unprecedented, consistently delivering product with merit, maintaining an unusually consistent image, and winning press attention that helped create a lifestyle brand that was well on its way toward proving it could evolve without losing core customers. So in mid-1993, when Lauren was pressed for capital due to his rapid expansion and decided to investigate alternative financing, the bankers at Goldman were there to help him. Late that year, Polo began seeking private placement funding— loans from wealthy investors—and circulated documents showing 1993 profits of $65 million on $689 million in sales (with $484 million of that in men's, including $130.7 million in those ever-so-profitable knit shirts). Ralph didn't hide the bad news, either: though the Rhinelander mansion had sales of $33.8 million that year, it was losing money.

After approaching a number of institutions, to no avail, the offering was withdrawn. Goldman Sachs and Polo's president, Mike Newman, who was driv-

ing the financing strategies, realized the company's tenuous situation would make it difficult to attract the sort of partner Polo needed. As they discussed alternatives, a question was raised: Would Goldman Sachs play Let's Make a Deal with Lauren? "In Ralph's mind, we were the premier company in our field," says Friedman, "and he wondered if we could take our capital and our brains and help his company grow." They could.

In October 1994, Goldman Sachs brokered a deal in which GS Capital Partners, a $1 billion investment fund the bank had formed two years earlier, bought 28 percent of Polo for $135 million, valuing the company at $482 million (excluding debt of about $200 million). GS bought the same share of Ralph's private design studio and trademarks. Ralph gave up a quarter and Strom 3 of his 10 percent of Polo in the transaction. "Ralph saw the Goldman money as a PhD from Harvard," says a Polo executive. "It gave him credibility."

The press said Lauren would primarily use Goldman's money to expand Polo's retail ventures. Polo also told the press that Goldman Sachs would be a passive partner, and taking the company public was not in the cards. Neither claim would prove quite true. As a minority investor, Goldman couldn't tell Ralph what to do, but it firmly believed that Polo could expand, and was advising him how to do it. Funds like the one that bought into Polo consider their investments finite, and typically seek to realize gains within a decade. So, of course, Goldman had an exit strategy. "You have to realize on your investment," says Friedman. "We expected it would eventually go public, but we had no time frame." The concurrent purchase of the design studio and trademarks was "part of the professionalization of [Polo Ralph Lauren], and the preparation to go public," Friedman adds.

Deep down, Ralph knew a public offering was inevitable. "Somewhere along the line I thought that I would have to [go public]," he says. "But I had no pressures to do it. I had made more money than anyone would ever believe, more than anybody that you read about from Michael Jackson on. So I had no need for the money. It was a challenge. This was my baby. Do you walk away from your child when it is five, or ten or fifteen? You say 'All right, Part Two. Where am I going?'"

Peter Strom knew where he was going—fishing. He'd always said he'd quit when sales reached $20 million a year; there was no reason for more. Now, with Polo raking in $1 billion-plus, he felt lucky, but besieged. "No one came in and said, 'Pete, you're doing great,'" he recalls. "They came in with problems. Fifty a day and every time, your stomach gets knotted up." His dream had become a nightmare. "Peter thought he'd never get out alive," says an executive who was close to him. "He had to handle an exit, and he worked on

it for fifteen years." His exit strategy "was up to Ralph Lauren, not me," Strom concurs. "Whoever was going to replace me would have to come with Ralph's blessing." That person hadn't proved easy to find—but find him, Strom had. In April 1995, Strom exited and Polo president Mike Newman, the financial architect of the Goldman Sachs deal, was promoted to vice chairman and COO. Not only was he a nice guy, Newman was also a sound financial hand "in an era of financial complications," says Marvin Traub.

Strom had learned to deal with Ralph. "Peter understood the man's sensitivities, his ego, his personality," says a colleague. "None of it was normal, but it was our life. Peter was clear and factual with Ralph. 'Here's what I would do. Do what you want.'"

Now, Newman had to manage the man whose name was on every Polo product. The boss was put in a bubble. Top executives learned to manipulate him. "Meetings were skewed to bend his mind," says one. "There were pre-Ralph meetings and pre-pre-Ralph meetings to decide what they wanted to brainwash him with. Most of the company's time was spent in meetings figuring out how to deal with Ralph."

He became even more isolated. "We all started seeing less and less of Ralph," says designer Nick Gamarello. Lauren had asked him to develop an equestrian line exclusively for the Polo Shops, but no one else in the company got behind it. Frustrated, Gamarello tried talking to Lauren about it, "but Ralph didn't have time for me," he says. "He wasn't involved in the day-to-day, although nothing could be finalized until he saw it." That caused endless bottlenecks; Ralph was overwhelmed with product. Little stickers were printed up to be put on everything from rigs to samples. "*RL LIKES*," they said. If he didn't like, he'd say, "You lost me." But it didn't feel like Ralph's company anymore. "When Ralph said, 'I want this,' you did it," Gamarello says. "But certain characters would look at each other and defy him. The bottom line became more important than listening to Ralph."

84

Though it was full of classic, glamorous gowns, and ended with a model clutching an Oscar, Ralph's April 1995 fashion show was a little too safe to be a winner. And shortly after the show, Gale Parker, his latest women's designer, the former Hollywood costumer, resigned to go to work for the Limited, the $2 billion low-price chain famous for its knockoffs. Lauren was outraged. He'd taken Parker in when she was no one and put her in charge; he'd loaned her his homes after each Collection so she could run away with her kids and recover; he'd even taken her son for a drive in his Ferrari. And this was the thanks he got!

But Parker was frustrated. She wanted Collection to push the envelope. Ralph could be pushed only so far. "You have to stand for something," says Maggie Norris, who replaced Parker. "Any great artist will always have the same script. How could you ever get tired of Gary Cooper and Audrey Hepburn?"

Creatively, Ralph was on hold. By strengthening Polo's balance sheet, Goldman Sachs had given the company the means to reinvent itself; but first, Ralph had to get back his women's fashion license. And that wasn't proving easy to do. Stuart Kreisler and Michel Zelnik had sales back up to $120 million, but Bidermann's debt was impairing their ability to produce goods, and Maurice Bidermann was embroiled in a French political scandal. Knowing the license would soon expire, needing the funds that could be gained from a sale, and as always unhappy with the wild expense of being in business with Ralph, Bidermann USA hired the investment bank Lazard Frères to sell Ralph Lauren Women's Wear.

As expected, Lazard valued the Lauren license at $88 million and let Polo know it was for sale. Stuart Kreisler was well rewarded for his efforts: his consulting contract was extended for another year, and he asked for and got advances on bonuses of $300,000, $250,000, and then another $110,000. But that wasn't enough for him. When Polo offered $22 million for the license, and asked Kreisler to meet with Goldman to discuss a deal, Kreisler refused until he got a severance agreement worth another $1.75 million.

Kreisler was prescient. That was in March. In June, Zelnik was fired, replaced by Bryan Marsal, a turnaround specialist who worked with bankrupt companies. Polo was still talking to Lazard, but negotiations had broken down; Marsal was asking $55 million for the license. "It was a cat fight," he would later testify. Before the month was out, Polo sought to cancel the license, asserting that Bidermann had not maintained a minimum net worth, had failed to deliver timely financial statements, and had failed to get approval before hiring Marsal. Two weeks later, Bidermann filed for bankruptcy, effectively halting the arbitration.

Ralph called Stuart. "Why can't I get this company?" he asked

"Your people made a lowball bid," Kreisler answered.

Bidermann was playing hardball. Marsal needed to sell the license so he could pay down Bidermann's debt, but he kept Kreisler in place to demonstrate his willingness to keep the license in order to get Polo to ante up more money for it. Kreisler was an irritant to Ralph. "Ralph did not want Stuart around," says Marsal. "They could socialize, but on a professional level, there was a complete absence of respect on Ralph's part."

Marsal's gambit worked. By mid-August, Polo had agreed to a $43.6 million sale; it closed that fall. "I think there was a fear that I might sell the product in Wal-Mart if it came to a liquidation, and that would be the last thing Polo would want to have happen," Marsal would soon tell the federal court hearing the bankruptcy case, explaining how he maximized the division's value. Ralph quickly named his executive equivalent of a utility infielder, Cheryl Sterling, who'd turned the Home collection around, as Kreisler's replacement and sent creative services to measure his office for new carpeting while Kreisler still occupied it.

Kreisler became Bidermann's problem—and a big one at that. Marsal tried to cancel his severance agreement, arguing that it was a fraudulent transfer—a sweetheart deal drawn up with Michel Zelnik's connivance to put Kreisler's claim ahead of other creditors in a bankruptcy; Kreisler knew all about bankruptcy. "Zelnik and Stuart were like brothers," says Marsal. "He had a very attractive contract from Zelnik and wanted it honored." Maurice Bidermann agrees. "Zelnik protect Kreisler because Kreisler protect Zelnik," he says.

Kreisler petitioned the bankruptcy court for his severance while he and Zelnik went into business together. The next summer, Kreisler's lawyers won him his $1.75 million. But Kreisler was soon back in court again, claiming they'd overcharged him, asking for a 25 percent discount on his legal bill. The court gave him 10 percent off. Bidermann says that in the end, Kreisler raked in $7 million from his two-year return engagement at Ralph Lauren.

85

tuart Kreisler's payoff was chump change next to the money the new Polo Ralph Lauren started printing once it had its women's license back. Ralph had decided to bring Collection in-house and license out lower-priced women's lines to Jones Apparel Group, the successor to the company at which Jerry Lauren once worked, and the same firm that Ralph had rejected in favor of Bidermann when the Kreisler Group went into bankruptcy in 1978. Ralph also forged a partnership with a denim manufacturer to take his fourth stab at making Polo jeans. Those alliances created today's Polo powerhouse.

Within twenty-four hours of getting the license back, Polo announced the launch of Lauren by Ralph Lauren, a "better," i.e., lower-priced, line with easier proportions, to be made by Jones. He simultaneously closed the Ralph line, even though "he wanted both," says an executive involved in making the Jones deal. "He wants it all: that's one thing you can count on with Ralph Lauren." But, on the eve of exchanging the mothering environment of a private company for the bullying Big Daddy of Wall Street, Ralph was finally learning discipline and the value of compromise. "It's what's needed," he would admit. "My job is to keep going."

Sidney Kimmel, whom Ralph had once abjured as a *garmento*, had turned Jones from a small children's wear company into a powerful contemporary fashion conglomerate. Launched in August 1996, Jones's Lauren line—with its $250 jackets, $140 pants, and $50 Oxford shirts—instantly attained a $100 million volume, 25 percent better than expected. The success caused analysts to upgrade Jones stock and made an initial public offering—or IPO—of Polo far more likely.

A garment executive in the know says Jones gave Polo an $80 million guarantee for the license. But Kimmel knew it would make a lot more than that. He saw what Kreisler "couldn't see or understand," says Bryan Marsal. An elitist, Kreisler cared only about the tippy-top of the fashion market. But that was no longer where the money was.

"Ralph wanted to make money," Marsal says.

Ralph made even more when he finally got the denim business right. He did that thanks to Mindy Grossman, the first top executive ever to leave Tommy Hilfiger for Ralph Lauren. After several years at Hilfiger, the blonde powerhouse had taken a job running Chaps, Ralph's lower-priced licensed line, in 1991, and within three years nearly sextupled its wholesale volume from $28 million to $160 million, before seeking a new challenge. When Lauren and Strom heard she was leaving Chaps, they offered her a position at Polo in new business development, charged with planning new ventures in intimate apparel and jeans. Both had been good businesses for Calvin Klein, and then, Tommy Hilfiger. Ralph wanted a piece of their action.

After the failures of Western Wear, Polo Dungarees, and Double RL, Grossman felt Polo had to rethink jeans, and create the perception it was offering a premium product, but in the mass market, which meant prices for basic items had to stay under $50, the clothes had to fit, they had to be heavily marketed, and Polo had to partner up with an organization that knew how to make denim. "People who lived and breathed jeans," she says.

A year after Grossman moved from Chaps to Polo, it signed a license for the Polo Jeans Company, and she was named its president. The licensee, Sun Apparel of El Paso, Texas, made jeans under several labels including Code Bleu, Todd Oldham, Sasson, and Robert Stock. Sun had its own manufacturing and denim washing facilities, so it could produce low-cost jeans. It built a company to Lauren's specifications, one that would not only make jeans but would also advertise them *and* open Polo Jeans stores.

Ralph had always taken a vintage western approach to jeans; Grossman pushed him to be young and modern, hoping to create "Polo customers for the rest of their lives," she says. So while Polo Jeans had to be inexpensive, it also had to "maintain an aspirational, premium-brand status." In other words, it had to offer the best $48 jeans on the market.

Polo Jeans Co. was launched a year after the license was signed, backed by a $20 million ad campaign. It generated over $100 million in wholesale volume its first year. Grossman did that because she was among the few Polo executives willing to tell Ralph the truth: that he had to accommodate new ideas and not depend quite so much on his Poloroid posse, despite its penchant for pleasing him. Grossman even tried to cut the Carlson & Partners ad agency out of the equation, arguing that Polo Jeans needed a fresh approach. Her honesty caused Grossman problems, but it was just what the business

needed. "I don't get it," Ralph would say in jeans meetings, "but maybe that's good."

Grossman also refused to make a headlong dive into what is termed the "urban" market, choosing to give up short-term volume to build a long-term business, so when urban-only lines like Phat Farm, Fubu, and Puff Daddy's Sean Jean, launched by authentic urban entrepreneurs, began nibbling away at Tommy Hilfiger's volume, Polo Jeans wasn't affected. Neither was it hurt by an association with urban culture that, whether through racism or mere changing fashion, might have alienated the core Polo customer while reaching for another, potentially more fickle one.

By 1997, Polo Jeans sales had hit $198 million and were projected to reach $350 million in two years. The next spring, a public offering of Sun was announced, but was canceled when a merger with Jones was arranged instead. It wasn't an accident; the combined company was what Bidermann/Lauren could have been had Lauren been more mature and Bidermann less volatile: a huge entity with a single mandate, capable of providing capital, sourcing, distribution, and market muscle to sell huge amounts of clothing.

The fashion culture had changed, and, at last, Polo had changed with it. Collection brands had become inconsequential, except insofar as they created a perception of quality that drove sales of lower-priced, higher-volume subbrands. By keeping a promise he'd made to the *Wall Street Journal* in 1994 to court people who "can't afford Ralph Lauren," Ralph had turned his company around. The strategy filled the company's coffers, too: worldwide retail sales of Polo/Ralph Lauren goods were nearing $5 billion by 1996.

86

The break with Bidermann proved a watershed; much of the tension in the women's design studio ended along with that license. All the women's Collection henceforth had to do was break even and create the right imagery. The women's design staff stabilized around a group of long-tenured designers, supplemented by fashion editors and socialites who came and

went—leading one Buffy-watcher to joke that Birrittella's job was now sitting in her office, outlasting them all. Critics pointed to old hands like Buffy and Ralph's ad agency chief Sandy Carlson and said they were gumming up the works. "Ralph had loyalties," says a designer who left. "He kept dead wood around, so nothing ever advanced. Turnover can be a good thing."

Ralph's image needed an airing out. But like Birrittella, Carlson was an immovable object. At Mindy Grossman's urging, Lauren talked to competing agencies early in 1996. Despite his unhappiness, in the end he didn't change ad agencies. Yet he remained desperate to counter Hilfiger's carefully cultivated image as a clean-cut, happy white boy who was down with the homies. "I can't let my turn be taken by that kid across town," Ralph would say. "I'm not giving it up."

He'd started fighting back fitfully in the early nineties, but a new image had yet to gel. And it seemed unlikely that the Sandy Carlson/Bruce Weber team would find it. Weber wasn't as hungry as he'd once been, and the terms of engagement had changed. Though Ralph's financial crunch had eased, the days of last-minute airplane tickets and break-the-bank shoots were over. "Bruce's fees *were* very high," says a friend of Weber's, explaining why Ralph continued supplementing Weber with other photographers, many of them much younger and less expensive. "But Ralph's ads didn't look as powerful without Bruce. Everyone who shot for Ralph tried to imitate Bruce. But you can't imitate and come out strong." In meetings, Ralph took to leafing through stacks of photos, then sending one of his posse running to fetch an old Weber photo from his archives. "That's what we should've done," he'd say. Then Bruce would get assignments again.

Luckily, Weber could still look forward, and in summer 1994, he created a fresh iconic image for Lauren when his first ad starring a stunningly handsome male model named Tyson Beckford, dressed in a bright red Polo Sport sweatshirt, appeared in magazines. The image was startling because of Beckford's proud blackness; unlike many black models before him, his look made no compromises with white expectations, yet he was clearly a Polo man. "Tyson was *sooo* clean," coos a creative services executive.

With Tyson as its figurehead, Polo Sport became the lead vehicle driving new customers into the Polosphere. After starring in ads for the men's collection in spring 1995, Beckford signed an exclusive contract with Polo that March, which paid him $550,000 a year. Then, with the Polo Jeans launch approaching, Lauren insisted Carlson bring in an outsider as a new creative director, and she hired Neil Kraft, who'd headed Calvin Klein's in-house ad agency during the

years when Klein freshened his image by using Kate Moss and "Marky Mark" Wahlberg as models. But Carlson made Kraft's life miserable.

So did Bruce Weber, who wouldn't talk to Kraft, who'd replaced a friend of Weber's at Calvin Klein. And Weber wasn't happy about what was going on at Polo, either. Though he'd created Ralph's latest male icon, and was shooting Ralph's latest contract model, a Texas teenager named Bridget Hall, for the Lauren line, Ralph kept using others, diluting the image. Patrick Demarchelier, who'd done the first Lauren beauty campaign with Clotilde in the 1970s, returned to shoot Naomi Campbell nude except for a pair of half cowboy boots for Collection. Steven Meisel shot a Ralph campaign. Herb Ritts photographed Laeticia Casta in Polo underwear. Edgy young photographers were hired, too, but Lauren proved fearful of their work. "Ralph just kept rejecting things until you gave in," says a Carlson exec. "Then he'd default to Bruce. Bruce took the kind of straight-gay picture Ralph reacted to."

But Weber would never be totally secure again. And sometimes Polo seemed to be purposely torturing him, hiring youngsters who'd started their careers working with him. Richard Phibbs, an art director at Carlson, moonlighted as a photographer. One day, Carlson stuck some of Phibbs's photos in with Weber's and Lauren picked them out—and gave Phibbs a Polo Jeans ad to shoot. Phibbs was soon banned from Weber's sets. The same thing happened to Arnaldo Anaya-Lucca. After taking head shots for Ralph's son Andrew, an aspiring actor, Anaya-Lucca was called into a meeting where Ralph was staring at prints of the pictures. "Did you take these?" Lauren demanded. A month later, he called his protégé into a meeting and announced that Anaya-Lucca would be shooting an important new ad campaign.

John Idol, the fresh-faced, all-American, former J. P. Stevens salesman, who'd run the Home collection with Cheryl Sterling in the 1980s, was another young executive who had a rapid rise at Polo. Named the head of licensing and menswear in addition to Home in 1995, Idol quickly introduced a channel segmentation strategy, targeting narrow consumer markets and developing products and marketing plans to reach them. The deals with Jones and Sun were part of this tiered-product marketing strategy, which was financed with other people's money.

That summer, Polo announced new men's lines that would carry purple and blue labels reading Ralph Lauren, priced above the Polo, Polo Sport, and Polo Jeans lines. "Blue Label" was designed to sell in department and specialty stores. "Purple Label," a new high-end line, would be sold only in the best department

stores and Polo Shops; Purple Label suits would retail for $1,500 to $2,000. Ralph saw Purple Label as a way to grab back the quality suit business from Giorgio Armani, who'd usurped him in the eighties. Outside the Polosphere, however, Purple Label was seen as sop to Ralph as his business went down-market, and Polo logos were splashed across goods from his jeans and sport lines.

"It is a vanity business," admits Stuart Kreisler, who wears Purple Label suits.

Appropriately, then, the Purple Label models were to be Tyson Beckford— and Ralph Lauren. Lauren fell in love with a shot in which Tyson looked like "a black Cary Grant," says Anaya-Lucca; it became the young photographer's first published picture. Carlson stopped a portrait of Ralph by Anaya-Lucca from running, but within a year, Anaya-Lucca was banned from Weber's sets anyway, just like Richard Phibbs before him. "Bruce was really threatened," says Anaya-Lucca, who left Polo six months later to go out on his own. As he walked out of Ralph's office, his mentor said, "Don't forget, I discovered you."

Purple Label did badly at first. "Idol was the plumber," says a Polo executive. "He had to reposition and fix it. He spent a lot of time and money on it." Idol induced Lauren to ease up on his tight fit and expand the line into sportswear in fall 1997. The label never sold all that well, but thanks to a massive ad campaign that made it seem as if Purple Label was significant, those pricey suits, manufactured by a Savile Row tailor, brought Lauren back to his original Anglo-American image.

Ralph's renewed interest in things English was sparked by one of England's prettiest young things, Diana, Princess of Wales. In January 1995, her friend Liz Tilberis, the editor of *Harper's Bazaar*, was slated to receive a CFDA Award, with the princess as the presenter. Lauren announced he couldn't attend the ceremony; a spokeswoman told the press he had a Goldman Sachs meeting that night, but he'd actually chosen not to go out of pique; he hadn't won any awards that year. He did agree to attend a lunch for Tilberis before the CFDA show at the home of Randolph Hearst, whose Hearst Magazines published *Bazaar*. And after a pleasant encounter there with Princess Diana, Lauren changed his mind and decided to go to the CFDA show—but only if he could sit at the princess's table. When he sat down for dinner that night, though, he saw to his dismay that Calvin Klein was seated next to the princess, with Hearst on her other side. Dining with them were Hearst's glamorous wife Veronica, Liz and Andrew Tilberis, the designers Donna Karan and Isaac Mizrahi, and supermodel Kate Moss. But neither they nor the meal of smoked salmon and chicken in puff pastry made Lauren feel any better.

Polo's relationship with *Bazaar* thereafter turned prickly. Lauren was furious, for instance, in summer 1996, when *Bazaar* ran a story pegged to the launch of the Polo Sport Woman fragrance with a layout featuring a series of photos of Ralph in boxing clothes hitting a heavy bag. Though he loved the pictures, which he thought made him look like Steve McQueen, he hated the layout and let Tilberis know; she'd later say that he'd complained it made him look like a munchkin.

A month later, Princess Diana attended a gala dinner in Washington, D.C., before a sample sale benefit for the Nina Hyde Center, chaired by Lauren, Anna Wintour, and Katharine Graham of the *Washington Post*. Backstage, Ralph "gave the princess grief about not wearing a Lauren dress and rattled her right before she went onstage," says a witness. "He isn't aware how gauche he can be." Afterward, Diana refused to dance with him. Tilberis, whose soft exterior hid a core of steel, loved telling people why. "He'd only come up to my breasts," the princess told her.

Ralph's flirtation with the princess, such as it was, finally ended three months later. The occasion was that year's Costume Institute Ball at the Metropolitan Museum, celebrating the fiftieth anniversary of Christian Dior's New Look. Diana flew in on the Concorde to join Liz Tilberis at the event. Lauren had a minion demand a place at dinner beside her (even though she'd be wearing Dior). But there was no room at the head table that included Dior owner Bernard Arnault and its designer, John Galliano, flanking the princess; the First Lady of France, Bernadette Chirac; her predecessor, Claude Pompidou; Tilberis and her husband; Gianfranco Ferre, Dior's former designer; Met chief Philippe de Montebello and his wife; Mme. Arnault; and Isabelle Adjani. The choice to exclude Ralph was, by all accounts, Diana's. "The palace was very much involved in everything to do with that dinner," says a *Bazaar* editor. Lauren, the odd man out, declined to sit elsewhere.

The snub was the straw that broke Lauren's back as far as *Bazaar* was concerned. "He was very unhappy with his coverage," says a top *Bazaar* staffer. "He felt he'd been given short shrift relative to others for several seasons." So, after buying eighteen pages of ads in 1995 for almost $900,000 and twenty-four pages in 1996 for over $1,260,000, Polo Ralph Lauren spent not a penny to advertise in *Bazaar* in 1997. That was even more startling because Tilberis, whom he'd once tried to hire, was quite openly dying of ovarian cancer—undergoing chemotherapy and a bone marrow transplant—while trying desperately to keep her magazine on track. "There was definitely a mutual upset," says one of her intimates. "She interpreted it as spite on his part. She'd say, 'It's Ralph again. I don't want to talk about it.' "

It was only the latest, but perhaps the cruelest, example of Lauren's system of reward and punishment. "She hasn't supported me, so why should I support her?" he said of Tilberis. The ads finally came back into *Bazaar*, but not before she groveled for them, running a photo of Lauren along with musings on his seasonal inspiration in March 1997, a story on him in April, a quote from him in August, and a photo of his clothes on the cover of the all-important September issue, with the cover line, "Courtney Love Wears Ralph Lauren." That was about as likely as Ralph Lauren wearing Versace.

Going public: Dylan, Ricky, Ralph, Jerry and David Lauren with NYSE
President Richard Grasso (in glasses) at the New York Stock Exchange,
June 12, 1997.

Culmination:
From Privacy to the Public Market

If you are out there, you must want to be.

—RALPH LAUREN

87

n June 1996, with the stock market soaring, Richard Friedman of Goldman Sachs called Ralph Lauren. "It's time," he said. "There's not a cloud in the sky. Let's think about going public." Going public would likely ensure the company's survival and ability to generate wealth, "for generations to come," Friedman says. Lauren was intrigued and excited—but also cautious. "This was the company's destiny," Friedman says, "but as shrewd as he is, he didn't know what it would take."

A month later, Lauren shook up his executive staff, hiring Hamilton South, who'd been a party planner at *Vanity Fair*, as his vice president of worldwide communications. Though he seemed an odd fit, South would quickly become a force in the company. "Ralph wanted to take a step back," says the advertising executive. "Hamilton was the answer."

Ralph had a lot to think about. It was inevitable that Polo would go public, but he still worried the idea with every bit of the zealous indecision that had long characterized his design process. "It was not a simple decision for him," says Marvin Traub. "He agonized over it. He had great concerns, being a private individual, about the exposure he would have, but at the same time, he was convinced it was the right move to build the business." So he questioned himself and his closest advisers, vacillating over what to do. "Just remember," Peter Strom always said, "if Ralph says jump off a bridge, wait; he may change his mind."

As he struggled to decide, Ralph grew detached. Frustration rippled through the ranks as decisions were made without him, and, inevitably, he belatedly reversed them. "I hate it," he'd fume. "You're ruining my company. If I go down we all will." Hamilton South inched into the void left by Lauren's soul-searching. He seemed to bring a lot to the table. "He had Hollywood connections, great contacts, great presence, great personal style, a gift of gab," says a member of the ad team. "He was the new boy."

South became a lightning rod for discontent. "Hamilton became Ralph and alienated everyone," an executive says. "He was accessible, warm, and cordial to

Ralph and the key players, and everyone else was treated like dogs. Even Buffy was nervous. We were told how to address him, e-mail only. Certain words were not allowed at meetings. 'Give it to me in two minutes or don't start.' It was like parochial school. People who'd been there seventeen years were being told how to talk. But Ralph liked him so much he could do no wrong."

In good times, Poloroids believed they were Ralph's kids. Now they felt like stepchildren. Ralph was "infatuated with Hamilton to the point of nausea," says a creative services executive. "Everyone else either loathed him or feared him." Including Liz Tilberis, editor of *Harper's Bazaar*, who believed that South helped steer Polo's ads out of her magazine and into its rival, *Vogue*, to thank its editor Anna Wintour for helping him get his new job. "I looked at the ads and thought, she's getting her payback," says a Poloroid.

By January 1997, it was clear—to everyone but Ralph—that Polo was about to go public. "I think about going public all the time," Lauren told *DNR*, but its story concluded, "Polo, the company is too public to be private. Ralph Lauren the man is too private to be public."

Publicly, Ralph was still straddling the fence. "It was never my dream to go public," he insists. "Money was never my goal, although I certainly needed money and was a guy who appreciated quality things. But it was never my end; that was doing what I was loving and finding that it was succeeding. The more I did, the more it kept going, and that was the greatest pleasure. That, and the ability to keep trying new ideas; the stretching, the going from one thing to another—that has been my greatest claim for myself."

But having conquered America, Lauren wanted to go global. "Either I had to go public," he says, "or it was never gonna grow. It was Europe; I was gonna take over Europe." Friends urged him to quit, to cash out, instead of attempting another Napoleonic conquest. "They said, 'Ralph, are you ready to stop?' I had too much energy in me to stop. A lot of people go public to get out; that wasn't my goal. In fact, it was just the opposite."

Within the Polosphere, the IPO rumors reached a fever pitch, which was inevitable considering that Mike Newman and other executives were calling around the company asking pointed questions about minuscule matters like costs and profits per square foot, and how much was being spent on antiques. The IPO was finally announced in April 1997. The accompanying filings claimed that Polo had $1.4 billion in revenues, $117.3 million in earnings, and royalty income of $137.1 million from nineteen licenses and fourteen international ventures. The filings also revealed that Ralph was personally earning $2.7 million a year.

A town meeting was held in the Reading Room at Polo to tell employees they would have the chance to buy stock at "inside" price. "They told us it was an exciting new time," says one attendee. "How we were poised for unimaginable growth. How Ralph wanted to ensure the company's survival for his family. How it was all about getting the money needed to bring Polo into the next century. But everyone smelled the beginning of the end. It was going to be duplication, not innovation. More layoffs, more belt tightening." The very next day, Lauren showed his women's Collection to an audience augmented with lots of Wall Street types. The new *New York Times* fashion critic, Amy Spindler, judged it "solid, sellable," but "no surprise whatsoever." Rather like the IPO.

A team was formed to sell the company to investors in what's called a road show. This core group of executives included Newman; South; the latest CFO; Polo's in-house film and video producer; Lenny Lauren's daughter, Beth, who worked in the art department; and executives from Goldman Sachs. Their presentation began with an introduction from an investment banker, followed by a video and a few words from Ralph. Then Newman spoke, then the CFO, and then Ralph stepped forward again for questions. A script was written for Newman. "Ralph, unfortunately, wouldn't be scripted," says a participant. "The whole thing was only supposed to take forty minutes and everyone was afraid he would ramble."

After a rehearsal in front of the young brokers who would be selling the stock for Goldman Sachs, Lauren was visibly upset. The questions he'd been asked didn't meet with his approval. "They don't get it," he worried. The road show team then piled into a limousine and headed for a second run-through at Morgan Stanley, another underwriter of the offering. The briefing there went better. "He wondered if we shouldn't have gone with Morgan Stanley," says the participant. "They spoke his language."

Originally, the IPO was planned for Friday, June 13, but Lauren nixed that unlucky date—and it was moved up to Wednesday, June 11, 1997. Wednesday had always been Ralph's favorite day to hold fashion shows. Maybe this would bring him good luck.

That morning, Lauren was invited to ring the bell opening the New York Stock Exchange. "I didn't want to," he says. "It's just not my style. It was just too showy for me to do that, yet I did go in 'cause I was invited for breakfast, and then the head of the stock exchange called me up to his office, and he said, 'Ralph, you gotta ring this bell.' And I did do it, and when I did it, I could feel the frenzy on the floor and the people waving and applauding, and it was a wonderful feeling."

The day got better; by the end of it, Lauren was a paper billionaire.

Though it was initially planned to sell at between $22 and $25, the IPO team had created so much demand that the stock was finally priced at $26. Polo employees, Lauren friends, and some fashion journalists, too, were given the chance to buy at that price, but it actually opened at $32 1/8, and hit $33 before the day was out. Lauren held 44 million shares and retained full control of a separate class of stock that gave him near-absolute control of the company and its board. Goldman Sachs earned $51 million that day, and still kept 22.5 percent of the company, worth another $500 million. What investors didn't know was that the stock had been priced so high, there was little room for growth. The stock peaked the next day at a high that would never be seen again—and "that's been a burden ever since," says Richard Friedman of Goldman Sachs.

But for the moment, Lauren was ecstatic. "He began to embrace the notion that he is not a designer but a mogul," says an executive. Hamilton South arranged for him to sit for an interview with Diane Sawyer, but "Ralph backed out," says a marketing executive. "He thought he was above that."

Ralph also gave some the impression that he now felt himself above the people who'd gotten him where he was. An old acquaintance ran into Lauren and asked how Peter Strom was doing. "He's very rich," Ralph replied, a little scornfully. "I thought, 'Bastard! What a terribly unkind thing to say,'" reports the acquaintance, who later mentioned the comment to Strom. "I could've gotten a lot more [money]," Strom replied. Indeed, Strom had done the math; he knew exactly how much more. A Polo executive recalls a lunch at which Strom quipped, "What would I have done with $139 million?" But he wasn't embittered. "Peter behaved as a gentleman," the acquaintance says. "But when Ralph made that comment to me, it summed up his life."

Strom doesn't hold a grudge about getting comparatively little cash for his stock in Polo. When he first acquired it, he'd had to borrow the money, and in return, he agreed to sell the stock back, at a price set by a pre-arranged formula, should he ever leave. "The company always lived up to its end," says Strom, "and I always lived up to mine. I can't say it didn't dawn on me that it was a formula in the company's interest. However, I made more money than I ever dreamed I'd make. I'm living very comfortably. I would have made a lot more if I'd stayed, but I never regretted for one minute that I didn't."

"Peter is not a sour man," says an executive who worked closely with him. "He knew he'd never get the full benefit of his stock. He knew Ralph too well."

After the IPO, Ralph "became absent," says an executive. "He was buffered, isolated, secluded." He and South agreed that he should be even more unreachable and enigmatic than ever. To employees, Ralph became a figure-

head, a mascot, and a peculiar one at that. He continued to show up at work in odd getups—one day, fresh off a helicopter from Montauk, wearing a black T-shirt and sweatpants, black trekking boots, mirrored sunglasses on a cord, and a military cartridge belt, he quipped, "As I got on the helicopter, I thought I looked like a commando with one bullet left." But now his dress-up games seemed more strange than inspiring. His charisma had turned into its opposite. "Being around him embarrassed me," says a Polo Sport salesman. "He sort of gave me the creeps." Especially when he showed up at the store in hiking boots, black leggings, a big flannel shirt, belted at the waist, and a big yellow plastic watch. "Do you like it?" he asked, waving the watch. "I had to buy a Ferrari to match it."

Hamilton South was promoted in spring 1997. "He impressed Ralph with the way he handled the road show," says a fellow executive. "He was unbelievably convincing." South felt he'd been given a free hand to run Polo's marketing. "He made all the decisions," says a subordinate. "He didn't go to Ralph with a lot, and it was very easy at first."

There were small victories. A new marketing executive, Marian Schwindeman, raised Polo's cool quotient, arranging screenings of independent films sponsored by Polo Jeans and creating short films that were shown in movie theaters. Ralph innovated, too, launching RLX—a performance-driven, high-tech line with athletic authenticity equal to its style—as an adjunct to Polo Sport, but he seemed somehow marginal to the process.

"Everything at Polo trickled down from Ralph," says a creative services executive. "And he was hating everything he saw." John Idol and Neil Kraft quit their respective jobs. Morale plummeted. The way Poloroids dressed was symbolic. In the old days, they'd always worn Polo. "You started seeing Prada and Fendi and Gucci," the executive says.

One other key executive left shortly after Polo went public. "The IPO changed everything," says William Merriken, the Denver, Colorado, retailer who, along with David Hare, had been Ralph's partner in Polo Retail, which operated dozens of Polo shops. Just before the IPO, Polo had bought Hare and Merriken out for $10 million. Merriken took the money and ran. Hare moved to New York to continue running Polo Retail, only now as a division of Polo Ralph Lauren. Ralph not only planned to pay more attention to his stores, he wanted them to be a major profit center for the company.

"Ralph puts out the edict, I am now a retailer," says an executive of the division. "We're buying back [stores], rejiggering where they are, redoing what exists, we're in expansion mode." Polo might still make its money in department stores, but its own stores would set the tone—and sell Ralph's message.

In July 1997, Peter Rizzo, a respected menswear retailer, left the bankrupt Barneys New York to become the executive vice president of Polo Retail. Lauren and Hare wanted Rizzo to retool their stores to be more like the Rhinelander. But that wasn't going to be easy. Most of the Polo shops were in malls, where they competed with department stores with larger in-store Polo boutiques that carried identical goods. Polo's wildly successful outlets created further competition. And its central control structure made things difficult—if not impossible—for local store managers. "They had no idea about the core business, about merchandising, about sell-through," complains one, whose store wasn't allowed to reorder basic bestselling items.

Polo decided to raise the standards of the Polo shops and refocus them on better apparel, to differentiate them from the mass retailers. But it was an uphill battle. David Hare left two months after Rizzo arrived; like Tasha Polizzi, one day he was there, and the next, he was gone. Hare won't explain the circumstances of his departure, and most others who were at Polo Retail then profess not to know what happened to him. But Marty Staff, who'd run the stores before Hare, says that Lauren made a deal with Hare "and David became rich, but it was not a friendly transaction. David was no longer necessary."

What happened? Hare's former partner William Merriken guesses that reporting to others after being in charge his whole career proved unacceptable to Hare. "David had great instincts and was used to turning on a dime without meetings and approvals," a Polo Retail executive agrees. "It was a dense process at Polo." He adds that Hare's abrupt disappearance "was just as strange as it sounds."

Rizzo lasted less than two years. In April 1999, he quit to become the president of Bergdorf Goodman. Rizzo was frustrated, says a store manager, by the company's reluctance to do more than give lip service to quality. "The wholesale businesses weren't developed enough to make exclusive product and give us a smooth product flow," the manager says. Only Polo's flagship stores in New York, San Francisco, Los Angeles, and Chicago got full product assortments, and even then, there were quality and price issues. "Nothing ever fit," says the manager. "A gray flannel suit in women's size eight would fit differently season by season. A cashmere sweater would be nine hundred dollars, but was worth maybe five hundred. It was driven by what they thought a Ralph customer would pay, but they wouldn't give her a $900 sweater. We got constant complaints."

The manager finally quit. Just in time, it turned out. The Polosphere was about to contract again. The euphoria of the public offering lasted until the end of 1997. "Everyone was so psyched," says a Poloroid. "We all bought tons of stock, but we couldn't sell for six months, and all of a sudden, the numbers

weren't there." That December, the stock price sank below $22. "Tommy Hilfiger was going up, Estée Lauder was going up, Gucci and Prada could do no wrong, and we were wondering if Ralph would go the way of Donna Karan," whose stock sank following her IPO, as investors learned of the designer's inability to stick to budgets and the way her deal was structured so that she got rich even as investors lost money.

Companies like Karan's and Lauren's were at the center of an intense debate in business circles. Were they luxury brands like Gucci, mere apparel companies, or, as in Lauren's case, hybrids? Luxury brands are more highly valued by investors because of their high recognition factor, their aspirational images, and their perceived (if arguable) ability to withstand economic downturns. Polo wanted to be a luxury brand, but the market saw it as an apparel company. And indeed, that's how much of its money was made—in low-end goods and outlet malls. "You couldn't send investors packets of Kool-Aid," a Poloroid jokes. "They didn't care that we used real mahogany."

Things got worse the next fall, when the stock bobbed below $20—and got stuck there. "Ralph was very unhappy, and the nervous tension spread through the company," says that Poloroid. Lauren was out of his league. No longer was he fawned over by the only press that mattered to him: it was the financial press that mattered now, and he couldn't buy its favor with advertising. Neither did he know how to handle analysts or change perceptions of his stock. He was expert at distilling clothes to a story. This was unknown territory. "They were unprepared and amateurish," says a marketing executive. Employees fretted.

"It was growing and dying at the same time," an executive says.

88

Most people are humbled when they visit the White House. Not Ralph Lauren. In September 1994, he was expected there as co-host of a fund-raising event for an effort he'd championed called Fashion Targets Breast Cancer. But on the Saturday before the Monday event, he declared he wasn't going, telling his staff that he and Ricky had decided First Lady Hillary Clinton was going to hog all the credit.

Finally, his staff talked him into it, and once he got to Washington, his mood brightened. That afternoon, just before he and Hillary received his CFDA colleagues in the Blue Room, Ralph wandered out on the Truman Balcony and declared, as much to himself as to the Polo executives who were with him, "I could be president." The advertising department promptly made up "Ralph for President" buttons. And the next month, his election was confirmed with cookies baked especially for his fifty-fifth birthday bearing his photo and the caption, *President Lauren*.

It was the start of a mutually rewarding relationship. At Mrs. Clinton's invitation, Polo creative services decorated the White House for Christmas, 1997, and in July 1998, Lauren won priceless publicity by kick-starting Mrs. Clinton's Save America's Treasures campaign with a $13 million donation toward a marketing program and the stabilization and cleaning of the 185-year-old Star-Spangled Banner that is displayed in the Smithsonian's National Museum of American History. At a ceremony, Mrs. Clinton praised Polo as the quintessence of American style, and the president said both he and his wife owned Polo American flag sweaters. What they didn't know was that Lauren's beneficence was in large part driven by competitiveness toward a rival who waved the flag as furiously as he did. "We're going to get the flag back from Hilfiger," Ralph told his staff. "He was furious that Tommy had appropriated the flag," says a Polo executive.

That December, Polo stock sold for $15.88 and Ralph (who'd lost half his paper fortune) and his executives had to tighten their belts again. Among others, Marian Schwindeman, the marketing woman who'd helped raise Polo's cool factor, was fired. Her supporters felt she'd failed to play the Polo game by giving Ralph credit for her ideas. "She was too successful, and she got attention," says one. "If something wasn't Ralph's idea, he'd get way scary."

Hamilton South had just been made Polo's president for marketing, earning $1 million a year in salary and bonus, overseeing marketing, advertising, communications, investor relations, and a $100 million budget. But if, as some say, South was manipulating the situation, then he'd wisely decided to let Polo's perennials keep their privileged positions. Simultaneously, Buffy Birrittella took back control in women's design, while on the men's side, Jerry Lauren, supposedly about to retire, stayed instead—and solidified his position when John Varvatos, the brilliant young designer who appeared to be his logical successor, quit to start his own line.

On the business side, the former Chicago tie salesman Lance Isham was named corporate president and set up a task force to study the company and

eliminate waste and duplication. "We started having to watch money," says designer Nick Gamarello. Then Jerry Lauren summoned Gamarello and started stuttering. "Are you trying to fire me?" Gamarello asked. He was sent to the human resources department, he says, and given hours to vacate the Polosphere. "Jerry said, 'Don't talk to Ralph.' " But as he was packing up, Lauren called him and said, "Get up here." Gamarello was shocked, not sad. "I loved Ralph, I respected him, I saw his faults but chose to admire him. We were always candid. I told him turtlenecks made him look like a squirrel."

"I feel sick about this, I'm sorry," Lauren said, but the task force had decided Nick was a sporadic worker and very extravagant. Gamarello laughed; he hadn't had a raise in five years. Today, he is design director for Stetson, helping turn the 137-year-old hat maker into a Laurenesque lifestyle brand selling clothing, furniture, and those famous Stetson hats.

Polo had "hit some speed bumps" early in 1999, in the words of Goldman Sachs director Richard Friedman. In what Lauren would later describe as the worst moment of his career, the company shocked Wall Street when it announced it would miss its quarterly earnings estimates. The problems were par for the Polo course: inventories were bloated and late deliveries were causing markdowns. But the consequences for a public company were new: Polo had to take a $65 million pretax charge against earnings. Mike Newman refused to comment except to say he was trying to lower costs and increase efficiency.

"They are committed to making cost control a way of life at Polo," a Goldman Sachs analyst said, attempting to soothe worried investors. Inside Polo, many blamed Hamilton South. "He buried Marian Schwindeman, he went after Buffy and failed, he went after Mike Newman," says another executive. Apparently, Lauren didn't mind. "Hamilton was like Ralph's boyfriend, but he wasn't," the executive continues. "They were flirty, affectionate. There was this weird thing going on."

In February 1999, 250 people, representing 5 percent of Polo's work force, were laid off; nine stores were closed; and the company was restructured— again—this time by price point instead of gender. Polo's growth was anemic in a bull market, and, to make matters worse, Tommy Hilfiger was projecting a 58 percent rise in earnings and its stock had doubled in value to $70. "I've been a big hero in this industry and I like being a hero," Ralph told *Time*. "When the stock goes down, I take it personally. People are asking, Where's Polo going? Are they out of steam?" *Time* said Wall Street thought of Polo as "a dandy living beyond its means" by opening ego-trip megastores unlikely ever to turn a profit.

"I was 6 foot 6 inches when this started," Ralph quipped.

Faced with nervous shareholders and employees and a skeptical investment

community, Polo went on a spending spree, seeking to beef up its earnings. In March 1999, it bought Club Monaco for $81.5 million (plus $29 million in assumed debt). Founded in Canada in 1981, Club Monaco was known for well-priced clothes that aped the styles of cutting edge labels like Prada. With its vertically integrated design-to-retail structure, it seemed a good fit for Polo, which promised Club Monaco's founder Joseph Mimran, who made $15 million from the deal, that it would invest heavily and expand the brand while continuing to let him run it. Polo's stock dropped, and the market was right. Fifteen months of bad results followed.

Then Polo bought its European licensee, Poloco, for $200 million, adding $200 million in annual revenues to Polo's bottom line. Mike Newman, who arranged both deals, compared Poloco's potential to that of the women's business, which had grown by a factor of seven in four years. But nothing helped. In November, more layoffs were rumored, and the first to go was Newman. "Ralph's confidence in Mike's ability to take the company to the next level was clearly in question," says Rich Friedman, who adds that while Newman's financial skills were right in the mid-nineties, marketing and merchandising had become Polo's new concerns.

"The stock was down, the expenses were difficult to control, someone had to be blamed, and it's not going to be Ralph," says a CEO friend of Newman. Ralph was blaming the man behind both acquisitions: Mike Newman. "You have to question the purchase," says a Club Monaco insider. "What was their motivation? For Ralph to step out of his own brand was a huge, huge step, and not a comfortable step. I don't think he wanted it to succeed. He's so brand-centric, so egocentric. To have to buy the cool factor must have caused him lots of grief."

Lance Isham took over for Newman. "Ralph will stick by a person," says a Polo executive, "and CEOs have bad years. But it was about more than numbers. Ralph wanted a merchant and strategist, and Lance was one of the best merchants in the company. He had a vision of how to build the company."

Hamilton South was the next to go. "People went to Ralph and started telling him they wanted to quit," says a creative services executive. "He started listening. Why were all his people succeeding—at other companies?" A South pal says Ralph's ego got involved. "Hamilton got his picture in the paper, and Ralph began watching and second-guessing him," she says. "Then Ralph started polling, asking about Hamilton." In early 2000, South's Polo career went south. The press, as usual, was told he resigned. "Ralph lost confidence," says Rich Friedman. "He needed a change."

89

R alph had long wanted to branch out into media, and had even flirted with publishing a magazine of his own. Now, he'd updated that desire: though he was quite late to the Internet party, he wanted his own dot.com, and in February 2000, after talking with many companies that rejected the notion as a conflict with his existing business, Ralph Lauren Media was formed, a 50–50 partnership between Polo and the NBC television network. "The next generation is here," Ralph crowed.

He had reason to celebrate. Though it was NBC that brought Internet credibility to the table through its MSNBC and CNBC units, Polo got the best part of the thirty-year deal. It required NBC to contribute $200 million in cash, free television and website ads, and online distribution for which NBC would get the bulk of any revenues. All Polo had to do was provide goods for online sale at cost, dispose of excess merchandise through its outlets, and take no money out until revenues exceeded $75 million. It would then get 10 percent. Lauren said he expected his new polo.com brand eventually to produce books, television shows, and movies. His younger son, David Lauren, and a former magazine publisher were named to head the new venture. Polo's stock rose from $14\frac{1}{2}$ to $16\frac{1}{4}$ on the news.

The blue pinstripe suit Lauren wore the next day as he walked down the runway after his latest fashion show showed that though he was going into new media, he knew the constituency to which he was playing—old-line Wall Street. Indeed, his cadres all looked like bankers that morning as they hustled editors, retailers, and financiers into seats. One month later, the NASDAQ stock market crashed—and the dot.com era died. A polo.com IPO suddenly seemed a long way off.

That's when Roger Farah appeared, a white knight come to the rescue. Peter Strom had first approached him to join Polo six years earlier. Farah proved worth the wait. The son of a Lebanese immigrant who'd sold bathrobes, he was a Wharton graduate who'd spent thirteen years at Saks Fifth Avenue, rising from

pajamas and underwear sales to become a merchandise manager. Three jobs later, he was named president of Macy's. Most recently, he'd presided over the painful restructuring of Venator Group, shutting down the legendary Woolworth chain, closing or selling thirty-five divisions, and letting go thousands of workers.

Despite his hatchet-man reputation, Farah was greeted as a messiah at Polo. "The first businessman since Strom," says an executive. "A merchant, a marketer, a brand-builder," gushes another. "Ralph needed what Roger had." Farah did seem to be a strong candidate to lead a company that needed a firm hand and Wall Street credibility. With the loyal, understated wholesale expert Lance Isham at his side as vice chairman, they were to be Polo's dream team.

Farah's presidency got off to a rocky start, though. That spring, he had to announce that Polo would once again miss its earnings estimates. Though it was still making huge profits, and sales of its high-end lines were up 30 percent, Polo's share price had fallen 39 percent in a year. Stock options granted to top executives were all worthless. Farah promised to cut overhead, stopped handing out late-model cars to executives, cut back on first class air travel and entertaining budgets, instituted bonuses based on performance, and changed warehouse procedures to speed turnaround and earn cash quicker. Analysts were dubious, even after Lauren and Isham both announced they were voluntarily giving up their bonuses, dropping the former's compensation 41 percent to $4.1 million and the latter's 59 percent to $1.4 million. The fired Newman, on the other hand, had made $2.6 million that year and would continue to receive payments of $75,305 every two weeks through the end of 2002.*

All of that was on Lauren's mind when he spoke to a journalist that month about his regrets over going public. "I have made mistakes before," he said. "I still don't know if I made a mistake or not." Then, stuttering, backtracking, and thinking aloud, he said that, despite it all, he still felt "my business is amazing. I have a media company, I have more buzz today going on, and if you walk into the stores, and ask about the RL business . . ." The sentence drifted off.

Lauren blamed the media for writing about his stock price woes instead of Polo's profitability. "You can't jack the stock up," he complained, even though, "I've had my biggest year, my hottest year." He said he was running a marathon when Wall Street wanted him to sprint and was furious that reviewers of his latest collection, who'd accused him of designing for investors not fashion editors, wouldn't acknowledge how well his goods were selling. Lauren wanted good sales *and* good reviews *and* a good stock price. One out of three certainly wouldn't do.

* Other recently fired executives declined to discuss their severance agreements, explaining that they had signed confidentiality agreements.

"So basically, I think that's the, to me, it's that kind of, the public puts you in an, it takes you away from the privacy and the world of where you are, which is very comfortable for me 'cause I like operating on my own, and planning my own world, and taking, stepping back and going for the long haul," he said. "I don't have to be today's hero, but I always reach out and I've always been first. I don't mind taking the chances but I take the chances because I know it's right for my company."

That quarter, Polo's performance exceeded estimates. Farah had managed to raise margins and revenues while lowering inventories. Which made the continuing problems at Club Monaco harder to bear. "You may be happy, but I'm not happy," Lauren told his annual shareholders meeting in August 2000. Though he looked great in a pearl gray suit and ice blue tie, he also seemed tired beneath his tan, with deep circles under his eyes. He'd greeted the crowd cheerfully. "My name is Ralph Lauren and I'm the chairman of the board," he said. Waving a mike like that other chairman of the board, Frank Sinatra, he quipped, "I always wanted to be that—and I don't sing."

But he quickly turned serious. "I hope you're gonna be happy," he said. "I'm not. I'm the largest shareholder in this company and I have stayed that way because I believe in this company, in myself, in our products. Polo stands for something; it's not fly-by-night; it's not the fashion of the moment." Yet a different company, one that did sell the moment's fashions, Club Monaco, was clearly on his mind. "Creating fashion at a price for young people is a growth area for the company," he said. "I feel that growth is just at the beginning. We've made some of the groundwork that will develop into big things to come."

As it happens, though, auditors had just concluded a look at Club Monaco's books. The very next day, Roger Farah flew to Toronto, summoned Club Monaco founder Joseph Mimran to his hotel room, and fired him. Mimran was not allowed to return to his office. Instead, an hour later, Farah told Club Monaco's employees that Polo had poured $40 million into their company and seen no return on its investment.

"Once somebody buys a company, it's their sandbox, it's their prerogative," Mimran says in a brief conversation. "I'm a big boy." Indeed, Mimran still admires Lauren. "Ralph's got a relentless creative drive, and he's ruthless," says a Club Monaco executive who is close to Mimran. "It's a rare combination." Roger Farah was another story. "He hired a guy who could do graphs," the executive says, "and it all changed. Farah said if he'd been there, he never would have bought it. But Joe never would have sold it to him—he doesn't get it. When you take a smallish company, you have to nurture it. They never let things play out."

That fall, Polo announced the closing of twenty-three Club Monaco and Polo Jeans stores, and a major change of direction, refocusing on the luxury market. That day, the stock went up almost 18 percent. Mindy Grossman soon quit Polo Jeans and went to work for Nike. And by May, a new strategy was in place at Club Monaco, redirecting it away from fashion's edge. Fashion at a price for the young had proved to be less a growth area than Lauren hoped.

A month later, polo.com went live on the World Wide Web and, despite a massive ad campaign, generated almost no buzz; a new head of Club Monaco was hired away from the quintessential moderate fashion chain, the Gap, and Polo revealed that its quarterly profits had declined for the second quarter in a row. Its plans to expand aggressively in Europe, opening new stores and introducing its Jones-made children's and Chaps brands there didn't seem to give Wall Street much comfort.

"I hate being evaluated by the minute," Ralph told W that month. "It's so contrary to the way I've worked. I've been a hero my whole career. Now you're judged by Wall Street. Talk about trendy. Wall Street is the trendiest business around."

90

On a crisp afternoon in October 2000, Ricky Lauren tossed a sixtieth birthday party for her husband on the grounds of their Bedford estate. Wearing a purple crewneck sweater, a pair of beat-up jeans with holes in them and Frye-style boots, Lauren showed up late, looked unhappy, and never smiled, not even when Ricky presented him with a chestnut bay and a saddle. He dutifully rode around the yard and danced with Ricky afterward, "but he didn't seem pleased," says an attendee. "It was like he was watching his own party."

The highlight of the day was a taped tribute from celebrities and friends who couldn't attend, including Hillary Clinton, who apologized for her absence, and Woody Allen, who'd also built a career on insecurity and shiksa lust. "Ralph always thought he could be an actor," Allen said on tape. "We had lunch one day and he said, 'Put me in a picture.' I said, 'Who do you see yourself as?' He

said, 'Steve McQueen, Gary Cooper.' I said, 'Ralph, you're a short little Jew.' He said, 'Not when I'm dressed.' "

The party took place in a tent furnished by Ralph Lauren Home. "It looked like the store on Madison," says the guest. "I kept thinking, all afternoon long, I was in an advertising shot." Indeed, as 2001 dawned, the whole world seemed to be turning into a Polo ad. Ralph's logo was everywhere, and so was his influence—reflected in collections by the world's hottest young fashion designers, some of whom hadn't even been born when Lauren made his first tie: Nicolas Ghesquiere, Veronique Branquinho, and wonder boy of the moment Miguel Adrover, who showed a T-shirt with an oversize Polo logo. "What Ralph Lauren stands for to [Adrover] is someone who did something that has a soul," Lauren said, explaining the phenomenon to a reporter. He'd taken to referring to himself in the third person a lot. It's hard to be a man *and* a brand.

Ralph had little reason to be glum. Finally, the Roger Farah effect was taking hold. Polo's business was turning around. Quarterly earnings steadily improved, and the stock inched back to its IPO price before Lauren showed his horsy fall-winter Collection, a smash hit. Sales of the women's Collection and Purple Label clothes for men had risen more than 75 percent in a year. The rest of the business was improving, too. In the early nineties, Lauren's children's lines were doing $50 million in business a year, but Tommy Hilfiger's kids' clothes were doing better. By changing licensees, Polo doubled that business.

Lauren's relationship with L'Oreal, the French cosmetics giant that had owned his fragrance business since the early 1980s, had also hit a bump in the road, with L'Oreal content to build on the Polo Sport subbrand through the mid-nineties, and let older, lingering scents like Lauren and Safari hold his place in the upper end of the market. "L'Oreal felt he'd had his day and the business was not going to grow," says a Polo executive. "Every designer goes through this." Finally, in 1998, Polo introduced a new scent, Romance, followed a year later by Romance for Men, Ralph for young women in 2001, and then, that same year, Glamorous, reestablishing him as a top-ranked perfume player. And in July 2001, Polo bought PRL Fashions, which owned Lauren women's wear in Europe, for $22 million, completing its takeover of its European business.

Lauren's spring 2002 collection was supposed to be shown on September 12, 2001, the day after terrorists attacked New York and Washington. Instead, Lauren showed a small collection at 550 Seventh Avenue eleven days later. "I've always been inspired by American heroes, cowboys and Indians and soldiers, people who've had adversity in their lives, and now I've added firemen and policemen," he told the crowd before the show. "He comes from nowhere and

somehow he makes it big. Things happen, he falls. But it's the guy that comes back that is very exciting.

"Everything I've done has been about emotion, feeling," he continued. "When I was growing up, I didn't have a lot. I had magazines, books, movies, and stores. Through stores, I was inspired. I thought, I want it. I said, 'Can I have it?' Our job is to not give up that inspiration, not give up that hope. If we give up and say we can't do business, we're wrong. It's your job and my job to inspire the world." Presumably by selling lots of white lace and creamy deerskin.

It was Lauren's best collection in years, a return to his prairie princess heyday. All white and tan, full of that delicate lace, leather, and chamois, it evoked hopeful images of a mythical frontier, and seemed to have been designed for a moment when the American spirit needed a quick pick-me-up. Yet his attempts to relate his products (not to mention his own Wall Street-battered persona) to the public mood struck observers as off-key, if not crass. Two weeks later, Lauren repeated his speech in a full-page ad in major newspapers, adding a promise to donate 10 percent of any purchase made that month in a Ralph Lauren store to something he called the American Heroes Fund—which he'd seeded with a $4 million contribution. The *New York Times* ran the ad, but described it as "unabashedly gooey."

Others were less charitable. "The WASP that Lauren uses to symbolize his brand would spearhead a charity effort like this in silence," wrote Russ Smith in the *New York Press*. "The whole idea is as smelly as Lauren's smarmy grin in the advertisement. . . . It's unseemly but then Lauren's entire career has never attained the 'class' he so grossly tries to convey."

Like most clothing makers, Polo lowered its earning forecasts. But as the effects of the attacks wore off, and spending on patriotic items increased, Lauren's business seemed to benefit. Polo's stock price began a slow, steady rise until, in spring 2002, it was bobbing just below its all-time highs. "Net-net, we're pleased," Farah said, just before Lauren showed an all-black, Edwardian-inspired fall Collection.

Attempting to redefine Polo's niche, Farah claimed that luxury items accounted for about one-third of the company's sales. But he defined luxury loosely, including gift items like silver frames and hurricane lamps that cost as little as $125. And he couldn't have been pleased a few days later when two minority employees—one black, one Filipino—filed discrimination suits against Polo and revealed in their filings that the United States Equal Employment Opportunity Commission had determined that minority employees of Polo were the victims of a bias toward a blonde-haired, blue-eyed image.

The EEOC said that a review of the company's procedures, which the *Wall Street Journal* discovered had been ongoing for several years, showed that Polo had no consistent policy for racial equality in employment practices, no regular postings of job openings, no specific application process for promotions and raises, and that white employees were paid more and got more frequent raises and promotions than nonwhite employees. It added that African Americans stayed in their positions longer, and got smaller merit pay increases, that white employees with less experience and less education got substantially higher merit increases and bigger promotions than similarly situated nonwhites, and that those discrepancies could not be explained by seniority, experience, education, performance, or merit. Denying the allegations, a Polo spokesperson claimed the company was committed to "a fair and diverse workplace." The EEOC did not sue the company, but no one in the fashion world was surprised by the revelation. Tyson Beckford notwithstanding, Ralph Lauren was still all about blonde hair and blue eyes.*

A few days after that, Ralph appeared on the cover of *Forbes*, fronting a story asking why Polo got no respect from Wall Street, even though Lance Isham, the company's number two executive, had just moved to London, where he promised to triple European revenues to $1 billion in five years. Farah's successes weren't helping either, even though he, *Forbes* said, was now running the show—not Ralph. The fashion world agreed. "Roger is completely in control," says a well-traveled garment executive. "He has credibility, he's tall, he plays golf, he walks the walk and talks the talk." It was even said that Farah had fired Lauren's long-time in-house lawyer, Victor Cohen, after Cohen went over his head to Lauren.

The *Forbes* story preceded Goldman Sachs's announcement that it would sell half its remaining Polo shares in a secondary offering in spring 2002. With the stock near its peak, the GS Capital Partners Fund, at its tenth birthday, walked away with a 600 percent profit on shares it had paid $5.20 for eight years earlier. Yet despite its windfall—and a report that soon followed of record profits in the fourth quarter of 2001—the stock price soon fell again, and even

* In August 2002, the *Wall Street Journal* would run a page-one story about racial tensions at Polo. Reporter Teri Agins revealed how a Rhinelander Mansion manager, Electra Preston, who is descended from both the founder of the Pulitzer Prizes and a head of the J.P. Morgan Bank, caused an incident in the store when she allegedly made an insensitive remark, how a manager at a Polo Sport store banished sales assistants who were black and Hispanic to the stockroom during a visit by Ralph, and how Polo and Ralph himself have struggled uneasily to come to terms with doing business as a bastion of WASPdom in a multicultural world. Lauren told Agins he didn't understand why blacks and Hispanics in his company tended to stick together, or even how his image could be perceived as unwelcoming to them.

Goldman Sachs admitted Polo had not paid off as well as it should have. "The company has real-world problems," Richard Friedman admits. "Nothing wrong with that." Though Lauren "agonizes to this day":

Why, oh why, did I go public? Ralph asks himself. "He torments himself more than is justified," Friedman says. "He's such a perfectionist, he sometimes doesn't let himself think of the big picture. He's raised the value of his company by three or four times, enhanced his personal wealth by the same magnitude. He's not a typical entrepreneur, but he's one of the most successful ever. It's a sign of greatness to always challenge yourself and not accept success. Because he torments himself, the company will perform better."

But what is Polo? That spring, as the company's attention shifted to Europe, it was redoubling its effort to be seen as a purveyor of luxury. "Ralph sent Lance there to re-position [Polo]," says a former executive. "He's not unsuccessful in Europe, but he's not perceived as fabulous and he wants to be." In his heart, Lauren wants to be like Hermès, the renowned French leather goods company. "It has heritage, quality, and positioning," the executive says—and also a mass-market foothold with its scarves and perfumes. The problem is, no brand has ever managed to maintain the delicate balance between luxury positioning and a $5 billion volume. Hermès sells about one fifth that amount.

Lauren has juggled perception and reality better than most. As when he opened the doors of his new 1940 Rationalist palazzo showroom in Milan, Italy, for a Purple Label men's fashion show in January 2002. "I still feel American, but I also feel international," he said. The disdain he'd expressed early in his career for European tailoring was forgotten. He needed European customers now; they still wore suits. His high-end clothing had stalled again in America. "He has no full-price men's business," scoffs the CEO of one of Polo's prestigious American accounts. "All he sells at full price are chinos and T-shirts, department store sportswear. Purple Label is only sold in a couple of stores." And according to the retailer, Polo pays to build the Purple Label shops, owns the inventory, pays for markdowns, and takes back goods that don't sell at the end of the season. Purple Label, in other words, is a lot of purple smoke and mirrors. And Polo looked at Europe as a House of Mirrors like the Rhinelander. Even if they lost money there, they would stress Ralph's most luxurious products, pushing only his top- and middle-level brands, leaving Chaps and Lauren out of the mix. Polo was now speaking to Wall Street as much as to London's New Bond Street, where he'd recently opened a palatial new store, all part of its effort to reposition itself as a pure luxury brand, all those outlets and cheap khakis notwithstanding.

The fact is that luxury products now represent an infinitesimal portion of Polo's business. "He'll flip-flop," says a former Polo executive. "He'll say he doesn't care if the beautiful things sell and then act as if that's the basis of his success. He lets his design people believe that, but it's not true. He'll berate them. 'Don't sell me out, don't compromise me.' But then he comes up with strategies to bastardize the product."

91

R alph's double mindedness is behind the remarkable persistence of Double RL, the jeans line that will not die. Beginning in the late nineties, Lauren pressed to revive it, even though his licensees at Sun and Jones had finally given him denim success. The problem was, he hadn't created Polo Jeans himself—it had its own design staff, which was behind the success of the line. And not only that, it wasn't the line he'd imagined for twenty years. Ralph Lauren–designed jeans had always been expensive and difficult to wear and had always failed. But he kept trying. He demanded a plan to revive the Double RL brand through the Polo Jeans Co. "Ralph's gotta have it," says one of his retail executives. "He's got such a tack in his ass! There's a level of resentment that he still can't control it all himself."

Lauren hoped to relaunch Double RL as a special capsule collection made by Polo Jeans and sold in its stores. But the officers who ran the license—and worked for Jones Apparel, not Ralph—looked at the product and had one word to say: "Markdown." What Lauren wanted couldn't be made at rational prices. "He's disconnected," says the retail executive. "He thinks his customer has a Bentley and two poodles. You'd see it when you walked him through a mall. He'd be amazed at who he'd see." He has no idea who wears his clothes, and he's probably better off that way.

Some Double RL items finally ended up on offer, in cheaper versions, as Polo Jeans stores began opening at the end of 1997. Lauren even bought a building just for jeans in New York's SoHo in 1998, but never used it for anything but fashion shows. A few more jeans stores opened through 1999, but in March 2000, with a total of thirteen stores operating, the head of the division left, and Polo closed all but one.

"What happened was, Ralph walked in, saw product he didn't love, didn't design, didn't own," says the Polo retail executive, "and the customer base was not one he really understood. It's an urban kid, fifteen to nineteen years old." Lauren wanted the Abercrombie & Fitch customer; that venerable old retailer's new line for college-age kids, advertised with sexy Bruce Weber photos, had become the Chaps of its generation.

Finally, Ralph was allowed a small victory. Late in 2000, he opened what was in essence a vanity store—a small shop on a side street in New York's SoHo shopping mecca selling Double RL clothes, vintage clothing, antiques, and photographs of icons of cool like Miles Davis, Steve McQueen, and Bob Dylan. Double RL denim jeans made on pre–World War II looms sell for $185. Vintage jeans can run into the thousands—and some of the salespeople in the store, who collect rare jeans themselves, will tell you why. They have the time. The store is often empty.

Some of Ralph's old friends think his life is empty, too. "Everything is a façade," says childhood pal Warren Helstein. "There is no Ralph. He's created an illusion. My friend, the real Ralph, was the guy that wanted to be somebody. Down deep, he's still the kid I knew, striving. He created an illusion. Then he went for the illusion. There's no there there. He's just an image with nothing behind it. He spent his whole life becoming somebody only to lose who he is."

New acquaintances agree. "I always wanted to give him a hug," an executive of the late nineties says. "Yes, he protected and maintained an incredible brand illusion, but he couldn't trust anybody, not Jerry, not Buffy. It must be awful to be like that."

George Friedman remained close to Ralph after L'Oreal bought Warner/Lauren—and admires his friend's accomplishment. "He has a very clear vision of what Polo Ralph Lauren stands for," says Friedman. "He understood how to institutionalize himself and create an entity out of his vision. He understood he stood for something. Polo connotes a quality lifestyle. The world has changed, but New England WASP is still the dominant aspiration in our culture, and, through the clarity of his vision, Ralph has come to epitomize the aspiration to old money. Others have tried. Only he has pulled it off. He's clearly positioned himself in people's minds, and the image is so powerful and continuous it supports everything underneath it."

You'd think he'd be happy, but Friedman isn't sure. "I don't know," he says. "From his point of view, happiness is achieving." Where does achieving end? Friedman smiles. "It's not easy being an icon."

Lauren works hard at it. He's even cultivated a comfy public persona, one-

third salesman, one-third stand-up comic, one-third suave lounge singer, which is sometimes off-key but impressive. "People who meet him think he's charming, soft, benign, self-effacing, and funny in a gentle way," says a former executive. "And he *is* wonderful when he's in a good mood, but he's not in a good mood very often. He's frustrated about growing older, about losing his looks."

So Lauren exercises every morning with his personal trainer, runs in Central Park, and generally arrives at his office around eleven A.M.; his driver, Carrington, gives his personal staff the heads up when Ralph is on his way in. After reading his press clippings, Lauren goes to meetings. Twice a week, his day ends with his advertising staff, making sure every blade of grass in his movie is properly mowed, the right shade of green, and playing on the right screens in the right towns—the gatefold of the *New York Times Magazine*, where he is the largest advertiser, the opening pages of *Vanity Fair*. When he doesn't go home for dinner, Ralph can often be found at Vico or Sette Mezzo, Italian restaurants he likes so much that he partnered with their owners in RL Chicago, an Italian restaurant that opened in his store there in March 1999. It's the only place in the world where regular folks can eat those fabulous Double RL steaks that he's always said he wants to market in another attempt to raise American taste.

Next moves still matter to Ralph. He and Jack Schultz, the Bloomingdale's executive, once sat in his office discussing his exit strategy. "He was wondering where it would all go," says Schultz. "How does he walk away? They have a hundred designers, but he approves every stitch. How will it run without him? He had no idea it could."

For now, Ralph has his health and seems unlikely to hang up his gloves. "But he has to be thinking, who can take over?" says a former executive. "They have to start grooming someone."

Ralph likes to think of Polo as a family, but in 2002, it seems unlikely that his family will do much more than profit from the persistence of the Lauren line. Lenny Lauren has an office and telephone extension at Polo, but little to do with the company. In 1995, when his daughter was married, he was described in a wedding announcement as an executive in business development and special projects there. A source inside the company says that stretched the truth: he's paid about $100,000 a year but "does nothing for Polo." Ralph once told an executive, "He's my brother, I've got to take care of him."

At age sixty-eight, Jerry Lauren continues at the helm of men's design and can still be found prowling Prada stores on weekends, but is dismissed by Poloroids past and present as dependent on, and a tool of, his younger brother. Ralph "was the engine," says Gil Truedsson. "Jerry sublimated his ego," says

Clifford Grodd. "He was a tremendously strong support and a great sounding board. He was very generous in nourishing his younger brother's ambitions." But he's seen as Ralph's whipping boy, repaid for his dedication with abuse, says the creative services executive. "Jerry's been beaten, humiliated in front of his design team. It's embarrassing. Ralph says, 'You're an idiot, this is crap, you don't know me, you're ruining me.' Jerry designs it all, and he is scared to death of Ralph."

He is also "totally envious," according to a Poloroid.

"You pay a price," says a friend of the family. "It gnaws at you."

"He acts as if it's his own company," says a longtime observer of the two. "But no matter how he looks at it, he is not Ralph Lauren."

Ralph's children seem loyal to him, too. They are always in the front row of his fashion shows. And David Lauren works for Polo. But friends say the children's relations with their father are complex. All of them are said to be "resentful that he's not been the best husband," says someone who knows the boys well. Others say that when they were growing up, Ralph called his kids funny-looking, competed with them, and put them down.

The oldest, Andrew Lauren, is both the farthest from and the closest to their father. He has lived out two of Ralph's dreams. With his eyes like dark pools and an attractive, sullen pout, Andrew has won jobs as an actor in several movies, including *Conspiracy Theory*. And he recently produced *G*, a movie about rap moguls in the Hamptons. But the soft-spoken, modest Andrew has had problems with his father.

Though he went to an elite New York prep school, Andrew's grades weren't spectacular, and he ended up at Buffy Birrittella's alma mater, Skidmore. He was quite successful there, even getting elected to class office, but then Andrew transferred to Brown University—at his parents' insistence. They thought Skidmore was déclassé. "Andrew didn't want to leave Skidmore," says a friend of the family. Years later he would tell intimates that he wished he'd never transferred.

But he wasn't totally under his father's thumb. One summer, as a *New York* magazine intern, he helped compile a list of who lived where in the Hamptons—just the sort of thing his father would hate. Rather than a candidate to run Polo, the understated Andrew is "an average guy with a good heart, class and integrity," says an admirer.

The youngest child, daughter Dylan, a brunette version of her mother, graduated from Duke and ran an event-planning business before opening in 2002 Dylan's Candy Bar, a lavish, fifty-five-hundred-square-foot emporium selling five thousand kinds of candy, right across the street from Bloomingdale's, proving she

is at least as much a perpetual child as her father and quite possibly the real inheritor of his genius. She also spends like him. Her business partner calls the place "the most expensive candy store in the world." If he landed there, the candy man who sold the young Ralph Lifshitz sweets in the Salanter Yeshiva school yard would surely know he wasn't in the Bronx anymore.

David Lauren, though short like everyone in his family, is square-jawed, long-haired, and model handsome. He's also bold, says a Polo executive. "He's an Alpha, he's authoritative, he throws the Lauren thing around." Ralph knew he'd made a mistake forcing Andrew to switch to Brown, so he let David go to the school of his choice: Duke. Dylan followed him there. Unlike Skidmore, Duke at least looks like an Ivy League school.

In 1990, during his sophomore year, David created a magazine called *Swing* with the help of a grant from the school and, over the years, put out seven issues. He said he wanted to run inspiring stories about people in their twenties, and promote traditionalism, quality, and intelligence instead of trendy, negative anger. With a little help from his father's name, *Swing* scored interviews with David Geffen, Paul McCartney, and Dustin Hoffman before David graduated. That same year, Martha Stewart put out the first issue of *Martha Stewart Living*, a lifestyle magazine, backed by Time Inc. Stewart would subsequently create a Polo-like product empire—and Lauren was keeping his eye on her.

Ralph began working on a secret plan, dubbed the Pony Project, to launch a magazine called *Lauren* with Hearst, the publisher of *Harper's Bazaar*. Ralph thought of it as a brand extension and a way to target his advertising. If it worked, he'd never have to deal with the likes of Clay Felker or Liz Tilberis again. Hearst figured it was presold to the hundreds of thousands of names he'd collected in a database of names of almost everyone who'd ever spent more than $100 in a Polo shop.

"Ralph had great aspirations," says a Hearst editor. "He wanted Tina Brown to edit it." But she was editing *Vanity Fair* at the time, so, in 1992, Annemarie Iverson, a former beauty editor at *Seventeen*, was named creative director and set up in an office at 650 Madison to produce four seasonal prototypes. Lauren wanted, *Advertising Age* surmised, to "control the editorial environment in which his company's advertising appears." There was a lot of that. Polo spent $10.5 million for ads in magazines in 1991.

A test issue was scheduled for April 1993, but Iverson left, so Ralph brought in Ed Klein, the husband of his public relations director, Dolores Barrett, and a highly regarded magazine editor. Klein hired an experienced art director, articles editor, and photo editor. His idea was to create a carriage trade glossy like *Connoisseur*, focused on Lauren-esque art, antiques, auctions, and lifestyles. He

put together a new prototype, and showed it to the Polo posse—Birrittella, Sandy Carlson, and Mary Randolph Carter—who promptly called Lauren to warn him that Klein was intent on destroying his image. A meeting with Ralph followed— at which Klein grew so exasperated, he flung the material he'd brought with him on the table and announced he was quitting. "Ralph couldn't talk about substance," says someone who was there. "He thought it was all about appearance and the rest was filler."

In late 1993, *Lauren's* third editor, John Howell, was sent to Ralph by a headhunter. Howell was the perfect candidate, having worked both for *Elle* and Calvin Klein, where he'd coined the name Escape for a fragrance and written product-positioning materials. "Ralph wanted his advertising/branding concept in real editorial," Howell says, "and he wanted it to look like his ads." Sandy Carlson had been named creative director of the magazine, but Lauren was "adamant that there had to be real editorial," says Howell, "although he made no specific suggestions" except that he wanted *Lauren* to look like the *Look* magazine of the 1950s and read like *The New Yorker*. Then he left for his ranch for the summer, leaving Howell up in the air. Finally, just after Labor Day, Howell was summoned to 650 Madison "for a meeting and by the way, you're hired," he recalls. Howell's job was to turn Carlson's latest dummy—which he considered no more than a multipage Polo ad—into a magazine.

Given offices at both Hearst and at Polo, Howell started work on an accelerated schedule—"like being strapped to a locomotive," he recalls. He met Ralph weekly. "He wanted everything immediately. He didn't understand you couldn't do it in a week or two. But Ralph can't talk things out; you have to show him." And he couldn't say what he wanted. "You had to feel your way." Carlson did layouts on subjects like the western writer Zane Grey, foreign correspondents, the Bugatti family, estate dogs, old ocean liners, Scott Fitzgerald, and how differently jeans are worn in different places. "But nothing pulled together," says Howell. "He wasn't getting what he wanted from pushing. And eliminating all possibilities is an exhausting way of doing a magazine."

Pictures were easy. Just as Lauren kept an archive of clothes, he also had one of old photographs. "I had to remind them to leave room for words," Howell says. "But they emphasized visuals—it's what Ralph understands." Anytime Ralph returned to the same subject twice, Howell tried to turn it into a story idea. "I kept accumulating what he liked and eliminating what he didn't." Early in 1994, Hearst let it be known it would publish two issues of *Lauren* in 1994 and four in 1995 with a circulation of 250,000. "The trigger has been pulled," a Hearst executive told the trade press. A mission statement for advertisers quoted Ralph: "*Lauren* is about people, places and things that continue to inspire us. It's

about the beauty of the world. It is not a magazine of the moment; it is a magazine of our time."

Howell began commissioning original material. But whenever layouts had to be shown to Ralph, Carlson would do them the most expensive way possible, with costly high-quality color prints. The legendarily tight-fisted Hearst, which was paying all the bills, began to question them, "and no one can nail down numbers like Hearst," says Howell, who had to explain where the money was going—and why. More problems arose when writers Ralph wanted proved unavailable. "If he wanted them, why couldn't he have them?" Howell says.

Finally, though, the problem with *Lauren* boiled down to words. "Not his forte," says Howell. "In my mind, he's someone who began life in another language. He's not a reader. He fancies himself a connoisseur of magazines, but text didn't capture his imagination. If there was no credible text, then what was he making?" When Carlson took pictures done for the magazine and reshot them as ads, Howell really started to fret. "To Ralph it was synergy," he says. "To a publishing person, it was dicey. Then David says, 'Gee, Dad, I want a magazine.' Here was a train coming down the track, and *Lauren* was in the way."

David Lauren had decided to relaunch *Swing* as a national magazine, and Ralph wanted Howell to advise him. "I felt right away that he was enthusiastic, idealistic, and overindulged, and would have problems," says Howell, who thinks David drew the wrong conclusions from his father's success and decided he could not only start at the top, but in a world he didn't know. Howell tried to help anyway. But then he went to a meeting to show Ralph a new dummy for *Lauren*, filled with layouts for story ideas he'd signed off on—"and he looked at it like it was an alien object because Carlson hadn't done it," Howell says. Though he kept showing up for work, Howell told Hearst he thought *Lauren* "was not going forward. But Ralph couldn't say it. Something in him was determined to avoid humiliation at all costs." The head of Hearst Magazines finally called Ralph, who never called back.

"That did not sit well," says Howell.

By April 1994, *WWD* was reporting *Lauren's* demise in an article on the launch of David's *Swing*. Ralph was not involved in *Swing* "in any way," said David, who claimed venture capitalists were financing him but refused to name them. Conveniently, Hearst agreed to distribute David's magazine. And that fall, Howell was asked quietly to fold his tents and disband his staff. He didn't say goodbye to Ralph. "What would I have said?" he jokes, "Why did you favor your son?"

David published his first issue of *Swing* that October out of offices on Madison Avenue. Polo was announced early as a big advertiser, taking six full pages at

$5,000 per. "His dad underwrote it," says Howell. "People got the word, help my son. What father wouldn't help his kid?" David sounded much like Ralph in press interviews, same rhthym, same cadence, same chatter about honesty and integrity. "I've been exposed to a certain life that gives me insight and a sense of myself and quality and it gets translated into my own thing," he said. The *Columbus Dispatch* was unimpressed. "*Swing* offers shallowness, pretty design and a blown opportunity" with articles that were "unremarkable and occasionally laughable," it said.

Despite their argument over *Manhattan Inc.*'s cover illustration of Ralph as Paul Revere a few years earlier, Lauren asked magazine guru Clay Felker, in semiretirement in California, to help David out with his first issue. "He had a real line of patter, he was a personable guy, but David was not a natural editor," Felker recalls. "He couldn't make up his mind" what his magazine was going to be. "The Laurens all have a problem making up their mind. In the end, Ralph always managed to hit it right." But Felker sensed that David was a different beast. "There were endless rewrites," Felker says, "and they always ruined the stories. He changed stories without telling the writers and that's not the way I ran magazines. It was very difficult to work with him. He was not a professional, nor did he seem to have much of an instinct for journalism."

Swing switched from Hearst to Hachette Magazines for support after less than a year. Just before the change, a Lauren advertising executive had mentioned to Ralph John F. Kennedy Jr.'s new magazine, *George*, which Hachette published. Why, Ralph demanded, was that kid getting so much attention? Kennedy was popular, the executive replied. "I'm more popular than he is," Lauren snapped. "David should be getting more attention."

Swing's performance was uninspiring, yet it survived for four years. Everyone at Polo was called upon to help David out. Only to them did Lauren admit that he'd lost millions supporting his son—around $10 million in all. Despite that, *Swing* sold only about ten percent of the copies it put on newsstands, less than ninety thousand copies a month. Though it did gain national attention—once—for a story called "Lesbians Until Graduation," it folded in November 1998, and twenty people lost their jobs. "[David] was a terrible flop as a magazine editor," says Clay Felker, who nonetheless offers some praise. "His father always wanted David to work for him. He feels he's a natural salesman, and he may be. He did a good job selling ads for a magazine that didn't have a lot of substance."

David soon joined polo.com, but Ralph wasn't satisfied. He admitted he wishes both his sons were working alongside him in the core Polo business. "I would like them to be here, but I know what it's like to want to do your own thing," he says. "I had to beg David to come in. He wants to be David. He says,

'I don't want to be Ralph.' " Yet in February 2001, David would appear on the cover of the *Industry Standard*, under the headline "The Crown Prince of Polo." And that fall, Lauren's communications department was reorganized—his umpteenth PR director "resigned"—and David went on Polo's payroll for the first time as its senior vice president of marketing, advertising and corporate communications. He has his work cut out for him. His father still goes ballistic when he gets bad press. "He wants respect and doesn't realize he already has it," says a former PR executive. "It haunts him 'til this day."

And David has gotten some bad press himself. In summer 2002, the *Daily News* revealed what many young people on the New York social scene had known for months: David Lauren had been having an affair with an actress named Aliza Waksal. There was nothing wrong with that except that Waksal's father, Sam, who'd founded a bio-tech company called ImClone, had recently been arrested and charged with insider trading, and daughter Aliza had been identified in the press as one of several members of the Waksal family who'd sold ImClone stock just before problems at the company were made public. The stock price of lifestyle diva Martha Stewart's public company had fallen as a result of her involvement with Waksal. Ralph's reaction to David's affair went unrecorded.

Finally, it's unclear how much Ralph cares about family succession. "David is very creative and intelligent," says a source at Goldman Sachs, "but he's not going to run a world-class multinational company like this. That takes a breadth of skills that very few have. Ralph hopes David will develop them, and will give him the opportunity to, but he won't favor him." Goldman Sachs should know: it still owns 11 million shares of Polo.

Despite his parsimonious reputation, Ralph has been, by all accounts, quite generous with his immediate family—and those he connects to it. "I got news for you, he sent a lot of money [to his family's synagogue, Young Israel of Mosholu Parkway] over the years," says Esther Wyszkowy, his neighbor from Steuben Avenue in the Bronx. "I give him credit. He never forgot. He don't forget who he is. Let people not make stories. He was a brilliant son to his parents 'til the day they died. He sent [his aunt] Bessie money, too. He sent her clothes. I bow my head to him. How many make money and get big and don't want to know anybody? This is not him."

Ralph has also been generous to P.S. 80, the school he fought so hard to attend. A few years ago, the student government reached out to famous alumni Robert Klein, Calvin Klein, Penny Marshall, and Lauren, says former principal Lawrence Gluck, "and Ralph was the only one who responded. He made a new

logo for their jackets," and paid for a new sound system and curtain for the school auditorium. "And for whatever reason, he didn't want any publicity." The same thing happned when Ralph donated money for Talmudic studies to his Manhattan temple.

Then there's Nina Hyde's special cause, breast cancer. In 2001, Ralph gave $5 million to create a Ralph Lauren Center of Cancer Prevention and Care at North General Hospital in Harlem. And he's been good to some old friends, too. A few years ago, Ralph reconnected with one of his old basketball buddies from the P.S. 80 school yard. Oscar "Ockie" Cohen, then the head of the Lexington School for the Deaf in New York City, called to say that one of his students was a Polo fan, and asked if Ralph would spend an hour with the child's class. "Ralph came out with his driver, walked in alone, and met with about a dozen students," speaking through a sign language interpreter, Cohen recalls. "They had a zillion questions. Our students are profoundly deaf. A lot of people lean back; he leaned in."

Then, Ralph turned the table on the students. "What should I do that I'm not doing?" he asked. "And he pulled out a pad and wrote down what they said," Cohen recalls. "After an hour, I intervened, but he said he'd stay." After another hour and a half of questions, photos, and autographs, Lauren finally departed. The next day, a box of Polo baseball hats and cologne arrived at the school, and Lauren's visit became an annual affair.

"He's the same person I played ball with," says Cohen, who was recently made the executive director of the Polo Ralph Lauren Foundation. "He's the warmest, most gentle person you could know, quiet, reserved, modest, no bull-shit, no airs. He told me he wants to give back because he feels so lucky."

Lauren's relationship to Judaism remains uneasy, at best. He constantly wonders why people call him a self-loathing Jew when he holds an annual Passover seder, lights candles on Hanukkah, and goes to temple on major holidays, publicly *davening* in a prominent pew. He even proclaimed his pride as a Jew when Frederic Brenner, a French photographer, invited him to be one of the children of Jewish immigrants photographed and quoted in a book and exhibition he put together, "Jews/America/A Representation."

In October 1996, Brenner brought Lauren and about two dozen other Jewish celebrities to Ellis Island for an event marking his book's publication. They posed in a labyrinth of their portraits that Brenner had constructed. On the way there, Lauren gave an interview to the Jewish Telegraphic Agency. "I'm very Jewish," he said, though he acknowledged that his religion isn't reflected in his work. In Brenner's book, Lauren wrote that he hoped American Jews would

instill Jewish beliefs and culture in their children. Sitting on the ferry to Ellis Island with Ricky, he pointed out that Andrew and David had both gone to Hebrew school and been bar mitzvahed, although he added that Dylan Lauren had not.

"I love that he became the essence of white Anglo-Saxon Protestant," says Brenner. "Jacques Chirac wears Ralph Lauren. It's amazing." The photographer decided that Lauren was of two minds about his religion. "As for many of us, who wanted to be Jewish?" Brenner asks. "For many people I've photographed, Judaism was bad news. There was a reaction against *shabbat* dinner at his mother's. Ralph didn't enjoy it. Nonetheless, he's concerned by his heritage. He is attached to something beyond the memory. This is the paradox we all live with. We have the capacity to take on the shape and color of the places we inhabit. But it's amazing how we become the other and still retain our selves."

92

Whither Polo? Ralph's partners at Goldman Sachs are sanguine about Polo's prospects. "I'd argue the company is stronger than ever," says Richard Friedman. "He's been bold in changing management; he's been forced to think about growth and costs."

So the question may be better put, whither Ralph? He seems to have abandoned lifestyle designing. "A diminishing trend," says a former creative services executive. "You used to be able to take a Polo ad, remove the logo, and still know it was Ralph Lauren. No more."

Ralph has bigger goals now. "He sees Ralph Lauren as a global brand beyond apparel and home furnishings," says Marvin Traub. "Who'd have thought of Ralph Lauren Paint with fifty-one shades of white? This urgency to add and create is very much part of the spirit of Ralph Lauren." Food products, restaurants, hotels, and media will likely be part of the picture—and pretty as a picture, too.

George Friedman, the cosmetics executive, sees Ralph as Everyman. "He's just like everyone else; that's the secret of his success." The question is whether he mistakes the movies in his head for reality. "Ralph has created a life for himself where it's very hard to tell what's real and what's not," says one of his first cus-

tomers. "He's shielded now," says Jeffrey Banks. "He doesn't know what's going on. People don't tell him things because they don't want to upset him." Even friends admit they worry about that. "He's come a long way and people in that position get further and further away from reality and there's no one to pull them back," George Friedman admits. Yet Polo has changed with the times, from a rare and precious independent movie to a big, expensive, mass-market blockbuster.

Much as he's evolved, Ralph has remained the same in certain essentials. "He can't interact. If the subject isn't him, he's lost," says an ex-employee. "He sees Cary Grant when he looks in the mirror and gets you to believe it—is that bad?" asks an old menswear colleague. "But he's driven by insecurity. He wants to get even. He doesn't like people who don't agree with him. He needs applause. There's a basic decency, yet even with all the success, you wouldn't classify him as a happy guy."

Ralph remains a battlefield where conviction and vulnerability are in constant combat. "He's very odd," says his close friend and ex-employee Ann Boyd, in the course of declining to be interviewed. "People, in one sense, like the publicity, but then it scares them and they pull away at the last moment. He does that a lot. I think an awful lot of Ralph; he sort of is astonished that he's got where he is."

And he's not done yet. At age sixty-three, retirement isn't even on the horizon. "I think basically, he's cursed," says Edwin Lewis, the southern supersalesman who betrayed Ralph by taking his secrets to Tommy Hilfiger. Lewis thinks Ralph is still the little boy who wanted to be a millionaire, never satisfied that he has enough. "I believed in the man who put the product together, and I do to this day, but I tell you, the man's crazy," Lewis continues. "Some of the stuff he does, it's so insecure and so small time, it just makes no sense."

Narcissists, of course, can never really win the object of their desire. And the replacements they *can* find leave them incomplete. "If money, fame, power, serial girlfriends, and a great family had made him happy, we wouldn't be having this discussion," says an ex-employee. Marvin Traub agrees that Ralph will never be satisfied. "But I think that's a strength," he says, with a sideways glance and a quick little smile. "He can be happy and restless as opposed to happy and content." A creative services executive sees his ex-boss as secure in what he's accomplished, yet "baffled by the question of how he'll be remembered. He'll say he'll be remembered as a man whose name became an adjective."

Ralph Lauren is the epitome of several of America's cherished dreams, wealth being one of them. Along with those dreams comes the American curse of always seeking the next frontier, wondering what lies beyond the next ridge.

"We all get report cards in many different ways, but the real excitement of what you're doing is in the doing of it," Lauren says. "It's not what you're gonna get in the end—it's not in the final curtain—it's really in the doing it, and loving what I'm doing. That's my high. What's next? I don't know. I'm just doing it."

Lauren has never been a social creature. He keeps to himself in Montauk and has never socialized much in New York City, preferring movies, controlled crowds of employees, and visits to his stores to parties where his discomfort is palpable. He's not considered a good neighbor in Bedford, where he chained off horseback riding trails that had been open for generations after tractors working on the property spooked two horses in 1989. He rerouted the trails around the perimeter of his property and has kept them closed since, says estate manager Michael Farina, because they would otherwise pass through his front yard. In the years since, they've grown over and neighbors, like music businessman Tommy Mottola, tycoon Carl Icahn, and Laurenesque lifestyle maven Martha Stewart have closed theirs, too. None of them have won any friends by violating the local traditions.

Ralph has tried harder to fit in at Round Hill, the Jamaican vacation colony that has evolved from a home for eccentric Englishmen into one more impressed by American businessmen. Lauren doesn't socialize much there, either, has his own path to the beach, and tends to sit by himself, although he's cordial when spoken to. "He came to the dining room one night in a sarong," says a resident of the colony. "He was trying, but Round Hill is not a place where you try, and it doesn't come easy for him." Another longtime resident says Ralph is considered aloof. "They call him Ralph Lifshitz, sneeringly," the resident says, "then they go to his dinner parties."

Of all the stage sets of his life, the Double RL in Colorado is the one where neighbors find him most at ease. "I feel small, minute here," Ralph said of the place that he's slowly expanded, buying up pieces of Marie Scott's property that had passed to others, "putting it all back together," according to rancher Charlie Hughes. He now owns about sixteen thousand acres.

Lauren spent "millions building roads, digging ponds, clearing pastures, and mending stables," Hughes continues. Ralph personally picked out the stones for the cookhouse fireplace and reproduced antique hinges for the doors. As usual, stories went around about his perfectionism: they had him importing crushed gravel from Montana and Wyoming because he didn't like the shade of gray of Colorado rocks, building and tearing down houses, and doing the same with the fifteen-mile fence that surrounds the property.

In fact, Lauren had been disappointed when he first visited the West and

found that there were no more cowboys, none of the forever fences of his dreams. So he decided that his ranch would have both. "I want everything to be real," he said. He built with antique logs, cedar shingles, and stone, and he did indeed tear down the main house and rebuild it, says Ted Moews, who designed all the houses.

The Lodge, as the two-story beamed-ceiling house is called, was taken down and rebuilt on a different site with larger logs and whiter chink joints. And the Double RL's four-rail split-pine log fence was stained several times after it started graying too soon. Lauren's contractors balked, pointing out what it would cost to restain it. "It doesn't make a difference," Ralph supposedly replied. "I have so much, I can't spend it."

The ranch also boasts Navajo rugs, Indian art, Mission furniture, and animal skins on the walls. The Little Brown Cottage, a mile away, is for guests. Stables and a cookhouse where Ralph sometimes breakfasts with his ranch hands are in between. They talk about the thousand head of cattle that produce Double RL-brand steaks for his guests and those lucky enough to be on his top-tier holiday gift list. After breakfast, Ralph rides Apache, his spotted Appaloosa, wearing chaps custom tailored for a snug fit.

In the city where he works, Ralph is sometimes seen, to use a cowboy turn of phrase, as all hat and no cattle—in other words, a fake. And often, he seems to beg to be so described. But even though Ralph never mentions Marie Scott, and he's been known to claim that the John Wayne film *True Grit* was filmed on his property even though it was actually set on another ranch nearby, Ralph has made a good impression on most of those who've met him on the set of his western movie.

"[The Laurens are] a credit to the community," says Charlie Hughes, the rancher who sold Lauren the Double RL. "He hired qualified help, and he runs it to make a profit. He doesn't hang out; he's visible, but he doesn't lord it over people. They ride all the time. He's got good riding skills. Lots of guys been riding fifty years around here, don't ride as good."

"He fixed it up, fenced it up, oiled all the logs, and built the caretaker a new house," says Marie Scott's old foreman, Mario Zadra. "He's a good common-sense guy. I've met Robert Redford a time or two. He's more artificial than Lauren. Lauren is down to earth, a good sharp businessman. He's done a lot for the area. He contributed to the town, the library, the schools. He's done a good job with them cattle, too. He has a nice herd. They feed them cattle good. I think he's making a go of it."

"[The Laurens] were small in stature, but as I got to know them, I came to

admire him," says William Waldeck, a local lawyer who represented one of Marie Scott's heirs. "Westerners want a straight shooter and not a lot of pretense. He even liked to dress in the kind of clothes worn by cowboys—not drugstore cowboys, but real ranchers."

Waldeck recalls that when the widow of Roy Lewis, a rancher who'd sold his land to Marie Scott, gave its new owner, Lauren, a pair of beat-up old Levi's her husband had worn, Ralph was ecstatic. "Can you imagine that?" Waldeck asks. "A guy like him loving jeans you'd find at Goodwill?"

On Colorado's Dallas Divide, at least, they think Ralph Lauren is the real thing, from his hat right down to what sits on his cattle-skin saddle.

Sources and Acknowledgments

Trying to reconstruct a life when the person who lived it won't help you can be a difficult task. In total, I contacted more than 850 people. Some declined to participate. A few, as discussed in the Author's Note at the beginning of the book, wished to remain anonymous. In the absence of their names, I thank them from the bottom of my heart for giving me their time and trusting me with their memories. The names of most of the rest are listed below. I have undoubtedly forgotten a few and to them, I apologize. The names that follow include people who gave interviews, people who helped me find people who gave interviews, and people who were simply helpful or kind as I tried to learn about Ralph Lauren.

Thanks, then, to Slim Aarons, Lewis I. Aaronson, Joseph Abboud, Natalie Albin, Tzvi Abusch, Milton Adesnick, Joe Aezen, Albert Aldasaro, Theoni V. Aldredge, Woody Allen (and his assistant, Sarah Allentuch), Robert Amdur, Arnaldo Anaya-Lucca, Gil Arazi, Robert Asch, Barry Augenbraun, Julian AvRutick, Jeffrey Banks, Roz Barasch, Harold Baron, Joe Barrato, Jack Barry, Wilkes Bashford, Serena Bass, Bob Beauchamp, Alexandre Beider, Phillip Benblatt, Mike Bernhardt, Harvey Bernstein, Michael Bernstein, Peder Bertelsen, Neil Betten, Tom Bezucha, Maurice Bidermann, Steve Bloom, Ralph Blum, Alvin Blumenfeld, Susan Boersen, Jerry and Helene Gerhardt Bond, Dennis Bookshester, Ann Boyd, Ed Brandau, Pam Branstetter, Steve and Marsha Bratter, Carol Stillman Braunschweiger, Steven Braunstein, Fredric Brenner, Judy Bring, Martin Bring, Ted Broome, Shirley Brower, Hank Brown, George Bruder, Nat and Lillian Buchman, Esther Buchsbaum, Joseph "Jeb" Buchwald, Jules Buchwald, Amanda Burden, Ellen Burnie, Joan Burstein, Sidney Burstein, Murray Burton, Albert Capraro, Patt Carr, Sal Cesarani, Rabbi Zevulun Charlop, Linda Churilla, Maggie Clare, Alberto Cohen, Doreen Cohen, Lois Schulman Cohen, Oscar "Ockie" Cohen, Sy Cohen, Mack Colin, Phineas Connell, Bill Connors, Alan Cooper, Joel Cooperman, Mel Creedman, Nancy Crumley, Rabbi Irwin Cutler, Rabbi Jerry Cutler, Steve Damsker, Susan Damsker, Rose Damsky, Leslee Dart, Rudy Davison, Alan Dershowitz, Sandy Lokietz Dworkin, Sam Edelman, Anthony Edgeworth, Lee Eisenberg, Arie "Lova" Eliav, Alvin "Eppy" Epstein, Sylvia Ettenberg, Charles Fagan, Erik Fallenius, Mike Farina, Josephine Fay, Seymour Feder, Doris Feder Blumberg, Herbert Feinberg, Daniel Feigen, Phil "Pinky" Feiner, Marvin Feinsmith, Clay Felker, Jerry Ferguson, Steve Finkel, Don Fisher, Alan Flusser, Angela Fowler, Luke Fowler, Neal J. Fox, Samuel G. Freedman,

Michael Fried, Melvin Friedland, George Friedman, Jeanette Friedman, Marty Friedman, Norman Friedman, Sorel Friedman, Dan Frucher, Alfred Fuoco, Nick Gamarello, Susan Gammie, Bernie Geizer, Shelly Geller, Neil Gerhardt, Morton Gitter, Ed Glantz, Lawrence Gluck, David Goldberg, Gary Goldberg, Les Goldberg, Paul Goldberger, Neal Goldman, Henry Gootblatt, Mort Gordon, Carolyn Gottfried, Bruce G. Boyer, Milly Graves, Vivian Moser Greene, Martin Greenfield, Charles Griffen, Bill Griss, Clifford Grodd, Mindy Grossman, Gloria Gresham, Don Guerra, Judith Haber, Emily Hacker, Melissa Hacker, Harriet Hand, Donald Harris, Claudia Hawkins, Rabbi Michael Hecht, Nancy Heitman, Steve Heitman, Rabbi Jonathan Helfand, Harvey Hellman, Warren Helstein, Jack Hiller, Nick Hilton, Norman Hilton, Marcia Hirsch, Fred Hirschberg, June Hochwald, Kristin "Clotilde" Holby, Martin Honig, Doug Hopkins, David Horowitz, Michael J. Horowitz, Jennifer Houser Hoglund, John Howell, Jonnie Hoye, Charlie Hughes, Joan Hyler, Luke Irons, Merle Jenkins, Kenneth Johansen, David Kantes, James Kaplan, Joel Kaplan, Chuck Kaufman, Brian Kaye, Jerry Kaye, Walter Kaye, Susan Kennedy, Jerome Kern, Richard Khentigan, Martin Klein, Alvin Kohn, Hester Koota, Pete Korn, Marilyn Kowaleski, Reed Krakoff, Stuart Kreisler, Melanie Kreuzser, Saul Krotki, Stanley Kupinsky, Murray Kurzman, Mark Kutsher, Jay Ladin, Eleanor Lambert, Brigitte Langevin, Leonard Lauren, Marvin Lederman, Gloria Leonard, Gary Lessin, Joel Levine, Lew Levine, Barry Levites, Barbara Levy, Edwin Lewis, Alex Liberman, Monte Lichtiger, Rabbi Seymour Liebler, Seymour Linden, Armand Lindenbaum, Mike Lobel, Daniel Loeb, Tom Low-Beer, Frank Low-Beer, Jerry Magnin, Jacques Malignon, Jay Marron, Bryan Marsal, Mark Matszak, Andrew McCullough, Barry McKinley, Nathan "Sonny" Meiselman, Nina Meledandri, Risha Meledandri, Bob Melet, William Merriken, Hank Meyerson, Ronnie Miller, Joseph Mimran, Ted Moews, Bernadine Morris, Arlene Morse, Sy Morse, Stanley Moses, Avrohom Moshel, Seymour Moskowitz, Jack Mulqueen, Westin Naeff, Avram "Doc" Nathanson, Marilyn Newman, Chris Nolan, Sam Norich, Maggie Norris, András Oblath, Dan Offen, David Oswald, Murray Palatnick, Jimmy Palazzo, Janie Paris Guerra, Ed Pastoucha, Rabbi Leonard Pearl, Dave Pensky, Richard Perez-Pena, Rabbi Jechial Perr, Shlomo Pfeifer, Rabbi Israel Pilchick, Steven Pilchick, Marilyn Pincus, Audrey Polinsky, Edwin Polsky, Judith Putterman, Sugar Rautbord, Robert Raymond, Abe Reiss, Jill Resnick, Hilda Riback, Dave Richman, Ronnie Roberts, Bobby Roman, Jean Rosenberg, Len Rosenfeld, Richard Roth, Jay H. Rothbaum, Howie Rothman, Irving Thomas Rothenberg, Ralph Rothenberg, Randall Rothenberg, Melvin Rothman, Joel Rudish, Jimmy Runsdorf, Jim Rushton, Sid Rutberg, Robert Ruttenberg, Steve Samtur, Shari Sant Plummer, Robert Schiff, William Schimel, Herb Schimmel, Norm and Leonore Schlissel, Ernie Schmatola, Charles Schnall, Nechemiah Schneider, Norman "Duke" Schneider, Jeffrey Schneier, Ian Schrager, Jack Schultz, Elaine Segal, Phil Seiden, Carol Sessler Howard, Larry Shapiro, Aliza Sharon, Matthew Shatzkes, Gerald Shaw, Carol Siegel, Mike Siegel, Leonard Sirowitz, Larry Sirolli, Irving Skydell, Anita Skydell Chanowitz, Bill Sofield, Marty Staff, Malcolm Starr, Bob Steckler, Michael Steinberg, Dr. Mike Stillman, Robert Stock, Harvey Stoller, Neil "Butch" Stoller, Seymour "Sim" Storch, Bohumir Strnad, Jan Strnad, Jeff Strnad, Dick Tarlow, Monika Tilley, Barbara Tilzer-Frankel, Emanuel Topal, Samuel Topal. Mike Toth, Isabelle Townshend, Jeffrey Trachtenberg, Goldine Eismann Triantafyllou, Louise Mead Tricard,

Pauline Trigère, Gil Trueddson, Carll Tucker, Yvette Vega at Charlie Rose, Salvatore Vergopia, Dov and Gila Vogel, Anne Wade, William Waldeck, Bruce Weber, Solomon Weider, Arlene Weiner, John Weitz, Howard West, Renee Whiteman, Abe Wiesel, Ted Wiesenthal, Louise Wilson, Brigitte Winkler, Robert Wolders, Daniel Wolf, Martin Wolpin, Esther Wyszkowy, Bonnie Young, Mario Zadra, Alan Zaitz, Steven Zaitz, Michel Zelnik, Vic Ziegel, Mel and Patricia Ziegler, and Loretta Wein Zimmer.

I want to single out Lenny Lauren, Marvin Traub, and Richard Friedman of Goldman Sachs, each of whom helped greatly despite understandably mixed feelings about the project. Ralph's best friend, Steve Bell, wanted to help, but finally did not at Lauren's request. I respect both impulses. Lynn Tesoro and Hamilton South, formerly of Polo Ralph Lauren, did the best they could under trying circumstances—and I appreciate it. Ralph Lauren's assistant, Kathleen Natoli, provided a conduit to him when all others were closed off.

A number of people who declined to give interviews for this book are quoted nonetheless, or provided information that helped me. That help and those quotes were given to me when I profiled Bruce Weber for the New York Times Magazine and Vanity Fair in 1985, and Ralph Lauren for New York magazine in 1992 and again in 1993. Though some of them would probably prefer to forget, I nonetheless thank the following for their contributions to my archives, and thence to this book: Ralph and Ricky Lauren, Bruce Weber, Nan Bush, Jerry Lauren, Buffy Birrittella, Sandy Carlson, Charles Fagan, Lee Mindel, Frances and Joey Grill, Tim Priano, Ruth Ansel, Vicky Pribble, Howard Read, Robert Miller, the late Donald Sterzin, Nancy Vignola, Dolores Barrett, Alexander Vreeland, Ann Magnin, Max Wilson, Gale Parker, and Polly Eastman. The editors who assigned or had a hand in editing those magazine pieces were Ed Klein and Michaela Williams at the Times, Tina Brown, Miles Chapman, and Pamela McCarthy at Vanity Fair, and Edward Kosner and Quita McMath at New York. I thank them all for helping me lay the foundation upon which this book was built. Portions of this book are also based on other reporting originally done for the New York Times and Manhattan Inc. I thank my editors at each: Nancy Newhouse and Harold Gal at the Times and Jane Amsterdam and the late Duncan Stalker at Manhattan Inc.

My education in genealogy and Jewish history began with the extraordinary Itzhak Epstein, a distant relation through marriage of Ralph Lauren, whom I met by serendipity and whose generosity was a gift I can never repay. Also helpful and kind were Carol Skydel, a Cutler relative and an official of jewishgen.org, an extraordinary website dedicated to Jewish family history; the staff and website of the American Family Immigration History Center at Ellis Island; genealogists Neil Rosenstein and Holly Tooker; Fruma Mohrer and Yeshia Mettle of the YIVO Society; Joe Majid and Richard Gelbile at the National Archives; Adam Davis of the Pinskers discussion group on Yahoo!; Sebastian Markt, Roland Winkler, Frank Mecklenburg, and Karen Franklin at the Leo Baeck Institute; Heidrun Weiss of the Jewish Community of Vienna; Ralph B. Hirsch of the Council on the Jewish Experience in Shanghai, and Elisheva Carlebach, Carol Lipson, Dena Fichot, Georg Gaugusch, Glen Strauss, Ellen Stepak, Rabbi Andrew Bachman, Anne Ginsberg, Nachum Boneh, and Ronit Zadikov.

Thanks, too, to Aliza Phillips at the Jewish Forward, to Anita Citron, to Gene Therriault and Peter Carucci of the New York State Department of Health, to Joyce

Grady at Bronx Civil Court, to Latoya Edwards at the Federal Archives in Kansas City, to Rabbi Michael Hecht, David Deutsch, Shuli Berger, Seth Taylor, and Sam Hartstein at the Boys Talmudical Academy, to Sally Oshins at Salanter Akiva Riverdale Academy, and to Richard Iannacone at CCNY, Eileen Sylvester at J.H.S. 80, Jill Lewis-Kelly at the Cooper Union, and Valeska Hilbig at the Smithsonian.

My research assistants were and are beyond compare. Thanks to the indefatigable Asli Pelit and Sarah Mandle, and to my transcriber, Ted Panken.

At HarperCollins, my thanks to Diane Reverand, who acquired the book; Cathy Hemming, who supported it throughout its long gestation; Marjorie Braman, who edited it with good humor, grace, sternness when necessary, and a skill I have never before encountered in book publishing; and to Janet Dery and Leslie Engel.

During the thirty months that I worked on this book, I also worked for three great magazines, *Travel & Leisure*, *George*, and *Talk*, the last two of which are sadly no longer with us. But my editors and colleagues Nancy Novogrod and Laura Begley at *Travel & Leisure*, Frank Lalli, Steve Gelman, Loren Feldman, Nancy Waits, and Phil Bratter at *George*, and Tina Brown, Bob Wallace, and Perry van der Meer of *Talk* are all still standing and deserving of thanks for tolerating my divided attention.

Jared Paul Stern and Richard Johnson, of Page Six at the *New York Post*, and particularly Christopher Ogden, were kind and helpful. I thank, too, my friends Stephen Demorest, Peter Herbst, Eric Pooley, Maer Roshan, Caspar Grathwohl, Phoebe Eaton, Steve Garbarino, and Denise Hale for support both moral and otherwise.

And finally, as always, my most profound thanks to my family, to Barbara, and to our Westie, Calpurnia. Because of Ralph Lauren, I appreciate them more than I ever did before.

Bibliography

Agins, Teri. *The End of Fashion*. New York: William Morrow, 1999.

Boyer, G. Bruce. *Elegance*. New York: Norton, 1985.

Cohen, Chester G. *Shtetl Finder*. Bowie, Md: Heritage Books, 1989.

Fitzgerald, F. Scott. *The Great Gatsby: The Authorized Text*. New York: Scribner, 1995.

Flusser, Alan. *Style and the Man*. New York: HarperStyle, 1996.

Gabler, Neal. *An Empire of Their Own*. New York: Crown, 1988.

Herskovis, Mayer. *Two Guardians of the Faith: The History and Distinguished Lineage of Rabbi Yom Tov Lipman Heller and Rabbi Aryeh Leib Heller*. Jerusalem: Graphit Press, 2000.

Howe, Irving. *World of Our Fathers*. New York: Harcourt Brace Jovanovich, 1976.

Lasch, Christopher. *The Culture of Narcissism*. New York: Norton, 1979.

McDowell, Colin. *McDowell's Directory of Twentieth Century Fashion*. London: Frederick Muller, 1984.

Milbank, Caroline Rennolds. *New York Fashion*. New York: Harry N. Abrams, 1989.

Morris, Bernadine, and Barbara Walz. *The Fashion Makers*. New York: Random House, 1978.

Peerce, Jan, and Alan Levy. *The Bluebird of Happiness*. New York: Harper & Row, 1976.

Perschetz, Lois. *W: The Designing Life*. New York: Clarkson N. Potter, 1987.

Rabinowitsch, W. Z. *Lithuanian Hasidism*. London: Valentine, Mitchell, 1970.

Rosenstein, Neil. *The Unbroken Chain: Biographical Sketches and Geneology of Illustrious Jewish Families from the 15th–20th Century*. New York: CIS Publisher, 1990.

Rosten, Leo. *The Joys of Yiddish*. New York: McGraw-Hill, 1968.

Silverman, Debora. *Selling Culture*. New York: Pantheon, 1986.

Taylor, Seth D. *Between Tradition and Modernity: A History of the Marha Stern Talmudical Academy*. New York: privately published, 1991.

Tilberis, Liz. *No Time to Die*. New York: Little Brown, 1998.

Trachtenberg, Jeffrey A. *Ralph Lauren: The Man Behind the Mystique*. New York: Little Brown, 1988.

Traub, Marvin, and Tom Teicholz. *Like No Other Store . . .* New York: Times Books, 1993.

Veblen, Thorstein. *The Theory of the Leisure Class*. New York: Dover, 1994.

Weber, Bruce. *Bruce Weber*. Los Angeles: Twelvetrees Press, 1983.

White, Norval, and Elliot Willensky. *AIA Guide to New York City*. New York: Three Rivers Press, 2000.

Index